Western European Illuminated Manuscripts of the 8th to the 16th Centuries

EDITION:
Marina Grigorieva

TRANSLATION:
Mireille Faure

PRESENTATION:
Sergueï Diatchenko

Printed and bound in
ISBN 1 85995 240 2

TAMARA VORONOVA - ALEXANDER STERLIGOV

Western European Illuminated Manuscripts

of the 8th to the 16th Centuries

in the National Library of Russia, St Petersburg

FRANCE, SPAIN, ENGLAND, GERMANY, ITALY, THE NETHERLANDS

PARKSTONE PRESS, BOURNEMOUTH
AURORA ART PUBLISHERS, ST PETERSBURG

CONTENTS

Preface 6

Western European Illuminated Manuscripts
in the National Library of Russia (by Alexander Sterligov) 7

The History of the Collection of Western European Illuminated Manuscripts
in the National Library of Russia (by Tamara Voronova) 29

Notes 38

FRANCE 42-213

Epistles of St Jerome - Evangelistary (9th century) - Evangelistary (third quarter of the 9th century)
Sacramentary - Evangelistary (10th century) - Psalter - The Rheims Missal - Gautier de Coinci. *Life and Miracles of the Virgin* - *Joseph of Arimathaea or The Holy Grail* - Brunetto Latini. *Li Livres dou Tresor*
Book of Hours of the Use of Paris - Praise to St John the Evangelist - Guyart des Moulins. *La Bible Historiale*
Book of Hours of the Use of Rome - Instructions to the Sovereigns - Honoré Bonnet. *Tree of Battles*
Les Grandes Chroniques de France (early 15th century) - Guido delle Colonne.
The History of the Destruction of Troy - Gerbert de Montreuil. *Violette, or Gérart, Count of Nevers*
Nicole de Margival. *The Tale of the Panther of Love* - Alexandre de Bernay.
Athis and Prophilias or The Siege of Athens - Collection of Sayings by Different Philosophers
Book of Hours of Mary Stuart - Book of Hours of François II, Duke of Brittany, of the Use of Paris
Luxembourg Book of Hours of the Use of Rome - *Poetry Description of a Tournament of 1446*
Matthaeus Platearius. *Book of Simple Medicine* (mid-15th century) - Martin Le Franc.
Argument between Virtue and Fortune - Guido Parati Cremensis (Guy Parat).
Three Treatises on the Preservation of Health - *Les Grandes Chroniques de France* (mid-15th century)
Gervais Du Bus. *Fauvel* - Thomas Aquinas. *Summa Theologiae* - Martin de Braga (Pseudo-Seneca).
On the Four Cardinal Virtues - Cicero. *On Old Age. On Friendship* - Jean de Courcy. *The Bouquechardière Chronicle* - Regnault and Jeanneton - Fifteen Joys of Married Life - Rolin-Lévis
Book of Hours of the Use of Paris - Jean d'Orronville (Cabaret). *Chronicle of Louis II, Duke of Bourbon*
The Hours of Louis of Orléans - Missal - *The Amboise Chronicle* - Plutarch. *Discourse on the Marriage of Pollion and Eurydice* - Matthaeus Platearius. *Book of Simple Medicine* (late 15th or early 16th century)
Dispute of Three Ladies - Petrarch. *Triumphs* - *Poetic Epistles of Anne of Brittany and Louis XII*
Jean Thenaud *The Triumph of Fortitude and Prudence* - *Orations of Cicero*
Statutes of the Order of St Michael

SPAIN 214-225

Matfres Ermengaus de Béziers. *The Love Breviary*

ENGLAND 226-233

The Venerable Bede - *Ecclesiastical History of the English People* - Evangelistary - *Bestiary*

GERMANY 234-243

Bible with Prologues - Bible: Old Testament. *Book of Prophets*
Kunrat von Ammenhausen. *The Book of Chess* - Prayer book *The Book of Sermons*

ITALY 244-277

Avicenna. *Canon* - Benoît de Sainte-Maure. *Le Roman de la guerre de Troie* -
Petrarch. *Remedies Against Both Kinds of Fortune* - Petrarch. *Rime. Triumphs* - Boccaccio. *Filocolo* -
Caton Sacco. *Semideus* - Livy. *Ab urbe condita* - Lactantius. *Works* - Agostino Barbadigo. *Instructions to Angelo Gradenigo* - Aloisio Mocenigo. *Instructions to Catarino Contarini* - The Agnese Portolano

THE NETHERLANDS 278-286

Chronologie Universelle - Ovid. *Metamorphoses* - *Prayer-book. Book of Service*

Key to the Abbreviations 287

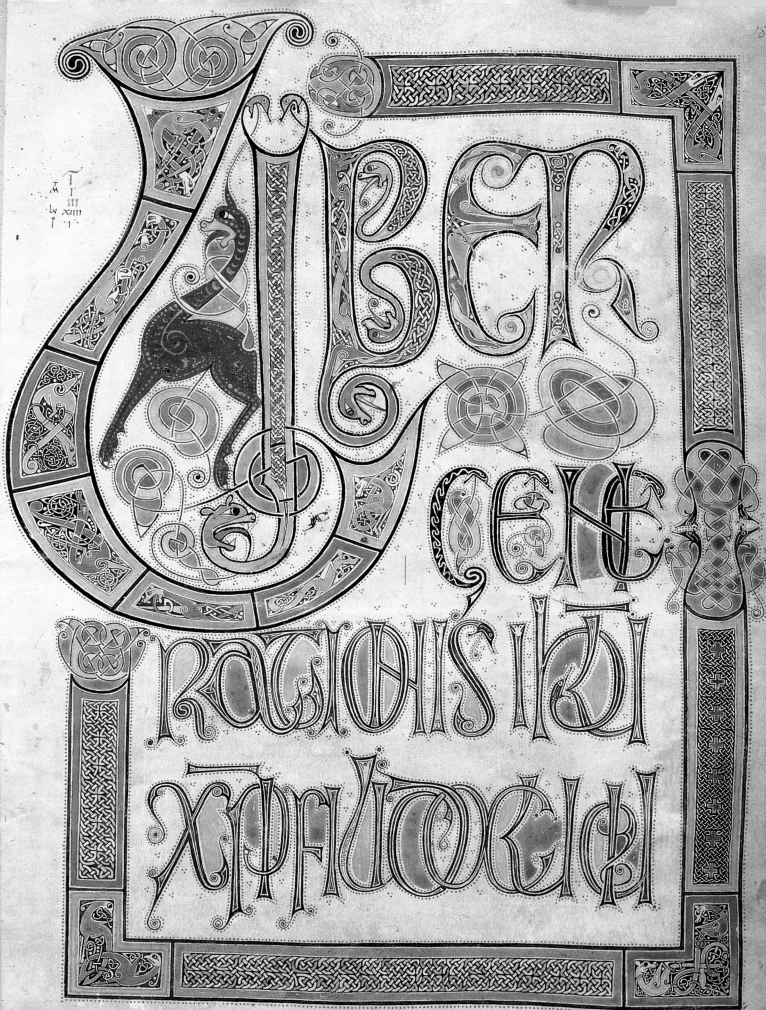

PREFACE

This book presents reproductions from sixty-nine Western European illuminated manuscripts kept in the Manuscript Department of the National Library of Russia in St Petersburg. The compilers' aim was to give as full an idea as possible of the manuscript illumination (often unknown even to specialists) in the St Petersburg collection. Some of the miniatures in the book are being published for the first time.

In order to show all the elements of the illumination and their relationship to the text, in most cases the whole page has been reproduced. Exceptions were made for manuscripts of particularly large format and for separate illustrations with a columnar format. Since the format of the pages is cited in the descriptions, the dimensions of miniatures, full-page or marginal, are not indicated.

Supplementing the articles are descriptions of the manuscripts and miniatures reproduced. As a rule, the titles are given either in the original language or in the form accepted in academic studies. After that the country in which the manuscript was executed is listed together with, when known, the place and date. Next the number of leaves is given, along with their dimensions (as well as those of the area of text), and whether they are of parchment or paper. Then the language in which the text is written is stated, followed by the number of miniatures and other elements of illumination and a description of the binding. Finally, the catalogue number assigned to the manuscript in the collection of foreign manuscripts in the Public Library is given. This is composed of five elements: the language (for instance, Fr. for French; if two or more languages are used, the abbreviation will be Rasn.); the format of the manuscript (F for folio, Q for quarto and O for octavo); the abbreviation v for vellum (parchment); a Roman numeral representing the subject designation (in accordance with the classification system worked out by Alexander Olenin, Director of the Public Library from 1808 to 1843); and an Arabic numeral denoting the manuscript's place in the inventory. For example: Lat.Q.v.I.13, Fr.F.v.XIV.3 or Rasn.Q.v.I.8. Olenin's classification comprises the following 19 groups: I — theology, II — law, III — philosophy and teaching, IV — history and geography, V — history of science, VI — medicine, VII — physics, VIII — chemistry, IX — mathematics and military science, X — mechanical arts, XI — free arts, XII — music, XIII — fine arts, XIV — literature and poetry, XV — rhetoric, XVI — linguistics, XVII — book printing (compendia), XVIII — history of literature (catalogues and inventories), and XIX — Latin classics (Cl. lat.).

The commentary describes the content, composition and specific features of the manuscript. Then follows a short assessment of the illumination from the historic and artistic points of view, and information on attribution. Quite naturally, not all the attributions are final and it is the compilers' hope that this publication will contribute to the further study of the miniatures in particular with regard to their place of execution and dating. Following that is information on the manuscript's provenance before its acquisition by the Public Library, as well as the assessment of the manuscripts that were housed for a time in the Hermitage.

Under Literature only the main works in which the given manuscript and its provenance and illumination are discussed or its miniatures reproduced are listed. The names of the works mentioned most often are abbreviated (a list of abbreviations is included: see p. 287).

The compilers would like to express their gratitude to Inna Mokretsova, Nicole Reynaud, Mikhail Liebmann and Alexander Nemilov, without whose constant attention and advice this publication would not have been possible. In addition, they would particularly like to thank François Avril, Curator at the Bibliothèque Nationale in Paris, for his helpful consultation, and Natalia Yelagina and Margarite Logutova of the Manuscript Department at the Public Library, for their valuable assistance in photographing the manuscripts.

Page 5 :
EVANGELISTERY. NORTHUMBRIA (?)
End of 13th century
Page of initials of the Gospels to St.
Matthew (Liber generationis). *F.18*

WESTERN EUROPEAN ILLUMINATED MANUSCRIPTS
IN THE NATIONAL LIBRARY OF RUSSIA

*A*nyone fortunate enough to have actually held a mediaeval manuscript in his hands must have felt excited at this immediate contact with the past. Both famous and unknown authors wrote philosophical, natural scientific and theological treatises, romances about knights and courtly love; humanists and theologists translated and commented upon the classical literature of antiquity; travellers wrote descriptions of their incredible journeys, and ascetic chroniclers recorded and kept alive the historic events of their times for future generations. One can imagine a scribe constantly at work in a shop in some quiet narrow street of a mediaeval town, or a monk diligently reproducing the words of Holy Writ over and over again in a monastery *scriptorium*.

The more elaborate and complicated the history behind a mediaeval manuscript and the more it is read, cherished and admired, the greater its charm. Often this special charm is enhanced by the joy of seeing a highly professional, exquisite example of the art of book illumination. The emotional impact of each of its components is increased by the alliance of the text, the specific technique of producing mediaeval manuscripts and a refined design.

Skilled artists turned the heavy volumes of chronicles and Bibles, works by ancient and mediaeval authors and small exquisite Books of Hours into tiny picture galleries hidden between the bindings. Fortunately, miniatures by Byzantine, Southern Slavic, Old Russian, Armenian, Georgian, Persian and Indian masters, which play an important role in the history of world art, have come down to us. This book is devoted to miniatures from mediaeval Western European manuscripts, whose features and importance will be further described.

Even in those rare cases when a building decorated with frescoes has survived without having been damaged and without having had its murals painted over in the course of successive ages at the whim of changing tastes, fluctuating temperatures and the effects of the atmosphere have substantially altered the original colour of the works. The fate of easel paintings is seldom much better: their colours have changed as a result of the effects of light and air, their paint cracks and chips off or they have been painted over or "renewed". The colours of gorgeous tapestries have also faded, while fragile stained-glass windows have seldom survived historical cataclysms. Only miniatures, protected to a large extent from damp air, light and dust between the covers of the book, convey the true, unchanged colours of mediaeval painting.

The skill and care with which the miniatures were painted also explain why they have remained in such good condition. The monks working in *scriptoria* were inspired with a profound veneration for the text with which they worked. Secular masters were motivated by the prestige of their workshop, further orders depending on the perfection of their technique. Commissioned by the aristocracy, the clergy, or the growing financial and mercantile bourgeoisie, illuminated manuscripts became luxury items whose skilful execution and expensive materials made them as valuable as precious pieces of jewellery.

Illuminated manuscripts have also been favoured because they have always been collectors' items which, before the foundation of public museums, were usually lovingly kept in libraries. But it is more than just their good fortune that determines the significance of the miniatures. In recent years more extensive and profound study of illuminated manuscripts has shown that they have such an important place in the arts that it would be impossible to conceive the artistic culture of the past without them.

Illuminated manuscripts were, as has been said, mainly intended for the social elite. Illiteracy and the tremendous cost of handwritten books limited the number of people to whom the artist could address himself. This exclusive character of illuminated manuscripts, however, did not lead them to become hackneyed. When manuscript production shifted in the thirteenth century from monasteries to city workshops, it was there that the artistic discoveries having an impact on art in general appeared. Scholars today often call illumination a "research field" for painting and a "laboratory of new inventions". The new artistic idiom, that is the treatment of space, the rendering of mass, volume and movement, etc., was largely worked out in illuminators' ateliers. The illustrative function of miniatures accounts for their being more narrative and detailed, and it made their authors attempt not just a representation of space, but one that would show the duration of time as well. "Early French painting," the French art expert Greta Ring wrote, "is bolder on parchment than on panel."

Miniatures also played a significant role in the appearance of new genres, primarily landscape and portrait painting. Given the freedom in the treatment of subject-matter and the considerably broader variety of themes used in illumination compared to easel painting, this was not at all surprising. One cannot help admiring the boldness, creative energy and ingenuity of miniaturists who propelled art forward in spite of the rigid limitations of tradition. Gradually they introduced new elements in drawing, colour scheme and composition, widening the scope of scenes, objects and decorative motifs by employing their observations from life more and more.

When assessing the role of illuminated manuscripts in the history of art, it should not be forgotten that an illustrated book, like many works of applied art, could be easily carried from place to place: upon marriage, princesses took with them the works of their country's most famous miniaturists; men of noble birth who settled into new lands received them by inheritance; they were given as trophies to the victor. Illuminated manuscripts circulated all over Europe, introducing new tastes, ideas and styles. There is no doubt that the influence of Parisian art on many countries in the second half of the fourteenth and early fifteenth centuries can be explained to a great extent by the spread of illuminated manuscripts.

Strong and mutually enriching ties can be traced not only with easel painting, but with sculpture as well. In developing the sculptural decorative scheme of Romanesque and Gothic cathedrals, manuscripts served as a source of themes, images and iconography. Representations found in manuscripts were used by enamellers, ivory carvers, weavers, stained-glass window designers and even architects. But the opposite trend also existed, sometimes very powerfully with illumination, drawing on the other plastic arts. Here too the study of manuscripts is very helpful in understanding the culture of the past. Up until the middle of the fifteenth century French miniaturists, including Jean Fouquet, were inspired by the splendid sculptures of High Gothic art. Having been strongly influenced by stained glass in the thirteenth century and by Italian frescoes in the fourteenth, in the fifteenth century illuminators incorporated the discoveries of Netherlandish painters, Italian architects and other contemporary sculptors and artists into their works. Significantly, illumination played an independent and important role in the complex and fruitful interaction of different artistic schools, forms and genres.

The collecting, studying and publishing of book miniatures has proved to be so important for the history of art that some concepts have had to be reconsidered. For example, earlier it was thought that the love of observation, attention to detail and interest in landscape in fifteenth-century European painting north of the Alps mainly resulted from the influence of the great Netherlandish masters, while now it is believed that these features were in fact the legacy of the Parisian school of miniaturists active in the late fourteenth and early fifteenth centuries. Without the illuminated manuscripts that have survived, whole centuries in the history of some countries would have been regarded as being devoid of painting; the names of many of those countries' artists are known only because of their illumination work.

It is not only in art historians that illumination arouses expectation and curiosity, for it is more evocative of the past than any other form of representation. As a "secondary art" and an interpretation of a literary work it is a precious record of how a particular text was perceived and understood. It also tells us what kind of images were inspired by the writings of antiquity, how they were incorporated into contemporary thought and in what way they were related to the thinking typical of that stage in the development of artistic culture.

The miniature tells us a great deal about daily life of that time. Thanks to illustrated works we know what people looked like, how they dressed, decorated their houses, on which chairs and at which tables they sat, what the ate, how their fought. Historians of military art have been able to reconstitute the tactics used in battle in the Middle Ages. In nearly all categories of the history of non liturgical culture we find examples of this nature. Apart from the aesthetic point itself, thanks to the faithfulness to the subject, specialists confirm that the celebrated castles of the Limbourg brothers, or the views of Paris or Tours in the manuscripts of Fouquet have become irreplaceable sources for the history of architecture; all the more so as many of the numerous buildings reproduced by the artists have long since disappeared.

Still, manuscript illumination deserves attention above all for its artistic merits and it needs to be more fully appreciated as part of our cultural heritage. Illuminated manuscripts are sometimes likened to chamber music, while easel or monumental painting is compared to a symphony. This simile is only partially true. Certainly, illumination is not meant for a large audience; a viewer's experience of it must be intimate. It necessitates a different understanding of what makes a work of art monumental, of what gives it scope, because in terms of variety and expressiveness of means, and as far as the possibilities for "orchestration" are concerned, illumination is no less symphonic than large-scale art.

The work of illuminators represents the most important stage in the development of book decoration. The system of adorning a manuscript gradually became more intricate and reached its peak in the fourteenth and fifteenth centuries. The miniaturist had at his disposal initials of various size, character and meaning; textual headings in colours and gold; horizontal ornament determined by the length of the line; borders made of elaborate floral ornaments, often with depictions of real and imaginary creatures or figures of people and monsters; decorations or filigree in the margins; elaborate bas-de-pages; and, finally, full-page miniature illustrations. If a manuscript was to be illuminated, a scribe left room for the initials, miniatures, medallions and for the illustrations covering part or the whole of the page. Sometimes, near these empty spaces reserved for the illustrations (or historiations) to the plot of the manuscript there were written instructions for the artist on what was to be depicted.

Then the artist's work began. By the time manuscripts were being made primarily in secular shops in towns rather than monasteries, illumination had become specialized. The master of the workshop supervised the whole process, made sketches and painted the most important pieces, or, if the commission was particularly prestigious, executed the whole illumination himself. One of his assistants, guided by his directions and patterns, would draw the design either with a silver or lead point or in ink, another would gild the appropriate parts, a third would paint and so on. Specialization helped to ensure high productivity and quality, but the invention of new devices, the treatment of a new subject-matter, or technical and artistic discoveries were usually the realm of the head of the atelier.

The master illuminators used superb and often costly materials. The main part of the miniature was realised on parchment, whose cost added to the responsibility of both the scribe and the artist, leaving no room for the slightest negligence in their work. In order to realise works as beautiful and as durable as possible, they spared no effort in « concocting » their binding mixtures and preparing their colours, with as much care as an alchemist. The artists often made their colours themselves, unwilling to confer this delicate task on their apprentices, and even occasionally made sure that the secret of one colour or another was never divulged outside the

atelier. The basis of the palette was often fundamentally made up of red, blue and gold, standard colours for miniatures, especially in France. Red was obtained from plant colours, but often cinnibar was used, and minium, from which derives the word miniature, as the artist who illustrated the first chapters of the manuscript was called the " miniator ". The most precious colour was lapis-lazuli, giving that astonishingly vibrant blue which gives rise to such admiration amongst the masterpieces of the ancient masters. Meanwhile, the wide use of gold, either in gold-leaf or in powder, gave a resemblance to the art of goldsmiths. The background was carefully prepared with tiny leaves of the precious metal, extremely fine and specially hammered, which explains why, for many centuries, the gold has stayed firmly fixed to the parchment, and seldom comes off.

The work of a scribe or miniaturist was far from easy. One tonsured craftsman from Corbie Abbey wrote: "Dear reader, as you turn these pages with your fingers try not to damage the text. No one but a scribe knows what hard work is really like. It is as gratifying for a scribe to write the last line as it is for a sailor to come home to his harbour. It was only the master's three fingers that held the writing cane, but his entire being suffered from the work." Some old treatises taught that gold must be burnished just lightly at first, then with more pressure and finally with such force that perspiration appears on the forehead. Sometimes seven layers of paint were applied and often the miniaturist had to wait a few days for the previous layer to dry. But the artist's devoted work was rewarded with wonderful results. "The Psalter of Louis IX seems to be a gem made of gold and enamel," wrote Emile Mâle, one of the most prominent experts on mediaeval art. "One does not know if it is the work of an artist or a jeweller. When the king opened his prayer book in the Sainte-Chapelle the miniatures were in complete harmony with the lazuli vaults, translucent stained glass and ornate shrines."

It is impossible not to admire the skill of the masters, their clear-cut drawing and the harmony of glittering gold and shining colour. Yet for a modern reader to appreciate the artistic merits of illumination fully, it is not enough to know how it was made, to have an abstract sense of its beauty and value. An attempt must be made to "read" these representations in as detailed a fashion as the people of the last quarter of the twentieth century possibly can. Illuminations not only illustrated a story or conveyed an idea, but gave rise to certain emotions, evoked sensations of joy or sadness, beauty or ugliness, love or fear. The language of religious symbols and poetical allegories was fully comprehended by contemporaries, and manuscripts and the miniatures in them were examined unhurriedly and seriously.

The art of illumination, which is inseparably linked to handwritten books, has a specifically intimate nature making it difficult to present to viewers. There is no way to exhibit manuscripts so that all their miniatures can be seen at one time and direct contact with the manuscripts is restricted to a narrow circle of specialists. Art lovers, then, must rely on reproductions in books. Illumination is particularly well suited to this, for, unlike easel or monumental painting, the dimensions of miniatures allow them to be reproduced life size. Furthermore, such a presentation enables the closest approximation to the way in which miniatures were appreciated in the past: seated in solitude in a quiet room near a window or a lamp one can look leisurely through an art book and study the illustrations as if it were an old manuscript. Your patience and attention will be rewarded by a new world opening before your eyes.

The splendid collection of Western European manuscripts possessed by the St. Petersburg Public Library has made it possible to arrange the present book historically. Not all national schools or periods are equally represented in this collection: there is no Ottonian illumination, and the Romanesque period is represented only by English and German manuscripts. However, it is possible to reflect many of the principal stages of the long history of illumination from the first achievements in the British Isles to the last, sixteenth-century, examples of this art. The Gothic period, in the course of which France became the leading European centre of book illumination, features most prominently in our collection. The following commentary was

BRIT
TA
NIA

THE VENERABLE BEDE.
Ecclesiastical history of the English nation.
Northumbria, 746.
Initials : Book 1. F.3v.

written taking particular account of the history and composition of the St Petersburg collection. Rather than being a brief review of the development of illumination, it is meant to be a guide of sorts, which — it is hoped — will help the reader to better appreciate each manuscript and miniature from an artistic and historical point of view.

Unlike Byzantium, where a tradition of decorating books had persisted from Classical antiquity, manuscript illumination in Western Europe did not actually appear until the sixth century. The first manuscripts in which the text was accompanied by decoration came from Italy and from the territory of present-day France where the Merovingian culture (named after the ruling dynasty) existed between the late fifth and mid-eighth centuries. The few works in the collection from the mid-seventh and the second half of the eighth century show that Merovingian illumination was dominated by a linear, graphic style reflecting the influence both of late Roman art and the style of Lombardy and Northern Italy (the depiction of figures and architectural motifs), and of the East, mainly Coptic Egypt (ornamental designs and colour). Manuscript production was centred in the monasteries of Fleury and Tours (Loire Valley), Luxeuil (Burgundy) and Corbie (Picardy). A page from the *Epistles of St Jerome* showing a depiction of a man, something extremely rare in the Merovingian period, is a very good example of Corbie illumination. It is the earliest miniature in the book and it reveals one of the main merits of Merovingian illumination: quick, free and emotional drawing.

The most vivid and original illumination, which, according to Carl Nordenfalk, "sheds light on the 'dark ages'" better than any other kind of art, took shape in the British Isles after their conversion to Christianity in the early seventh century. The term "insular art" is used to designate works of this region and period — a felicitous settlement of the dispute between the advocates of Irish, Celtic and Anglo-Saxon primacy as regards the origins of this major phenomenon in the history of European culture.

Using and developing the local ornamental traditions existing in the decorative and applied arts, insular illumination successfully subordinated an endless variety of geometric, plant and animal designs, as well as the dynamic evolution and variation of interlaced patterns, to the rectangular pages of manuscripts. The main sources of this art were the monasteries of Ireland and Anglo-Saxon Northumbria, whose scriptoria produced the first masterpieces of Western European illumination.

The Northumbrian monasteries of St Peter in Wearmouth (founded 674 AD) and St Paul in Jarrow (founded 681 AD) were among the most original centres of manuscript decoration. Manuscripts brought back to Northumbria (together with relics) from Rome by Abbot Ceolfrith included what was known as Cassiodorus' *Codex Grandior* (sixth century). Scribes striving to follow the Italian pattern made the Wearmouth and Jarrow scriptoria the main source of the Mediterranean influence in insular manuscripts. It was there that the "St Petersburg *Bede*" was executed in the middle of the eighth century. The importance and uniqueness of this manuscript in the history of illumination is not just a result of its being one of the earliest decorated non-liturgical works, but is mainly due to its being the first known European manuscript to have a historiated initial, i.e., an initial containing a figure and with some sort of narrative purpose.

The creative energy of the Irish and Anglo-Saxon craftsmen was most strongly and fully expressed in the adornment of the Evangelistary. The scribes' veneration for the Scriptures manifested itself in their desire to embellish them and make them into works of art. Early mediaeval Western European illumination's leading principle was thus maintained, with the goal of embellishment replacing the classical idea of illustration. Ornaments, as the principal means of decoration, were taking up more and more space on the parchment pages. In general, the most heavily decorated were the opening pages, known as "carpet pages" since they were completely covered with multicoloured interlace patterns. These bright pages, along with initials, indicate the beginning of each Gospel.

The small, austere initial letters of antiquity gradually developed, became larger and more elaborate, eventually including the following letters of initial words in an ornamental design, so that finally they evolved into whole title pages on which the word itself was an object of art. With truly boundless imagination, the craftsmen invented ornamental compositions, coming up with endless ways of alternating and joining rectangular and curved forms, the fragments and "panels" which, like pieces of tile, made up mosaic designs. There was also a mosaic-like quality in their use of colour.

The famous Durham Gospels (Cathedral Library, MS.A.II.17; with initials of modest size), the Gospel Book of Durrow (ca 675; Dublin, Trinity College Library, 57; with initials occupying a third of the page), the Lindisfarne Gospels (ca 690; London, British Library, Cotton MS. Nero D.IV; its initials nearly the size of the entire page) and the Book of Kells (ca 800; Dublin, Trinity College Library; showing the ultimate development of this tendency) marked each of the stages in this main, "classical" trend within insular art.

The Lindisfarne Gospels, from the Northumbrian monastery on the island of Lindisfarne, was the first manuscript to open with a visually impressive introduction — the Canon Tables (*Canones Evangeliorum*). These were compiled around 330 by Eusebius of Caesarea and later employed by St Jerome. Although they had always been presented in the shape of an arcade, it was only in the British Isles that they became a source of a striking decorative effect. The arcades of insular manuscripts can be compared to a slender portico or grand portal leading to the "building" of a book. The embellishment of the Evangelistary now in the Russian Public Library, including the arcades of the canon tables and the initial pages, was executed applying the aesthetic discoveries made in the Lindisfarne *scriptorium*. Judging by its structure, high quality and calligraphic style, the manuscript is an example of the mature stage of insular illumination, from roughly the same period as the Book of Kells.

Insular manuscripts were not merely a local episode in the history of Western European art. Miniaturists from the British Isles, bringing with them both their ornamental motifs and techniques of decoration, played an important role in the development and sometimes in the foundation of monastery scriptoria on the continent. Insular influence continued to be felt even in the Carolingian period, the next major stage of quests and revelations in the history of illumination.

For more than 150 years, from the late eighth to the early tenth centuries, in the Frankish Empire established by Charlemagne and extending over what is now France, Germany and southern Flanders, there was a flourishing of art referred to as the Carolingian Renaissance. The Empire's political and ideological programme sought to follow the traditions of the Roman Empire and to rival Byzantium. Culturally, this manifested itself in a strict aesthetic code which included an attempt to revive antiquity. Of all the surviving examples of Carolingian art, it is illumination that most fully and vividly expresses the artistic ideals of the era.

Compared with their predecessors, Carolingian miniaturists strove for greater unity and harmony in their books. They achieved a better balance between the decorations and the text, and reined in the abundance of ornamental motifs found in Merovingian and insular works, subordinating them more strictly to the shape of a page or a two-page spread. The value of individual miniatures also grew, and a tendency towards rendering the three-dimensional quality of figures emerged. A desire to compete with Byzantine imperial codices and even to surpass them in ornateness led to the wide use of gold and silver in manuscript decoration. It seems that Byzantine manuscripts written in gold and silver on purple-coloured parchment — a tradition dating back to the *Carmina Figurata*, a luxurious manuscript created for Constantine I by his court poet Publilius Optatianus Porphyrius — were especially highly prized. Golden backgrounds also appeared. In the Carolingian period, then, the foundation was laid for some of the basic artistic principles underlying Western European illumination.

Despite common aesthetic premises, the manner and style of Carolingian illumination differed depending on where and when the manuscript was produced. During the reigns of Charlemagne and his successors (amongst whom Charles the Bald was particularly fond of beautiful manuscripts) the art of illumination developed not only in the workshops of Aachen and other places in the Rhine land, but also in Tours, Rheims and Metz. The illustrations in this book show the ways in which the styles of some of these schools and trends varied.

An example of a striving for lustre and opulence, of a manuscript being made not just to glorify the Holy Word but also to praise a patron and satisfy his vanity, is the Evangelistary known as the Purple Gospelbook[21]. Artistically, it echoed the work of the court workshop of Aachen that produced the *Coronation Gospels* (Vienna, Weltliche Schatzkammer), Kunsthistorisches Museum which for centuries was used for swearing in the Emperors of the Holy Roman Empire. The origins of the artists of that workshop — who were active in the early ninth century and displayed an especial closeness to Hellenistic traditions — are still a subject of conjecture. The manuscripts that experts group together in the "Coronation school" and which kept appearing until the end of the ninth century, all display "Greek" modelling, a specific technique and silver and golden lettering on purple parchment. Possibly, this trend was indeed started by Greek artists who fled the iconoclasm in the East and found refuge at Charlemagne's court.

The *Sacramentarium* Gregorianum was made at the Monastery of St Amand, which produced manuscripts for the court of Charles the Bald. Because of its use of ornamental motifs from the British Isles, this particular trend in Carolingian illumination of the second half of the ninth century is sometimes referred to as Franko-insular.

The *Evangelistary* from Tours demonstrates how firmly the traditions of the Carolingian Renaissance had taken hold by the tenth century. Tours possessed, at the St Martin and Marmoutier Abbeys, what was then probably the most prolific scriptorum. It was established during the abbacy of Alcuin (796–804) and reached its height under the abbots Adalhard (834–843) and Vivian (844–851). The Tours school was able to recover after the Norman raids in the middle of the ninth century without losing its main features — a lucid, logical composition, a use of ornamental motifs that sought to imitate those of antiquity and a balance of the pure outlines of the initials and borders with the text. An illumination from another *Evangelistary* probably made in the Ottonian period, in the eleventh century, still shows the strong influence of the traditions of Charlemagne's court.

The Romanesque period can be said to comprise the golden age of illuminated manuscripts. History probably never again saw such a fine fusion of all the component elements: the book format and the proportions of lettering and text, page texture, two-dimensional miniatures and historiated initials, the black text on white parchment with polychrome illumination which became more and more dominated by gold, especially glittering gold leaf. Certain general features of Romanesque art helped this harmony: simple, expressive silhouettes, local colour, fixed compositions with a monumental rhythmical organization, and a tendency towards symmetry. It was a period when artists, harking back to Carolingian and Byzantine patterns, developed their own idiom using an invariable set of stereotypes and symbols that could be employed at all times. It was this that prompted Focillon to speak of the "eternal immobility of Romanesque art". Page decoration, with increased economy and concentration, became drawn, so to speak, into separate miniatures and particularly into initials that came to form the main type of illumination in Romanesque manuscripts. The historiated initials of monumental Bibles, which were copied in scriptoria in large letters and sometimes extended over many volumes, began featuring the figures of acrobats and various fantastic beasts incorporated into the ornament (the Weissenau Bible).

The Romanesque period also saw an increased variation in the themes of illuminated manuscripts. Greater numbers of classical works, life stories of saints, and chronicles were being copied. Different legal, didactic, geographical and natural philosophical treatises also appeared.

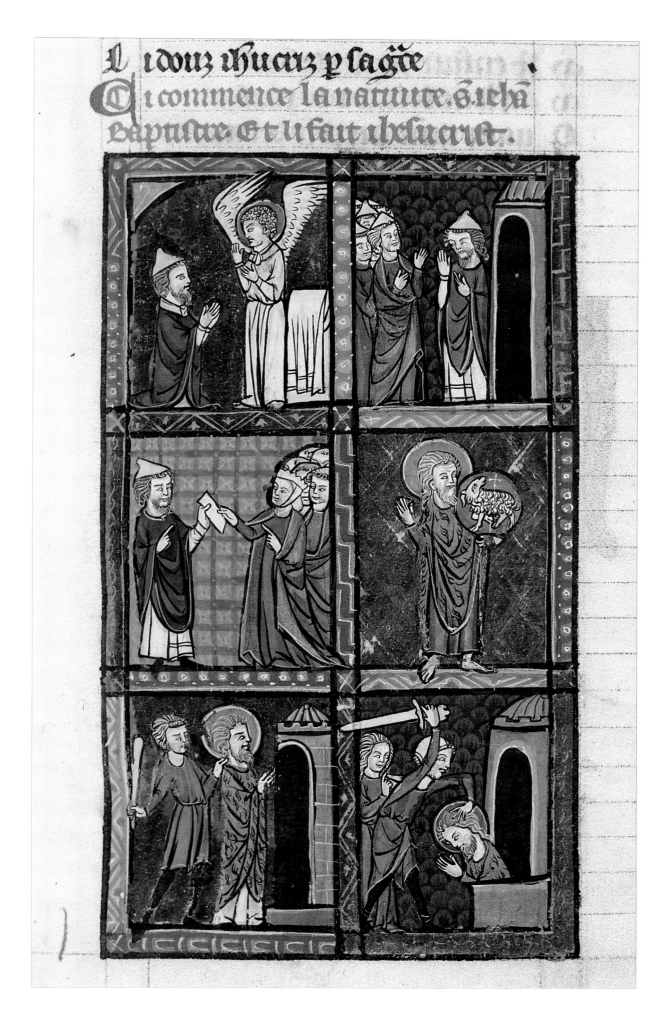

GAUTIER DE COINCY.
Life and Miracles of the Virgin.
France (Soissons?). 13th century (ca. 1260-1270)
History of John the Baptist. F.31

The St Petersburg *Bestiary*, produced at the height of English Romanesque illumination, was one such work. In it the use of old iconographic patterns was enriched to some extent by the artist's actual experience in watching creatures well known to him, although they are still treated in a heraldic manner and seem to be pasted on to the parchment pages. Sometimes very expressive movements were captured, giving a typically Romanesque impression of "moving immobility". A single approach, determined by the format of the page, governed both the miniatures, which were in rectangular borders, and the text.

The chronology of the Romanesque period in manuscript illumination differs for the various national schools. In England and France the style covered the eleventh and twelfth centuries, with the Gothic appearing in the early thirteenth century; while in Germany the eleventh century was still closely connected with the Ottonian Renaissance, and masterpieces of Romanesque illumination were produced in the thirteenth century. One of them, the *Bible* from Weingarten Abbey, was illuminated in the first quarter of the thirteenth century by the artist known as the Master of the Berthold Missal. Romanesque book illumination was almost exclusively produced in monastery scriptoria; manuscripts, to use the phrase of Jean Porché, were major "instruments of monastic culture". Therefore, their embellishment not only bore the imprint of general religious ideas, but also of the traditions of the particular order and abbey, the taste of the abbot and the type of manuscripts available in the monastery library. However, such influences were no more than an impetus to the strong individual gift of the best artists. The powerful talent of the craftsman from the Swabian monastery of Weingarten and the strong plastic quality and sense of drama in his depictions of the prophets made Carl Nordenfalk see him as both a follower, "possessing almost a hypnotic force", of the traditions of the two-century-old Reichenau school and a distant forerunner of Claus Sluter and Michelangelo.

While the early periods in the evolution of illuminated manuscripts are illustrated only by separate and disjointed examples, St Petersburg's rich collection of French works, which comprise the main part of this book, makes an extensive and chronological presentation of the Gothic manuscript possible. The history of illuminated manuscripts in France as a cultural phenomenon of national scope started in the tenth century with the Capetians, because prior to that time there were only separate, though prominent centres of illumination (such as Rheims and Tours) on the territory of present-day France. From the thirteenth century, manuscript illumination flourished in France, and it undoubtedly became the leading school in Western Europe, dictating the style of other national schools.

It is in France, in St. Denis, with the assistance of the well known Abbot Suger, that the conception of art nouveau was first formulated. From there, in the heart of Ile de France, like circles forming from a pebble thrown into a pond, new artistic ideas began to spread all over France, then even further, to other European countries. Architecture became the predominant form of art, producing innovation of a truly revolutionary character, leading to the building of glorious French cathedrals. The elements of gothic architecture which were propagated, such as ogival vaulting, fine columns, rose windows and gables, enriched the decorative motifs in the illumination of manuscripts. Besides these exterior signs of a new style, we can see in primitive gothic illumination changes of a deeper, more fundamental nature. The eye of the artist is of a more earthly character, more attentive. He is more interested in volume, in the movement of the figures, in concrete details of the real world. The whole structure of illumination is transformed and enriched by new processes.

The thirteenth century was marked by more than just a transition from one style (Romanesque) to another (Gothic). It was a time of decisive changes in illumination, when monasteries were giving way to court workshops and secular town shops as the main centres of manuscript production. For obvious reasons, Paris became France's dominant cultural centre: it was the seat of what was then Western Europe's main research and educational institution, the University of Paris, as well as of a royal court that was pursuing a successful policy of unification and was for quite some time the principal commissioner of the most luxurious manuscripts. It was

in Paris that such typically "French" traits as high skill, clear-cut drawing, a harmonious colour scheme, based on the use of gold in combination with red, blue and white, and carefully balanced decor started to take shape. They are exemplified by the *Psalter* produced by a Parisian workshop in the first half of the thirteenth century.

The tax records for Paris in 1292 mention — along with architects, painters, sculptors, stained-glass artists, jewellers, carvers and tapestry weavers — seventeen illuminators. They were familiar not only with the inventions of different Parisian masters, but also, through merchants and travelling artists, with the most recent achievements in other countries. Having assimilated and reworked these innovations, they returned them to their countries of origin enriched and stamped with incontestable Parisian taste. Dante described the work of the artists of Paris, while in the second half of the fourteenth century Petrarch complained that the whole world was dependent on the whim of Parisian fashion, that "one has to use their scribes and illuminators". As a result of Paris's centralizing role, French illumination became a uniform artistic phenomenon in the thirteenth and fourteenth centuries.

Social and cultural changes, as well as the appearance of new readers and patrons put an end to the hegemony of religious literature and led to the production of more secular works, such as romances, treatises and historical writings which introduced new themes, often of a secular and true-to-life character, into illumination. From this point and for a long time to come, the development of French court culture was determined by an increased tendency towards romantic chivalry. Roland, the hero of the past, gave way to Tristan and Isolde. The Virgin became the main object of religious veneration: whole poetic works were devoted to her , as well as extensive series of miniatures (*Life and Miracles of the Virgin*) in which, for the first time, each episode of the story was depicted separately. In brief, the changes undergone by Gothic illumination by the end of the thirteenth century can be summed up as a shift from the strict and relatively simple ornamentation of the first Gothic manuscripts, with their lucid drawing and large surfaces of colour, to exquisite lines and refined and gracious figures. The ensemble of all the elements of the miniature and the text was becoming more and more elaborate; John Ruskin aptly compared the new Gothic "well-illuminated Missal" to a "fair cathedral full of stained-glass windows". The *Rheims Missal* is such an ensemble.

To the wonderful script of the text, with its ornamental display entwining large historiated initials, is added the exceptional series of miniatures on full page composing the *Credo* of Joinville. The calendar at the head of the manuscript is a gothic invention: each month is illustrated by medallions representing the signs of the zodiac and allegorical scenes depicting seasonal workers.

The Rheims missal was executed at the transitional stage from Early to High Gothic, and is stylistically similar to the works of Honoré, the first Parisian miniaturist whose name we know and whose manner we can trace to some extent by comparing archival records with the surviving manuscripts of the late thirteenth century. By that time French illumination had already achieved the combination of balance and elegance which would in the future be an important distinctive feature of its national school and, as early as the beginning of the fourteenth century, even determine the style of less flamboyant manuscripts (*Joseph of Arimathaea or The Holy Grail*).

The transition from Early to High Gothic was marked by a decisive change in the artists' attitude towards the margins in which ornamental design was increasingly expanding. Sprays started to sprout from the initials into the margins and between the columns of the text, gradually turning into more elaborate foliate ornaments that eventually occupied all empty spaces, becoming lavishly decorated borders and frames. Drolleries — fantastic creatures and acrobats that in the Romanesque period began inhabiting historiated initials — were randomly dispersed in the margin leaving more room in the initials for narrative episodes. These figures were balanced on stalks, interlaced with designs of ivy, vines, flowers, leaves and berries, or composed

separate scenes. The origins of these entertaining motifs and decorative studies from nature still remain a subject of dispute. Some find the sources of these "menageries" and "botanical gardens" in the experiments of Italians, others connect them with elements in English illumination, while others still trace them to the Netherlandish interest in the surrounding world or consider them "a realization of the German dream". It is to Paris, however, that they apparently owe their popularity, for it was from there that they spread all over Europe as a fashionable element.

The restructuration of the illumination closely follows the process of evolution of gothic art. Even in the rational system of the architecture of articulatory structures, decorative motifs are to be found : mythical and human figures, leaves, vine-stalks and grapes, all sculpted in the stone in naturalistic style. The interest in "naturalistic decoration" is very close to the literary manner of that time. In the celebrated Roman de la Rose by Guillaume de Lorris, there is a question of "little beasts capering in thirty different fashions" as can be seen in the margins of gothic manuscripts.

This phenomenon was unquestionably connected with the culture of popular fairs, the performances of jugglers, acrobats and trained animals, and with the naturalistic elements of mediaeval theatre. *Li Livres dou Tresor* by Brunetto Latini was one of the first French manuscripts to feature a whole troupe of jugglers on stalks sprouting on the page.

The early fourteenth century found French illumination developing even greater refinement. The line of the drawing grew still lighter and more sensitive, and the proportions of human figures became more elongated. They started to bend like tongues of flame; their silhouettes danced as if at a royal ball, giving the rhythm of folds and draperies a special musical character. The intense, rich colours of Gothic illumination gave way to subtle combinations of colours and light tinting. Grisaille, a dignified grey monochrome, appeared, aptly described by the French novelist André Malraux as "the art of minstrels", and the leading miniaturists commissioned by the higher aristocracy could justly be called court artists. A growing interest in narration, in details from life and in imparting an entertaining quality became another important aspect of illumination.

An artist who emerged in the first three decades of the fourteenth century succeeded in summing up the achievements of the Parisian school and shaping from them a new quality for the future. This artist was Jean Pucelle, whom Erwin Panofsky considered as important for the development of painting in the North as Giotto and Duccio were for Italy. Jean Pucelle mastered the elegance of silhouettes, quick virtuoso drawing and grisaille that made it possible to render volume to perfection. Employing the discoveries of Tuscan and Sienese artists and striving to create depth of space, he turned the first timid attempts to overcome the abstract two-dimensionality of backgrounds into true architectural compositions. Pucelle was also bolder than his predecessors in his use of the margins. In them he continued to elaborate the main scene, demonstrating his skill as a story-teller. He made the movements of figures more lifelike and the compositions freer and richer. It is largely thanks to Pucelle's innovatory treatment that in the fourteenth century intimate and refined illumination, seemingly the most delicate and elitist of art-forms, became the one best suited to the demands of the time and, in contrast to architecture and monumental art, the least affected by the destructiveness of the dramatic events that took place in the middle of that century (the beginning of the Hundred Years' War, the decline of the economy and the plague). Pucelle's traditions remained influential and fruitful until the last decades of the century, and "court illumination became the quintessence of the art of the age" (François Avril).

Manuscripts in the St. Petersburg Public Library clearly show the merits of this aristo-cratic art. Among them, for example, are the small *Book of Hours of the Use of Paris*, a virtuoso masterpiece; *Les Louanges de Monseigneur Saint-Jehan l'Evangeliste*, illuminated by the Master of the Coronation of Charles VI in a lyrical, soft and slightly feminine manner; and the monumental Bible Historiale, the illumination of which was executed by several artists

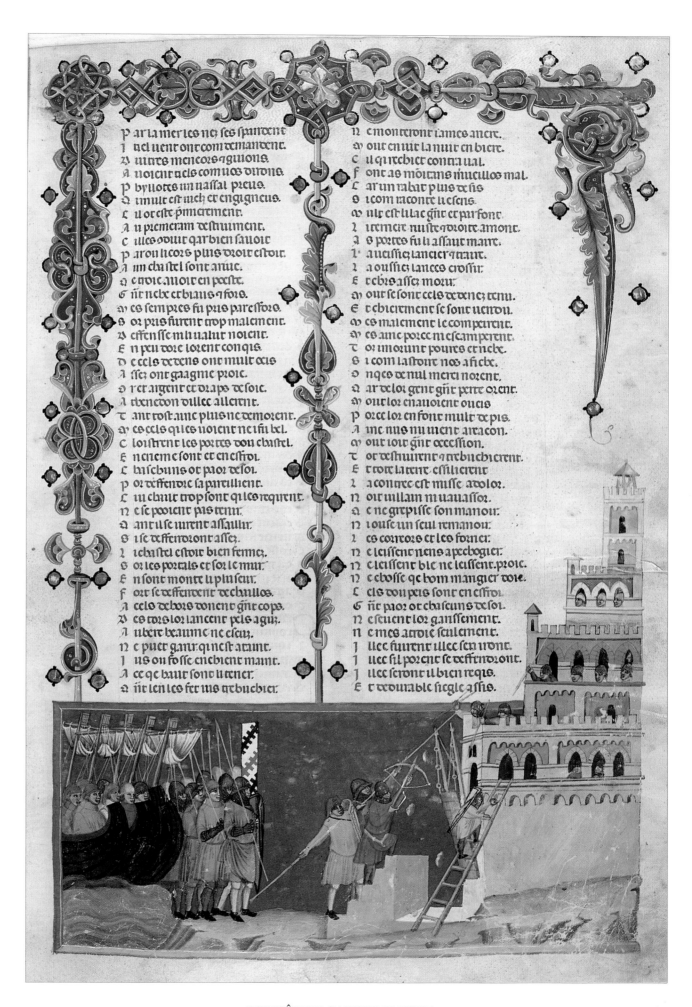

BENOÎT DE SAINTE-MAURE.
The Book of the Trojan War.
Italy (Bolognia?). Early 14th century.
The Greek warriors, arriving by ship,
prepare to storm Troy.

(the frontispieces, probably by Jean Pucelle's most loyal follower at the court of Charles V, Jean Le Noir).

This book contains only a few, though quite interesting examples of fourteenth-century manuscript illumination from other Western European countries. Closest to the French manner, especially its southern variety, was Spanish illumination. In the middle and second half of the century a specific cultural milieu formed in the north-western Mediterranean area, with Avignon as its centre. It embraced southern regions of France, certain Italian provinces and Catalonia. The richly ornamented *Lo Breviari d'amor* executed in Lérida, Catalonia, close in style to the illumination of Provence, can be attributed to that cultural sphere. It was distinguished from the Parisian school by a brighter colour scheme, a certain stiffness in the drawing and the presence of Moorish influence.

Italian illumination in the fourteenth century was very definitely composed of different centres or regional schools, among which Bologna, where the scribes' shops clustered around the famous university, was prominent. Although all Italian illumination was affected by the great Italian painting of the fourteenth century, in the middle of the century the Bologna masters were especially sensitive to Giotto's lessons. The influence of frescoes can be seen in the monumental style, the colour scheme and the initial in Avicenna's *Canon* as well as in the illustrations to *Le Roman La Guerre de Troie*. This latter series of miniatures executed in the bas-de-pages is remarkable both for its length and detailed drawing; it is also interesting because it is one of the best examples of continuous pictorial narration — a device that goes back to classical friezes and ancient scrolls, which was adopted and transformed in mediaeval times (for example, the famous Bayeux Tapestry) and thoroughly developed in Italian illumination, in Naples, Bologna and Lombardy, primarily in the illustration of romances. According to expert opinion, the Roman's ingenuity, the careful treatment of the illustrated text and use of realistic detail, make it a sign of a transition to a new stage, the age of humanism. Another and a more definite sign of the development of humanism in Italy is provided by an early copy of one of Petrarch's works, which was illuminated in Milan.

The illumination of the German Das Schachzabelbuch (*The Book of Chess*) dates from the very end of the fourteenth century. In addition to certain peculiarities of the national style (which, incidentally, also varied from place to place — in Swabia, the Rhineland, Saxony, or Prague, then effectively the capital of the Holy Roman Empire and the centre of a strong school), such as the use of a different facial type, of angular figures foreign to French illumination, and a new colour scheme, the miniatures of Das Schachzabelbuch are of interest for their rare iconography and genre details. They also display some features of the International Gothic style then flourishing in many European centres.

The greatest achievements of this style in manuscript illumination at the turn of the fifteenth century were primarily connected with France as a result of the development there of the court art described above. It was at the French court that the tradition of learned patronage and love for books first appeared. This tradition was initiated by John the Good, continued by the "wise king" Charles V, whose library contained nine hundred volumes on a variety of subjects, and flourished under Philip the Bold, the Duke of Burgundy, and, of course, under Jean, the Duke of Berry, whose name is often mentioned in connection with this notable period in the history of illumination. The role of Paris as the arbiter of fashion was consolidated under the Valois princes; the patronage of the court and of the aristocracy, who did not want to lag behind, attracted artists to Paris from other countries. From the middle of the fourteenth century, a great number came from the Netherlands, bringing with them a taste for colour, light and three-dimensional representation, and an interest in realism. A combination of these tendencies and the traditions initiated by Pucelle resulted in one of the most interesting phenomena in the history of art, known as Franco-Flemish illumination.

The craftsmen working for the Duke of Berry combined the "regimented ballet of chivalry and

gallantry" so vividly portrayed in Jean Froissart's Chronicle with the ingenuous joy of life and daintiness of late Gothic culture, its interest — in spirit already humanist, — in Classical antiquity, and the growing realistic tendencies of Netherlandish urban culture. The framework of the Parisian fourteenth-century school of illumination was becoming too small for the expanding and more complicated imagery; Pucelle's "dolls' houses" were unable to contain the fantasy of the masters working for the Duke of Berry, and the first attempts at portrait and landscape painting were being developed. Easel painting joined illumination at the end of the fourteenth century. Italy was on the threshold of its fifteenth-century artistic revolution and in the Netherlands art was soon to be transformed by Jan van Eyck. Artists of the Berry circle such as Jacquemart, the Boucicaut Master, the Master of the Rohan Hours, and especially, the Limbourg brothers, revolutionized the art of book illumination.

The interest in motifs of genre, history and exoticism, incited the illuminators to enlarge the iconography, basing the movements, the poses, the processes and realia on frescos and on Italian and Flemish paintings. These innovations were concentrated into the illustrations of illuminations, where the interiors lost their toylike aspect, and, whilst being constructed with a still somewhat awkward perspective, acquired a force of persuasion hitherto never seen. There appeared for the first time the voluntary use of an airy, floating perspective ; a sunny or a starry sky stretching away above the earth. In the masterpiece of the Limbourg brothers, Les *Très Riches Heures du Duc de Berry*, designed with effect but somewhat lacking in historical accuracy as "the swan song of gothic agony" the views of nature, brilliant with precious colours, stand out like real, precise countryside ; idealistic, they nonetheless remain portraits of nature.

Alongside these great innovators, sometimes working in collaboration with them on the decoration of a manuscript, were other talented artists. Thanks to the painstaking research of scholars (particularly Millard Meiss), the works of other artists have been distinguished among the many miniatures produced at that time in Paris and at the courts of the princes. This book, for example, contains works by the Pseudo-Jacquemart, the Master of the Coronation of the Virgin, the Luçon Master, and the Master of the Apocalypse. The illuminators of *L'Information des Rois et des Princes*, *Les Grandes Chroniques de France*, and *Historia Destructionis Troiae* (which was probably executed in collaboration with Italian artists) are still unknown. Taken together, the manuscripts in the Public Library of Russia provide a fine opportunity to appreciate the elegant art of French manuscript decoration of the "golden age" of European illumination, and demonstrate the wide variety of subject-matter then popular in literature. They comprise Books of Hours (prayer books for domestic use, which were the most common type of manuscript in the fifteenth century), didactic and historical works, and romances, the illumination of which shows with particular vividness the elegant and fairytale world of chivalrous society. Established in the fourteenth century, the system of illumination used for romances required that rectangularly framed miniatures be integrated into columns of text, of which there were two or three on a page. The illustrations were usually adjacent to, or connected with, the initials and the ornamental border. The adornment of the Book of Hours is an example of exquisite marginal decoration of a type that soon became widespread. Its miniatures, exemplifying Franco-Flemish art interpreted in a refined Parisian style, are evidence of the growing intricacy and richness of the colour scheme that marked the reign of Charles VI.

The illustrations to other manuscripts reproduced here, little known or unknown even to specialists, possess their own merits; their publication is expected to add to the knowledge of art from the age of the Duke of Berry. The extremely difficult period in the Hundred Years' War, which followed the defeat at Agincourt (1415) when, according to the famous historian Jules Michelet, "not only the king, but also the kingdom, France itself, was taken prisoner", had an impact on the whole of French art. France found itself divided into several parts that at times were even at war with each other. Captured by England and lying in ruins, Paris lost its unifying role and several trends appeared in the development of art. Fleeing the ruined capital, artists went to Burgundy, the Loire, the South and abroad. Although tremendous progress was being made by Italian and Netherlandish masters in the second quarter of the fifteenth century, in

France it was the least productive period for art as a whole and for illumination in particular. Miniatures from this period employ only familiar devices and lack inspiration. Three Books of Hours, produced at this time, are now in the Library collection: the *Luxembourg Book of Hours* and those belonging to Mary Queen of Scots and Francis II, last Duke of Brittany . *Mary Stuart's Book of Hours* is of great historical interest; its illumination, executed in the circle of the Bedford Master, the most skilful and prolific artist working in Paris under the English, is remarkable primarily for its further development of ornamental borders. Artistically speaking, the most interesting of the three is the *Luxembourg Book of Hours* because in it the traditions of the Paris school were modified by the then more advanced Netherlandish art.

Of all the centres of Italian illumination in the late fourteenth and first half of the fifteenth centuries, Lombardy was the closest to France. There, at the court of the Visconti dukes of Milan, chivalrous art flourished in the same international (or, as some experts prefer to call it, "soft") style that was dominant in Paris, Bourges and Dijon and at the court of King Wenceslaus in Prague. Lombard miniatures combined an aristocratic, refined quality with a sharp, observant and objective attitude that bordered on naturalism — traits typical of late Gothic culture. Giangaleazzo Visconti, a passionate bibliophile, was the patron of such outstanding masters as Giovanni dei Grassi and Michelino da Besozzo, who decorated and illuminated splendid manuscripts with unsurpassed virtuosity. Under Filippo Maria Visconti and Francesco Sforza, inheritors of both the Duchy of Milan and a taste for beautiful manuscripts, this tradition of illumination was continued by Luchino Belbello da Pavia and Bonifazio Bembo. *Semideus*, a manuscript then included in the ducal library, is a good example of Lombard illumination. Together with the glitter of colours characteristic of Michelino da Besozzo, it has the minute details and expressiveness of Luchino Belbello's manner and, in its exciting battle-scene illustrations, shows the love for tinted drawings so typical of Lombard illumination and so much favoured by Bembo.

While in Milan and Pavia manuscripts such as *Semideus* were still being produced, Renaissance culture was already triumphant in other parts of Italy and particularly in Florence. Manuscript illumination in Italy was not marked by such revelations as transformed painting, sculpture and architecture, but it should, however, be borne in mind that humanist writings were as much an instrument of Renaissance culture as the manuscripts created by monastery scriptoria had been of the mediaeval culture. The victorious Renaissance first appeared in Florentine illumination under Cosimo Medici the Elder, manifesting itself in a type of ornamentation for humanist writings (the works of the classics of antiquity, Dante, Petrarch and Boccaccio) with decorations on the title page of the manuscript and sometimes also at the beginning of major sections and of chapters. The text was written in clear-cut humanist script framed by ornamental borders that often included a design of white vine-stalks or banderoles — the so-called bianchi girari. The same motif was employed in the initials. An example of the typical Florentine manuscript style which soon not only won popularity all over Italy but was also commissioned by foreign lovers of humanist literature, is Petrarch's *Canzoniere*. Trionfi.

The adornment of title pages included coats of arms and such typical motifs of Renaissance decoration as putti, garlands, medallions and sometimes "portraits" of the authors. Two of these "portraits" are reproduced here: one of Boccaccio in a manuscript the illumination of which is close to the Neapolitan school, the other of Livy in a miniature at the beginning of his *History of Rome*, depicting the famous Roman historian as an Italian humanist. Fifteenth-century Venetian illumination in our collection is represented by two interesting and typically Venetian manuscripts — instructions given by the Doge to the important officials of the "Queen of the Adriatic". Such formal instructions, usually illuminated by the best miniaturists, were then cherished as family heirlooms. The style of this particular artist, a leading Venetian illuminator, was influenced by the great masters of "large-scale" painting, a common phenomenon in Italian illumination.

While the richness and diversity of Italian Renaissance illumination is naturally in no way fully conveyed by the few miniatures included in this book, once again the St Petersburg

collection of French works is full enough to illustrate all the main trends and kinds of French illumination of the middle and second half of the fifteenth century.

The hope of a better future following the end of the Hundred Years' War, a national upsurge, a rationalistic and businesslike spirit, as well as the cultural influence of Italy and the Netherlands, brought about a revolution in the life of central France. The period in the history of French painting began which is termed the first (or early) Renaissance. It reached its peak between the 1440s and 1470s.

The Loire valley became the cradle of the early Renaissance, with Tours as its capital and Jean Fouquet its most talented and influential master. Fouquet was faced with the complex task of translating traditional manuscript illumination into the language of the Renaissance. It is most likely that, as a young man, this native of Tours studied painting in the studio of a Parisian miniaturist. He was closely associated with the architects, sculptors, stained-glass makers and jewellers of the Ile-de-France, and was well acquainted with Netherlandish easel painting and the discoveries of Van Eyck. Having spent a few years in Italy, Fouquet was introduced to the art of the Renaissance. His artistic knowledge was enormous, yet he retained his own style, and everything he learned enabled him to create a whole arsenal of new methods and techniques. Jean Fouquet's masterpiece, the Hours of Etienne Chevalier (Chantilly, Musée Condé, MS. 71), was as much a turning point in the development of French illumination as the works of Pucelle and the Limbourg brothers had been earlier. In its illumination Fouquet solved the problem of space: the compositions of its miniatures are commensurate with the figures and filled with realistic details as never before. He also developed the concept of landscape in illumination; his poetic interpretation of real scenery was far ahead of his time. The numerous Renaissance motifs, architectural and decorative, in his miniatures do not appear to be foreign elements, but fit organically into his artistic world.

The frontispiece to the treatise by *Martin Le Franc*, executed either by Fouquet himself or under his direct guidance, show the full charm of the master's world, so harmonious and lucid, carefully balanced, and featuring a radiant landscape reminiscent of the artist's native Loire. A later manuscript, the *Chronique de Louis de Bourbon* , was illuminated by one of Fouquet's followers, who maintained the master's love for Italianate decorative motifs and was skilled at organizing battle scenes compactly and setting them against a landscape background.

Another centre of mid-fifteenth century art was the court of René, titular king of Naples, Count of Provence and Duke of Anjou and Lorraine. Not just a patron of the arts, he was himself a writer and artist, called the "last of the troubadours". The twists of his own fate had an important bearing on the art of the illuminators he patronized. His love and appreciation of Netherlandish painting began when he was held prisoner in Burgundy. At the same time, René was aware of the innovations of Italian artists, whom he invited to his court. But the most important factor was the atmosphere at the court itself. The King loved pastoral festivals and jousting tournaments and he built small, cosy castles decorated according to the latest style, a fashion which, in keeping with the flourishing humanism of the time, idealized antiquity and the age of knighthood. The peculiarity of this double-sided culture was best expressed by the artist who illuminated the King's allegorical novel, The Cœur d'Amours Epris (Vienna, Nationalbibliothek, MS. 2597). For some time experts believed that this "Master of the Heart" was King René himself, but now they are more inclined to think that he was Barthelemy d'Eyck from the Netherlands, also the creator of some major panel paintings. One of his early works in the realm of illumination is the *Description d'un Tournoi Fait en 1446*, and another manuscript of the same kind also in the Russian Public Library, the *idyll Regnault and Jeanneton*, which was probably illustrated according to King René's own drawings. At any rate, these two manuscripts clearly show René's original taste and convey the flavour of a unique period in the history of French culture, marking the transition from the Middle Ages to the Renaissance.

The scope of French manuscript illumination in the middle and second half of the century was very diverse; there is still much to be studied. Specialists are continually trying to attribute many of the surviving manuscripts to various masters and local schools. This is how such names as Maître François and the Master of Jouvenel des Ursins (probably connected with the illumination of the Roman de Fauvel) have appeared, as well as the Maître de Charles de France, to whom the illumination of treatises by the Pseudo-Seneca (Martin de Braga) and Cicero (both in one volume) is ascribed. An artist of unique style worked for the powerful Rolin family in Autun (the Rolin-Lévis Hours). The style of the prolific Rouen school is distinctive for its somewhat dry graphic quality (the Bouquechardière Chronicle by Jean de Courcy). Illuminated literary works appeared in a widening variety of genres, from the philosophical and theological treatise, Summa Theologiae, by Thomas Aquinas to a novel based on episodes from life, Les Quinze Joies de Mariage. The latter is also of interest as an example of miniature painting on paper (the tinted drawings in the Description d'un Tournoi and Regnault and Jeanneton were not finished illustrations, but sketches). Scientific treatises including various works on medical treatment and the use of herbs became more popular. The iconography for illustrating such encyclopaedic reference-books, which dated back to the works of scientists from late antiquity and from the Arab countries, had been consistently expanded and elaborated since the Romanesque era and was greatly enriched by the Italians. With about fifty years between them, the miniatures to the two treatises by Platearius (44, 60) show how this iconography was being preserved and developed.

The art of manuscript illumination in Burgundy developed simultaneously and in close connection with miniature painting in France. The culture of this "intermediate state" was no less complicated than its political history. The Netherlandish provinces, which were then a part of Burgundy, had an advanced burgher civilization that gave birth to the great masters of the Northern Renaissance who mainly produced easel paintings. The Burgundian court represented the festive sunset of chivalry, outdoing Paris in flamboyant fêtes, refined fashion and elaborate etiquette. It held tournaments, cherished the idea of the Crusades, established the Order of the Golden Fleece and welcomed poets, historians, translators, sculptors, painters and architects. The peak of this gallant culture was reached under the last dukes, Philip the Good and his son Charles the Bold. The library which belonged to the Great Duke of the West, as Philip was called, owed its size to his patronage policy; the library was enriched not only by the collecting of existing manuscripts but also by the commissioning of new ones.

Philip the Good had several establishments of miniaturists working for him, which meant that they were connected with court culture rather than that of the town. Although Burgundian illuminators must have been aware of the new ideas of such great contemporaries as Jan van Eyck, Rogier van der Weyden, Hans Memling and Hugo van der Goes, they largely adhered to the aristocratic traditions of French illumination dating back to the beginning of the century. Two manuscripts executed for Philip the Good exemplify this: the treatise by Guido Parati Cremensis (46), with a splendid "group portrait" of Philip the Good and his attendants at the beginning, and the famous *Grandes Chroniques de France*, the masterpiece of the St Petersburg collection. Both manuscripts were executed by Simon Marmion, one of the most talented miniaturists of the fifteenth century, and characterize his work very well. Marmion, who was of about the same age as Fouquet, personified a completely different line of development. Born in Amiens, in 1458 he settled in Valenciennes, where he headed a shop of illuminators until his death. His style is distinguished by its typically French traits, such as calligraphic and elegant drawing, the decorative effect of pure, though soft and subtle colour combinations, and a fairy-tale quality of narration. Simon Marmion absorbed and developed the Parisian art of telling the story in an exciting way, at length and in interesting detail. His great skill as an illustrator enabled him to combine narrative and illustrative functions without having to resort to any new devices. He combined depictions of various (consecutive or parallel) events on the same page, both dividing and connecting them with fragments of architecture and landscape. This complex, yet uniform, structure did not disrupt the surface of the page and helped unite the miniature, marginal

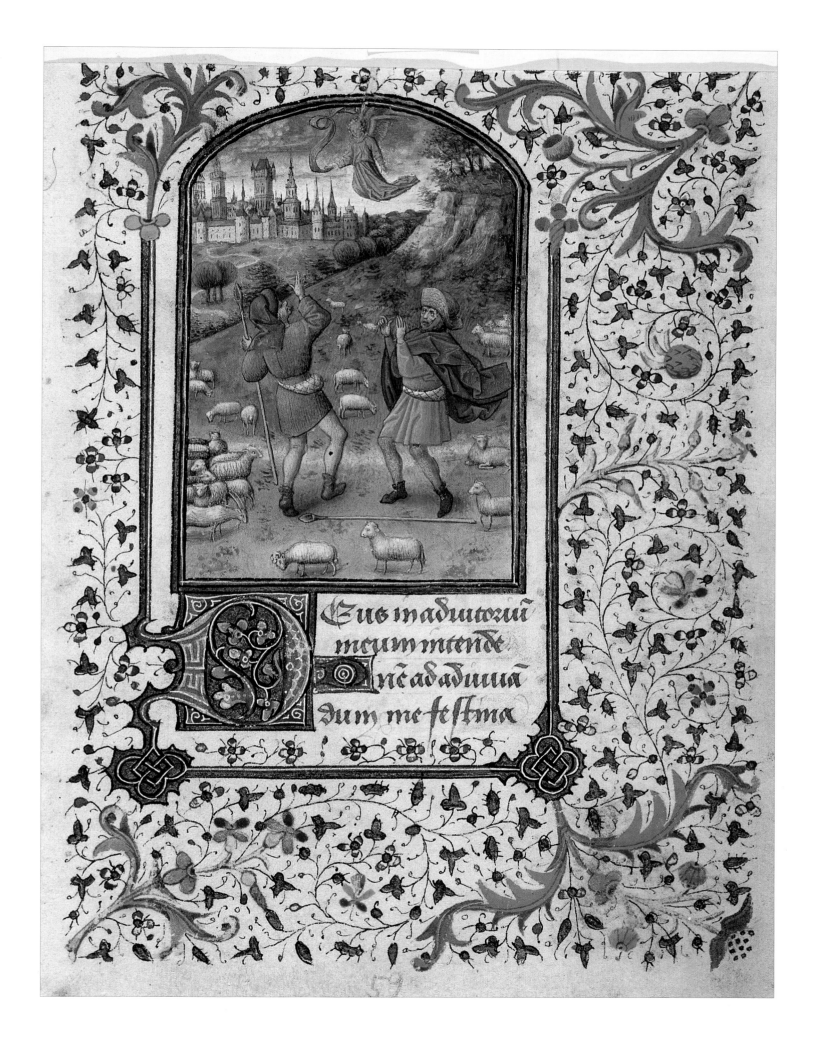

LUXEMBOURG BOOK OF HOURS
Flanders (Bruges).
Mid 15th century. The Annunciation. F.52.

decorations and text into a single ensemble. The sense of balance inherent in French art helped Marmion to preserve the clarity of his complicated compositions. His elegant and poetic art was bound to be liked at Philip's court; Marmion was highly praised both during his life and in the early sixteenth century, when he was named the "prince d'enluminure".

The Burgundian school of illumination was not uniform. There was also a Netherlandish trend with centres in Brussels, the capital of Brabant, as well as Ghent and Bruges, the richest cities of northern Flanders, which came to the fore in the mid-fifteenth century. A particularly large number of manuscripts were created in Bruges, where artists were commissioned by their lord, Louis de Bruges (Gruthuse), prominent burghers, noblemen close to the duke, and exalted foreigners, such as the king of England. One of these Flemish shops produced the monumental Chronologie Universelle, unusual for the form and composition of its pages, which, together with Ovid's Metamorphoses commissioned by a relative of Louis de Bruges, gives an idea of Flemish illumination. The illumination of Brabant is represented here by a few pages from a modest prayer book, the Liber precum. Orationes, combining, as was then common, texts of different dates in one binding.

After the collapse of the duchy of Burgundy, doomed to failure in its struggle against the unification policy of Louis XI, the French-oriented trend in its illumination became part of the process of formation of a single national art, while the masters of the northern cities, which had been taken by the Habsburgs, continued working completely in the main stream of Netherlandish art.

The art of Fouquet, Marmion and the Master of the Heart marked the peak of fifteenth-century French illumination. This, however, was followed by a decline. Although formal, technical perfection was maintained, the ornamental decoration of manuscripts became more and more standard. The artists put the whole force of their talent into the illustrations, which gained their own value independent of the manuscript. The process of miniatures turning into paintings was irreversible; lavishly ornamented "unique" manuscripts were becoming primarily works of pictorial art. Fifty years after Fouquet, the last miniaturists were simply imitating easel paintings, often even depicting their frames.

But there was another, even more fatal reason for the decline of illuminated manuscripts. The age of the hand-written book was coming to an end. Its successor, the printed book, was invented at the time that Fouquet was producing his masterpieces. His followers, who were working in growing competition with the more popular and affordable printed books, did not have the creative power of the great master from Tours. Having borrowed some formal devices and motifs from him, without understanding their imagery, they devalued his discoveries.

However, there were still many talented illuminators working at the turn of the sixteenth century, being commissioned by the higher aristocracy and the royal court. The most distinguished of these patrons were Anne of Brittany — the wife of two French kings who succeeded one another on the throne, Charles VIII and Louis XII. The latter inherited a large library which he diligently continued to expand both with manuscripts brought back from his Italian campaigns and with new commissions. While still Duke of Orléans, Louis XII came into the possession of a Book of Hours illuminated by one of the most interesting followers of Fouquet, Jean Colombe, head of an active atelier in Bourges. Louis XII and Anne of Brittany commissioned many splendid manuscripts from another prominent artist working at the end of the century, Jean Bourdichon, who succeeded Fouquet as Court Painter. His style was highly skilled, his colours, although somewhat sugary, were harmonious, and he rendered the splendour of gold-embroidered fabric and the rich floral ornamentation in the margin with illusionistic effectiveness. Bourdichon's imitation of Italian architectural decoration, which he had borrowed from his teacher, developed further under the influence of the popularity which Italian culture gained as a result of the campaigns by Charles VIII and Louis XII. One of his best works, *Epistres en vers françois* dediés à Anne de Bretagne et Louis XII, shows another trait of his style: highly

idealized portraits. In them realism was replaced by courtly flattery, as if anticipating the artists of the "Sun-King". It was not for nothing that he was referred to as "the good Bourdichon". Nonetheless, his portraits of Anne of Brittany in the St Petersburg manuscript are among the best depictions of the Queen. The illumination of the Discours sur le Mariage de Pollion et d'Eurydice by Plutarch (59) was close to Bourdichon's style, though at that time a combination of Italianate and Gothic motifs reminiscent of the décor of the Loire valley castles (a specific variation of the French Renaissance) had become commonplace in French miniatures. The same devices were also mastered by the artists from Rouen working for Cardinal Georges d'Amboise, the notable turn-of-the-sixteenth-century politician, as well as by those Anne of Brittany brought to court (L'Altercation des Trois Dames). Miniatures were highly appreciated not only by the royal couple but also by a wide circle of court officials, as is demonstrated by a copy of Petrarch's Les Triomphes, a frontispiece to the Chronique d'Amboise ascribed to the atelier of Jean Perréal from Paris (another famous miniaturist working at the turn of the century) and by the lavishly decorated Missal created for one of the Queen's attendants.

Renaissance culture reached its height under Francis I. Italian artists, sculptors and architects were eager to work at the French court. The art of printed book decoration was gaining strength in the atmosphere of humanistic literature and learning. Illuminated manuscripts began to be commissioned by the king's closest courtiers only in special cases, to some extent by force of habit. The Livre du Triomphe de la Force et de la Prudence, in which the French traditions of illumination were fused with the Italian fashion brought from beyond the Alps, is a rare example of the dying art. Quite characteristically, Geoffroy Tory from Bourges, then already a famous typographer and type designer, is thought to have been one of the artists who created the wonderful group ceremonial portrait, the frontispiece to the Discours de Ciceron.

By the middle of the sixteenth century illumination was largely exhausted as an art form. Its last representatives worked in Italy in the Mannerist trend. The miniatures produced in Venice were not illuminations in the old sense of the word; instead of being illustrations they became

allegoric compositions incorporated, for example, in one case into the Instruzioni date al podesta di *Lendinaria Catarino Contarini* and in another into the *Portolano di Battista Agnese*. Though executed on parchment, they completely abandoned specific "book" features as well as the old traditions, and were effectively easel paintings.

At the beginning of this century Olga Dobias-Rozdestvenskaïa, an expert on mediaeval culture, wrote: "The appearance of a parchment codex instead of the papyrus scroll coincided with a great world revolution that removed classical pagan antiquity from the scene and opened the way for the new world, barbarian in origin and Christian in faith. The parchment codex (and manuscript illumination!) became a companion and a symbol of this world." A thousand years after it appeared this "new world" grew completely decrepit, as did the manuscripts, defeated by the printed book, which became "a companion and a symbol" of the civilization ushering in modern history.

Alexander Sterligov

THE HISTORY OF THE COLLECTION OF WESTERN EUROPEAN ILLUMINATED MANUSCRIPTS
IN THE NATIONAL LIBRARY OF RUSSIA

T he National Library of Russia (until 1992, public library Saltykov - Chtchesrine) contains one of the world's largest collections of Western European manuscripts. In addition to documents, mostly French state papers dating from the thirteenth to eighteenth centuries, it includes manuscripts from the seventh to seventeenth centuries, among which there are wonderful examples of French, Netherlandish, English, German, Italian and Spanish illumination.

The private collection of Piotr Dubrovsky (1754–1816), an official at the Russian Embassy in Paris, formed the basis of the Department of Manuscripts of the Public Library, into which it was incorporated in 1805, nine years before the library's official opening. Still earlier, in 1795, the book and manuscript collection of the Polish Counts Zaluski was transferred from Warsaw to St Petersburg for the library, which was then being organized. However, since most of the manuscripts from that collection were later returned to Poland [1], it is the Dubrovsky collection that remains the nucleus of the library's fund of Western European manuscripts. This nucleus was later augmented by the mediaeval manuscripts amassed by Count Piotr Suchtelen, Russia's ambassador to Sweden in the first quarter of the nineteenth century, and then by the manuscripts from the Tsar's private collection (known as the Hermitage Collection). Finally, after the October Revolution in 1917, manuscripts from the royal palaces of Pavlovsk and Peterhof as well as from the Stroganov and Yusupov Mansions, were transferred to the library.

Dubrovsky's collection, put together during the last decades of the eighteenth century in various European countries, primarily France, is valuable for its wide variety and great historic significance [2]. Distracted by his famous collection, experts for a long time neglected Dubrovsky himself, with the consequence that both his biography and his personality remain somewhat hazy, requiring further study. But his life was an unusual one: he served at foreign diplomatic missions for more than twenty years, including fourteen years in France, the last few of which (he stayed in Paris until June 1792) coincided with the French Revolution. How an ordinary clerk of the Senate, who graduated from the Kiev Theological Academy in 1772, was five years later promoted to be a priest at the Russian Embassy church in Paris remains a mystery. Perhaps he was related to the writer and translator Adrian Dubrovsky, who was patronized by the brothers Alexander and Semion Vorontsov. At any rate, we know that Dubrovsky started buying books and manuscripts on his arrival in Paris in 1777, mainly with money provided by the Counts Vorontsov. He established close contacts with many French bibliophiles — owners of manuscript collections, librarians, archive and literary workers — who helped him to accumulate his vast collection, or, as he called it, his museum. Ex Musaeo Petri Dubrowsky was the inscription put on almost all the manuscripts the collector bought, together with the date of purchase, and from the latter we can see how quickly this incomparable collection gained precious and sometimes unique codices in Greek, Latin and all the contemporary European languages. The Russian historian Nikolai Karamzin visited Paris in 1790 and described the Russians he met there. He wrote of Dubrovsky that, though not rich, he "was able to collect a great library and many manuscripts in different languages. He has original letters from Henry IV, Louis XIII, XIV and XV, Cardinal Richelieu, the Queen Elizabeth of England and others. He knows all the librarians here and through them obtains rare objects for a trifle, especially in this time of trouble. On the day when the people plundered the Bastille archives, N (Dubrovsky) bought for a louis d'or

a whole pile of papers, among which were a few sentimental letters by some miserable prisoner to the Head of police and a diary of another prisoner from the time of Louis XIII" [3].

Did Dubrovsky himself visit the Bastille on June 14–15 1789? It is hard to believe that on those days when all Parisians rushed to the Bastille, Dubrovsky would not have been present at a place where manuscripts — including such unique items as the police file on Voltaire or a large volume by one of the fortresses's most famous prisoners, Latude, — were to be obtained. A book which Dubrosky's good friend, the republican Abbot Rive (1730–1791), published when he was city librarian in Aix contains an interesting eye-witness account of the plunder of the Bastille archives: "Hardly had the Bastille fallen when numerous interesting works and valuable manuscripts came to light: some of which had been exiled there for their bold style which insulted religion, the government or high officials; others because they contained a state secret which had had to be hidden from the eyes of the crowd... The moment these manuscripts were liberated, all, or at least the greater part of them, fell into the hands of barbaric and ignorant people, who, knowing neither their true value nor usefulness, sent those precious vestiges of human reason to the knife of a bookbinder, a paper-maker, etc. The biggest collections were bought for three sous a pound by butter, tobacco and grocery dealers [4]." Quite possibly, it was thanks to Abbot Rive, then a well-known connoisseur of mediaeval manuscripts, that Dubrovsky later managed to get hold of part of the Bastille archives, including some documents of the prisoners and over thirty manuscripts imprisoned together with their owners. It is no coincidence that the inventory of Dubrovsky's own library listed fourteen copies of the rare book from which the quotation above was taken. [5]

Dubrowsky carried out many diplomatic missions for the Russian government, not only to France but also to Germany, Spain, Portugal, England and the Netherlands. These destinations, of which he kept a record during his service, made it possible in some cases to establish the origin of various pieces from his collection.

Dubrovsky's collecting in Paris became far more extensive during the revolution of 1789, especially after the Russian government broke off relations with revolutionary France and the staff of the Russian Embassy left Paris. Dubrovsky stayed on as secretary to M. Novikov, who had been made chargé d'affaires. With libraries and archives being plundered, rare books were cheap in France. Jacques Ancelot, a French writer who saw Dubrovsky's manuscripts in 1826, when they had already been in St Petersburg for fifteen years, was fully justified in praising the collector for having saved treasures which otherwise would quite certainly have been destroyed. For example, Ancelot stated that Dubrovsky had saved from destruction unique manuscripts from the Abbey of Saint-Germain-des-Prés, which owned many thousands of volumes, "in spite of all the obstacles and impediments he constantly encountered". [6] It would be appropriate to mention here the following statement made by Professor Anton Ivanovsky, an honorary librarian of the Public Library in the middle of the nineteenth century: "We obtained the precious manuscripts from France not as war trophies, but as a result of Dubrovsky's patriotic act ... Though these manuscripts are lost to France, fortunately they have not been lost to history." [7]

The Russian government sent Dubrovsky on diplomatic missions to other countries in Europe and in some cases the records

Orations of Cicero.
France. Binding

of those trips helped to determine the origin of various parts of his collection [8]. For instance, before the revolution he visited Spain and Portugal, a trip apparently so rich in valuable purchases that Dubrovsky was even going to publish a book about it at his own expense in which he planned to include maps, plans and illustrations [9].

Dubrovsky spent three years (1792–95) in Holland, and also visited Hamburg and other German towns, constantly adding new manuscripts and archival papers purchased during his travels to his collection. His interests ranged from precious mediaeval manuscripts of the most exquisite taste to the letters of scholars and contemporary manuscripts whose historical value he could at that time have only guessed at.

His first purchases may have been some mediaeval manuscripts from the Celestine Monastery of St Mary in Paris. This monastery refused to obey the 1768 edict reforming the Celestine order, and in April 1778 the Parisian Parliament directed that it be closed. We know that in the 1770s and 1780s the monastery's large library began to be misappropriated by the monks, sold and given away to private individuals, primarily two famous bibliophiles of that time, the Marquis de Paulmy and the Duke of La Vallière. Dubrovsky's acquaintance with Abbot Rive, librarian to the Duke of La Vallière, possibly began shortly after his arrival in France. It may have been Rive who helped Dubrovsky to purchase twelve manuscripts dating from the twelfth to fifteenth centuries which had belonged to the Celestines. Judging by the scribes' notes and the bindings, eight of these manuscripts had been produced in the monastery scriptorium. The most valuable of the Celestine manuscripts in Dubrovsky's collection, however, are three of the five monumental volumes of a thirteenth-century Bible with splendid ornamented initials (the first and the fifth volumes are in the Bibliothèque de l'Arsenal in Paris). The Bible was presented to the monastery by the man considered to be its founder and patron, Louis of Orléans, son of Charles V. We cannot rule out the possibility that the Bible belonged to Charles V, whose love of books earned him the nickname of the Wise. L. Delisle, the most prominent nineteenth-century expert on the manuscript stocks of the Bibliothèque Nationale, wrote that in 1397 or 1398 Charles VI gave his brother Louis of Orléans permission to take two Bibles that had belonged to their father from the library of the Louvre Palace. One of them, signed by Charles V and Louis of Orléans, is now in the Bibliothèque Nationale; the other, in five volumes, was split into two parts in the eighteenth century, one of which stayed in Paris, while the other was bought by Dubrovsky. The beginning of the second volume (the first in Dubrovsky's collection) bears a fifteenth-century inscription, only half of which is discernible, stating that that volume, together with the other four, was a gift to the monastery from Louis of Orléans.

It is worth noting that only the Celestine manuscripts carry the collector's signature in Russian: Perhaps Dubrovsky put it there before he decided to create his famous museum.

Dubrovsky's "museum" was well-known even during the collector's lifetime. "The richest collection of the centuries," as it was called by Vestnik Yevropy, a journal of that time, was not brought to St Petersburg until 1804, [10] four years after Dubrovsky himself returned to Russia. In St Petersburg it was first housed in the collector's apartment, attracting, according to that same journal, crowds of visitors "to the squalid walls of that modest dwelling", including "dignitaries, artists and men of letters", who wanted to see the manuscripts with their own eyes. Among these visitors were Count Alexander Stroganov, the chief director of the imperial libraries, Count Piotr Suchtelen, a well-known bibliophile, Alexander Olenin, the Public Library's future director, F. Adelung, the author of the first published description of Dubrovsky's collection, [11] and Metropolitan Eugenius (Bolkhovitinov), the author of famous vocabularies of Russian writers and of many works on Slavonic and Russian archaeography. With Count Stroganov acting as intermediary, negotiations on acquiring the collection for the Public Library began in the early 1804. The Count's original letters and notes on those negotiations written in preparation for a report to Alexander I still exist. [12]

On 18 January 1805 Count Stroganov wrote that it was desirable to purchase Dubrovsky's collection as soon as possible, since the latter's "reduced circumstances could force him to sell it to some foreign country." The country in question was England, which had made Dubrovsky a very generous offer. The Count concluded his report by noting that "...no private individual has ever had such rarities. Collecting them required twenty-six years of tireless zeal, lucky opportunities, being in Rome, Madrid and Paris, and, finally, the French Revolution itself ... Dubrovsky," he continued, "who has collected these treasures and who wishes to dedicate them to his native country, is working on a plan for the establishment of a special Manuscript Depository in the Imperial Library, (because) these treasures deserve to occupy the first place in it." Stroganov's report carried the following resolution: "Reported on 27 January 1805 — it is highly recommended that these manuscripts be accepted and the request satisfied." [13] That same day the Tsar issued his rescript to the Count: "Count Alexander Sergeyevich! In reference to your report regarding the establishment of a special Manuscript Depository at the Imperial Library based on the highly valuable collection of Aulic Concillor Dubrovsky which he wishes to dedicate to the country... you are entrusted with the task of accepting the said collection from him and, in keeping with his desire and talent, of appointing him curator of this depository, which, due to its importance, will have to constitute a special department of the Imperial Library and be subordinate only to the head director." [14] Dubrovsky's collection had an important advantage over other privately owned ones of the time in that it largely consisted of whole sets of manuscripts that had formerly been part of monastery libraries, state archives or private collections, as opposed to separate, unconnected autograph

Regnault and Jeanneton.
Binding in morocco commissioned by Piotr Dubrovsky

documents or manuscripts that had belonged to famous people and were then purchased at auctions by collectors. The first type of manuscript in Dubrovsky's collection is represented by the books from the Abbey of Saint-Germain-des-Prés and the Bastille, the second type by the codices that had belonged to the kings of France or members of the royal family, as well as to major landowners and dignitaries in France and other countries.

Since the manuscripts from the Saint-Germain-des-Prés library comprise the largest part of Dubrovsky's collection, a short description of this library, which once owned half of the unique manuscripts reproduced in this book, may be of interest.

The library of the Abbey of Saint-Germain-des-Prés occupied a special place among those of mediaeval France. The Abbey was founded in Paris by the Benedictines in 558 and so the library was put together by the monks over many centuries. Many of its manuscripts bear inscriptions by owners or scribes dating back to the tenth century. The library received generous gifts and contributions. It flourished particularly in the seventeenth and eighteenth centuries, when scholar monks, working in teams, started publishing mediaeval works on a large scale, for which purpose they collected old manuscripts in France and other countries, such as Italy and Germany. Many manuscripts that were needed for the publication of patriotic or historical works were not just loaned to Saint-Germain by other monasteries, but were given to it for permanent storage. Corbie Abbey, located near Amiens and famous for its scriptorium, made the greatest contribution. Its precious collection of manuscripts, put together by the monks over the course of eight hundred years, began to suffer plunder during the civil wars of the sixteenth and seventeenth centuries. Many works came into the possession of private individuals, and the library fell into decay. In 1638, Cardinal Richelieu ordered that about four hundred of the most valuable manuscripts from Corbie be given to the Abbey of Saint-Germain-des-Prés, from where twenty-five were purchased by Dubrovsky together with other mediaeval manuscripts. The collection of the Saint-Germain-des-Prés library was being constantly enriched

during the second half of the seventeenth century and the whole of the eighteenth. Two important acquisitions were, in 1735, books and manuscripts that had belonged to Pierre Séguier, a seventeenth-century Chancellor of France, and, in 1755, the collection of Chauvelin, Keeper of the Seal, which included, among others, the library of the Harlay family.

Following the theft of many of the abbey's manuscripts in 1791 and the fire that destroyed almost all of the library's printed books in 1794, the collection was transferred to the Bibliothèque Nationale in Paris in 1795–96. Delisle, writing about the 1791 incident, said that the thieves had stolen many manuscripts, most of which, remarkable for both their age and their illumination, became the property of the secretary of the Russian embassy in Paris, i.e., Dubrovsky. Some of Dubrovsky's Saint-Germain manuscripts, however, have other purchase dates written on them, specifically, 1777, 1778, 1780, 1788 and 1792. Only one carries the date 1791, the year of the biggest act of pillage at Saint-Germain. At the same time, Dubrovsky, far from hiding the fact that the bulk of his collection came from the famous abbey, was, on the contrary, proud of it. It is certain that manuscripts from Saint-Germain first started appearing at auctions many years before the revolution and not just after the robbery in 1791.[16]

The collection made by Piotr Suchtelen (1751–1836) ranks second after Dubrovsky's in terms of both size (it included 262 mediaeval manuscripts and about thirty thousand separate documents) and value. It was acquired by the Public Library in 1836 from his son and heir, Count Konstantin Suchtelen.

Piotr Suchtelen was of Dutch ancestry, born in Greve in the Netherlands, into an impoverished noble family that had moved there from Sweden in the sixteenth century. In 1788, he joined the Russian army as a lieutenant-colonel and finished his military career as a general. Suchtelen particularly distinguished himself during the two Russo-Swedish wars of 1788–90 and 1808–9. Thanks largely to his military, and above all, diplomatic, the Russian army successfully

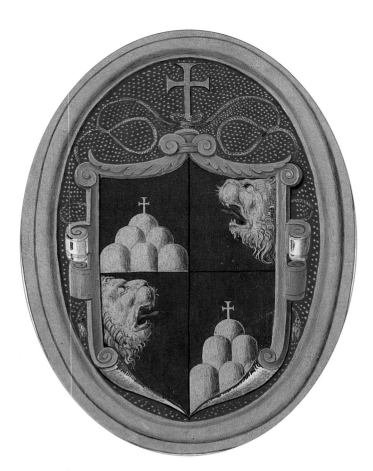

Portulan de Battista Agnese.
Italy (Venice). 1546.
Coat of Arms of owner?

cripts, it contained collections of coins, medals and maps. Philip Wiegel, the author of memoirs which were very popular in Russia, visited Suchtelen at that period. He wrote: "...the man's knowledge was petrifying, but he was so modest that he had no intention of even surprising anybody with it, let alone scaring them... He was equally aware of all the mathematical sciences, all branches of literature, philosophy and theology; in art he was a reliable and skilful judge. But how he managed to store away the treasure of his erudition when half of the day was taken up by his work remains a real mystery." Wiegel also left a detailed description of Suchtelen's "library-office" in the Mikhailovsky Castle: along the walls "going up half their height were cabinets standing close together made of plain wood without glass or curtains. Their shelves contained treasures which any bibliophile would envy; it seemed that the Elzevir editions alone were countless. In the middle of the room, one behind the other, there were extremely ugly desks topped with volumes that had not yet been found a place. The desks had drawers going all the way down to the floor whose depths housed other treasures such as unique manuscripts and collections of prints and medals... He was a real bibliophile. This is a luxury that requires above all time and thrift. All his life General Suchtelen, who was neither rich nor poor, spent half his income on books, and at his death left his heirs a library that was bought by the state, for no individual could afford it." [18]

Suchtelen's collection grew particularly fast during the last decades of his life. While living in Sweden he kept up his correspondence with scholars and bibliophiles in Europe and closely studied auction catalogues, all of which helped him to regularly add to his book and manuscript collections. Most of the auction catalogues belonging to Suchtelen, which were later incorporated into the book collection of the Public Library, still have the prices paid written in by hand, probably by his agent. For example, we know that Suchtelen purchased the fourteenth-century Latin manuscript of Petrarch (10)* at the 1817 sale of Count MacCarthy's library in Paris, for 400 Francs.

Unlike the documents in Suchtelen's library, his manuscript collection has never been an object of special study. Only separate volumes, particularly the illuminated ones (the works by Petrarch and Ovid included here), have been described. This small collection, half of which is made up of Latin and French manuscripts from the eleventh to fifteenth centuries, was, however, put together with great care and knowledge by the collector and certainly deserves attention. Those manuscripts whose original binding survived were put in a special cardboard case, with the name of the manuscript and the date of its execution tooled in gold on the case's spine. But most manuscripts were freshly bound in brown leather with a blind-stamped border on the front cover and the title tooled in gold on the spine. On the inside of the front cover of each manuscript there was Suchtelen's ex libris which included his coat of arms and the inscription: *Bibliotheca Suchtelen. Aequa mente.*

Finally, the third collection of foreign manuscripts came from the Hermitage, where it had been part of the Tsar's private library. It included 482 volumes and entered the Public Library in 1861. This book presents five manuscripts from that collection, namely, the Weissenau Bible, the Missal, the small Book of Hours, *Les Grandes Chroniques de France* adorned by the "prince of illumination" Simon Marmion, and Gian Battista Agnese's *Portolano*.

The Hermitage library, with both book and manuscript sections, was founded by Catherine the Great in 1767 and she built it up for nearly thirty years thereafter. Its nucleus was formed by the book and manuscript collections of Diderot, Voltaire, D'Alembert and Ferdinando Galiani, purchased by the Empress. These were added to the manuscripts that had belonged to Peter III and his father, which mainly dealt with the history of Germany (Nuremberg, Saxony, Brandenburg, Holstein, Danzig, Hamburg, etc.). Twenty-seven Latin manuscripts from Weissenau Monastery in Swabia were bought during the reign of Alexander I. But perhaps the most unique Western

stormed Sveaborg, which was then considered an impregnable fortress, and as a result Russia was able to annex Finland. When he was made a count in 1822 (he had been a Russian citizen since 1806), Suchtelen was allowed to include a silhouette of the Sveaborg fortress in his coat of arms, which also appears in his *ex libris*. Soon after the end of the Russo-Swedish War Suchtelen was appointed ambassador to Sweden. During the war with Napoleon in 1812 Suchtelen took part in a number of battles, and in 1813 he accompanied Jean Baptiste Jules Bernadotte (then the heir of King Charles XIII of Sweden) in his campaigns against the French and the Danes. After the conclusion of the Treaty of Paris he returned to the Swedish court in Stockholm as Minister Extraordinary and Plenipotentiary of Russia, a position he held until his death at the age of eighty-five. Despite the Swedes' initially cold attitude towards Suchtelen as a result of the loss of Finland, he became extremely popular in Swedish society, particularly in literary and artistic circles. This explains the presence in his collection, in addition to the letters written by contemporary diplomats and politicians, of others by famous scholars, writers, artists and antique dealers who sometimes presented him with their manuscripts or even parts of archives. The famous Swedish chemist Jons Jakob Berzelius (1779–1848), for instance, gave Suchtelen part of his correspondence, including 158 letters from various European scholars [17]. Suchtelen obtained manuscripts by Carl von Linné or Linnaeus (1707–1778), the Swedish doctor and scientist who devised the system for classifying plants and animals, as well as a set of material that had belonged to the well-known Swedish orientalist, explorer and writer, J.J. Bjørnstal (1731–1779). But Suchtelen started accumulating his library, which besides manuscripts contained unique publications, before embarking on his diplomatic career, whilst he was still in Russia. In 1801–2, being a favourite of the young Alexander I, he was appointed first Quartermaster-General and then Inspector of the Engineering Department. Suchtelen's office was situated in the former throne room of Paul I in the Mikhailovsky Castle, where the late Tsar's library was also located. Aside from books and manus-

European manuscript in the collection of the Hermitage library was obtained under Nicholas I: the above-mentioned *Grandes Chroniques de France*.

Odd items continued to be added to the Western European manuscript collection during the second half of the nineteenth century. In 1889, for example, the library received a small, yet quite valuable collection from Count Alexander Stroganov (1795–1891) — a general aide-de-camp and a member of the State Council — containing twenty-six manuscripts, seventeen of which were written on parchment in Latin and French. Most of the manuscripts are decorated with beautiful miniatures and ornamental designs and have splendid gold-tooled bindings bearing Stroganov's *ex libris*. Two books from the collection are presented here: *Le Livre des Simples Medecines* by Matthaeus Platearius, which probably belonged to Charles of Anjou and then to King Charles VIII of France, and the *Historia Destructionis Troiae* by Guido de Colonne from Jean-Louis Gaignat's collection, which was sold at auction in Paris in 1769.

Count Stroganov's manuscript collection was given to the Public Library in accordance with its owner's wishes. The rest of his book collection was bequeathed to the library of the University of Tomsk.

In 1917, the Public Library acquired manuscripts from the former Yusupov Palace, Pavlovsk Palace and the Peterhof "Cottage" Palace. Among them there were illuminated manuscripts from the fourteenth and fifteenth centuries (primarily Books of Hours) executed by marvellous artists. [19]

While the texts of the older manuscripts included here are mainly theological, those from the thirteenth to the sixteenth centuries are primarily secular works — chronicles, historical treatises, romances, long poems, encyclopaedias, philosophical and allegorical treatises and translations of classical authors (Cicero, Plutarch, Ovid, etc.). The only exceptions are Books of Hours, works which include a calendar, excerpts from the Gospels, psalms and prayers arranged in accordance with the canonical hours of the day. The Library currently has 130 mediaeval illuminated manuscripts; the number of miniatures in them is, of course, much greater. Some manuscripts, such as *Les Grandes Chroniques de France* and the Rheims Missal, which are the gems of the St Petersburg collection, contain over 150 lavishly illuminated folios.

The study of the illuminated manuscripts in the Public Library from the point of view of their provenance helps scholars to determine the composition of collections that played a great role in the history of mediaeval culture, although these collections are now non-existent or dispersed. The collection of Corbie Abbey was one such ancient library in France. Among later collections, the library of Charles V was undoubtedly the most famous; its 600th anniversary was marked in 1968 by the Bibliothèque Nationale with a remarkable exhibition. [20] In 1424, during the lifetime of Charles V, his library consisted of 1200 volumes. By the end of the reign of his son Charles VI it numbered only 823. In 1435, it was bought by John, Duke of Bedford, the French regent, and was almost completely dispersed after his death in the same year. Part of it entered English collections and, although the majority of the manuscripts stayed in France, many major European and American libraries have masterpieces originating from that famous collection. Almost a quarter of the manuscripts from the library of Charles V that were displayed in the Paris exhibition came from London, Cambridge, Oxford, New York, Copenhagen, the Hague, Leiden, Nuremberg, Hamburg and Brussels. Some manuscripts from the library of Charles V were obtained by Philip the Good, Duke of Burgundy, back in the fifteenth century.

The beautiful *Le Livre des Simples Médecines* by Platearius (acquired by the Public Library in 1889 with the Count Stroganov collection) was owned by King Charles VIII of France, as were two manuscripts that were commissioned by the King himself: one of the *Histoire de Vénitiens* by Guillaume de Dormans and the other of the *Chronique d'Amboise* which features a miniature showing the presentation of the manuscript itself to Charles VIII. Both manuscripts bear the royal coats of arms. A copy of the *Chronique de Louis de Bourbon* by Jean d'Orronville was made for Anne de Beaujeu, who was the older sister of Charles VIII and regent during his minority. It contains a biography of Louis II of Bourbon, who was a regent for Charles VI. The Bourbon coat of arms and the motto *Esperance* in the manuscript bears out the fact that it belonged to the royal family.

A few manuscripts in the St Petersburg collection originate from the library of Louis XII and Anne of Brittany. The King's signature — *Loys* — appears on pages of the beautiful Book of Hours and a French version of Petrarch's *Triumphs*. Louis XII considerably increased the royal collection in the Louvre with the addition of some famous collections, such as the library of the Dukes of Milan containing manuscripts that had belonged to Petrarch. The Public Library collection contains a treatise on military art, *Semideus*, that was presented to Filippo Maria Visconti by its author, Caton Sacco, and subsequently brought to France from Italy by Louis XII. [21]

**Signatures of Jean d'Albret, Jeanne d'Albret,
Henri I and Henri de Navarre
on the Bible Historiale by Guiart des Moulins. F.1v.**

**Signature of Marguerite de Valois
on the Bible Historiale by Guiart des Moulins. F. 1.**

The present book includes two manuscripts that were made for Louise of Savoy, the mother of the French King Francis I. One of them is the allegorical *Livre du Triomphe de la Force et de la Prudence*, and the other is a more ornate copy of Platearius' *Livre des Simples Médecines*. For some time the latter manuscript belonged to Charles V, as is proved by his signature on three of its pages. It may be that the book changed hands when Francis I was captured by Charles V at the Battle of Pavia in 1525.

Of other manuscripts belonging to royal families the best known are the fourteenth-century *Bible Historiale* by Guyart des Moulins in two volumes (formerly owned by the house of d'Albret from Navarre) and the Book of Hours of Mary Stuart (1542-1587), given to her by her uncle Francis, Duke of Guise, when she was the fiancée of the Dauphin, the future Francis II. The signatures of Henry IV, his grandfather, mother and wife, Margaret of Valois, appear on the blank pages at the beginning and end of the second volume of the Bible Historiale. Mary Queen of Scots's Book of Hours also bears numerous inscriptions written by its owner, the earliest made when she was twelve, during her stay in France (ff. 12v–13r): *Ce livre est à moi. Marie, Royne*, 1554. All the others were made during her imprisonment in England that began in 1568 and lasted for nineteen years. Eight pages of the book carry quatrains written by the unfortunate Queen of Scots (ff. 81v, 129v, 130r, 137r, 138r, 158r, 159r, 172r).

*I guide these Hours, and the day
In the true order of my life
Leaving my sad sojourn
Here my light to enhance (F° 81V)
A heart martyrized by outrage
By scorn or by refusal
Has the right to say*

*I am not what I was
Marie (F° 129V)
Old age is a malady which may not be cured
And youth a blessing which no-one can reconcile
Knowing that as soon born, man is near to death
And that he who believes in happiness, works with a will.*

Apart from the quatrains by Mary Stuart, are those manuscripts containing signatures amongst which are notably those of the Count of Nottingham, Lady Arabela Semour, Elizabeth Shrewsbury, the Count of Essex, the Count of Sussex, Sir Walsingham, etc. As was shown by A. Lobanov-Rostovski, all were stamped after the execution of Mary in 1587, when the book became the property of a courtier of James I. It remained in England until 1615.

Next to the manuscript collections owned by the royal family, the library of Philip the Good, Duke of Burgundy, was undoubtedly the best of all those of the French nobility. Only the royal collection in the Louvre Palace could compete with the one put together by the four Dukes of Burgundy in the fifteenth century. The Burgundian collection grew particularly during the reign of the third duke, Philip the Good (1419–67). Numerous artists, writers and translators were generously paid by the Duke to add their works to his library. Suffice it to say that after Philip the Good's death the library had approximately one thousand volumes as compared to the 250 listed in the inventory of 1420.

Ten manuscripts from the Public Library have been traced to this famous collection, most of them commissioned by the Duke himself. The manuscript, containing the romances *Roman d'Athis et Prophilias* ou *Le Siège d'Athènes, Roman de la Violette* ou *de Girart Conte de Nevers* and *Le Dit de la Panthère d'Amours* (both 37), was inherited by Philip the Good from his father. The most famous work in the collection is *Les Grandes Chroniques de France*, illuminated by Simon Marmion and his disciples, although other manuscripts are perhaps just as unique and interesting. Among these are a translation of treatises on medicine by the Italian physician Guido Parati Cremensis, *Trois Traitiez de la Conservation et Garde de la Santé*, which is dedicated to Philip the Good and still has its old Burgundian binding; *Chronologie Universelle*, a huge volume with numerous beautiful miniatures; *L'Estrif de Vertu* et de *Fortune*, a didactic treatise by the poet Martin Le Franc containing a miniature attributed to Jean Fouquet; the fifteenth-century three-volume Grandes Chroniques de France produced at the Abbey of Saint-Denis; and a treatise by Jean Châlons, Philip the Good's Chancellor, on true faith (*La Faulté de la loi sarrazine et la verité de la sainte foy chrestienne*; Fr.F.v.I.8). Three more manuscripts, each bearing the signature of the Holy Roman Emperor Charles V, grandson of Mary of Burgundy and the only heir of Charles the Bold, also used to be part of the Burgundian collection. One of them (Fr.F.v.IV.5) is an anonymous continuation of William of Tyre's *Historia rerum inpartibus transmarinis gestarum*, the most complete work on the history of the Crusades (the St Petersburg manuscript was written and illuminated in the thirteenth century at Saint-Jean d'Acre in the Holy Land). [22] The second manuscript dates from the fourteenth century. It originally consisted of two works, which were French translations of Latin treatises, *Epitoma Rei Militaris* by Vegetius and *Gesta Romanorum*. Dubrovsky split it into two separate volumes (Fr.F.v.IX.1; Fr.F.v.IV.6) leaving the autograph of Charles V in the second, comprising the *Gesta Romanorum*. The fact that the first treatise also originates from the Burgundian collection was discovered only in the process of preparing the present book for publication. The third manuscript contains a fifteenth-century verse copy of *Le Roman de Troie* by Benoît de Sainte-Maure (Fr.F.v.XIV.6), one of the most popular literary works of the Middle Ages. A lengthy inscription by Dubrovsky on the first blank page proves that this last manuscript was owned by the Duke of La Vallière.

The library of René, titular king of Naples, Count of Provence, and Duke of Anjou and Lorraine (1408–1480), was among the most remarkable of those collected in the fifteenth century by French princes. As his son and grandson had died before him and he had no other direct heirs, René left the library to his nephew Charles of Anjou. The collection was dispersed soon after the latter's death in 1481,[23] with some of the manuscripts falling into private hands, then being sold by auction and finally ending up all over Europe, from England to Russia. Seven manuscripts from the Public Library's collection (including five in this book), as V. Shishmariov has shown, are from King René's Library.[24]

René I is an important figure in the history of the fifteenth century. He was related to the French royal family, his grandfather Louis I, Duke of Anjou, was the brother of Charles V, Charles VII was his brother-in-law, and the English King Henry VI became his son-in-law in 1445. He lived in the reign of Louis XI, and was unlucky in both politics and military campaigns, but compensated for this by being a generous patron. King René inherited his love for the arts and sciences from his mother, Yolande of Aragon, whose artistic taste was remarkably developed (in 1416 she bought the famous *Très Riches Heures* of the Duke of Berry; Chantilly, Musée Condé, MS.65), and from his grandfather Louis I, Duke of Anjou (who commissioned the extensive Apocalypse series of tapestries, now at Angers). He inherited his love of the arts and of science. Like all noblemen who followed the example set by the King, his court was large and he liked festivals, hunting and tournaments, which he described in detail in the *Livre des tournois*, his last book. This almost legendary King ("le bon roi René") pursued various activities and had a wide range of knowledge and interests. The composition of his library reflects this; it has been largely reconstructed on the basis of surviving inventories and bills. Along with the works of the Church Fathers and outstanding mediaeval theologians (the Public Library owns a manuscript of St Thomas Aquinas), his library contained the writers of antiquity — Plato, Herodotus, Livy and and Boèce. René was interested in all literary genres, from grammatical treatises to collections of songs, from Dante to Boccaccio (there is also a copy of the latter's novel, *Filocolo*, in the Russian Public Library).

René was also a patron of the newly emerging craft of printing and possessed sixteen printed books (a considerable number for those times), among which were the first editions of Cicero, Justin, Herodotus, St Jerome, St John Chrysostom, Lorenzo Valla and several books on law; he also owned many richly bound volumes decorated with beautiful miniatures (his collection contained over forty illuminated manuscripts). All this shows that René was as much a passionate bibliophile as he was a scholar. Paul Durrieu discovered that King René would first order a rough copy on paper ("une sorte de minute originale"), with all the illustrations, briefly sketched ("rapidement esquissé"), that were to be included in the final manuscript. Then the text would be beautifully written on parchment and the sketches transformed into full-colour miniatures ("les portraitures transformées en miniatures peintes en toutes couleurs")[25].

The Public Library has two of the surviving examples of this first stage in the creation of a manuscript — *Regnault and Jeanneton* and *Description d'un tournoi fait en 1446* — both on paper.

We know that King René was interested in nature and the sciences. He had a collection of rare animals, grew flowers and new plants, and studied their nature, reading special illuminated treatises. His library inventory lists two manuscripts of the *Herbolista*, one in Hebrew and the other in Latin. It is very likely that the French translation of this famous mediaeval book in St Petersburg, decorated with the coat of arms of Charles of Anjou, is connected with René's library.

BRUNETTO LATINI.
Li Livres dou Tresor.
France. Binding

As has already been mentioned, in the middle of the eighteenth century two manuscript collections belonging to French public figures — Achille III de Harlay (1679–1739), president of the Parisian Parliament, and Pierre Séguier (1588–1672), Chancellor of France — were stored in the library of the Abbey of Saint-Germain-des-Prés, the source of many of the mediaeval books and documents purchased by Dubrovsky.

The Harlay collection was obtained by Saint-Germain-des-Prés in 1755 from Chauvelin, Keeper of the Seal, who inherited it from Achille IV de Harlay, the last in the "dynasty of the first presidents of the Parisian Parliament". In the sixteenth century, the ancestors of Achille IV de Harlay accumulated a large collection of manuscripts, including original letters, works on history and, particularly, on French public law[26]. The manuscripts acquired by Dubrovsky from this collection included several hand-written books, as well as some historical documents from the opening period of the French sixteenth-century religious wars (the letters of Charles IX, Catherine de' Medici, Henry III, the governors of various provinces and military commanders, etc.). Five manuscripts in the Public Library unquestionably belonged to the Harlay collection; all of them are bound in brown leather and have the Harlay coat of arms stamped in gold on the front and back covers. They include a unique eighth-century copy of the Bede's *Historia Ecclesiastica*.

The library of Pierre Séguier is usually referred to as the Bibliotheca Coisliniana after his grandson Henri-Charles du Cambont de Coislin, Bishop of Metz, to whom it passed. According to contemporaries, Séguier's library, which contained 4,000 manuscripts and 10, 000 books in many languages on all fields of knowledge then known, was the largest private library in France in the seventeenth century and could compete with the royal collection[27].

Psalms or Hymns to the Grace of God dedicated to Monseigneur le chancelier by M. de la Serre.
Binding bearing the coat of Arms of Pierre Seguier.

Séguier, Chancellor of France under Richelieu, Mazarin and Colbert, was an ardent bibliophile and collector. We know that he used every opportunity offered by his position to buy valuable manuscripts and books, and often charged his numerous correspondents in the provinces, such as governors and quartermasters, with the task of informing him of the sale of private libraries and even individual manuscripts. It was through these channels that he purchased several manuscripts from the libraries of Laurent Bochel, a Parisian lawyer, and of Philippe Desportes (1546–1606), a poet from the circle of Pierre de Ronsard, which were dispersed in the first half of the seventeenth century. The Russian Public Library has a fifteenth-century Italian manuscript of Livy (14; according to the inscription on the inside of the front cover, it used to belong to Bochel) and a French manuscript of the verses of Reclus de Molliens, a twelfth-century poet, from Desportes's collection which contains an inscription by him (Fr.O.v.XIV.2). Louis de Machon, a canon at

Toul, acted as the Chancellor's agent in purchasing books in Lorraine, for which he was repaid by Séguier's special patronage. Among the books once owned by Séguier and now in the Bibliothèque Nationale, Delisle discovered around a dozen received by Séguier as gifts from Louis de Machon. The St Petersburg copy of the Statutes of the Order of St Michael has an inscription recording Machon's ownership on the first page. There is evidence that while on official business in Normandy in 1639–40 during the rebellion of the Nu-Pieds, Séguier used the opportunity to visit the libraries of Cannes and Rouen in order to see, and sometimes buy, unique manuscripts and books. In 1650, during the time of the Fronde, the Chancellor had to leave Paris and put his library in the care of his librarian Pierre Blaise. Séguier repeatedly instructed him to cherish his "treasure", writing: "M. Blaise, I have no doubt that you will take care of my library, but a lover always worries about the object of his affection; I ask you to take care of my beloved, as I call my library. It is my passion".[28]

Séguier had a beautiful gallery built in his palace with three large adjoining rooms in order to house his library. The gallery was decorated by famous architects and artists of the time. Among the 1,400 letters to Séguier in Dubrovsky's collection are five by Charles Lebrun from Rome telling the Chancellor of the copies he was making from old Italian masters, Raphael in particular, for his gallery.

Séguier was one of the founders of the French Academy and for thirty years its sessions were held in his house. He was also involved in the establishment of the Académie des inscriptions et belles-lettres (1663). Séguier's library was always open to scholars and writers and in appreciation for having this opportunity, Academician Jean Ballesdens presented Séguier with a few manuscripts from his own collection, including the fifteenth-century Bestiary now in the Russian Public Library (Lat.Q.V.15).

The best manuscripts in Séguier's collection usually had leather or morocco bindings decorated with his coat of arms and gold tooling on the front and back covers. There are twelve manuscripts in the Public Library which still have the original binding commissioned by Séguier. One of them is particularly splendid: the cover is wrapped in lilac velvet and has the chancellor's coat of arms embroidered on it in gold and silver. Entitled *Psaumes ou cantiques sur les attributs de Dieu dediéz à monseigneur le chancelier par M. de la Serre*, the manuscript was copied by the calligrapher Nicolas Jarry in 1647 (Fr.F.v.I.7). Although Séguier had three librarians working for him, there was no complete inventory of all the manuscripts (Oriental, Greek, Latin and French) which comprised the most valuable part of his collection. A month after Séguier's death in 1672 an inventory of his library was compiled for valuation purposes. It consisted of four parts: the first included state papers, letters, ambassadors' reports and parliamentary registers, etc., along with manuscripts on canon law, medicine, philosophy and theology, the works of the Church Fathers, Bibles, Missals and various poetical works; the second listed volumes, mainly illuminated, in Latin, French, Italian and Spanish relating to history and literature, as well as drawings, prints and geographical maps; the third part enumerated all Greek and Slavonic manuscripts; while the fourth section covered all the Oriental texts. Séguier's widow kept the library intact for many years; the first items to be sold were books. In 1686, a catalogue of the manuscripts was published that was an exact copy of the 1672 inventory, but without the cost of each book [29]. Though the possibility of selling the collection to the royal library was discussed, the manuscripts passed to Séguier's grandson, the Duke of Coislin. In a continuation of the tradition established by his grandfather, the Duke wished to give scholars access to the library and started by commissioning the venerable Benedictine Father Montfaucon to compile a complete catalogue of the manuscripts, which was published in 1715. The Duke was so pleased with the catalogue that after his death in 1735 the entire collection, in accordance with his will, passed to the Benedictine Abbey of Saint-Germain-des-Prés. In 1739, two lists of the manuscripts in the Coislin collection were published in Montfaucon's classic work Bibliotheca bibliothecarum. The first, entitled Catalogue des Manuscrits de la Bibliothèque de Coislin, Latins, Français, Italiens, Espagnols, had 986 entries, the other, Autre catalogue de la Bibliothèque de Coislin qui contient les Manuscrits suivants — 1468 entries. The first list was prefaced by a remark from the compiler: "The numbers of this library are not reliable. It is very difficult to detect any system in them. One can find the same number repeated many times".[30] Given this confusion, there is a real possibility that many of the items absent from Montfaucon's list were already missing, having become part of private libraries at the time the collection was transferred to the abbey. This probably explains why some St Petersburg manuscripts originating from Séguier's collection, such as the two-volume Bible Historiale by Guyart des Moulins [31], were not in the library of Saint-Germain-des-Prés. Most of Séguier's manuscripts now in the Public Library, however, were listed by Montfaucon, and their numbers usually coincide with the ones assigned to them by the Chancellor's librarians (on the bottom of the inside front cover). Forty of the Public

Library's manuscripts have now been traced to Séguier's collection, though this is an incomplete figure because it only covers works on parchment. A complete list of the manuscripts that were once in this collection of the Chancellor of France has yet to be compiled.

The collection of the Russian Public Library reflects both the history of manuscript collecting and bibliophile activity in nineteenth-century Russia and, because of the rich information it provides on the history of patronage by Western European state figures who were lovers of books, is a wonderful monument of world culture.

Tamara Voronova

1. *Sigla codicum manuscriptorum qui olim in Bibliotheca Publica Leninpolitana extantes nunc in Bibliotheca Universitatis Varsoviensis asservantur*, Cracow, 1928. M. Gorecki, "The Zaluskys' Library of the Republic of Poland", *The Journal of Library History*, vol. 13, 1978, p. 408–431.

2. P. Thompson, "Biography of a Library: The Western European Manuscript Collection of Peter P. Dubrowsky", in: *The Journal of Library History*, vol. 19, 1984, No 4, p. 477–503.

3. N.M. Karamzin, *Letters of a Russian Traveller*, Leningrad, 1984, p. 275, 661 (in Russian).

4. *Dissertation sur un recueil des lettres originales, au nombre de LXXIV, écrites de la propre main de Henri IV, roy de France et de Navarre à M. de Bellièvre, chancelier de France par M. l'Abbé Rive, Bibliothécaire de la ville d'Aix-en-Provence*, Paris, 1790, p. 3, 4.

5. *Catalogue des livres français à Monsieur P.P. Dubrowsky, gentilhomme russe, attaché à la légation de S.M. l'Empereur de Russie à Paris.* (The manuscript is housed in the Public Library as Fr.XVIII.21.f.7, No 40.)

6. The Service Record of Piotr Dubrowsky, Curator of Manuscripts at the Imperial Public Library (Public Library Archives: 1805, file 40, document 20).

7. J. Ancelot, *Six mois en Russie*, Brussels, 1827, pp. 113–115.

8. A.D. Ivanovsky, I. *Archaeological Research Undertaken by the State Chancellor Count N.P. Roumiantsev and the Kievan Metropolitan Eugenius II. 2. The role of Libraries in Russia and the Contribution of Piotr Dubrowsky, Baron M.P. Korff and General I.V. Isakov*, Kiev, 1869, p. 36 (in Russian).

9. M.A. Obolensky, "Russian Printing Houses in Paris in the 1790's", *Bibliograficheskiye zapiski, vol. 5*, 1858, p. 155, 156 (in Russian).

10. H. Martin, *"Histoire de la Bibliothèque de l'Arsenal"*, Paris, 1900, p. 495.

11. L. Delisle, vol. 1, p. 99, note 6.

12. *The Europeen Messenger*, 1805, part. 20, N°5, p. 54 (in Russian).

13. A. Adelung, "Nachtricht von der Dubrowskijschen Manuscripten-Sammlung in St. Petersburg' in: *Russland unter Alexander dem Ersten (Ed. H. Storch) St. Petersburg*, Leipzig, 1805, vol. 6, p. 82-113.

14. Letters and notices by A. Stroganov written for the report to Alexander 1. Housed in the Public Library ; F.IV, 493, f° 3-3 v. 5-7 v. 494, f° 69-70 v. (in Russian).

15. Ibid.

16. Rousskaïa starina, 1899, No. 1, p. 134 (in Russian).

17. *Mémorial du XIVe centenaire de l'abbaye de Saint-Germain-des-Prés*, Paris, 1959.

18. L. Delisle, *Op. cit.*, vol. 2, 1874, p. 139.

19. L. Delisle, vol. 2, p. 54-58.

20. T.P. Voronova, "P.P. Dubrowsky, 1754–1816, and the Saint-Germain Manuscripts", in: *The Book Collector*, vol. 27, 1978, pp. 469–478; M. François, "Pierre Dubrowsky et les manuscrits de Saint-Germain-des-Prés à Léningrad", in: *Mémorial du XIVe centenaire de l'abbaye de Saint-Germain-des-Prés*, Paris, 1959, p. 333–341.

21. A.D. Ljublinskaja, "Archives de J.J. Berzeliuse se trouvant à la Bibliothèque publique Saltykov-Chtchedrine de Léningrad", in: *K. Svenska Vetenskapsakademiens. Arsbok för ä 1958*, p. 305.

22. *Notebooks of Philip Wiegel*, part 2, Moscow, 1892, p. 43, 44 (in Russian).

23. *Report from the Imperial Public Library for the year 1861*, St. Petersburg, 1862, p. 11-12, (in Russian).

24. *Report from the Imperial Public Library for the year 1850*, St. Petersburg, 1851, p. 22, (in Russian).

25. *Report from the Imperial Public Library for the year 1889*, St. Petersburg, 1893, p. 8-15, (in Russian).

26. O. Dobias-Rozdestvenskaïa, "Exhibition of Western European Illuminated Books of Hours in the Public Library: March 28 – April 4, 1926", *Bibliotechnoye obozreniye*, vols. 1/2, Leningrad, 1927, p. 3–18 (in Russian).

27. O. Dobias-Rozdestvenskaïa. *Histoire de l'atelier graphique de Corbie de 651-830 reflété dans les "Corbeienses Leninopolitani"*, Leningrad 1934, p. 173.

28. "La Librairie de Charles V", in: *Bibliothèque Nationale: Catalogue de l'exposition*, Paris, 1968.

29. One of these manuscripts is housed in the library of the Academy of Sciences in St Petersburg. See: M.L. Auger, "Un manuscrit de Charles V et de Philippe le Bon à Léningrad", in: *Scriptorium*, 22, 1968, No. 2, p. 276–279.

30. E. Pellegrin, *La Bibliothèque des Visconti et des Sforza, ducs de Milan au XVe siècle*, Paris, 1955, p. 317 (catalogue "B", No 599).

31. A. Lobanoff. *Lettres, instructions et mémoires de Marie Stuart, reine d'Ecosse, publiés sur les originaux et les manuscrits du State Paper Office de Londres et des principales archives et bibliothèques de l'Europe*, London, 1844, vol. 7, p. 245, note 1 ; 346-352.

32. Doutrepont.

33. *Les Grandes Chroniques de France. Enluminures du XVe siècle.* Introduction by T. Voronova, Leningrad, 1980.

34. J. Folda, *Crusader Manuscript: Illumination at Saint-Jean d'Acre, 1275-1291*, Princeton, 1976, p. 176-178, pls 3-22.

35. P. Durrieu, "La Bibliothèque du bon roi René", in: *Congrès international des bibliothécaires et des bibliophiles tenu à Paris du 3 au 9 avril 1923* (reports and memoires published by F. Mazerolle and Ch. Mortel), Paris, 1925, p. 442–447.

36. V.F. Shishmariov, "The Library of René of Anjou and the Collection of Manuscripts in the Public Library in Leningrad", *The Middle Ages in the Manuscripts of the Public Library*, 2. (Ed. by O.A. Dobias-Rozdestvenskaïa), Leningrad, 1927 (in Russian).

37. P. Durrieu, *Op. cit.*

38. R. Kerviler, *Le chancelier Pierre Séguier*, Paris, 1874, p. 156–166.

39. L. Delisle, vol. 2, p. 81-83.

40. L. Delisle, vol. 2, p. 80.

41. P. Séguier. *Catalogue des manuscrits de la bibliothèque du défunt monseigneur le chancelier Séguier*, Paris, 1686, p. 36, 45, 48, 119.

42. Montfaucon.

43. Ibid., vol. 2, p. 1067-1123.

44. Ibid., p. 1067.

FRANCE

SPAIN

ENGLAND

GERMANY

ITALY

THE NETHERLANDS

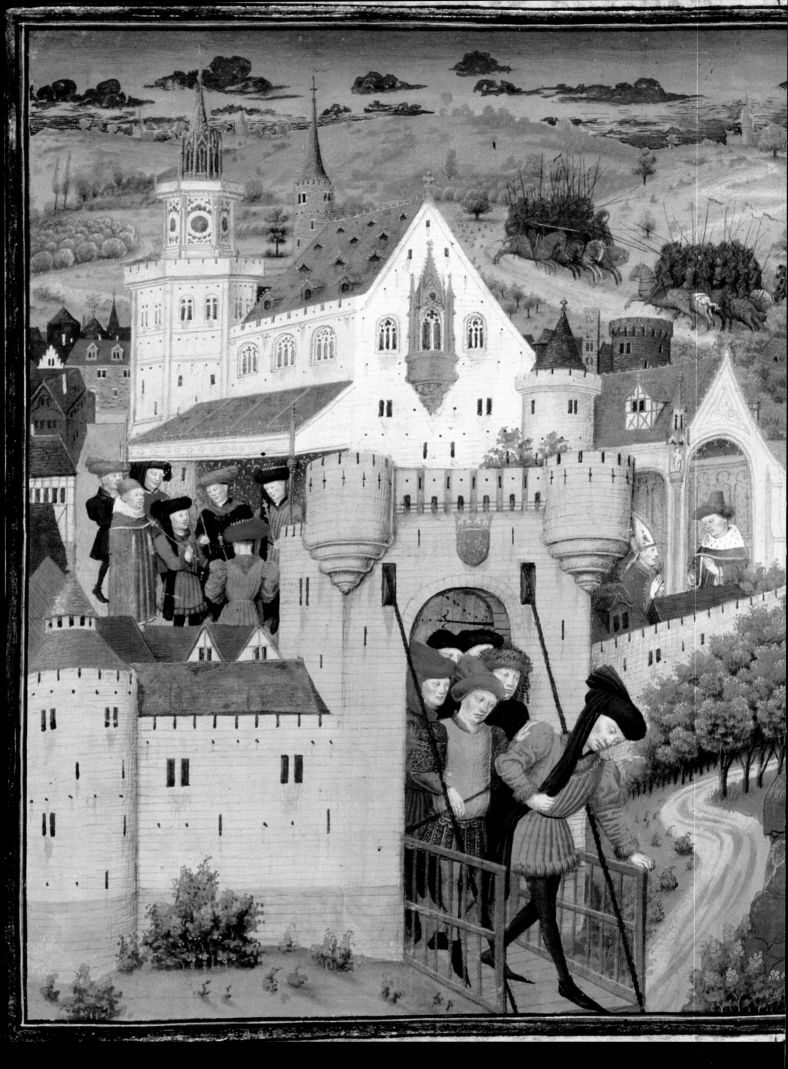

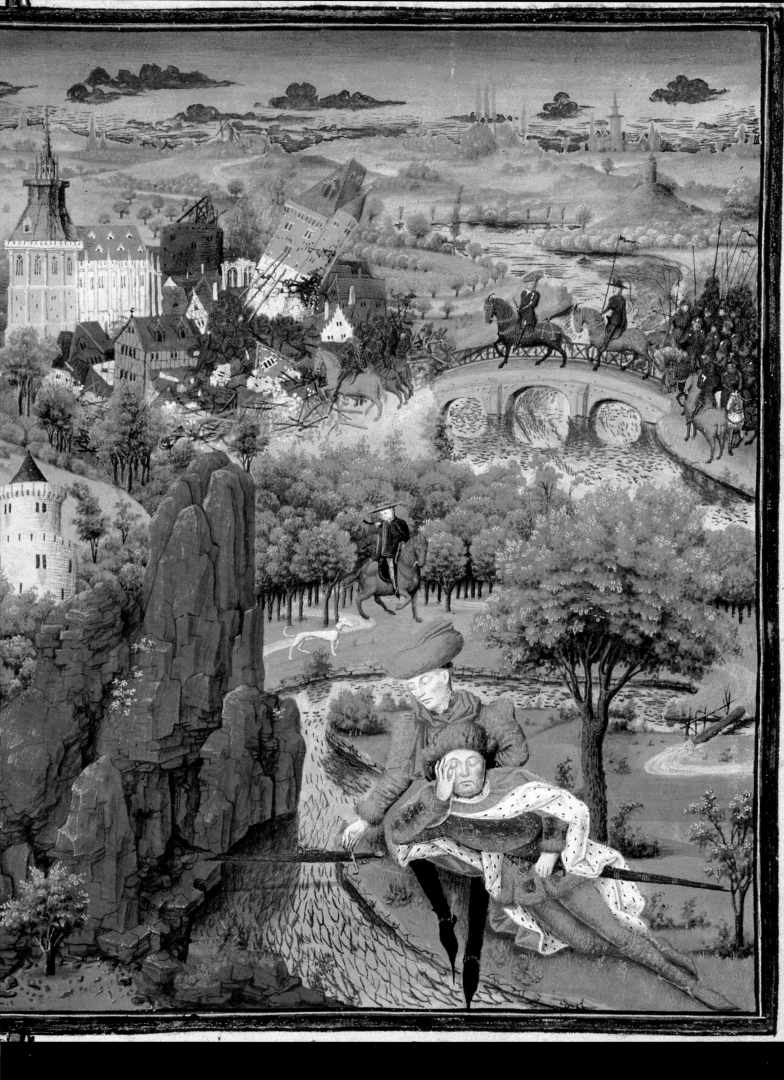

1
EPISTLES OF ST JEROME
Hieronymi Epistolae

France (Corbie). Ca 700.

42 ff. 209 x 152 mm (text 155 x 110 mm). Parchment. Latin.
1 miniature and 15 initials.
Binding: 17th century; white parchment over cardboard.
Lat.Q.v.1.13.

St Jerome — Eusebius Hieronymus Sophronius (347?–420) — is one of the four Latin (western) Fathers of the Church. His Latin translation of the Bible, known as the Vulgate, was declared the official Latin text by the Council of Trent in 1545. St Jerome's numerous epistles are devoted to moral issues such as the upbringing of children, patience in sufferings, continual self-perfection, the merits of monastic life, etc.

The manuscript includes four epistles: *Epistula 125 ad Rusticum, Ps. Hieronymi Epistula 42 ad Oceanum, Epistula 17 ad Marcum presbyterum and Epistula 147 ad Sabiaianum*. The four epistles are preceded by chapter 51 from a book of church dogmas by Gennadius, a priest from Marseille, written in the 5th century.

The monastery at Corbie in Picardy was founded in 660. Many of its first monks came from the more ancient abbey at Luxeuil. This explains why the initials in this early work from Corbie are of very similar type to those seen in illumination from Luxeuil. W. Koehler compared the miniature reproduced in this book with the illumination of another manuscript from Corbie, *Gundohinus Evangelium* (Autun, Bibliothèque Municipale, MS.3).

The manuscript was listed in the 11th- and 12th-century catalogues of the Corbie library where it was housed until 1638, when Cardinal Richelieu ordered that it should be transferred, with other Corbie works, to the Saint-Germain-des-Prés library. At the end of the 18th century the manuscript was acquired by Piotr Dubrovsky.

ENTERED THE PUBLIC LIBRARY IN 1805 WITH THE DUBROVSKY COLLECTION.

LITERATURE: Montfaucon 1739, 2, p. 1125, No 145; Gillert 1880, p. 250; Staerk 1910, 1, pp. 17–23, pl. VI; 2, pl. XIX; Zimmermann 1916, pp. 65, 187, figs 88a, b, 92; "Drevneishiye latinskiye rukopisi Publichnoi biblioteki. 1: Rukopisi V–VI vv.", Srednevekovye v rukopisiakh Publichnoi biblioteki (ed. by O.A. Dobiash-Rozdestvenskaya), 3, Leningrad, 1929, pp. 51–54; O. Dobias-Rozdestvenskaïa, Histoire de l'atelier graphique de Corbie de 651 à 830 refletée dans les Corbeienses Leninopolitani, Leningrad, 1934, pp. 115, 116, 128, 129; Codices latini antiquiores (ed. by E.A. Lowe), part 11, Oxford, 1966, p. 11, No 1616; Christian de Mérindol, La production des livres peints à l'abbaye de Corbie au XIIème siècle, vol. 2, Lille, 1976, pp. 1058, 1059; W. Koehler, Buchmalerei des frühen Mittelalters, Munich, 1972, pp. 90, 98, 99; Latin MSS 1983, pp. 15, 16, No 16.

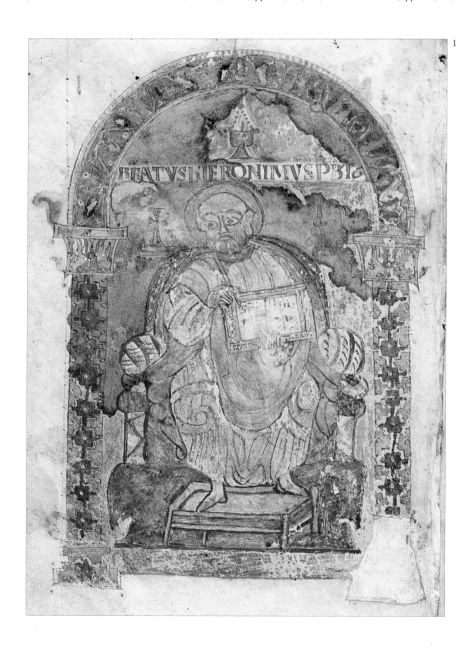

1

EVANGELISTARY
Tetraevangelium

France (?). 9th century.

174 ff. 318 x 275 mm (text 240 x 180 mm). Parchment. Latin.
2 miniatures and 2 unfinished drawings. 12 canon tables within ornamental arcades.
Binding: early 19th century (commissioned by the Public Library). Dark-blue marbled paper over cardboard with spine and corners in brown leather; the spine has the name and the emblem of the library stamped in gold. Lat.Q.v.I.31

The manuscript contains the four Gospels with prologues and canon tables. The script suggests that the manuscript was executed in the 9 th century. The leaves with the depictions of the Evangelists Mark and Luke were added later. These two energetic pen drawings reflect an attempt at three-dimensional modelling and sharply contrast with the style of the miniatures depicting the Evangelists Matthew and John. Carl Nordenfalk, however, thinks that all four miniatures were added later, in the 11th century, and detects the influence of the school of Charlemagne's court in the miniatures. The provenance of the manuscript is unknown (Staerk suggested that at some time it belonged to Saint-Germain-des-Prés). Piotr Dubrovsky purchased it at the end of the 18th century.

ENTERED THE PUBLIC LIBRARY IN 1805.

LITERATURE: Gillert 1881 v.6, p. 500; Staerk 1910, 1, p. 47; J.-B. Thibaut, Monuments de la Notation Exphonétique et Neumatique de l'Eglise Latine, *St Petersburg, 1912, pp. 18–23; Latin MSS of the 5th - 12th centuries, p. 24, n° 51.*

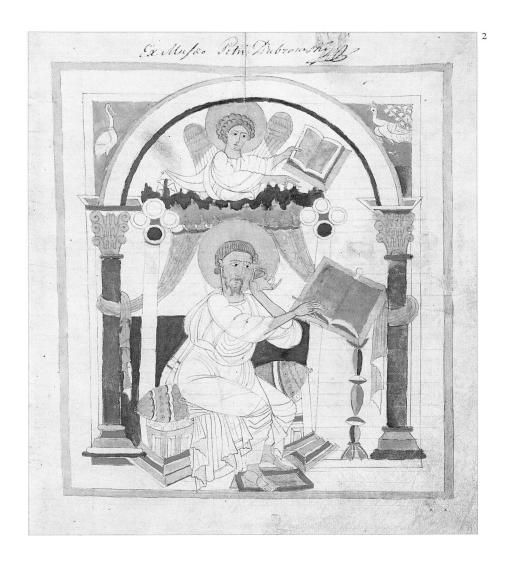

2

1. F. 3v: FRONTISPIECE.

The miniature depicts St Jerome seated on some sort of throne with a book in his hands. Above him is the legend: Beatus Hieronimus pbio [presbitor]. The colour scheme and the two-dimensional depiction of an arch resting on columns and decorated with mosaic-like ornamentation is typical of Merovingian illumination. Similar decoration is known not only in manuscripts, but also in applied art. The archaic shape of the lamp hanging from the arch is reminiscent of examples of the time that have come down to us. The figure of St Jerome is derived from a late Classical model interpreted in two-dimensional fashion by the Corbie illuminator.

2. F. 24r: MATTHEW THE EVANGELIST.

The miniature is framed with a rectangular border and constructed on a ruled page. Above the Evangelist is a canopy with drapery; a winged figure resembling an angel, the symbol of Matthew, is shown at the tympanum of the arch, and there are a heron and a peacock in the upper corners. The artist's desire to follow classical patterns is revealed in the shape of the arch, the column capitals and, most importantly, in the modelling of the draperies, which are finely executed in pen. At the same time, he had difficulty conveying movement and spatial relationships. The miniature's main merits are the exquisite calligraphic drawing and the composition's overall serene harmony.

EVANGELISTARY
Tetraevangelium

France. Third quarter of the 9th century.

199 ff. 285 x 195 mm (text 145 x 110 mm). Purple parchment. Latin.
Text in silver letters with initials and headings in gold. 4 medallion-shaped miniatures showing
the Evangelists and their symbols at the beginning of each Gospel; 12 coloured arcades framing
the canon tables. Binding: 17th century (French). Dark-red morocco over cardboard
with gold-stamped border; blue-marbled paper fly-leaves; gold-tooled border and gold stamped
designs on the spine. Lat.Q.v.I.26.

Due to the colour of its parchment the manuscript is also known as the Purple Gospelbook. It contains the four Gospels preceded by the prologues of St Jerome and canon tables.

With its purple-stained parchment, text written in silver and initials and headings in gold, and the combination of Roman capitals and uncial script in gold of the headings with early Carolingian minuscule, the manuscript is a rare yet typical example of Carolingian art. The crudeness of the illumination contrasts with the refined quality of the script, but, in spite of this crudeness, there is an obvious continuation of Eastern, Greek prototypes: three-dimensional modelling, the figures of the Evangelists holding scrolls and the Corinthian capitals in the arcades. These elements are characteristic of the trend in Carolingian illumination that started at the court of Charlemagne with the adornment, probably by Greek masters, of the famous purple Coronation Gospels (turn of the 9th century; Vienna, Kunsthistorisches Museum). In the 820s–830s, the influence of this school was pronounced in Rheims, and then, in the second quarter of the ninth century, in Metz and Tours. The St Petersburg manuscript was probably produced in one of these artistic centres in the third quarter of the 9th century.

Olga Dobias-Rozdestvenskaïa, following the opinion of Wilmart and Staerk, put forward a view that the manuscript was executed in the monastery scriptorium at Corbie (significantly, this scriptorium was under the strong influence of the school of Tours). However, it is not mentioned in any of the old Corbie catalogues studied by the French scholar Christian de Mérindol. The manuscript was purchased by Piotr Dubrovsky in France sometime before 1792.

LITERATURE: Gille 1860, p. 31; Staerk 1910, 1, pp. 42, 43; 2, pl. XLI; Laborde 1936–38, 1, pp. 2, 3; O. Dobias-Rozdestvenskaïa, Histoire de l'atelier graphique de Corbie de 651 à 830 reflétée dans les Corbeienses Leninopolitani, *Leningrad, 1934, pp. 164–166; Old Latin MSS 1965, pp. 98–100; Christian de Mérindol,* La production des livres-peints à l'abbaye de Corbie au XIIème siècle, *vol. 1, Lille, 1976, pp. 1122, 1123; Latin MSS of the 5th to 12th centuries, p. 24, No 50.*

3

3. F. 4r: OPENING PAGE.
This page is a perfect example of the grand "imperial" style in book decoration. The classical proportions of the text and the page itself are in perfect agreement with the elegant outlines of the Roman capitals and the colour harmony of the background and the text.

4. F. 79v: THE EVANGELIST MARK.
Two medallions showing the Evangelist and the winged lion, his emblem, are painted on purple parchment in heavy colours unusual for Western European illumination (this probably explains why they have not been well preserved). Mark, who holds a purple scroll, is depicted as an antique philosopher. Though somewhat primitive, the artist's bold pictorial manner is not devoid of a certain down-to-earth expressiveness. In the other miniatures with the Evangelists the medallions are flanked not by towers, but by columns topped with Corinthian capitals or peacocks (for example, The Evangelist Luke, f. 109v).

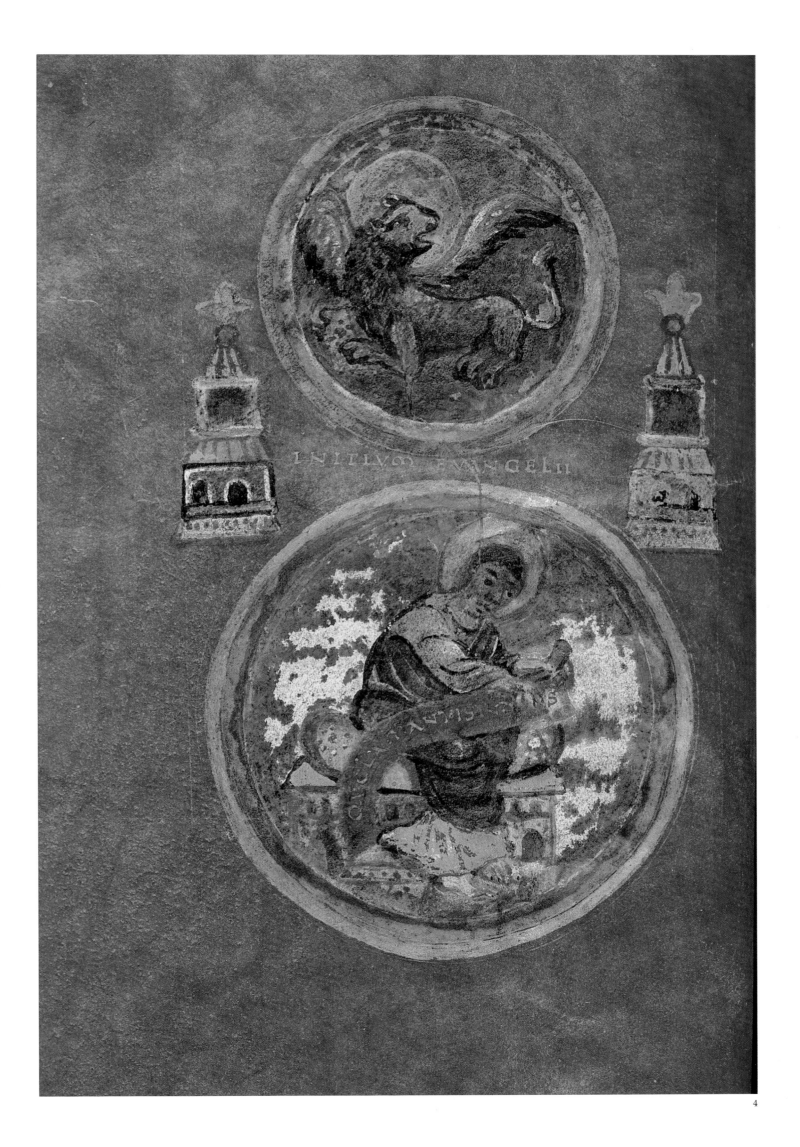

INITIVM EVANGELII

4

5-8
SACRAMENTARY
Sacramentarium Gregorianum

France (Saint Amand). 9th or 10th century.
208 ff. 270 x 205 mm (text 190 x 120 mm). Parchment. Latin.
FF. 13v to 16r show bright ornamental borders framing the patterned initials
and text written in gold; small initials in red, green and gold; headings in red and green.
Binding: 17th century (French). Darkred morocco; gold-tooled
designs on the border and spine; gilt-edged.
Lat.Q.v.I.41.

The *Sacramentary* starts with the services used in the ordination of the priests and daily offices while its main part consists of the Canon of the Mass and the Masses performed through the whole church year.

The style of the illumination places it within a group of Sacramentaries produced in north-eastern France during the last quarter of the 9th century. The *manuscript* is particularly close to works done at the scriptorium at Saint-Amand, which executed court commissions. The design of the ornamental two-page spreads with initials is similar to those in the so-called Second Bible of Charles the Bald (871–873; Paris, Bibliothèque Nationale, MS.lat.2). The bird-like ends of the initials are identical to the arcade capitals in the Gospels of Francis II (Paris, Bibliothèque Nationale, MS.lat.257), while the design of the initial on f. 15v is analogous to one found in the Sacramentary in the Österreichische Nationalbibliothek in Vienna (MS.958, f. 5v). Thus, the decoration of the St Petersburg *Sacramentary* serves as a modest, though representative example of a specific trend in the late Carolingian art connected with the court of Charles the Bald.

Judging by the choice of the saints, this manuscript was written and illuminated at Saint-Amand for Tournai. It was later acquired by the Benedictine monastery at Perrecy near Macon in Burgundy. It was bought by Count Josef-Andrzej Zaluski in 1756 in Paris, as is proved by the owner's inscription.

ENTERED THE PUBLIC LIBRARY IN 1795 WITH THE ZALUSKI COLLECTION.

LITERATURE: Gillert 1881, p. 500; Staerk 1910, 1, pp. 74–127; Laborde 1936–38, pp. 1, 2, pl. I; K. Camber, Codices liturgici latini antiquiores, *Freiburg, 1963, No 926; Latin MSS of the 5th to 12th centuries, p. 29, No 72.*

5, 6. FF. 13v–14r: OPENING OF THE COMMON PREFACE (*Vere dignum*).

7, 8. FF. 15v–16r: OPENING OF THE CANON OF THE MASS (*Te Igitur*).
Employing certain elements of insular illumination, such as full-page initials terminating in bird-heads and interlace pattern enclosed in a frame, the artists from Saint-Amand managed to create a new type of composition, one that was decorative and calligraphic. Severe and logical, this composition is truly monumental. Dominating the colour scheme, in addition to gold and silver (the latter has been affected by time), are various shades of red, from pink to dark red, which is typical of manuscripts from Saint-Amand.

PER OMNIA SAECULA
SAECULORU · R · AM·

DNS UOBISCUM · R̄
ET CUM SPŪ TUO·

SURSUM CORDA · R̄
HABEMUS AD DNM

GRATIAS AGAMUS
DNO DO NRO · R̄

DIGNUETIUSTUM Ē·

5

6

7

IGITUR CLEMENTISSI
ME PATER PER IHM
XPM FILIUM TUUM
DNM NOSTRU· SUPPLI
CES ROGAMUS ET PE
TIMUS· UT ACCEPTA
HABEAS ET BENEDICAS
HAEC DONA HAEC MU
NERA· HAEC SCA SACRI
FICIA INLIBATA·
INPRIMIS QUAE TIBI OF
FERIMUS PRO ECCLE
SIA TUA SCA CATHOLICA·
QUAM PACIFICARE·
CUSTODIRE ADUNARE·

8

9-11
EVANGELISTARY
Tetraevangelium

France (Tours). 10th century.
196 ff. 297 x 225 mm (text 205 x 140 mm). Parchment. Latin.
8 multicoloured arcades framing the canon tables, the opening pages of the Gospels
and the prologues of St Jerome are written in gold and silver on purple bands
and enclosed in a multicoloured rectangular frame; 11 golden, silver
and multicoloured initials with headings in gold, and silver headings on purple bands;
the full-page initials at the beginning of each Gospel form compositions
with the framed headings on the facing pages; small red, golden and silver initials.
The text of the prologues of St Jerome is written in gold.
Binding: 17th century. Brown leather over cardboard; the Séguier arms in gold tooling on the
front and back covers; the Séguier monogram and arms on the spine; the edges with red spots.
Lat.Q.v.I.21.

The manuscript contains the four Gospels, the prologues of St Jerome and canon tables.

The illumination of the manuscript displays some signs peculiar to works produced in Tours, such as a well-balanced composition, the skilful employment of the parchment background and a preference for "metallic" ornamentation. Though it reached its climax before the Norman conquest in 853, the school of Tours nevertheless retained these features at the end of the 9th and in the 10th centuries. The St Petersburg manuscript was probably executed by the school of Tours during this later period. The manuscript's provenance is a mystery up until the 17th century, when it entered the collection of Pierre Séguier. It was acquired with his collection by the Saint-Germain-des-Prés library in 1735 and was subsequently purchased by Piotr Dubrovsky some time before 1792.

ENTERED THE PUBLIC LIBRARY IN 1805.

LITERATURE: Gillert 1880, p. 271; Staerk 1910, 2, pp. 213, 214; J.-B. Thibaut, Monuments de la Notation Exphonétique et Neumatique de l'Eglise Latine, *St Petersburg, 1912, pp. 40, 41; W. Kohler,* Die Karolingische Miniaturen, vol. 1: Die Schule von Tours, *Berlin, 1930, pp. 391, 392, figs 59d–g, 60; O. Dobias-Rozdestvenskaïa,* Histoire de l'atelier graphique de Corbie de 651 à 830 reflétée dans les Corbeienses Leninopolitani, *Leningrad, 1934, pp. 105, 106;* Latin MSS of the 5th to 12th centuries, *p. 30, No 76.*

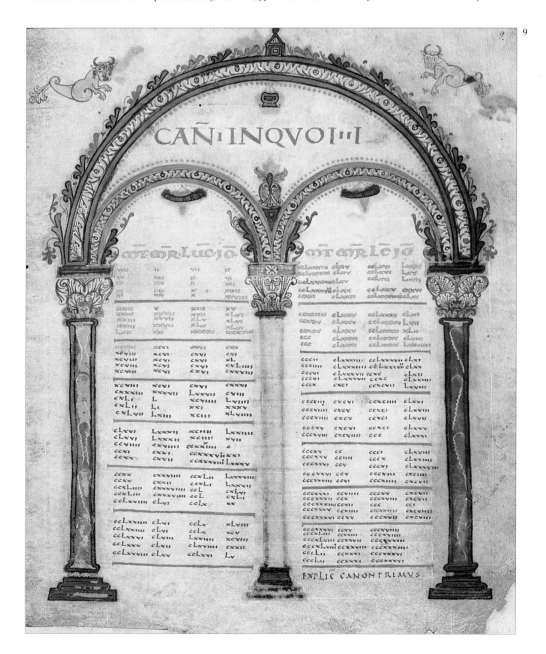

10

11

9. F. 9r: FIRST CANON TABLE.

The slender arcade has some traits of the classically-oriented
art of the school of Tours at its peak. The columns, which are
painted to imitate marble, the acanthus scrolls decorating the
capitals and the widely employed palmette motif all hark back
to Classical Antiquity. The carefully balanced composition is
parallelled by a restrained colour scheme. The red dots along
the inner side of the arches are evidence of insular influence.
Worthy of note are such details as the lamps hanging from the
arches and the bulls shown in the upper corners with tails
ending in palmettes. Other leaves with canon tables have birds
depicted in the upper corners.

10, 11. FF. 16v–17r: THE INITIAL PAGE
TO THE GOSPEL ACCORDING
TO ST MATTHEW (*Liber generationis*).

Together with f. 16v, where the opening text is written in gold
and silver on purple bands and enclosed in the same kind of
rectangular frame, f. 17r forms a marvellous two-page
composition. The pattern used in the frames and in the initials
seems to be entwined with gold and silver strips creating a
jewel-like effect enhanced by the silver birds and palmettes
decorating the initials. In spite of the abundance of ornament
the whole composition of the spread has an airy feeling to it and
is not overloaded. This effect is also achieved by the placement
of the text on purple bands rather than staining the whole face
of the parchment purple.

PSALTER
Psalterium

France (Paris). Between 1218 and 1242.
170 ff. 216 x 150 mm (text 120 x 85 mm). Parchment. Latin.
24 miniatures (medallions in the Calendar) and 190 historiated initials opening psalms and
prayers in colours and gold leaf; 10 larger initials for "liturgical" psalms
(one of them full-page); numerous minor initials and line decorations in blue, red and gold.
Binding: 17th century. Gold-tooled red morocco over card-board; the Séguier monogram and
arms on the front and back covers; marbled paper fly-leaves; gilt-edged.
Lat.Q.v.I.67.

The Psalter includes a Calendar, Psalms and Prayers. The contents of the Calendar and the Litany suggest the manuscript's Parisian origin. Lavishly adorned by excellent masters, it was undoubtedly designed for a high-ranking commissioner or for ceremonial services. Laborde described its illumination as "refined, charming, precious and possessing rare elegance in the spirit of the masters of the Sainte-Chapelle. Indeed, the style and high quality of the manuscript's decoration is close to the art of Parisian court workshops of the 1220s to 1240s that produced the famous Moralized Bibles. The finely polished gold leaf together with the dominating reds and blues creates a typically Parisian colour scheme. The characters' expressive and unconstrained gestures, the skilful modelling of folds

and the exquisite linear drawing herald the advent of the Gothic style in illumination. The manuscript is an example of the rare 13th-century psalters in which the beginning of every psalm is indicated by a historiated initial.

The manuscript belonged to François de la Morlière, as is proved by an inscription on f. 169v: *Franciscus de la Morliere scripsit* (La Morlière is the name of a castle and a seigniory in Brittany). In the 17th century, the manuscript was part of Pierre Séguier's library: a double unpaginated leaf with a miniature of *David Enthroned* and the Séguier arms above it was added to the beginning of the manuscript during its rebinding; from 1735 it was housed at Saint-Germain-des-Prés. Piotr Dubrovsky purchased it in Paris some time before 1792.

ENTERED THE PUBLIC LIBRARY IN 1805 (1849–61 THE HERMITAGE, 7.5.2).

LITERATURE: Cat. Séguier 1686, p. 5; Gille 1860, pp. 36, 37; A. Franklin, Les Anciennes Bibliothèques de Paris, vol. 1, Paris, 1867, pp. 117–120; Delisle, 1868–81, vol. 2, p. 56; Yaremich 1914, p. 37; Laborde 1936–38, pp. 3, 4, pl. II; C. Nordenfalk, "Insulare und Kontinentale Psalterillustrationen aus dem 18. Jahrhundert", Acta archaeologica, 10, 1939, pp. 107–120; R. Haussherr, "Ein Pariser martyrologischer Kalender aus der ersten Hälfte des 13. Jahrhundert", Festschrift Matthias Zender, 2, Bonn, 1972, pp. 1076–1103; I.P. Mokretsova, "Ikonograficheskiye osobennosti frantsuzskoi psaltiri XVIII veka iz sobraniya Gosudarstvennoi Publichnoi biblioteki imeni M.E. Saltykova-Shchedrina", Problemy paleografii i kodikologii v SSSR, Moscow, 1974, pp. 337–354; R. Branner, Manuscript Painting in Paris during the Reign of Saint Louis, Berkeley, Los Angeles, London, 1977, p. 207; Mokretsova, Romanova 1983, pp. 26, 34, 35, 37, 38, 112–143.

12

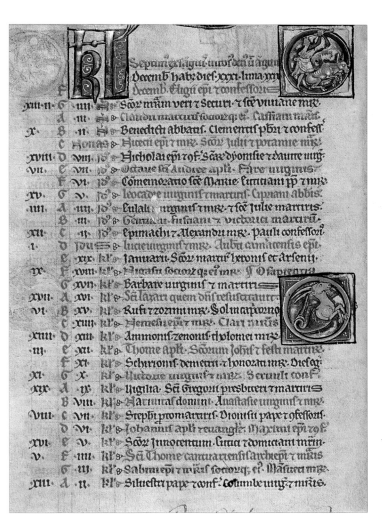

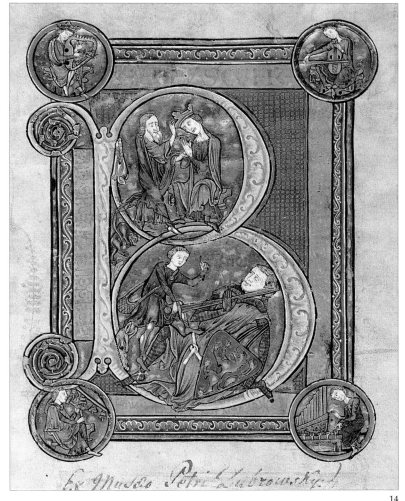

12. FRONTISPIECE - DAVID ENTHRONED.

13. F. 6v: PAGE FROM THE CALENDAR: DECEMBER.

In keeping with the established pattern illustrations in the Calendar are painted in medallions enclosed in rectangular frames. The miniatures depict a scene with a peasant slaughtering a calf and Capricorn, the sign of the Zodiac for December. At the bottom is the ownership inscription of Dubrovsky.

14. F. 7r: INITIAL TO PSALM 1 (PSALM NUMBERS ACCORDING TO THE VULGATE).

The upper part of the initial shows Samuel blessing David as King of Israel, and the lower part has David killing Goliath. Goliath's shield has a golden lion against a red background. In the upper left medallion David is shown playing the harp, in other medallions musicians play the viol, organ and bells.

15. F. 29v: INITIAL TO PSALM 26.

The scene within the initial shows David being annointed by Samuel. This and the following illustrations to liturgical psalms, that are part of daily services, demonstrate particularly vividly the artists' skill in building a complex and striking page ensemble with the calligraphic script, coloured filigree ornaments and the initial sparkling in gold and brilliant colours.

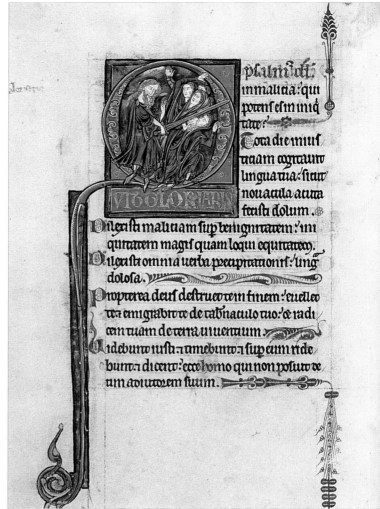

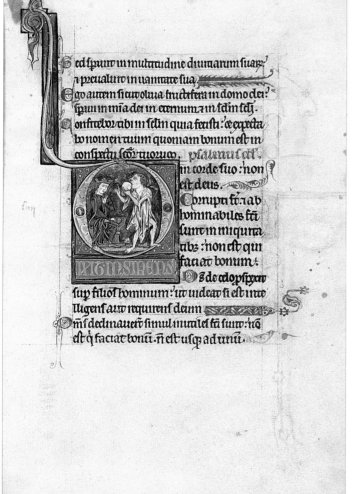

16. F. 44r: INITIAL TO PSALM 38.
King David is shown kneeling before the Lord, pointing at his
mouth and swearing "…that I sin not with my tongue".

17. F. 56v: INITIAL TO PSALM 51.
This text on the wickedness of a mighty man is illustrated
by a depiction of Doeg the Edomite killing the priest. The initial
displays the artist's ability to inscribe a dramatic multifigured
composition within a letter.

18. F. 57r: INITIAL TO PSALM 52.
King David faces a madman who is eating bread: according
to iconographic tradition this was the way to illustrate
the text on "the workers of iniquity… who eat up my people
as they eat bread".

THE RHEIMS MISSAL. "BREVIARIUM ROMANUM"
Missel à l'usage de Saint-Niçaise de Reims

France (Reims). Between 1285 and 1297.

336 ff. 233 x 162 mm (text 147 x 105 mm). Parchment. Latin.
24 medallions in the Calendar, 33 historiated initials and 1 miniature in the text; 28 ornamented
initials; 20 full-page miniatures; numerous filigree initials and decorations in blue and red.
Binding: 18th century (commissioned by Piotr Dubrovsky). Lilac velvet over cardboard;
orange paper fly-leaves; gilt-edged.
Lat.Q.v.1.78.

The Missal is a liturgical book containing the service of the Mass for the entire year, sung parts of the Mass, a Calendar and Litany. The St Petersburg manuscript also includes the *Credo de Jean de Joinville*, a theological treatise by Jean de Joinville (1224–1319), companion-in-arms of King Louis IX and his historiographer. The Missal's illumination is remarkable for its elaborate iconography revealing an outstanding knowledge of theology. In addition to the regular calendar illustrations and a large number of historiated initials, it has eighteen full-page miniatures to the *Credo*, as well as two miniatures inspired by the Lignum Vitae (*The Tree of Life*), a treatise by St Bonaventura (1221–1274). All these illustrations form two-page compositions based on subjects from the Gospels and the Old Testament and are united by a common theological idea.

The Missal's illumination is marked by its excellent quality. The elegant elongated figures, the carefully balanced rhythm of the silhouettes, the calligraphic drawing and the light palette with fine gradation of each colour make the decoration of the *Rheims Missal* a marvellous example of French manuscript illumination of the late 13th century. It was not without reason that Laborde compared it with the *Breviary of Philip the Fair* (Paris, Bibliothèque Nationale, MS.lat.1023) and, therefore, with the art of Honoré, the leading Parisian artist of that time. According to modern scholars the style is typical of northern France and the most likely place of execution is Paris (Mokretsova, Romanova).

In fact its very distinctive style is unknown in Paris itself, and there is every reason to believe that it could be a masterpiece from a Champagne atelier, maybe even from Rheims, as at least two other manuscripts are known to be connected with Champagne : a monumental Bible, and four volumes coming from Rheims Cathedral and housed in the library of that city, (Rheims. mss.39 - 42) ans a Book of Hours from the Walter Art Gallery in Baltimore (w. 98) whose Calendar, today in Stockholm (Nationalmuseum, ms. B. 1648) mentions the obituary of a Champagne nobleman, Henri de Bayon. Baltimore manuscript : see recent catalogue by Lilian McRandall, *Medieval and Renaissance Manuscripts in the Walter Art Gallery*, vol. 1, France, 875 - 1420, Baltimore - London, 1989, p. 119-123, notice 49. pl. Vb, fig. 100-101.

The manuscript was executed for the church of St Nicaise in Rheims, but its subsequent history is unknown. It was purchased by Piotr Dubrovsky in France at the end of the 18th century.

**ENTERED THE PUBLIC LIBRARY IN 1805 WITH THE DUBROVSKY COLLECTION
(1849–61 THE HERMITAGE, 5.2.13).**

LITERATURE: Gille 1860, p. 37; Yaremich 1914, p. 38; Ch.-V. Langlois, "Observations sur un Missel de Saint-Nicaise de Reims, conservé à la Bibliothèque de Léningrad par W.W. Bakhtine", in: L'Académie des Inscriptions et Belles-Lettres. Comptes-rendus des séances de l'année 1928. Bulletin d'Octobre–Décembre, Paris, 1928, pp. 362–368; G. Lozinski, "Recherches sur les sources du Credo de Joinville", Neuphilologische Mitteilungen, 31, 1930, No 5/8, pp. 170–233; Laborde 1936–38, pp. 9, 10, pls VI, VII; L. Friedman, Text and Iconography for Joinville's Credo, Cambridge (Mass.), 1958; Mokretsova, Romanova 1270-1300, pp. 194–231.

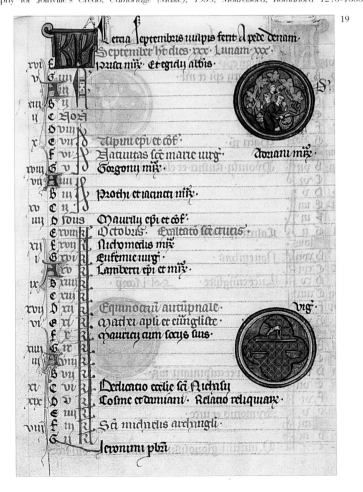

19

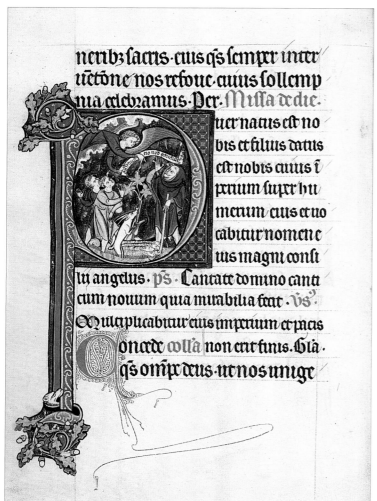

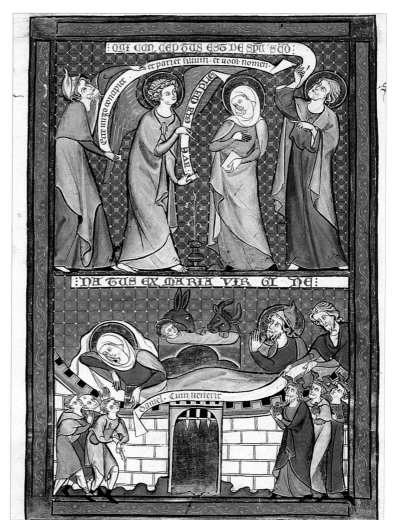

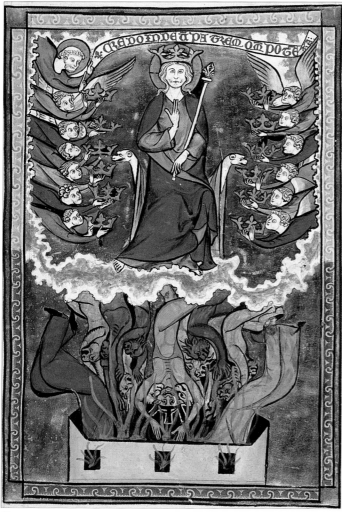

20

21

22

19. F. 8r: LEAF FROM THE CALENDAR: SEPTEMBER.
The month of September is represented by a scene of harvesting grapes at the top and the zodiacal sign of Libra at the bottom. Leaves from the Credo and miniatures inspired by the Lignum VitaeFF. 19v–20r.

20. CREDO F. 19v.
On the left, God the Father, enthroned and crowned, surrounded by angels holding wreaths. In the top left-hand corner, St Peter shows the text of the first article of the Credo, inscribed on a banderole (Credo in Deum patrem omnipotemtem). At the bottom of the miniature are fallen angels, acquiring demonic features, struggling in an architectural structure symbolizing Hell.

21. MINIATURE. *Credo.* F. 22.
The upper part of the left-hand page shows the Old Testament Trinity and Abraham with the Prophet Daniel hovering in the upper left corner; at the bottom is the Burning Bush, Moses removing his shoes and Gideon with the fleece; the Apostle Andrew is in the margin with a banderole.

22. F. 42v: INITIAL.
The Annunciation to the Shepherds.

23. F. 20.
The Creation of the World. God, standing, with a halo in the form of a cross, blessing Adam and Eve and the animals. On one side and the other, the sun and the crescent of the moon. In the margin, the Prophet Heremiah holding a banderole showing the text of his prophecy, prefiguration of the first article of the Credo.

Page 56
24. MINIATURE. *Credo.* F. 21 v.
The right-hand page bears the Annunciation with the Prophet Isaiah and James the Greater (top), the Nativity with the Prophet Daniel and the Adoration of the Shepherds and the Magi (bottom). All elements of this two-page illustration — the subjects taken from the Gospels and the Old Testament and inscriptions containing extracts from prophecies and apostolic epistles — are connected with the theme of the Nativity.

Page 57
25. MINIATURE. *Credo.* F. 26.
The gospel scenes of Christ's sacrificial death on the cross (f. 26r) face the Old Testament ones on f. 25v which allude to his redemptive sacrifice.

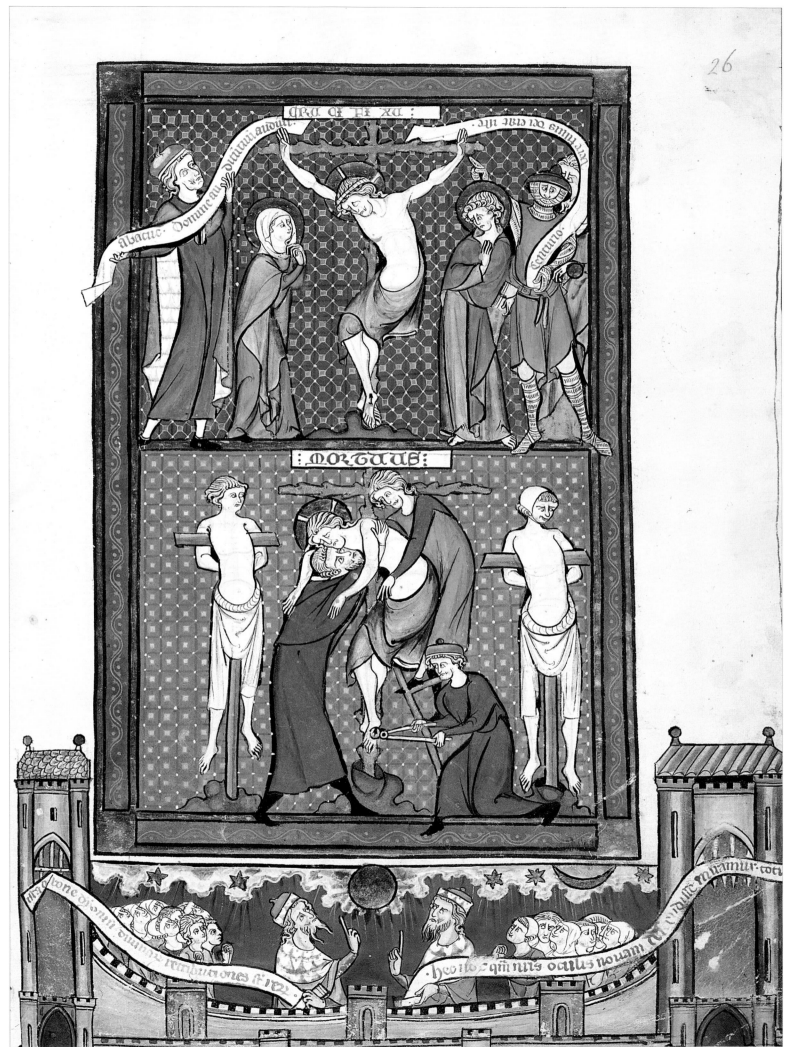

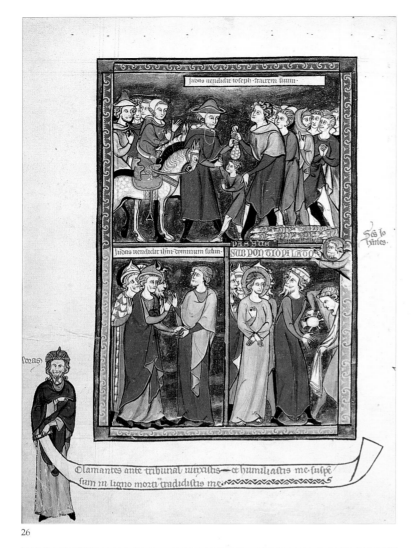

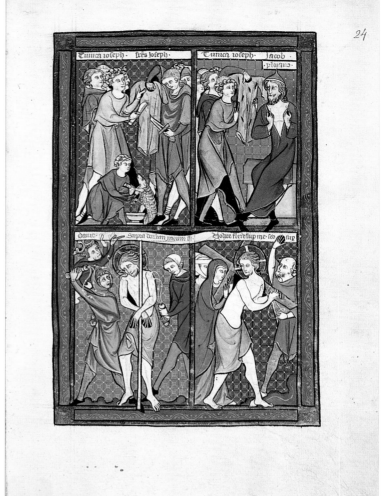

26

27

28

26, 27. FF. 23v–24r.

At the top left Joseph's brothers are selling him into slavery; at the bottom is Judas receiving thirty pieces of silver (left), Christ before Pilate, who is washing his hands, and the Apostle John coming out of the border (right); in the margin is the Prophet Ezra. At the top right are Joseph's brothers smearing his coat with kid's blood and Jacob with Joseph's coat; at the bottom are the scenes of the Flagellation of Christ and Christ Bearing the Cross. The Old Testament scenes in the upper row of miniatures are interpreted as prefigurations of the Gospel scenes shown below.

28. MINIATURE. *Credo.* F. 25 v.

At the top left are scenes of the sacrifice of Isaac and the prophecy of Caiaphas, at the bottom are a Passover scene, King David and a sibyl. The right part of the spread shows the Crucifixion, the Prophet Habakkuk and the centurion; below is the Deposition, and the bottom of the page shows the apocryphal story of a solar eclipse in Heliopolis being watched by Dionysius the Areopagite and Apollophanes.

29. MINIATURE. *Credo.* F. 59 v.

The upper part of the left-hand page shows Jonah being swallowed by the whale and Christ telling the story of Jonah; at the bottom are Christ and Jonah in a boat and the Prophets Jonah and Hosea.

Page 60

30. MINIATURE. *Credo.* F° 61 v.

Analogies from the Old Testament: above, Elijah on his chariot; below, Jonas appearing from the stomach of the whale; King David.

Page 61

31. MINIATURE. *Credo.* F° 60.

On the right-hand page is the Lamentation (top), Samson slaying the lion, the Descent into Limbo and the Apostle Thomas coming out of the border (bottom). The Old Testament and Gospel subjects relate to Christ's descent into Hell after his death.

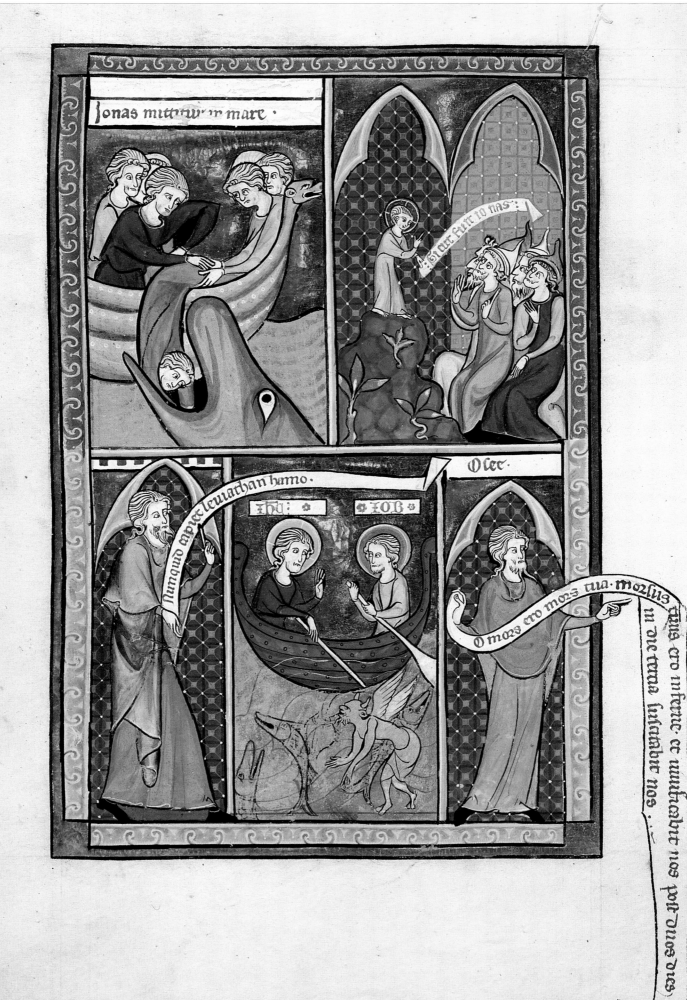

Ionas mittitur in mare.

Oiee.

Nunquid capies leuiathan hamo.

IHU: IOB

O mors ero mors tua. mozsus tuus ero inferne. et nuntiabit nos in victima saluabit nos post dues dies.

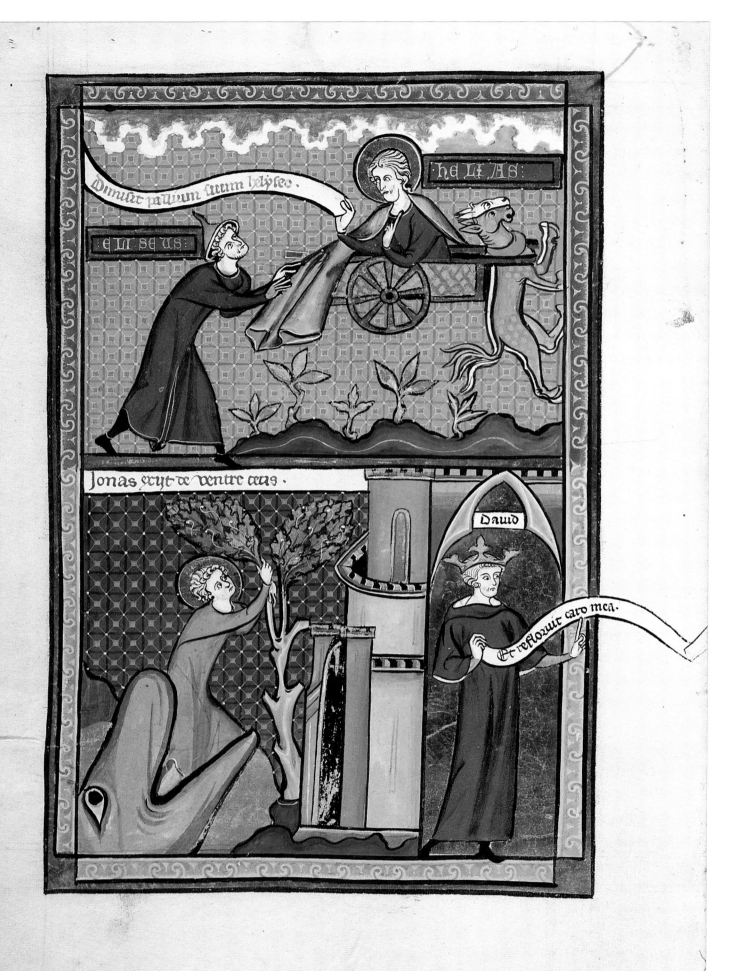

30

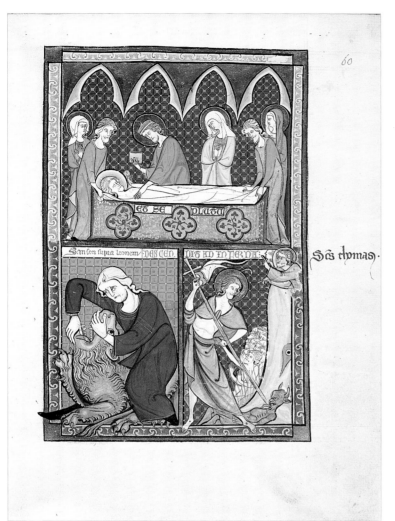

31

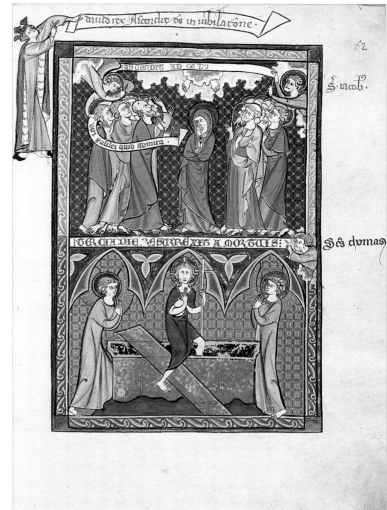

32

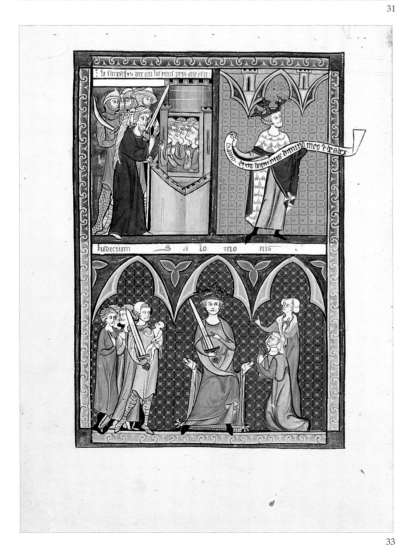

33

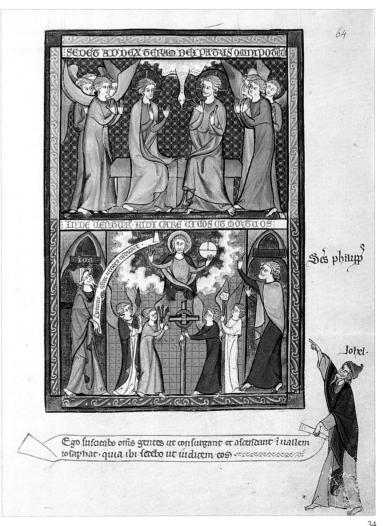

34

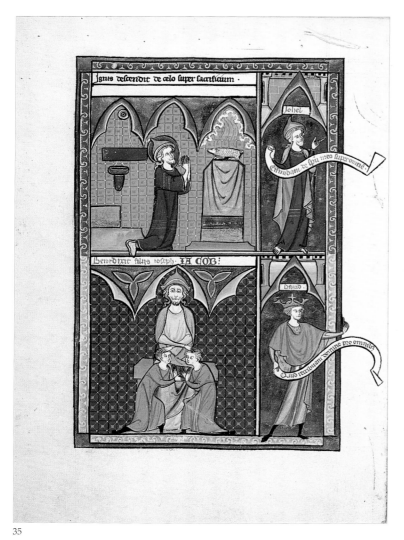

35

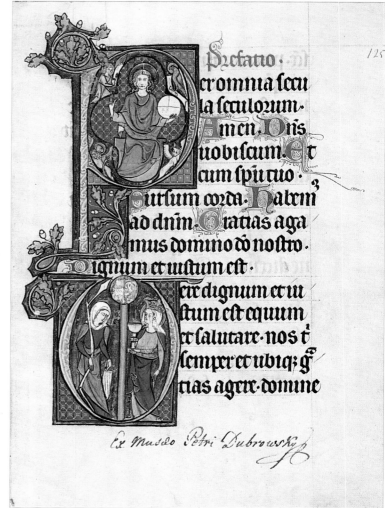

Ex Museo Petri Dubrowsky

36

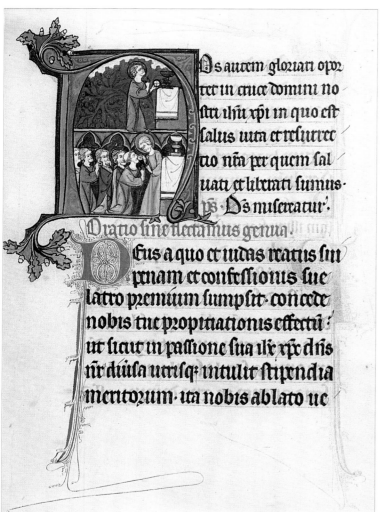

37

Page 61
32. F. 62
Subjects from the Gospels : at the top, the Ascension with the
Apostle James showing a text ; at the bottom the Resurrection;
in the border, the Apostle Thomas ; in the margin, King David.

Page 61
33, 34. FF. 63v–64r.
At the top left is a scene with a Saracen and French barons
taken captive, an episode in which Joinville himself took part,
and King David; at the bottom is the Judgement of Solomon. At
the top right is the New Testament Trinity; and at the bottom
are Christ the Judge, Job and the Apostle Philip; the Prophet
Joel is in the margin. The miniatures are united by the theme of
the Last Judgement.

35. F. 65 v
At the top, the descent from fire on the altar of Elijah ; the
Prophet Joel ; at the bottom, the blessing of Jacob ; the king
David.

36. F. 125r: INITIALS.
Christ in Glory. Synagogue and Church.

37. F. 107v: INITIAL.
The Communion of the Apostles.

38 F. 66.
At the top, the Pentecost ; the Church, at the bottom, scenes of
the mysteries of the Church. The illustrations are annotated by
texts from the Apostles Bartholomew and Matthew, and by the
Prophets Simon and Micah.

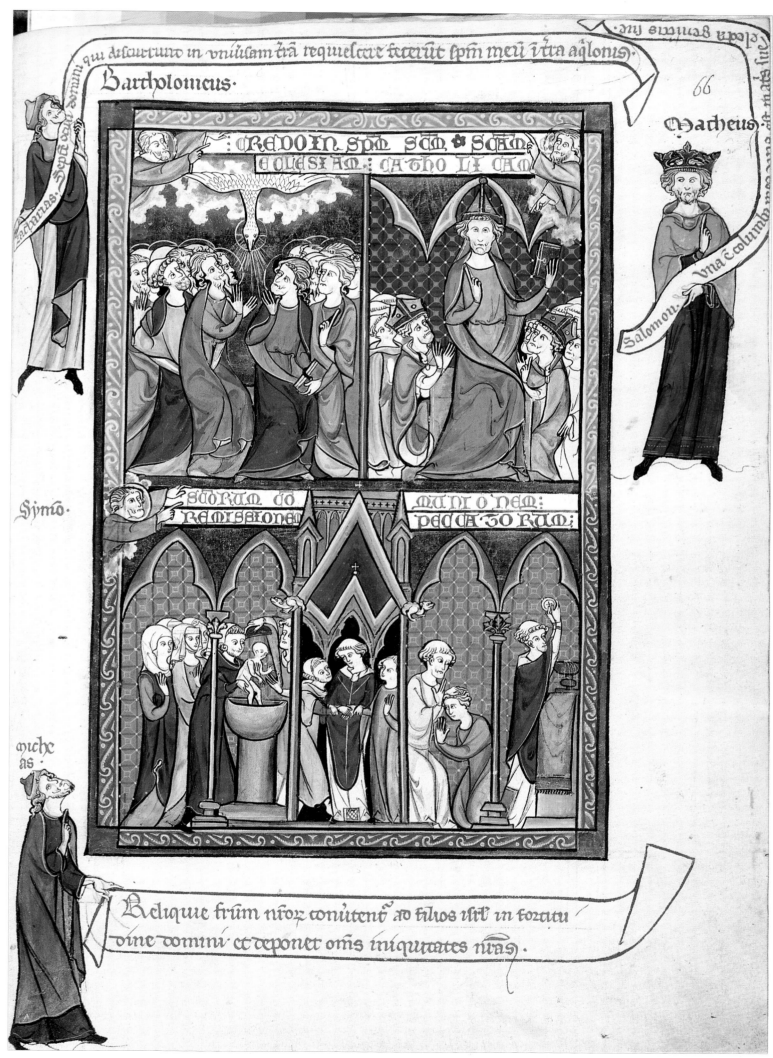

Bartholomeus.

Matheus.

Symō.

micheas.

CREDO IN SPM SCM SCAM ECCLESIAM: CATHOLICAM

SCORUM CO REMISSIONEM MUNIONEM: PECCATORUM:

contulisti· intercedente beata sember
uirgine maria· et presens nob reme
dium ee facias et futurum· Per· alia·

Perficein nob qs domine gratiā
tuam qui iusti symeonis expe
ctationem implesti: ut sicut ille mor
tem non uidit· priusquam xpm do
minum uidere mereretur: ita et nos
uitam obtineamus etnā. Per eude·

Inisti· bi benedicit
meditabitur albis·
sapientiam et lingua
eius loquetur iudiciū
lex dei cā loze ipsius ·ps·
Noli emulari in ma·

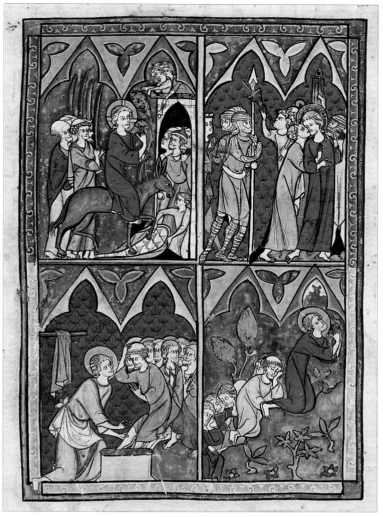

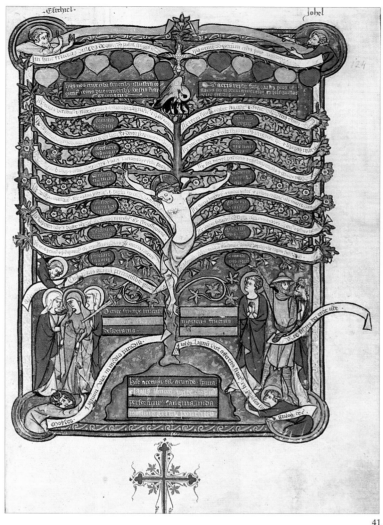

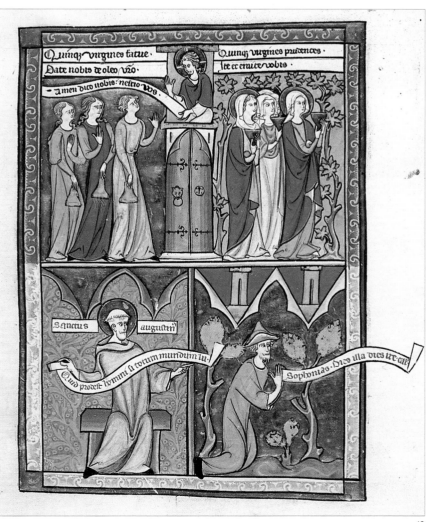

39. F. 70r: INITIAL.
St Benedict and the Monks by a Fishpond (bottom).

40, 41. FF. 123v and 124. *The tree of life.*
Top left : Christ entering Jerusalem. The kiss of Judas and
Christ's arrest : at the bottom, the washing of the feet ; the
prayer of the Chalice. Right : the mystical Cruxifiction on the
Tree of Life ; in the corners, the Prophets Ezekiel, Joel, Moses,
and the Apostle James. At the top, the symbol of the Holy
Ghost : a pelican feeding its young with its own blood. Bottom
left, Mary, pierced with a sword, Mary Magdalene and Mary
Cleophas. The subject of this illustration comes from a poetic
treatise of the Tree of Life. Experts point out that these two
miniatures are different in their way from the illustrations
of the Credo de Joinville (Mokretsova, Romanova).

42. MINIATURE. *Credo.* F° 189 v.
At the top left are the Wise and Foolish Virgins; at the bottom
left is St Augustin and the Prophet Zephaniah.

Page 66
43. MINIATURE. *Credo.* F° 190.
At the top right is the Marriage Supper of the Lamb;
at the bottom right is the Last Judgement. The Prophets Daniel
and Ezekiel are in the left margin and the Apostles Matthew
and Jude (Thaddeus) are in the right. This is the last pair
of illustrations to the Credo; they interpret the final
stipulations of the Creed on the resurrection of the dead and
everlasting life of the righteous.

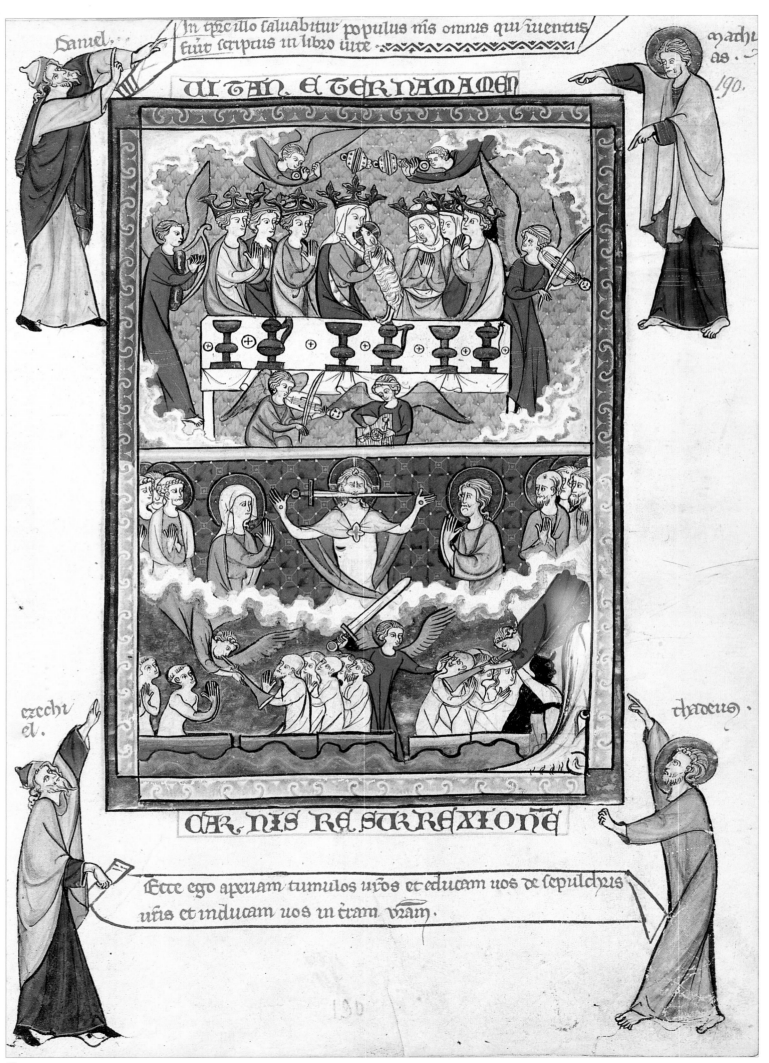

44-51
GAUTIER DE COINCY
Life and Miracles of the Virgin
La Vie et les Miracles de Notre Dame
France (Soissons?). Late 13th century.
285 ff. 275 x 190 mm (text 205 x 135 mm). Parchment. French.
15 historiated initials; 65 pages with miniatures at the beginning of the chapters and sections
of the manuscript (containing between one and eight scenes each); numerous small initials in
blue and red with gold. Binding: late 18th century (commissioned by Piotr Dubrovsky).
Pale lilac velvet over cardboard; doublures of green shagreen, with gold-tooled decoration
on the inside of the covers; fly-leaves of gold brocade; gilt-edged. Fr.F.v.XIV.9.

Gautier de Coincy (1177–1236) was the author of a poetic work, very popular in the Middle Ages, containing the legends of miracles worked by the Virgin. The poem falls into two parts preceded by a prologue and seven songs. Part one comprises 35 miracles, and part two has 23 (about 30,000 verses all together). Gautier was prior at Vic-sur-Aisne near Soissons, and later of the St Médard Abbey in Soissons. Written between 1218 and 1233, his poem is based on 12th-century Latin legends by Hugues Farcit, Germain de Laon and others, which he translated into French and supplemented with stories of the local miracles of the Virgin that had taken place in Soissons, Laon, Chartres, Bourges and Vic-sur-Aisne during his own lifetime. Although over 80 copies of the poem have survived, experts who have studied the St Petersburg manuscript consider it to be the earliest and the most complete. The volume contains, besides the poem, other verses by Gautier, as well as the poem *Li regres de la mere Jhesu Christ* by Huon de Cambrai, prayers, extracts from the lives of the anchorite monks and other texts in prose and verse by unknown authors.

The question of the date and place of execution arouses controversy: some experts place it at the end of the 13th, and others in the 14th century. The study by Mokretsova and Romanova, based on an analysis of its miniatures, which display some traits typical of illumination from northern France (Picardy?), dates it to the last decades of the 13th century.

For its style and iconography, the St. Petersburg manuscript is not an isolated case. F. Avril compares it to two other copies of prayer books by Gautier de Coincy, housed in the Bibliothèque Nationale de France : the first (ms. 25532. French) older, or in any case contemporary

to the one studied here, certainly issues from the same atelier, and may even be attributed to the same artist. The set of miniatures in the second copy (22928 ; French) is slightly later, and is, for the most part, a literal copy of the St. Petersburg masterpiece.

Several masters took part in the illumination of the manuscript, ingeniously creating series of small miniatures that form narratives of a sort and as a rule are not based on any iconographic prototypes. Despite a certain angularity to the figures and their monotonous gestures, the pictorial narrative is quite fascinating. Green, grey and, particularly, black were added to the colour scheme characteristic of Parisian masters. The use of lancet elements borrowed from architecture (see, for example, f. 103v) shows the penetration of Gothic motifs into French illumination of the second half of the 13th century.

The only surviving copy of fifty of the dissertation by Abbot Rive Librarian to the Duc de la Valliere, on this manuscript belonged originally to Piotr Dubrovsky. It gives the history of the manuscript as follows: it was made and presented by the author to his friend and patroness Ade de Soissons. After her death the manuscript was for some time preserved in the family and then came into the possession of the St Médard Abbey where it remained for the following century. The abbey presented it to Charles V, but under Charles VI it was stolen, together with other manuscripts, by the English conquerors. At the beginning of the 18th century the manuscript was purchased by Baron Guillaume de Crassiers. After the sale of the Baron's library in Liège in 1755 the manuscript was in Holland, from where it was probably acquired by Piotr Dubrovsky (before 1790).

ENTERED THE PUBLIC LIBRARY IN 1805 WITH THE DUBROVSKY COLLECTION.

LITERATURE: Montfaucon 1739, 1, pp. 604, 606; Dissertation sur le manuscrit intitulé Œuvres poétiques de l'Abbé Gautier de Coinsi, Prieur de Vic-sur-Aisne, Paris, 1790; Bertrand 1874, p. 172; Laborde 1936–38, 1, pp. 37, 38, pls XX, XXI; A.P. Ducrot-Granderye, "Etudes sur les Miracles Nostre Dame de Gautier de Coinsi", Suomalaisen Tiedeakatemian toimituksia, ser. B, 25, Helsinki, 1932; A. Längfors, "Miracles de Gautier de Coinsi. Extraits du manuscrit de l'Ermitage", Suomalaisen tiedeakatemian toimituksia, ser. B, 34, Helsinki, 1937; Shishmariov 1955, Livre de Lecture, p. 211; E. Kraemer, "Huit Miracles de Gautier de Coinsi. Edités d'après le manuscrit de Léningrad", Suomalaisen tiedeakatemian toimituksia, ser. B, 119, Helsinki, 1960; L. Lindgren, "Les Miracles de Notre Dame de Soissons. Versifiés par Gautier de Coinsi. Publiés d'après six manuscrits", Suomalaisen tiedeakatemian toimituksia, ser. B, 129, Helsinki, 1963; Shishmariov Fund 1965, p. 39; Gautier de Coinsi, Les Miracles de Nostre Dame (publ. by V.F. Koenig), 4 vols, Paris, Geneva, 1966–70 (2nd ed.); Romanova 1975, pp. 190–193; Mokretsova, Romanova 1984, 1270-1300, pp. 21, 22, 31, 102–147.

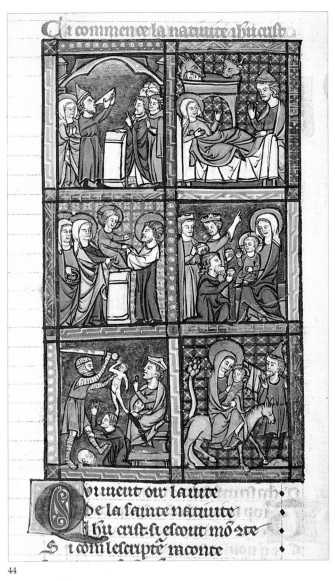

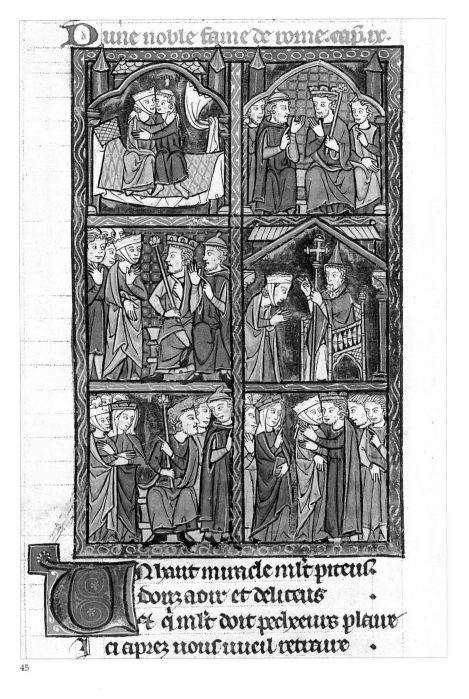

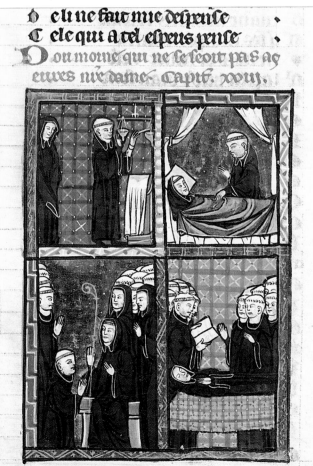

44. F. 8v: THE NATIVITY (6 scenes).
The scenes depict successive Gospel episodes up to and including the Flight into Egypt.

45. F. 76v: ABOUT A NOBLE ROMAN WOMAN (6 scenes).
The miniature narrates the woman's sin and repentance and the intercession of the Virgin.

46. F. 96r: ABOUT A MONK (A PRIOR FROM PAVIA)
who never missed the Hours of the Virgin and who after his death appeared at night to the sexton of his monastery (4 scenes).

47. F. 81r: ABOUT THE DEATH OF A MONEY-LENDER
whose soul is taken away by the devil and about a beggar woman to whom the Virgin and the holy virgins appear (4 scenes).

Qi iart el pius denker piure .
Lamors del usurier ⁊ de la poure
fame. Capitlm . x .

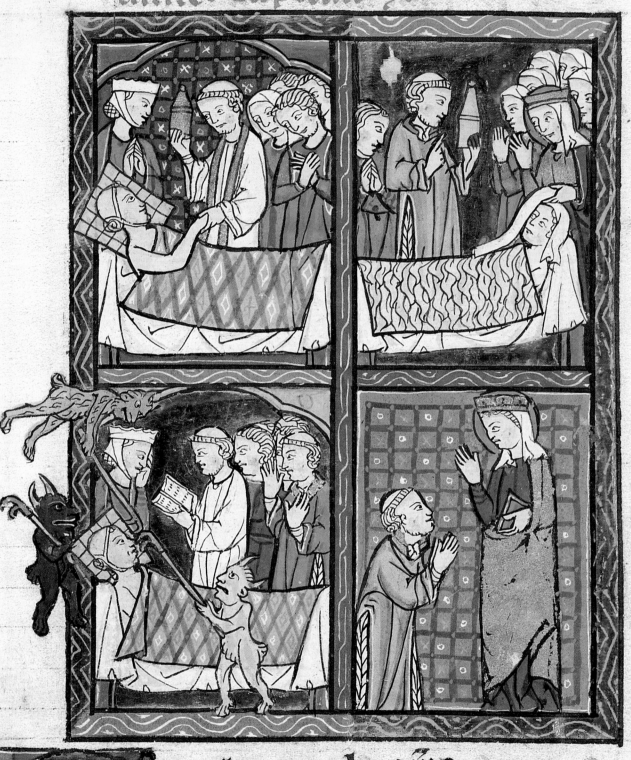

Uit li miracle nre dame .
Sont si piteuz ⁊ douz p mame
Nest nul q̇ bie les recitalt .
C ui touz liaiaɀ nen aptalt .

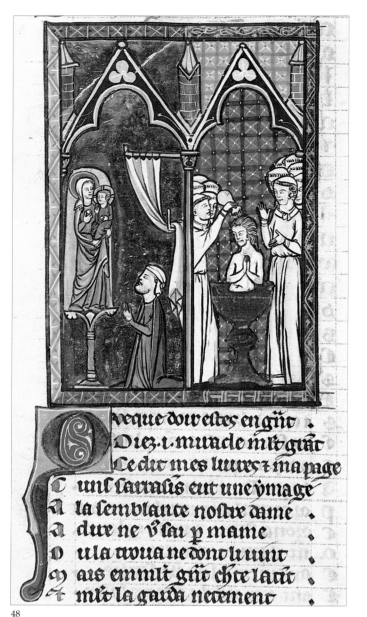

veque doiz eftes en gut .
Oiez .i. miracle mlt grut
Ce dit mes liures z ma page
unf farrafis eut une ymage
A la femblance noftre dame
a dire ne v̊ fai p̃ mame
O ula trua ne donc li uint
m̃ ais emmlt grut chte latit
m̃lt la garda neuement

48

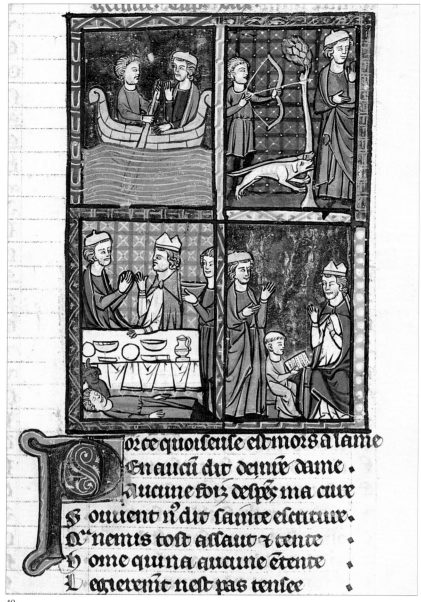

or ce quoi ceufe eft mors a lame
En auci diz deiuie dame .
ucune foiz defpz ma cure
ouuent n̄ dit fainte efcriture .
n̄ nemis toft affaut z tente
h ome qui na aucune etente
l egierement neft pas tenfee .

49

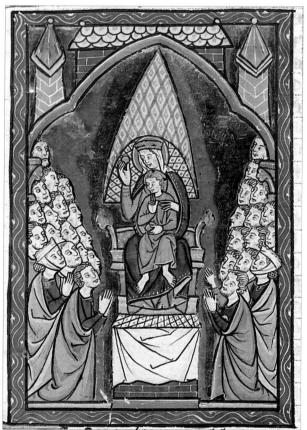

50

48. F. 103v: ABOUT A SARACEN
who venerated the image of the Virgin and who helped to
convert many Saracens to Christianity (2 scenes).

**49. F. 115r: ABOUT THE PRAYERS
TO THE VIRGIN AND
TO ST JOHN THE EVANGELIST**
which helped a noble seignior to escape the traps set by the
devil in the image of his servant (4 scenes).

**50. F. 230v: THE VIRGIN ENTHRONED
WITH ALL SAINTS (Apotheosis of the Virgin).**
This is the final illustration to the poem.

**51. F. 144r: ABOUT AN EMPRESS TEMPTED
BY THE DEVIL (8 and 4 scenes).**
Since this is the longest story in Gautier de Coincy's poem,
it is accompanied by the most elaborate pictorial narrative.
It relates the dangerous adventures and devilish temptations
experienced by the virtuous wife of a Roman emperor, and how
the Virgin comes to her rescue.

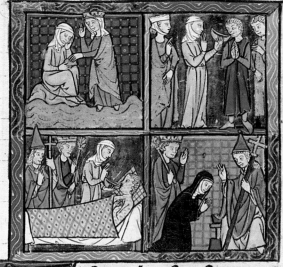

en lamer fu deliurez plaie
nře dame. Capitulum xxiiij.
D un clerc. Capitulum xxviij.
D el ymage de nře dame. xxx
U e miracle qui defendi les la
medis nře dame. xxvij
D e la chetiue domme ʒ de la
doutance de la mort. xxxxxx
U es salutations de la glieuse
uirge la nie dieu
D une empereïs q̃ fu temptee en
duise maniere cap p̃mum

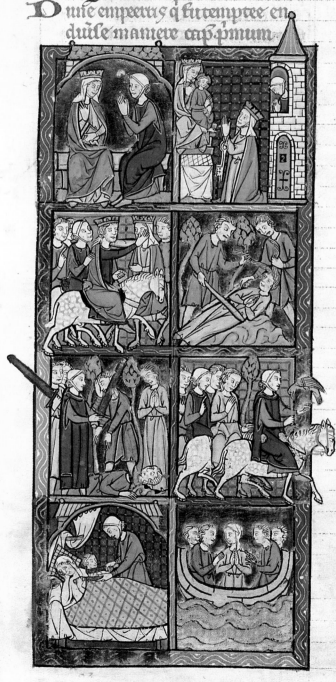

As sages dist ʒ fait sauoir
Li sages liures de sauoir
La peur de dieu cõmce
initions de sapience
D iscrez ʒ sages est sanz doute
Qʼ uñ le crient ʒ uñ le doute
Qʼ uñ criént dieu uñ est pfaiz
Qʼ uñ criént dieu entox ses faiz
G arde touz tan chose ne face
D ont enuers li tres se messace
H om qui toz tans est peureus
B eneois est et eureus
Qʼ dieu ne crient sachiez sãz doute
N ul mal a faire ne redoute
Qʼ doute dieu p̃ tout doute a
D une emperis qui douta
D e tout son cuer de tote same
N ře seigneur ʒ nře dame
F qui mit ama chastee
E n ionece ʒ en ione ee
V n biau miracle uieul retire
Q eromans dou lati traire
L empereris dou git empire
Qʼ toustans croist nongs nepur
Qʼ la sorse est de chastee
F ontaine ʒ doiz de netee
S il e mesface reciter
Qʼ ua chastee puisse esciu
C es gñs seigneurs ces gñdes dames
Qʼ por les cors pdr les ames
E o en enf les enlandonet
P le franc gu cors a bandonet

52-55
JOSEPH OF ARIMATHAEA OR THE HOLY GRAIL
Le Roman de Joseph d'Arimathie
ou le Roman de l'Estoire dou Graal

France. Early 14th century.

139 ff. 292 x 220 mm (text 230 x 175 mm). Parchment. French.
42 miniatures in rectangular borders accompanying the initials, filled with vine leaf ornaments
on a gold background. Binding: 16th century. Light-brown leather over cardboard; gold-tooling
and the coat of arms of Gui II, Viscount of Melun, and the motto Ingenium superat vires on the
front and back covers; parchment fly-leaves; gilt-edged; 7 bands on the spine. Fr.F.v.XV.5

The St Petersburg manuscript is a prose version (*version dérimée*) of Part One of a three-part verse novel by Robert de Borron, a French poet who lived in the late 12th and early 13th centuries. In it he attempted to Christianize the main theme of the Arthurian romances about the Holy Grail. The novel tells of the exploit of Joseph of Arimathaea, his captivity and escape from prison, the appearance of the Holy Grail before him and the magic force of the holy cup opening to him.

Written in two columns, the narrative consists of several chapters. The beginning of each is marked by an initial and an accompanying miniature of the same width as the columns. The manuscript must have been decorated by several artists. For example, the miniatures set against a golden background, with brighter colours and simplified pen drawing, stand out from the all others. Laborde, pointing to the elegant movements of the characters and their noble heads, placed the illumination in the 1350s. On the basis of an analysis of the script, Romanova dated the volume to the early 14th century. This does not contradict the style of the miniatures, which are rather archaic and have some traits typical of both the late 13th and early 14th centuries.

Laborde discovered that in the 16th century the manuscript belonged to the d'Arbaleste family, specifically to Gui II, Viscount of Melun (1512–1570). In the 17th century, it was part of the Séguier collection, and from 1735 it was housed at Saint-Germain-des-Prés. The manuscript was purchased by Piotr Dubrovsky some time before 1792.

ENTERED THE PUBLIC LIBRARY IN 1805 (1849–61 THE HERMITAGE, 5.3.54).

LITERATURE: Cat. Séguier 1686, p. 15; Montfaucon 1739, 2, p. 1109, No 821; Gille 1860, p. 38; Bertrand 1874, p. 190; Delisle 1868–81, 2, p. 58; Laborde 1936–38, pp. 5, 31, pl. III; B. Woledge, H.P. Clive, Répertoire des plus anciens textes en prose française depuis 642 jusqu'aux premiers années du XIIIe siècle, Geneva, 1964, p. 77; Romanova 1975, pp. 194, 195, ill. 14, fig. 15.

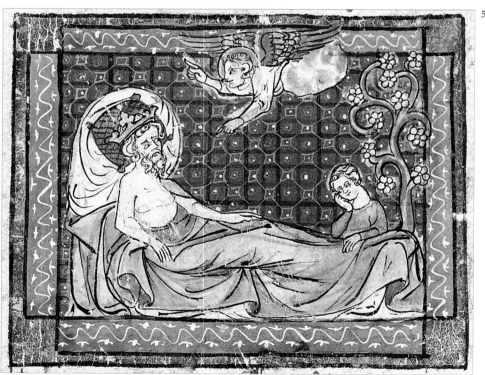

52

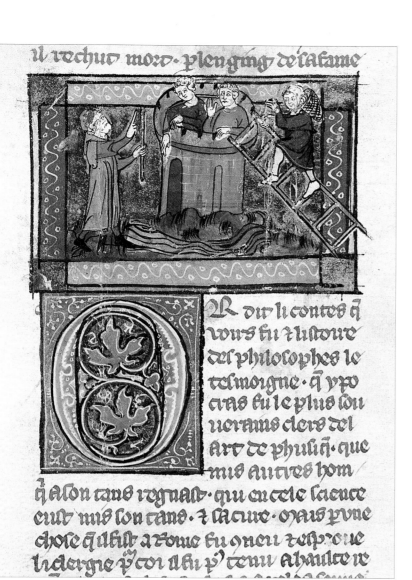

52. F. 7r: INITIAL AND MINIATURE.

An angel appears before King Evalach. Young Joseph is by the king's bed. The artist's inability to cope with foreshortening (note the angel's wings and the pillow on the king's bed which are treated two-dimensionally, as in Romanesque illumination) is compensated for by the beautiful penwork and the harmony of the subdued tones.

53. F. 85v: INITIAL AND MINIATURE AGAINST A GOLD BACKGROUND.

The miniature shows the construction of a house for Hippocrates on an island (of Larissa?). Holding a baton in his hand, Hippocrates, "the wisest of all doctors", is directing the work of the masons.

54. F. 110r: INITIAL AND MINIATURE.

The miniature illustrates the story of King Crude putting Joseph and his companions in jail for forty days without food or water and King Mordrin setting them free. This is one of the best pictures in the manuscript in which the miniaturist skilfully arranged the colours and demonstrated fine draftsmanship in rendering the facial features of the characters, their cheeks lightly highlighted.

55. F. 134r: INITIAL AND MINIATURE.

King Mordrin at Joseph's death bed.

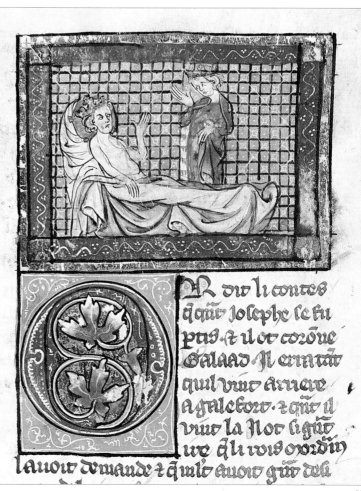

56-71
BRUNETTO LATINI
Li Livres dou Tresor

France. 1310-1320.

149 ff. 310 x 220 mm (text 210 x 150 mm). Parchment. French.
115 miniatures; 4 historiated initials marking the beginning of the preface and each part; large
initials with red and blue ornamentation against a gold background and stalks with drolleries
spreading into the margin and between the columns of the text; numerous small initials.
Binding: 16th century. Brown morocco decorated with blue, red and green mosaic. The centrepiece
is in the shape of a six-pointed star, in the middle of it on the front cover is an eagle (perhaps
the owner's impresa) and, on the back cover, the motto in magnis et voluisse sat est.
Fr.F.v.III.4.

The *Trésors* is a vast encyclopaedia by Brunetto Latini (ca 1230–1294), a Florentine politician, scholar, poet, historian and philosopher who was a friend of Dante's. Written in French during the author's exile in France (1260–67), it consists of three books: Book One starts with Biblical history, proceeds on to the history of Troy, Rome and the Middle Ages, and ends with natural history, giving a lot of information on astronomy, geography and detailed descriptions of animals and birds. Book Two is devoted to ethics; it quotes old and contemporary moralists, and dwells on the typical virtues and vices of mankind. Book Three is the most original and deals with politics and the art of state administration, which, according to the author, is the most important and noble kind of knowledge.

The illumination is rich and varied. The artist possessed a truly uninhibited imagination: the margins of eighteen leaves are filled with numerous grotesques or drolleries: animals, mummers and freaks who fight and play pranks; acrobats balancing on ropes, juggling and turning cart-wheels; musicians playing trumpets, flutes, viols, tambourines, organs and bagpipes; also birds, hares, deer, lions and scenes of wild boar hunting with dogs, and even the Creation of Eve. Konstantinova suggests that the theme of a performance by travelling comedians that begins on f. 11 with the depiction of a trumpeter unites the series of grotesques. The monkeys

are thought to be disguised comedians and the monsters — puppets from the show. At any rate, the drolleries in the St Petersburg manuscript make up one of the most elaborate, interesting and earliest such series in European illumination. Unfortunately, some of the grotesques were cut off during subsequent bindings. The drawing was executed by a highly skilled master, the finest penlines subtly highlighted in watercolour and white. The postures and movements are often beautiful and noble. The artist also made very skilful use of both gold leaf and powdered gold pigment. The iconography in the section on natural history employs traditional models which can be traced back to Romanesque bestiaries. Stressing their "gracious fantasy, charm and elegance", Laborde dated the miniatures to about 1330 and distinguishes in them some traits of Picard illumination. Konstantinova, however, holds that they were produced by "a secular Parisian workshop" in the late 13th century and sees some English influence in the grotesques. In our opinion, the general style of illumination is more typical of that of northern France at the beginning of the 14th century.

The manuscript belonged to Pierre Séguier and in 1735 it was transferred to Saint-Germain-des-Prés; at the end of the 18th century it became part of the Dubrovsky collection.

ENTERED THE PUBLIC LIBRARY WITH THE DUBROVSKY COLLECTION IN 1805 (1849–61 THE HERMITAGE, 32.5.3).

LITERATURE: Cat. Séguier 1686, p. 116; Montfaucon 1739, 2, p. 1100, No. 476; Gille 1860, p. 51; P. Chabaille, Li Livres dou Trésor par Brunetto Latini publié pour la première fois d'après les manuscrits de la Bibliothèque Impériale, de la bibliothèque de l'Arsenal et plusieurs manuscrits des départements et de l'étranger, *Paris, 1863; Bertrand 1874, p. 94;* Il Tresor di Brunetto Latini volgarizzato da Bono Giamboni raffrontato col testo autentico francese edito da P. Chabaille emendato con MSS ed illustr. de Luigi Gaiter, Bologna, *4 vols, 1878–83; Yaremich 1914, p. 38; Laborde 1936–38, pp. 25, 26, pls XVI–XVIII; A. Constantinova,* "Li Tresors of Brunetto Latini", *The Art Bulletin, 19, 1937, pp. 203–219, No 2, figs 1–24; E.J. Carmody,* Li Livres dou Tresor de Brunetto Latini, *Berkeley, Los Angeles, 1948; V.S. Liublinsky,* "Predvaritelnye itogi izucheniya rukopisi", in: *Neizvestny pamiatnik knizhnogo iskusstva, Moscow, Leningrad, 1963, pp. 26, 41, 68, 69; Romanova 1975, pp. 197–199, fig. 29; Golenishchev-Kutuzov 1972, p. 239 (pl.).*

56. F. 18r: PAGE FROM
A SECTION OF BOOK ONE.
This section is devoted to the Prophets. The miniatures show
the Prophet Daniel in the lions' den, which is depicted
as a fortress tower, some other prophets and the three Hebrews,
Shadrach, Meshach and Abednego, in the fiery furnace.

lome auoec les autres ki la estoient
en prison · il prophetisa en babilonie
et blasmott les babilonyens leur ma
uuaistiet mais li peuples distrahel
locisent entraysson pour cou que il
les reprendoit des carnes et del diables
que il faisoient · et fu mis ou sepulcre
dou fil lesu noe · qui ot anon arpha
sar enlons des mors · De daniel

Daniel prophe
tes uaut au
tant adire
comme ongemens
de dieu v homme
amiable · il fu
estrais dela lignie
iudas · et cil deson
ancestre furent
noble si come rois et empreurs · il en
fu portes enbabilonie auoec le roy
iouachin auoec les · trois enfans et
la fu il fais sires et princes detous
les cateus il fu hom glorieus et de
grant biautet · et ot noble corage et
caste cors · et fu parfais enfort · et conis
soit des secrees cozes · et sauoit cou qa
uenir teuoit · De adias prophette

Adias li pro
phettes fu
dela citet
Elye · il dist lonc
tant deuant le
roy salemon q
il teguerproit
la loy dieu pour
nour de une
femme · et quant il fu mors et same
partie de cest siecle · ses cors fu mis
entiere de touste · i kesne en ephison
De jaro

Ado prophettes
nasqui ensal
marie · il fu en
voyes a herobam
qui sacrifioit les
uiles adieu que lde
mourast auoec
lui mais il ni de
moura pas · et p
chou li auint que quant il sen repai
roit uns lyons lestrangla pour cou qil
auoit failli ason compaingnon · et puis
fu entieres jado embelleem · De thobie

Thobias pro
phettes uaut
au tant
adire comme biens
dedieu · et fu fieus
ananie delaligni
e neptalim · il
nasqui en la citet
de la region dega
lilee · Gamalnazar le prist pour cou de
moura il en escil en la citet de niniue
il fu iustes entoutes cozes · il donna tot
cou quil auoit as prisons et as poures ·
il enseuelisoit les mors desamain puis
auula p fiens dune aronde ki li chei es
iols · mais a la fin diex li rendi sane
ue · x · ans apries · et li donna grant ri
caiche · et fu entieres apries sa mort en
niniue · Des iii esfans sidrac misac abde

i troi na
enfant fo
furet
estrait dou
royal lig
nage · et fu
rent de la
glorieuse

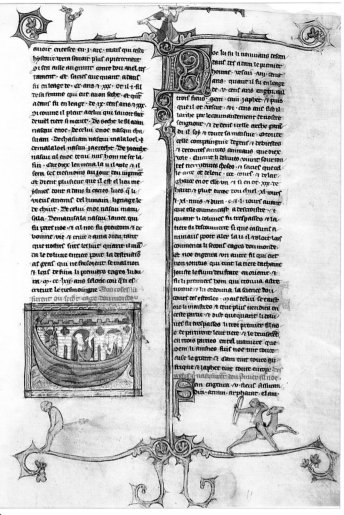

57

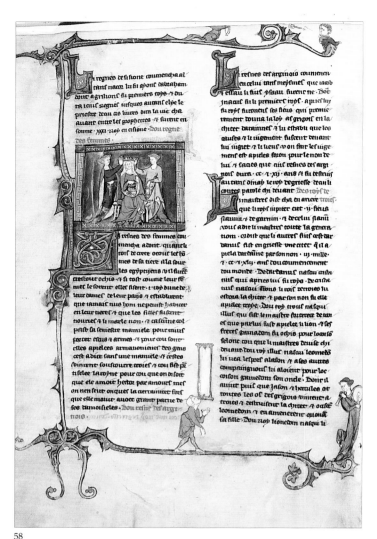

58

59

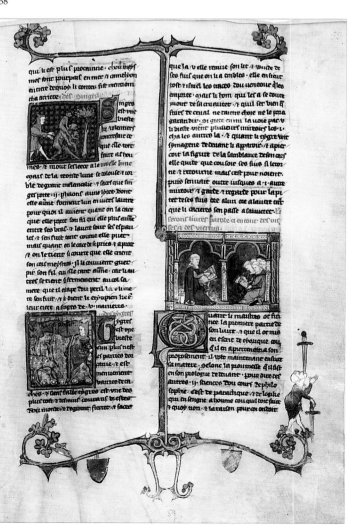

60

de poissons · ses marles est li mudes
tont elle concort · De la serre

et par tele maniere garist desa mala
die · Des sierainnes

luisant est loins se il a la teste ague
par mesure · Mersmement et seil est bn
espars parmi le pis · Des esmerillons

mais devters orient engenrent femme
les · Des belotes

57. F. 11r: BEGINNING OF A SECTION
OF BOOK ONE.
The text, telling of the "second age of the world", is illustrated
with a depiction of Noah's ark. Noah is holding a dove announ-
cing the end of the deluge. In the margins are a hare playing a
musical instrument, an acrobat playing a large golden trumpet
and a blue and a grey monkey fighting.

58. F. 13v: BEGINNING OF A SECTION
OF BOOK ONE.
The text about the reign of women is illustrated with a depiction
of a lady being crowned. In the margins are grotesque freaks, a
hunchbacked acrobat juggling and balancing on the stalk as if it
were a tightrope, and a woman playing a flute and a tambourine
simultaneously.

59. F. 46v: PAGE FROM A SECTION
DESCRIBING CREATURES THAT INHABIT
THE SEA. ; THE ARTIST GIVES FREE
REIN TO HIS IMAGINATION.
The illustration shows a whale, two shell-fish (or crabs)
and dolphins.

60. F. 59v: FIN DU PREMIER LIVRE ET
PROLOGUE DU DEUXIEME TRAITANT
DES VICES ET VERTUS PROPRES AUX
HOMMES.
Illustrated by a scene in which a monk is teaching his disciples.
In the margin, juggler balancing a sword.

61. F. 45v: SWORDFISH (upper right).

62. F. 47r: SIRENS (lower right).

63. F. 50v: FALCONS (left).

64. F. 54v: WEASELS SHEEP (top).

Page 78
65. F. 55r: CHAMOIS (upper right).

Page 78
66. F. 57r: ELEPHANT.

Page 78
67. F. 55: WOLF.

Page 78
68. F. 56: HORSES.

Page 78
69. MOUTONS. F° 54 v.

Page 78
70. F. 59: MONKEYS.

71. F. 59v: BEGINNING OF A SECTION.
THE SECTION IS DEVOTED
TO THE MAIN FEATURES OF OBJECTS
WHICH ARE GROUPED IN PAIRS:
HOT – COLD, WET – DRY.
Concentric circles symbolizing water, air and the celestial sphe-
re surround a monk who is administering the last sacraments to
a dying man. The drolleries at the top include a monkey luring
birds into a trap with its flute; at the bottom two monkeys, one
on a deer and the other on a goat, are engaged in a mock fight.
One of the monkeys has a shield with a coat of arms – a red
lion on a golden background – which is often encountered in
similar scenes in French illumination.

Chreue
uernel
t buffes
sont vne ma
niere de bu
tes ki som
de si bonne
conoissance

Que de loing conoissent les gens q̔ uien

li fans
est li
plus
grande bieste
qui soit
dent sont y
noire · t ses
vies est a pie

les premoistes ki est samblables a · i.

dou sablon pour vne enuie de nature q
telle piere ne viengne al hommes ·

utroie
est vne
bieste
es parties din
de · st est gran
te q̄ne asnes
a si a crupe de
cerf · t pies t

iambes de lyon · cief de cheual · iola de
buef · bouce grande iusques as oreilles

uient mour · se fuelle de louer ne le ga
rist de mort · Dou cheual

cheuals
est vne
bieste
de moue grit
gnoissanche
Qui repaire
tous iours
entre les hou

mes t leur doune agarre desens t raison
tant que il gnoissent leur singnour · t

il gist auoec la fumiele · t se tu uieus en
genrer vace tu loieras le diestre · Del brebis

rebis
est v
ne sim
ple bieste plai
ne depais t de
paour ki re
noist ses fius

Les marles t les fumieles entre grant
tourle doelles au baueler seulement a la
conoissance de sa uois · t pour chou que

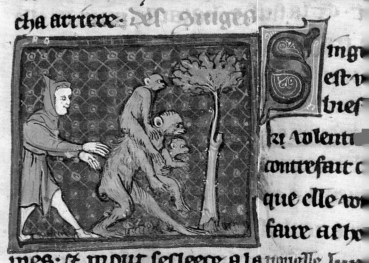

nge
est v
nief
ki uolenti
contrefait c
que elle u
faire as ho

mes · t mout sesleece a la nouuele lun
q̄ir de la reonde lune se dolouse t

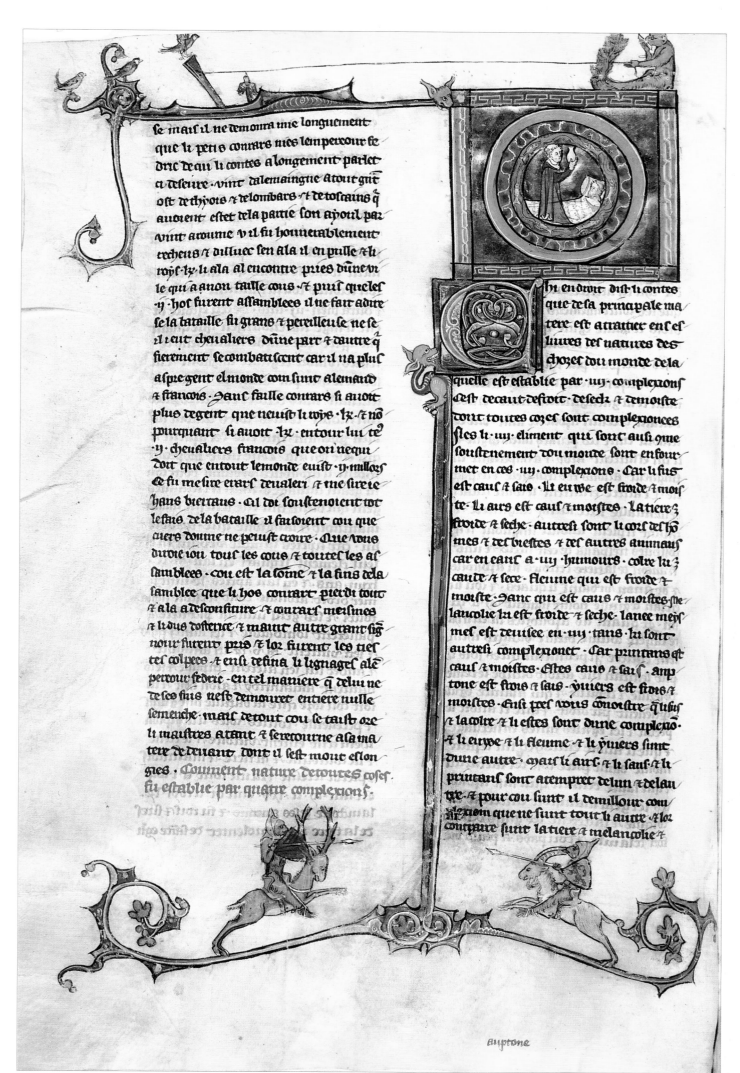

se mais il ne demorra mie longuement
que li petis contars mes lempereor se
dric de au li contes a longement parlet
a teseire · vint dalemaingne atout gut
ost de thyois · τ delombars · τ detoscains q
auoient estet dela partie son ayoul par
uint a roume · u il fu honnetablement
recheus · τ dilluee sen ala il en pulle τ li
roys · lx · li ala al encontre pres dune vi
le qui a anon taille cous · τ puis queles
·y · hos furent assamblees il ne fait adire
se la bataille fu grans τ perilleuse ne se
il i eut cheualiers dune part τ dautre q
fierement se combatiscent car il na plus
aspre gent elmonde com sunt alemand
τ francois · Sans faulle contars si auoit
plus degent que neuist li roys · lx · τ no
purquant si auoit · lx · entour lui te
·y · cheualiers francois que on nequi
doit que entout lemonde euist · y · millors
de fu mesire erars deualeri τ me sire
hans bietraus · cil doi soustenoient tot
lestas dela bataille il faisoient con que
cuers domme ne peust croire · Que vous
diroie iou tous les cous τ toutes les as
samblees · con est la some τ la fins dela
samblee que li hos contart perdi tout
τ ala a desconfiture τ contars meismes
τ li dus dostrice τ maint autre grant sig
nour furent pris τ lor furent les tres
tel colpees τ ensi defina li lignages ale
perrour sedric · en tel maniere q delui ne
de ses fins nesb demourer entiere nulle
semenche · mais detout cou se taist ore
li maistres atant τ se retourne a sa ma
tere de deuant dont il sest mout eslon
gies · Comment nature detoutes coses
fu establie par quatre complexions ·

hi endroit dist li contes
que dela principale ma
tere est atraitre en ces
liures des natures des
chozes dou monde dela
quelle est establie par · iiij · complexions
cest decaut desfroit deseck τ demoiste
dont toutes cozes sont complexionees
iles li · iiij · element qui sont ausi que
soustenement dou monde sont enfour
met en ces · iiij · complexions · car li fus
est caus τ sais · Lt euiwe est froide τ mois
te · li aurs est caus τ moistes · La tiere z
froide τ seche · autresi sont li cors des ho
mes τ des biestes τ des autres animaus
car en eaux a · iiij · humours · colre lu z
caute τ sece · fleume qui est froide τ
moiste · Sanc qui est caus τ moistes · me
lancolie lu est froide τ seche · lanee meys
mes est deuisee en · iiij · tans · li sont
autresi complexionet · car printans est
caus τ moistes · Estes caus τ sais · amp
tone est frois τ sais · yuiers est frois τ
moistes · Ensi pel vous connoistre q lifus
τ la colre τ li estes sont dune complexio
τ li euiwe τ li fleume · τ li yuiers sunt
dune autre · mais li aurs · τ li saus · τ li
printans sont atempret delun τ delau
tre · τ pour cou sunt il demillour com
plexion que ne sunt tout li autre · τ lor
contaire sunt la tiere τ melancolie τ

72-81
BOOK OF HOURS OF THE USE OF PARIS
Heures à l'usage de Paris
France (Paris). Second half of the 14th century.

201 ff. 30 x 20 mm (text 14 x 6 mm). Parchment. Latin and French.
10 miniatures in ornamental borders of golden ivy leaves on black stalks; golden initials
against coloured backgrounds. Binding: 16th or 17th century. Brown morocco with gold-tooled
fleurs-de-lis; marbled paper fly-leaves. Case: 19th century. Erm.lat.17

The Book of Hours is not complete. It includes a Calendar in French, a reading from the Gospel according to St John, the Hours of the Virgin, the Penitential Psalms, the Litany and prayers. The format is unique; this is the smallest known manuscript book from that time. Yet even in these microscopic miniatures, which require a magnifying glass to study them, the artist showed an ability to arrange his characters, to depict them in natural postures and to give a hint of the elements of landscape and details stipulated by iconographic tradition in rendering Gospel themes. *The Nativity, the Annunciation to the Shepherds and the Flight into Egypt* are remarkably expressive. The Gothic architectural forms framing the miniatures, the exquisite palette which employs, in addition to the traditional red and blue, lilac and cherry-red, and the virtuoso technique indicate that the illumination was executed by a first-class miniaturist who was probably from Paris.

Gille and Laborde suggested that the Book of Hours had belonged to a member of the French royal family. It was purchased in 1860 by Alexander II of Russia for the Hermitage (5.2.107).

ENTERED THE PUBLIC LIBRARY IN 1861
WITH THE HERMITAGE COLLECTION OF WESTERN EUROPEAN MANUSCRIPTS.

LITERATURE: Gille 1860, p. 47; Dobias-Rozdestvenskaïa 1927, p. 6; Laborde 1936–38, p. 37.

72

73

72. F. 17r: THE ANNUNCIATION.

73. F. 48r: THE VISITATION.

74. F. 80v: THE NATIVITY.

75. F. 96v: THE ANNUNCIATION TO THE SHEPHERDS.

76. F. 105r: THE ADORATION OF THE MAGI.

77. F. 114r: THE PRESENTATION IN THE TEMPLE.

78. F. 123r: THE CORONATION OF THE VIRGIN.

79. F. 132v: THE FLIGHT INTO EGYPT.

80. F. 146r: CHRIST ENTHRONED.

81. F. 191r: THE CRUCIFIXION WITH THE VIRGIN AND ST JOHN THE EVANGELIST.

74

75

76

77

78

79

80

81

GUYART DES MOULINS
La Bible historiale

France (Paris). Third quarter of the 14th century.

The manuscript consists of two volumes of 299 and 249 ff. 455 x 315 mm (text 290 x 215 mm).
Parchment. French. Volume One has a miniature on the frontispiece and 40 narrative miniatures
preceding the books of the Bible; Volume Two has a miniature on the frontispiece and 11
narrative miniatures. Both volumes have numerous large and small initials in gold and tempera;
running titles are in red and blue with filigree ornament and gold.
Binding (each volume): 15th century. Blind-stamped brown leather over wooden boards;
10 bands on the spine. In the 17th century (?), the binding was re-covered with mauve and gold
brocade. The boards have holes from the locks and traces of 2 clasps. Gilt-edged.
Fr.F.v.I.1/1–2.

The manuscript is a French adaptation of Peter Comestor's 12th-century Latin *Historia Scholastica* written around 1295 by Guyart des Moulins, a canon and later Dean of St-Pierre d'Aire at Artois. This text consists of a summary of the historical sections of the Bible and it enjoyed a remarkable success until the 15th century. Volume One of the St Petersburg manuscript contains the Old Testament and the Psalms; Volume Two contains the rest of the Old Testament from the Song of Solomon and the New Testament.

The St Petersburg manuscript is one of the splendidly illuminated 14th-century copies of the *Bible Historiale* that were produced for the highest French nobility. The elegant drawing, the graceful elongated figures with small heads, the curled hair and beards, and the light and joyful colour scheme bear the stamp of the refined Parisian style. The particularly skilful and delicate grisailles decorating the frontispieces prompted Laborde to describe the illumination as "wonderful work by a Parisian master of the end of the 13th century, the time of Jean Pucelle and Honoré". Correct as he is in his appreciation of the quality of the illumination, Laborde undoubtedly erred as to the date, for the St Petersburg Bible reveals a debt to the refined art of Pucelle maintained by the Parisian school during the whole of the 14th century; it was not without reason that Millard Meiss termed it a "*late Pucellesque Bible*".

The St Petersburg manuscript was illuminated by several artists, among whom the author of the frontispieces (perhaps Jean Le Noir) and the illustrator of the section devoted to the Creation are particularly notable. In his study (see Literature) Avril holds that several other masters, designated by him "D", "E" and "L", who participated in illuminating the *Bible Moralisée* from the Bibliothèque Nationale in Paris (MS.fr. 167), which he placed between 1350 and 1355, also took part in the ornamentation of the St Petersburg Bible. The quality of illumination of the St Petersburg manuscript indicates that it was produced for a client of high rank.

In the 14th to 16th centuries, the manuscript belonged to the house of d'Albret, who ruled Navarre, as is proved by the numerous autograph ownership inscriptions: the back cover of Volume Two is signed by Isabeau d'Albret and Charles d'Albret (d. 1415). The latter was Constable of France and the cousin of Charles VI, who allowed him to unite his coat of arms with the royal one in 1389. The new d'Albret coat of arms was added on ten pages of the manuscript after the illumination had already been completed. The first blank page of the same volume has the signatures of Jean d'Albret, who became King of Navarre in 1484, Henry II of Navarre, his daughter Jeanne d'Albret and Henry III of Navarre, the future Henry IV of France; its reverse is signed by Margaret of Valois, the wife of Henry IV. In the 17th century, the manuscript belonged to Pierre Séguier, which is proved by the code numbers d860 and d861 on the fly-leaves of the front covers of the volumes. However, Montfaucon's catalogue of Séguier's manuscripts that were transferred to Saint-Germain-des-Prés in 1735 does not list the numbers 847 to 871. Therefore, it would seem that Dubrovsky obtained the Bible from a source other than Saint-Germain-des-Prés.

ENTERED THE PUBLIC LIBRARY IN 1805 WITH THE DUBROVSKY COLLECTION
(1849–61 THE HERMITAGE, 5.3.19).

LITERATURE: *Cat. Séguier 1686, p. 98; inv. p. 21; Gille 1860, p. 35; Bertrand 1874, p. 11; Delisle 1868–81, 1, p. 335; Laborde 1936–38, pp. 13–17, pls VIII–X;* La librairie de Charles V. Bibliothèque Nationale. Catalogue de l'exposition, *Paris, 1968, p. 92; F. Avril,* "Un chef-d'œuvre de l'enluminure sous le règne de Jean le Bon : La Bible Moralisée, MS. fr. 167 de la Bibliothèque Nationale", *Fondation Eugène Piot,* Monuments et mémoires publiés par l'Académie des Inscriptions et Belles-Lettres, *53, Paris, 1972, p. 110, No 2; Meiss 1968–74, the late 14th century; pp. 104, 106, 380, Nos 25, 36; Romanova 1975, pp. 155, 159, 160, fig. 48; S. Neretina,* "Obraz mira v Istoricheskoi biblii Guiart'a de Moulins'a", *in:* Iz istorii kultury srednikh vekov i Vozrozhdeniya, *Moscow, 1976, pp. 106–141.*

82. Volume One, F.1: OPENING PAGE.

The miniature shows a symbolic picture of the universe. At the top, framed by Gothic architectural forms, is the Trinity enthroned: Christ with a cup, God the Father with an orb and the Holy Ghost with a book. Below are the choirs of angels of various grades and the respective nine orders of the high Church hierarchy: patriarchs, prophets, apostles, etc. The lower part is occupied by a cosmogonic composition with the jaws of Hell in the centre, and with concentric circles symbolizing the earth, water and celestial spheres, and the signs of the zodiac. The d'Albret arms on the left and right with fleurs-de-lis are a later addition. Each of the three columns of the text begins with a historiated initial depicting, respectively, Guyart de Moulins before the Virgin and Child, Peter Comestor and St Jerome presenting his translation of the Bible to the Pope.

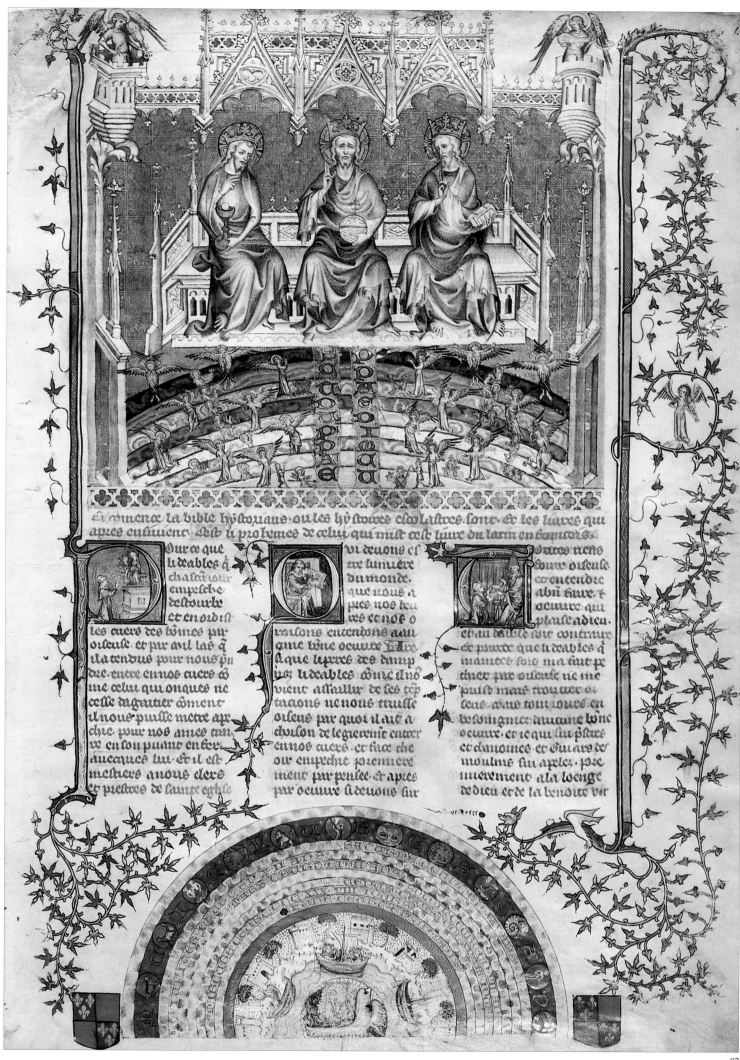

en commence la bible hystoriaus ou les hystoires escolastres sont. et les liures qui
apres ensuiuent. Cest li prologues de celui qui mist cest liure du latin en romans.

Pour ce que
li deables q̃
chascun iour
empesche
destourbe
et enordist
les cuers des hõmes par
oiseuse. et par cil las q̃
il a tendus pour nous pñ
dre entre en nos cuers cõ
me celui qui onques ne
cesse daguaitier cõment
il nous puisse metre ar
riere pour nos ames trai
re en son puant enfer
auecques lui. et il est
mestiers a nous clers
et prestres de sainte eglise

vi deuons es
tre lumiere
du monde.
que nous a
pres nos heu
res ce nos o
roisons entendons aut
que bone œure. Pro
si que li pres des damp
nez li deables cõme il nous
vient assaillir de ses tep
tacions ne nous truisse
oiseus par quoi il ait a
choison de legierement entrer
en nos cuers. et face che
our empesche premiere
ment par pensee. et apres
par œure si deuons sur

pource riens
plour oiseuse
et entendre
a bn̄ fiure. ⁊
œure qui
plaise adieu.
et au deable soit cõtraire
et pource que li deables q̃
maintes fois ma fait pẽ
cher par oiseuse ne me
puist mais trouuer oi
seus. ains tout iours en
le soingnier aucune bone
œure. et ce qui sui pistres
et chanoine. et guiars de
moulins fui apres. pre
mierement a la loenge
de dieu et de la benoite vir

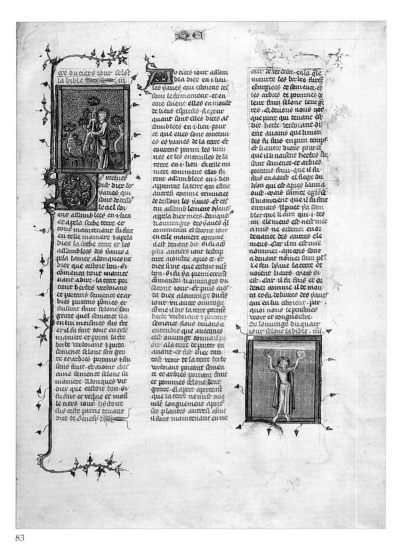

83

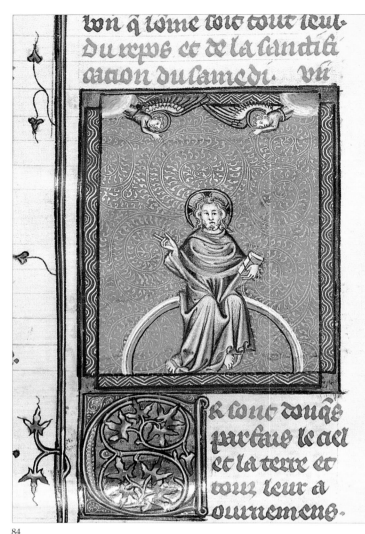

84

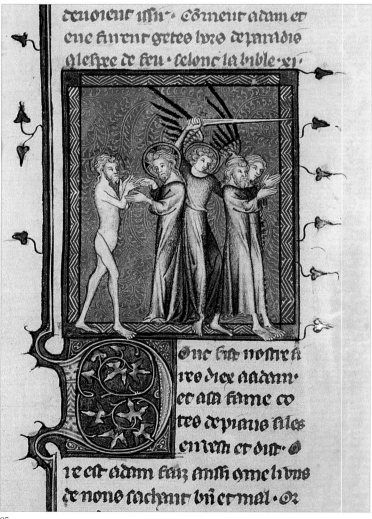

85

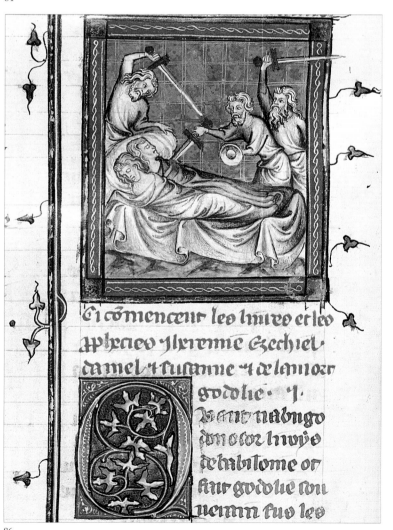

86

en no gloire pdurablement.
amen · Ci fine le second liure
de paralipomenon ·
Ci comence le liure de Esdras.

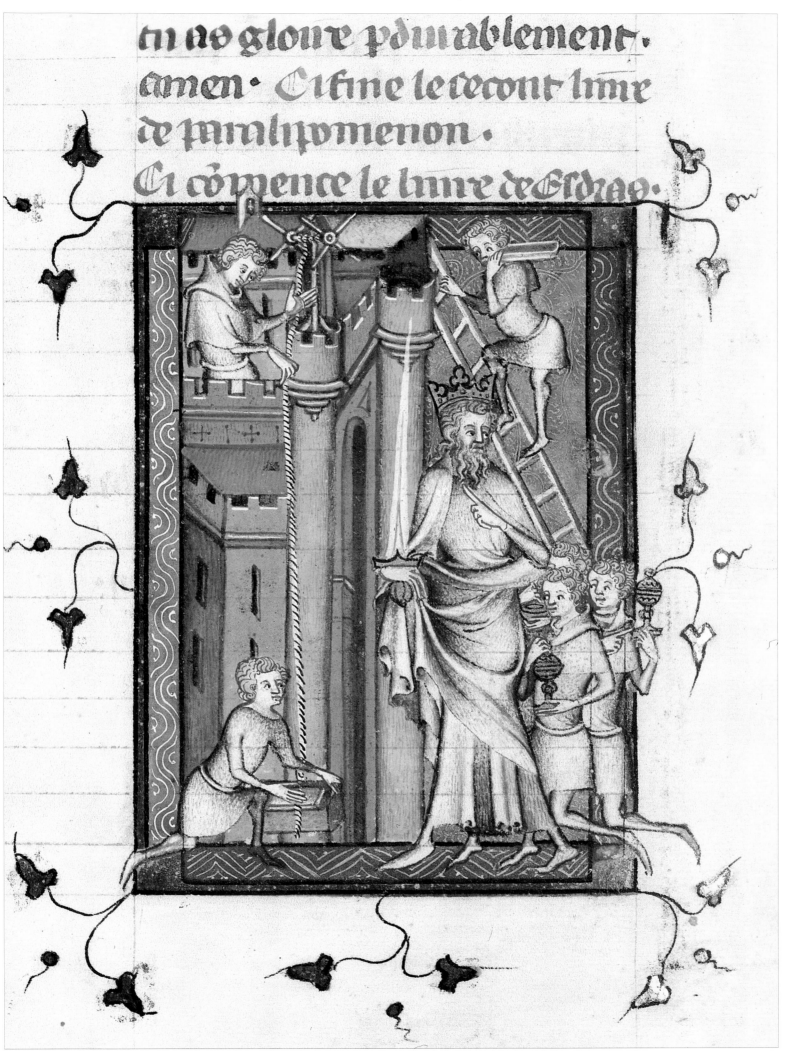

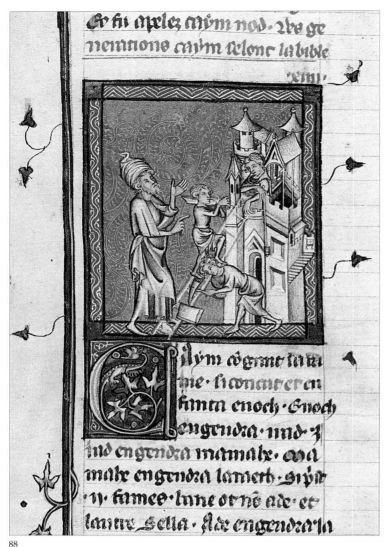

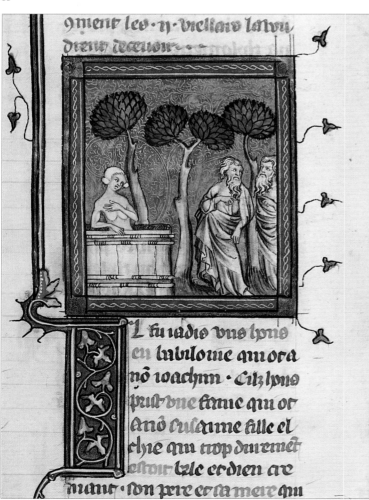

Page 84
83. Volume One, F. 5r: THE THIRD DAY OF CREATION.
THE FOURTH DAY OF CREATION.
The miniature depicts the creation of dry land and vegetation, and the creation of the sun, moon and stars.

Page 84
84. Volume One, F. 7v: THE SEVENTH DAY OF CREATION.

Page 84
85. Volume One, F. 10v: THE EXPULSION
OF ADAM AND EVE FROM PARADISE.

Page 84
86. Volume One, F. 245v: ILLUSTRATION
TO THE BOOK OF JEREMIAH.
The murder of Gedaliah, "whom the king of Babylon hath made governor over the cities of Judah".

Page 85
87. Volume One, F. 207v: ILLUSTRATION
TO THE FIRST BOOK OF ESDRAS.
The miniature shows the construction of a temple in Jerusalem ordered by Cyrus, King of Persia, and the bringing of "the holy vessels of the Lord".

88. Volume One, F. 12v: CAIN BUILDING A CITY.

89. Volume One, F. 218v: ILLUSTRATION
TO THE BOOK OF NEHEMIAH.
Men of Judah come to Nehemiah in Shushan and tell him of the destruction of Jerusalem.

90. Volume One, F. 253v: ILLUSTRATION TO THE BOOK OF DANIEL
(Susanna and the Elders in the Garden).
The subject is based on the Book of Susanna.

91. Volume Two, F. 1r: FRONTISPIECE.
The Annunciation, the Nativity, the Crucifixion with the Virgin and St John the Evangelist, the Resurrection and the Descent into Limbo are at the top; the Last Supper and Mary Magdalene are at the bottom. The coat of arms of the house of d'Albret appears on either side of the miniature.

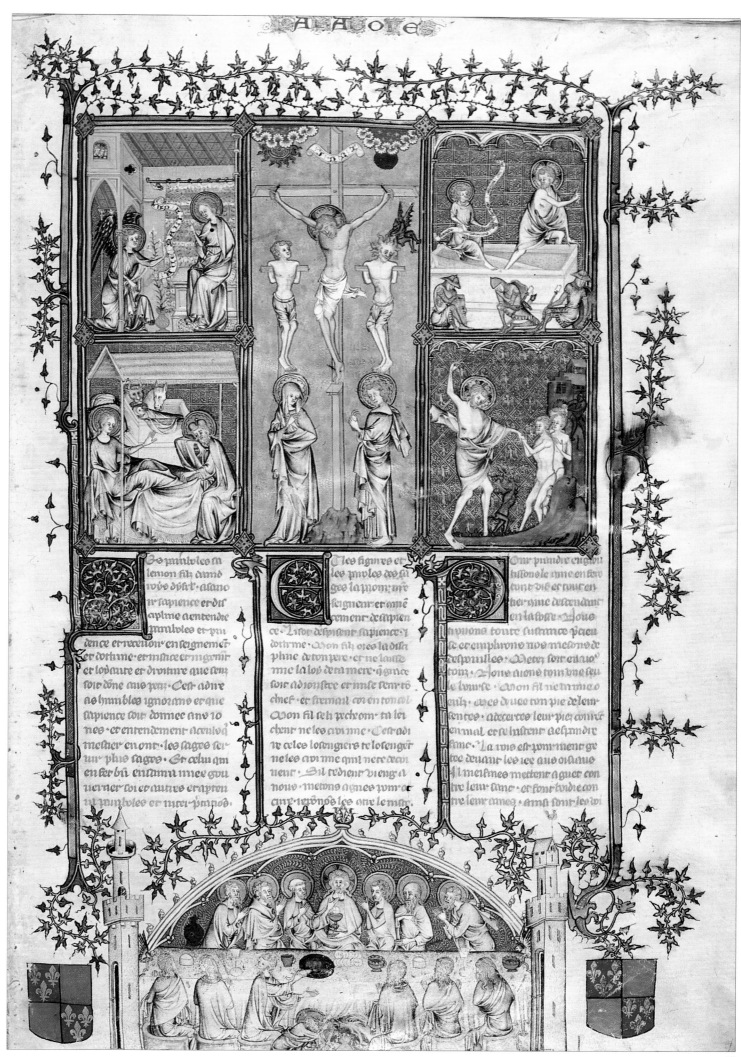

91

92-99
PRAISE TO ST JOHN THE EVANGELIST
Les Louanges de Monseigneur Saint-Jehan l'Evangéliste
France (Paris). 1375–80.

115 ff. 230 x 150 mm (text 145 x 90 mm). Parchment. French.
16 miniatures; 9 historiated and 14 ornamented initials preceding the prologue
and the chapters; numerous smaller red and blue initials with filigree ornament.
Binding: 18th century. Lilac velvet over cardboard with stamped designs;
2 gilded silver clasps; gilt-edged.
Fr.O.v.I.1.

This mystical work by "Brother John of Germany", a Dominican monk, consists of a prologue and twenty-two chapters relating the life of St John the Evangelist. The text of the manuscript has not yet been published.

The miniatures are executed in grisaille, lightly touched with gold, pink and, occasionally, blue and green. Of simple composition, they charm the viewer with their subtle lyricism, delicate modelling and exquisite drawing, the traits typical of the Parisian school of the 14th century. The elegant silhouettes, curled hair, beautiful draperies and borders with ivy-leaf ornament prompted Laborde to attribute the illumination to the school of Jean Pucelle. Romanova's dating of the manuscript is the 1330s. According to François Avril, however, the manuscript was commissioned by a member of the royal family during the lifetime of Charles V, and was produced between 1375 and 1380. Avril supposed that the author of the miniatures was the Master of the Coronation of Charles VI.

The manuscript belonged to Pierre Séguier in the 17th century and was transferred with his collection to Saint-Germain-des-Prés in 1735. As is shown by Dubrovsky's inscription at the end, it was purchased by him in Paris in 1780.

ENTERED THE PUBLIC LIBRARY IN 1805 (1849–61 THE HERMITAGE, 5.2.100).

LITERATURE: Cat. Séguier 1686, p. 11; Montfaucon 1739, 2, p. 1101, No 537; Gille 1860, pp. 47, 48; Bertrand 1874, p. 36; Delisle 1868–81, 2, p. 48; Laborde 1936–38, pp. 18, 19, pl. XI; F. Avril, "Un chef-d'œuvre de l'enluminure sous le règne de Jean le Bon: La Bible Moralisée, MS.fr.167 de la Bibliothèque Nationale" Fondation Eugène Piot, Monuments et mémoires publiés par l'Académie des Inscriptions et Belles-Lettres, 58, 1972, Paris, p. 98; Romanova 1975, pp. 199–201, figs 30, 32.

92

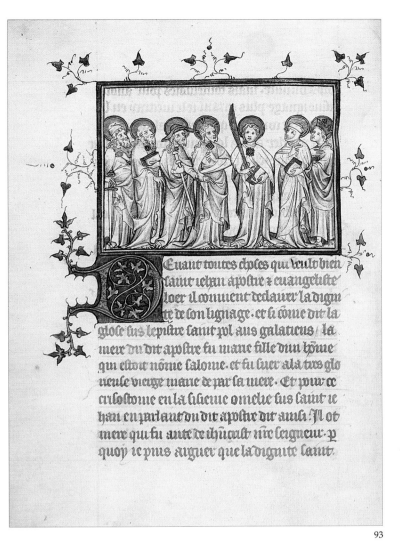

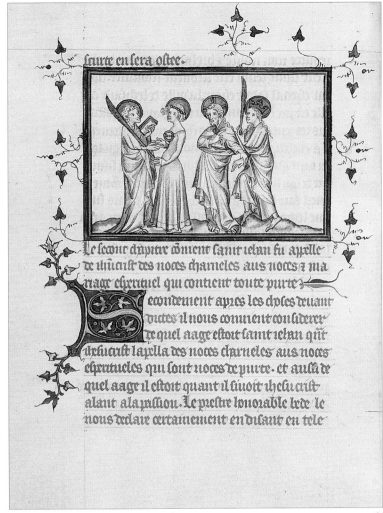

93

94

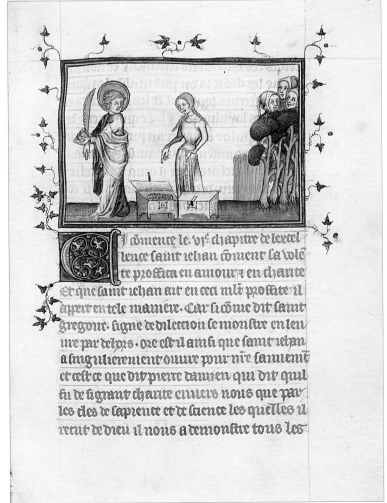

92. F. 1r: INITIAL TO THE PROLOGUE.
St John the Evangelist is shown with an eagle, his emblem.

**93. F. 4v: MINIATURE TO CHAPTER ONE
(On the Noble Background of St John).**
St John is depicted with his mother and the Virgin, and Christ with the Apostles James the Less, James the Greater and Peter.

**94. F. 9v: MINIATURE TO CHAPTER TWO
(How St John the Evangelist was Called by Christ from Earthly to Divine Marriage).**
St John is shown with an "earthly", and Christ with a "divine" bride.

95. F. 53r: MINIATURE TO CHAPTER SIX.
St John rejects earthly gain.

95

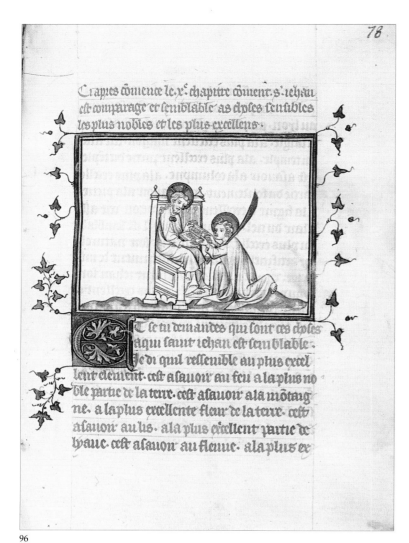

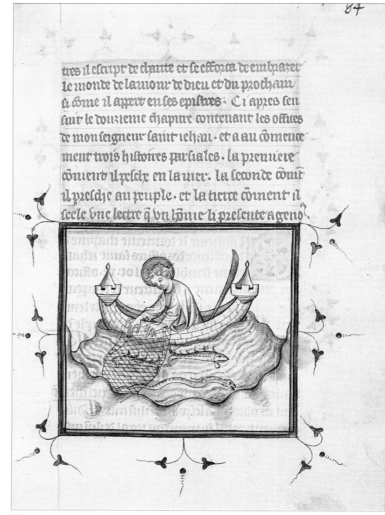

96. F. 78r: MINIATURE TO CHAPTER TEN.
St John is shown kneeling before Christ, offering him an open book.

97. F. 84r: MINIATURE TO CHAPTER TWELVE.
This miniature illustrates the first of three related stories in the manuscript: St John is shown netting fish in the sea.

98. F. 90v: MINIATURE TO CHAPTER FOURTEEN (On the Death of St John).
The Saint is shown lying in front of an altar in a chapel, beardless and juvenile, as indicated in the heading. In the lower margin the inscription in cursive scipt reads "Le trépassement S. Jehan" destined for the artist.

99. F. 84v: MINIATURE TO CHAPTER TWELVE.
This illustrates the second story: St John is shown as a "fisher of men" preaching to the people.

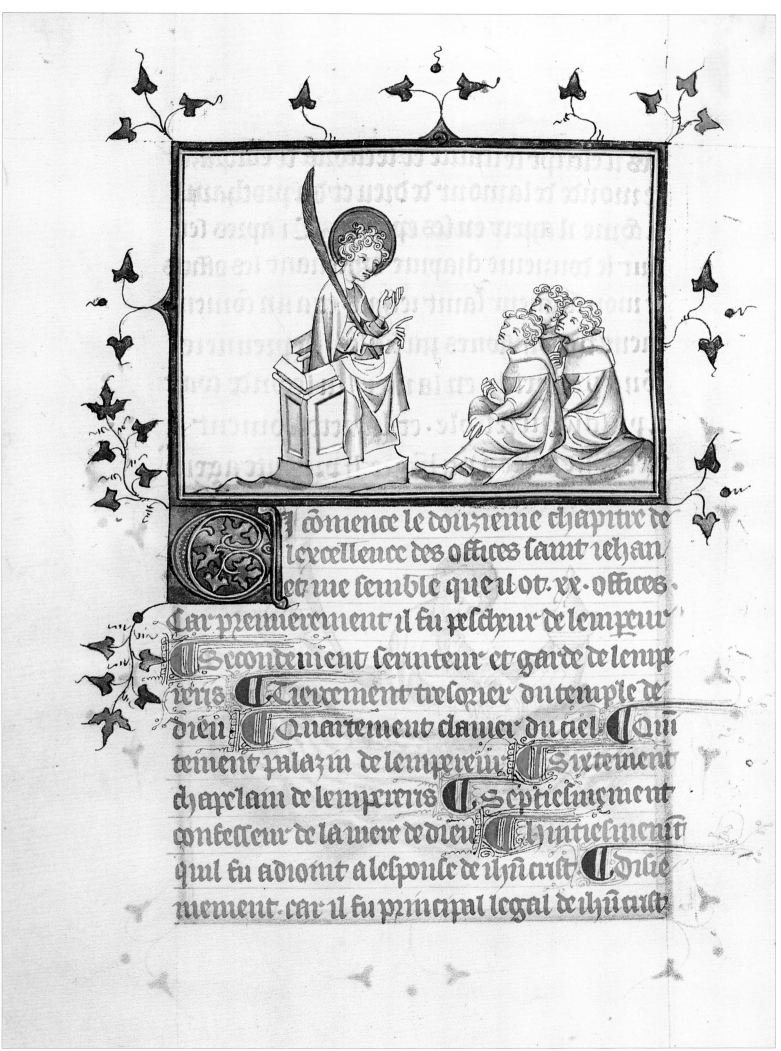

Jl comence le douzieme chapitre de lexcellence des offices saint iehan. Et me semble que il ot. xx. offices. Car premierement il fu pescheur de lempeur Secondement serenteur et garde de lempe reurs Tiercement tresorier du temple de dieu Quartement clauier du ciel Qui tement palazin de lempereurs Sixtement chapelain de lempereurs Septiesmement confesseur de la mere de dieu Huitiesment quil fu adioint a lespouse de ihu crist Dilie mement car il fu principal legal de ihu crist

BOOK OF HOURS OF THE USE OF ROME
Heures à l'usage de Rome
France (Paris). Late 14th or early 15th century.

171 ff. 215 x 155 mm (text 110 x 72 mm). Parchment. French and Latin.
13 miniatures; initials in red and blue with gold; calendar headings in blue, red or gold;
decorative bands; every page has a border in blue, red and gold with foliated ornamentation
and dragons. Binding: 19th century. Red velvet over cardboard. Rasn.Q.v.1.8.

The composition of this Book of Hours is standard; it includes a Calendar of the Church year in French, readings from the Gospels, the Hours of the Virgin, the Penitential Psalms, the Litany, the Hours of the Cross, the Hours of the Holy Ghost, the Office of the Dead and prayers.

The delicate colour scheme of the illumination, its striving for realism combined with aristocratic refinement, and its borders, which are sometimes ornate and sometimes dainty and which sparkle like gems, make this small volume a very good example of the Franco-Flemish style that blossomed in Paris at the end of the 14th century. "Here," Olga Dobias-Rozdestvenskaïa wrote, "there is already a feeling of life and a sense of beauty everywhere."

She suggested that the Book of Hours was decorated in the workshop of the celebrated miniaturist Jacquemart de Hesdin. Millard Meiss, who made a significant contribution to the study of French illumination of the late 14th and early 15th centuries, ascribed the illumination in the St Petersburg manuscript to an artist conventionally called the Pseudo-Jacquemart, and dated it to 1410. It should be noted, however, that the miniatures in the Book of Hours were done by at least two different artists.

The first and last blank leaves of the manuscript bear unidentified coats of arms, with monograms and the motto *nunc et semper*, that were added later. The manuscript's provenance remains obscure.

ENTERED THE PUBLIC LIBRARY IN 1925 FROM THE YUSUPOV COLLECTION.

LITERATURE: Dobias-Rozdestvenskaïa, the late 14th century, p. 14, Liublinskaya 1939, Miniatures françaises, pp. 861–869; Old Latin MSS 1965, p. 14; Meiss 1968–74, pp. 264, 265, 325, 401, No 28, figs 255, 256, 259; Meiss 1974, the Limbourgs, p. 414.

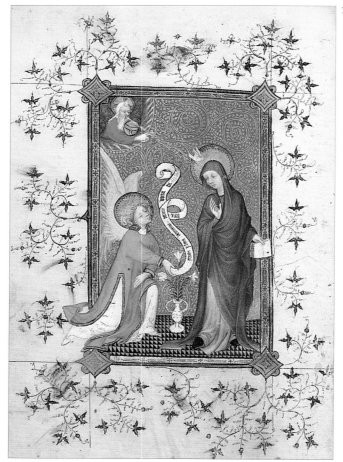

100

100, 101. FF. 23v–24r: THE ANNUNCIATION.
THE VIRGIN AND CHILD (80 x 70 mm).

This two-page composition opens the section of the Hours which contains the prayers read during Matins. While it was common to illustrate Matins with the scene of the Annunciation, the Virgin and Child Enthroned with Angels was most unusual. The difference in style between the two miniatures is obvious. The Annunciation, which stands out from the other miniatures in the manuscript (in French Books of Hours this subject was often painted by the head of the workshop), is marked by a

particularly pronounced poetic quality and a delicate colour scheme. The scarlet robe of God the Father against the more reserved red background with gold design, the exquisite combination of the soft pink of the archangel's wings with his light green dalmatic decorated with gold and his light, luminous hair, and the dull lilac clothing of the Virgin set against the deep blue of her cloak, are all indicative of the miniaturist's masterly use of colour. This page is attributed to the Pseudo-Jacquemart.

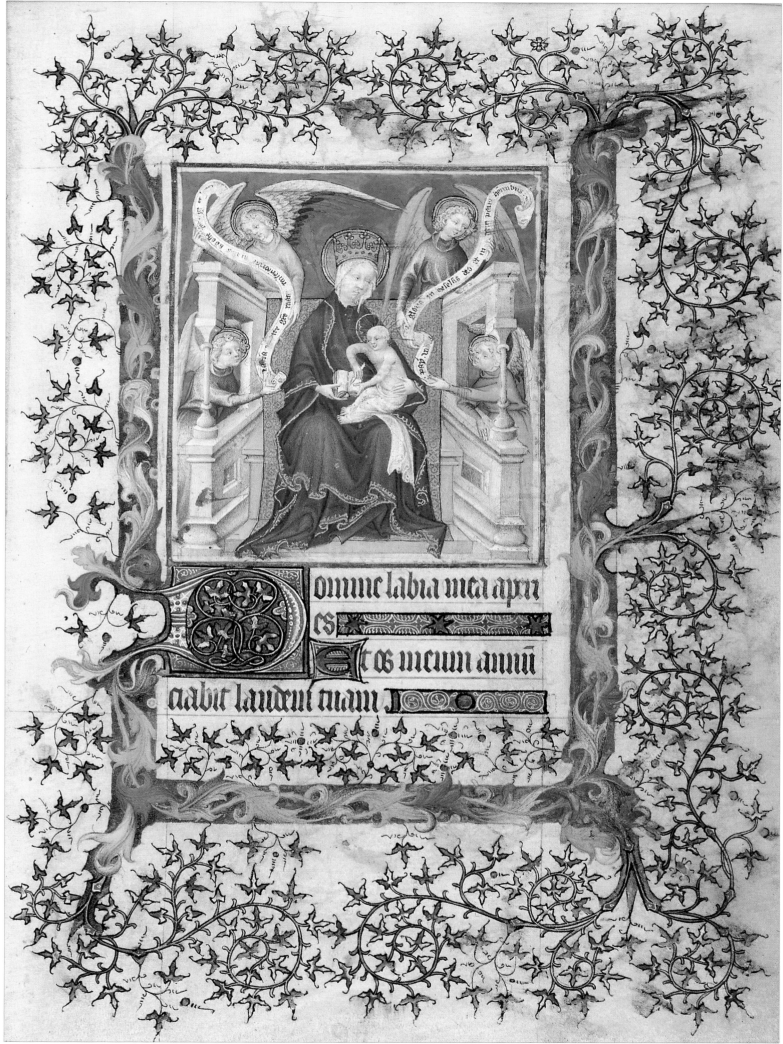

omine labia mea apri
es
t os meum annu
aabit laudem tuam

101

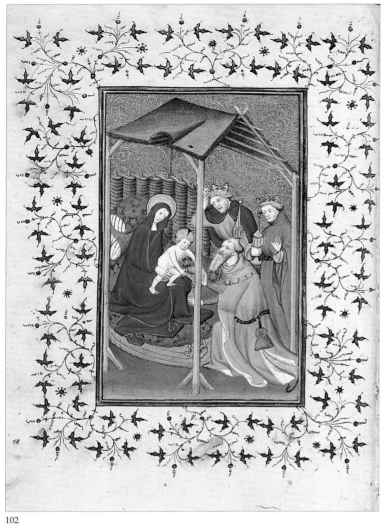

102

103

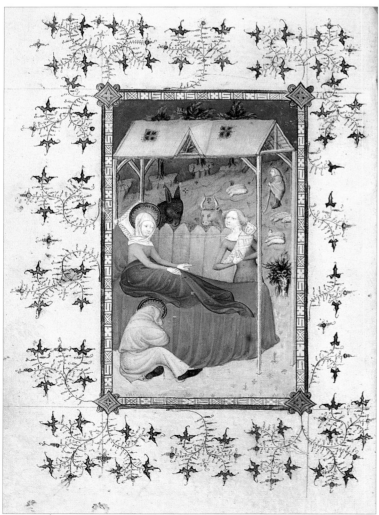

104

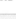

102, 103. F. 68v - 69: THE ADORATION OF THE MAGI

The use of a double page is characteristic of the Book of Hours : the miniature is framed by delicate spiral stems with gold leaves, whilst the initials of the text and a profusion of colourful ornamentation is bordered far more richly : (dragon intertwining the ornamentation).

104. F. 57v: THE NATIVITY.

While the other master's colour scheme is less complex, his attitude towards his subject is warmer and more intimate. The figures of Joseph huddled up and a shepherd with his sheep in the background are very touching. According to Meiss, the author of this miniature might have worked for the Duke of Berry some fifteen years earlier.

105. F. 78v: THE FLIGHT INTO EGYPT.

The landscape containing stylized "hills" topped with trees is typical of the Parisian school. These two miniatures are a clear example of the new realistic approach introduced by netherlandish artists ca 1400.

Page 96

106. F. 128v: THE DESCENT OF THE HOLY GHOST.

Page 97

107. F. 134v: ILLUSTRATION TO THE OFFICE OF THE DEAD.

The miniature shows a burial service. The artist made very skilful use of various gradations of colour, from white and greyish-blue to velvet black, set against the red and gold background.

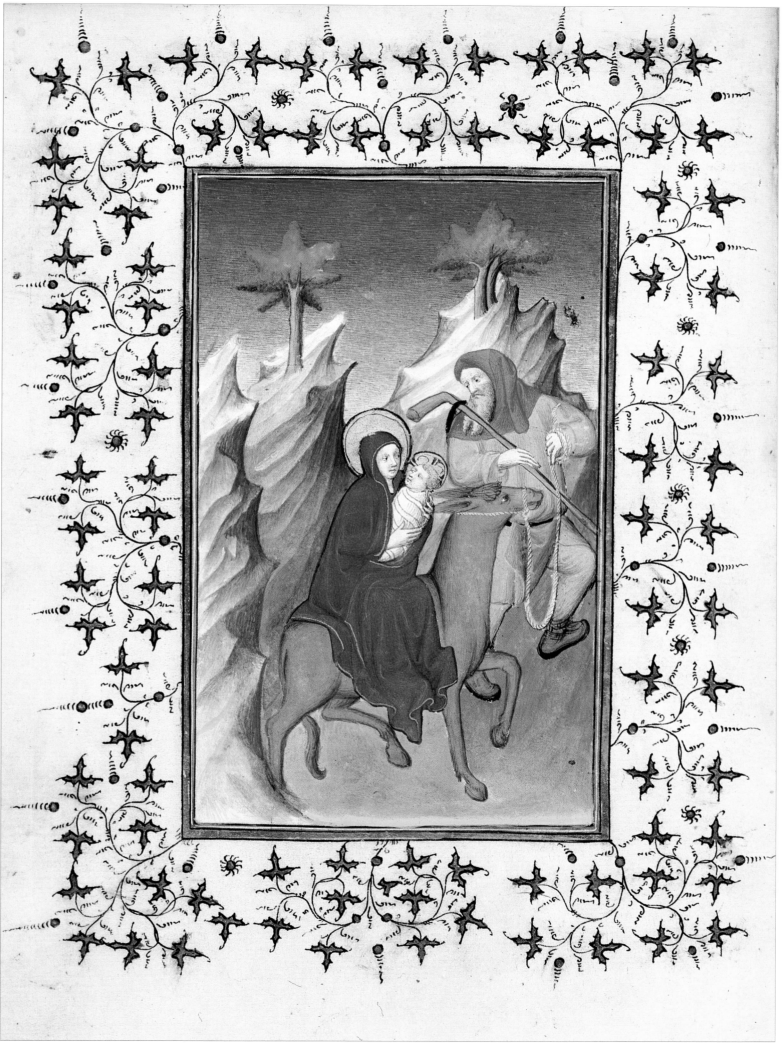

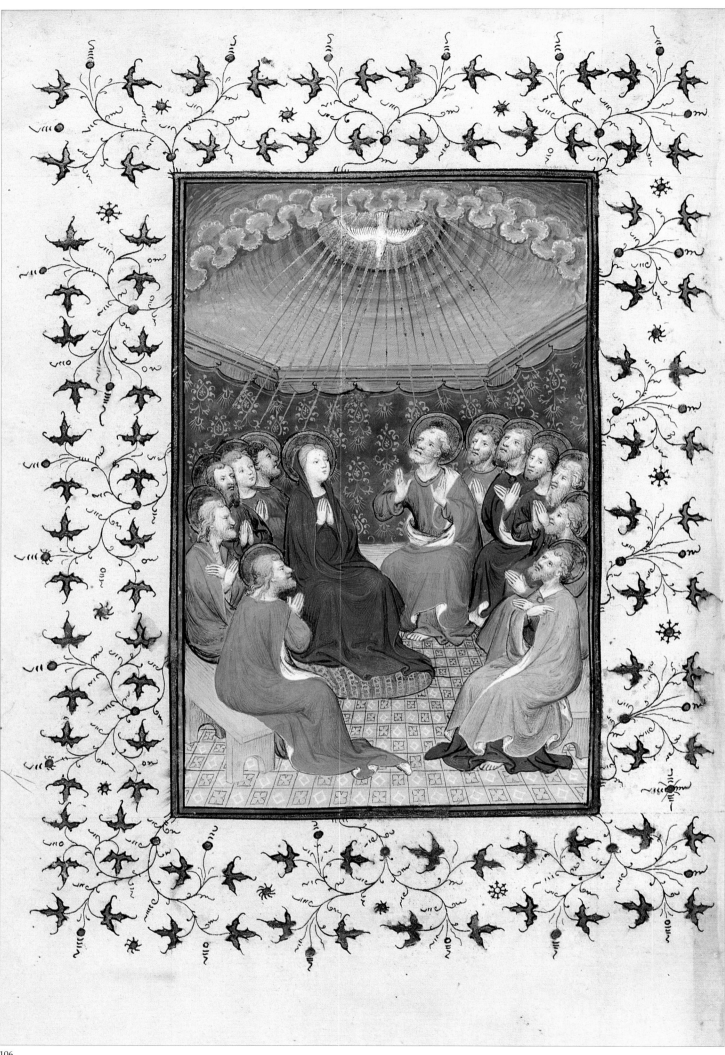

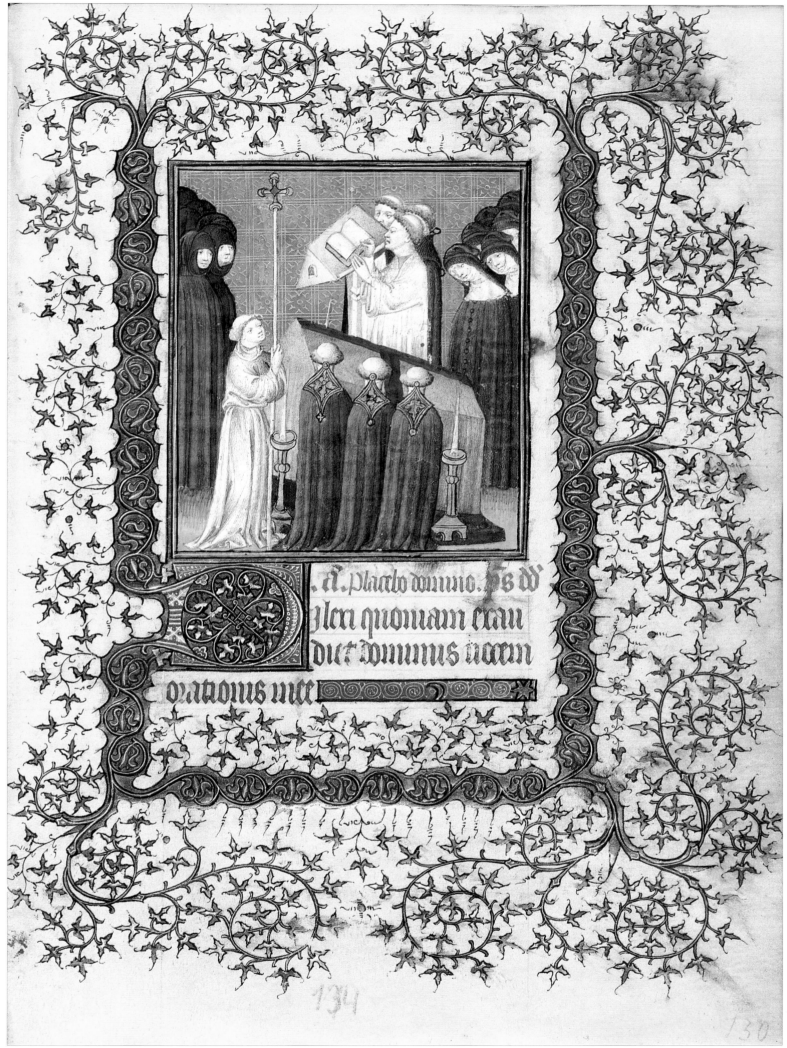

INSTRUCTIONS TO THE SOVEREIGNS
L'Information des Rois et des Princes
France. Ca 1410.

*163 ff. 320 x 230 mm (text 200 x 140 mm). Parchment. French.
16 miniatures, 4 of which are large, preceding each book; initials in red and blue with gold;
borders with vine and floral ornamentation; numerous small initials in gold against a purple
background. Binding: 18th century. Reddish-orange velvet over wooden boards
(from the old binding); clasps of silver-gilt.
Fr.F.v.III.2.*

Written for Louis, the son of Philip the Bold, the manuscript is a French version of the Latin treatise *De informatione principium*, consisting of four books on the qualities essential to a sovereign, wisdom and justice, and on his duties towards himself and his subjects. The translation by Jean Golein, a Carmelite, was commissioned by Charles V. It enjoyed such popularity that it was published at the beginning of the 16th century. The St Petersburg text was probably copied from the original of 1379 kept in the library of Charles V (Paris, Bibliothèque Nationale, MS.fr.1950). The inventory of 1380 shows that the Duke of Anjou borrowed the manuscript and returned it to Charles VI. The illumination in the St Petersburg copy is richer than in the Paris one and is typical of the late 14th and early 15th centuries. However, the copy is little known to specialists and is not included in Meiss's fundamental study. Laborde described the style of its small miniatures as an "imitation of the Boucicaut Master": the scenes are constructed simply yet convincingly; the figures, almost pure grisaille, stand out against the ornamental or plain blue backgrounds; gold is introduced

sparsely, and white is mainly used in modelling; the faces have a painterly quality. The larger miniatures are built differently: they show a bold juxtaposition of rich colours, the facial outlines are reinforced in pen, and the figures are concealed by elaborate draperies. Four ballads, authorship of which, according to Laborde and Shishmariov, can be ascribed to René I, Duke of Anjou, were added later at the beginning of the manuscript.

The manuscript was probably executed for Louis II, King of Sicily and Duke of Anjou, and was housed in his library. Subsequently it passed to his son René (the arms of René and his second wife Jeanne de Laval were later added on f. 10v). At the end of the manuscript (f. 163r) is another coat of arms, also added at a later date, which has a golden leopard set against a red semicircular background. Shishmariov suggested that it was that of the house of Laval, the Dukes of Guyenne. In the 17th century, the manuscript belonged to Pierre Séguier, from whom it passed to Saint-Germain-des-Prés in 1735 through the Duke of Coislin. Dubrovsky purchased it at the end of the 18th century.

ENTERED THE PUBLIC LIBRARY IN 1805 (1849–61 THE HERMITAGE, 5.3.30).

LITERATURE: Cat. Séguier 1686, p. 15; Montfaucon 1739, 2, p. 1113, No 1047; Gille 1860, p. 56; Bertrand 1874, p. 93; Shishmariov 1927, vestiges de la Bibliothèque de René d'Anjou, pp. 167–177; Laborde 1936–38, pp. 45, 46.

108

109

108. F. 10v : ARMS OF RENÉ D'ANJOU AND OF JEANNE DE LAVAL.

109. F. 163: ARMS OF LAVAL, DUKES OF GUYENNE.

110. F. 10r: OPENING PAGE OF BOOK ONE.
The kneeling author (or translator), a monk wearing a red vestment trimmed with ermine, presents his book to the young sovereign; the ceremony is attended by people representing various estates. The characters depicted are probably Louis II and the author of the treatise (Laborde identifies the second figure as Gilles de Rome, the Archbishop of Bourges (1247–1316), but since there is another scene of presentation on f. 5r it probably represents Charles V and Jean Golein).

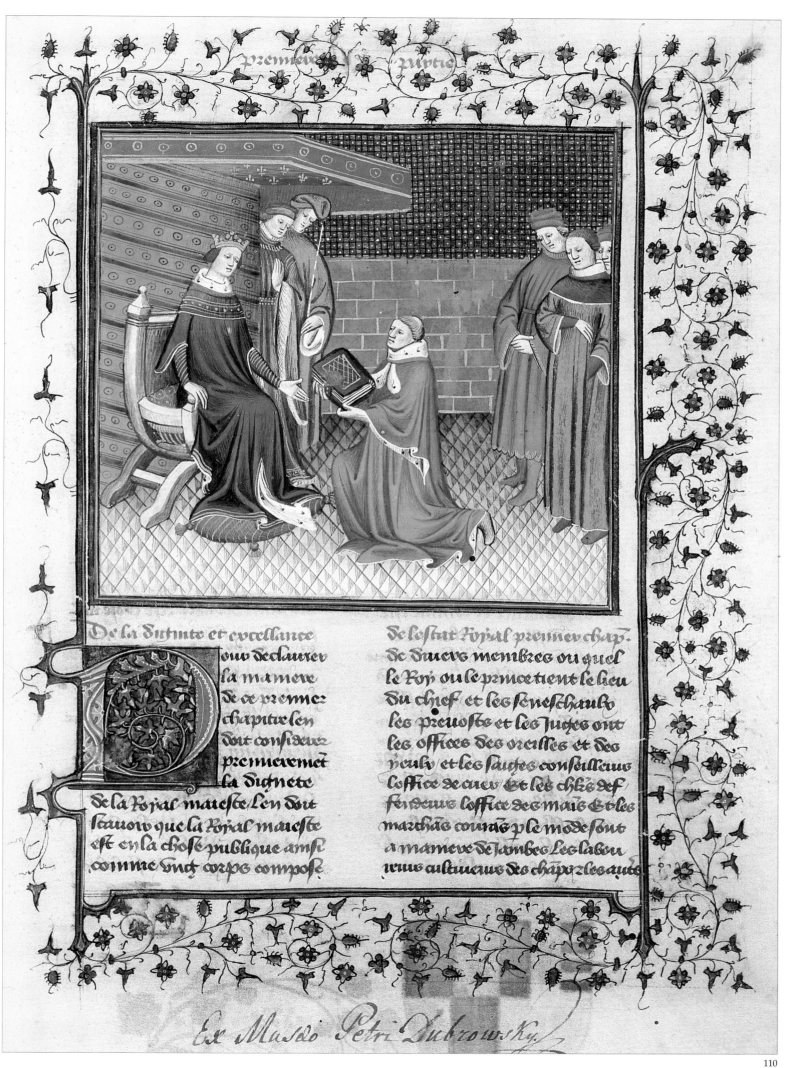

110

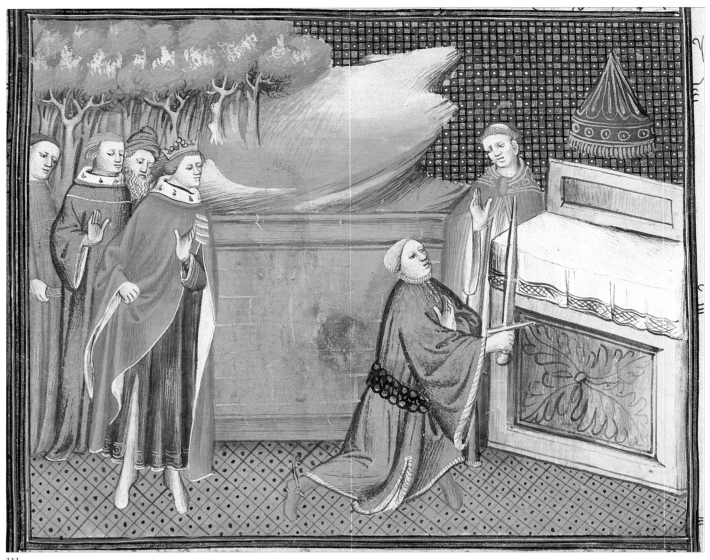

111

112

111. F. 44v: ILLUSTRATION TO CHAPTER 26.
This chapter says that "the king must be chivalrous when receiving guests."

112. F. 62r:
ILLUSTRATION TO CHAPTER 34.
The text teaches that "the king must be severe with evil petitioners." The king's councillor, dressed as a priest, stands at his side.

113. F. 119v:
HEAD-PIECE TO BOOK THREE.
This book explains that "to doubt wisely is quite necessary and appropriate for the king." The king, accompanied by his councillors and attendants, is shown as a knight takes an oath before the altar in his presence.

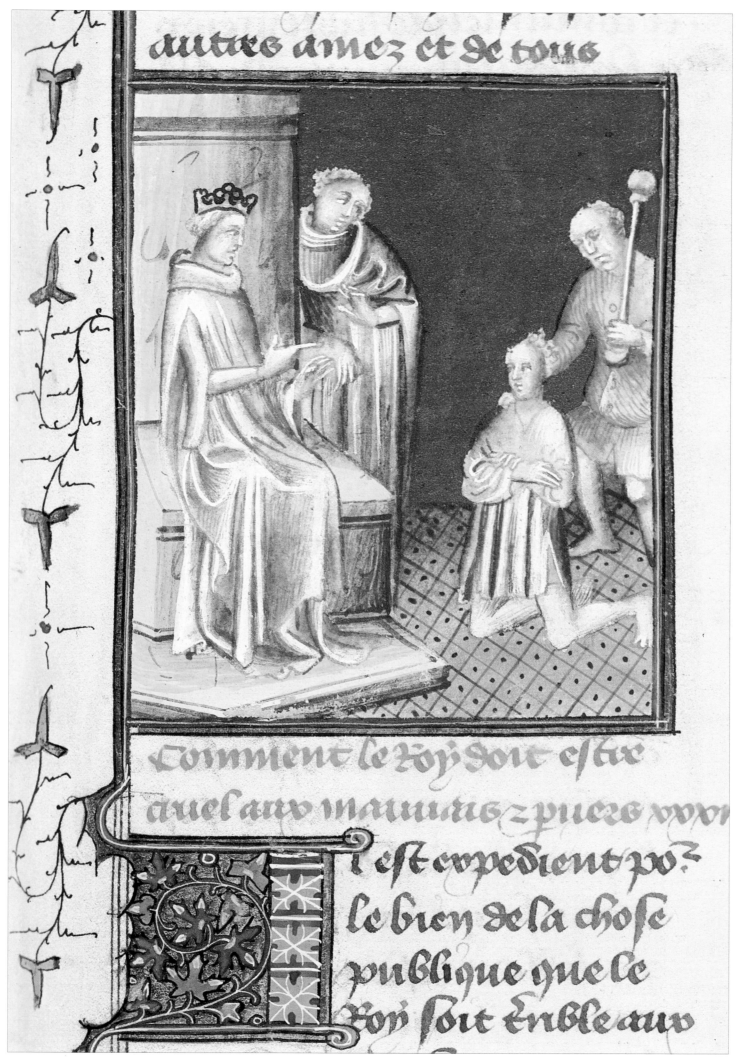

Comment le Roy doit estre
cruel aux mauuais z piteux xxxi

est expedient pour
le bien de la chose
publique que le
Roy soit enble aux

114
HONORÉ BONET. TREE OF BATTLES
L'Arbre des batailles

France. Early 15th century.
109 ff. 275 x 220 mm (text 200 x 150 mm). Parchment. French.
1 miniature; numerous ornamented initials in gold, red or blue; headings.
Binding: 16th century. Dark-purple velvet over wooden boards;
metal boss and corners on both covers; traces of two clasps.
Fr.Q.v.IV.1.

Honoré Bouvet or Bonnor (born ca 1349), prior of Selonnet, diocese of Embrun, was a French author of didactic works. He was close to the royal family and dedicated his work (written between 1386 and 1389) to Charles VI. The manuscript consists of four parts: the first one tells of the attacks on the Holy Church of Rome by different schisms and heresies from the beginning of the Christian faith to the present and has 12 chapters; the second part consists of 19 chapters and tells of the destruction and tribulations in the four great kingdoms of Babylon, Macedonia, Carthage and Rome; the third part describes battles in general; the fourth and main part consists of 133 chapters and speaks about the types of battles.

L'Arbre des batailles was extremely popular at the time when the devastating Hundred Years' War was reaching its climax. Many 15th-century copies still exist — there are thirty in the Bibliothèque Nationale alone. The text was first published in Lyons in 1480. Though Laborde dated the St Petersburg manuscript to the end of the 14th century, the style of the miniature, with its lively bright colours and skilfully modelled robes, together with the expressive energetic movements of the warriors and the decorative border with acanthus leaves in the corners and flowerpots, indicate that the volume was produced at the beginning of the 15th century. The miniature was probably painted in a Parisian workshop in the 1410s.

The manuscript belonged to M. de Courtebourne (?) in the 16th century. In 1570, he presented it to J. Rumet (?) (the ownership inscription on the reverse of the upper cover). The code number 0 291 on the cover has a configuration typical of Séguier's collection and suggests that he may have owned the manuscript in the 17th century, although Montfaucon has another manuscript listed under that number, in his catalogue of the Séguier collection. There is also another number, 2024, which might have been from the library of Colbert; Montfaucon, however, omitted that number (Montfaucon 1739, 2, p. 954).

Piotr Dubrovsky purchased the manuscript at the end of the 18th century.

ENTERED THE PUBLIC LIBRARY IN 1805 (1849–61 THE HERMITAGE, 5.2.45).

LITERATURE: Cat. Séguier, *Invides miniatures*, 1686, p. 10; Gille 1860, pp. 56, 57; Bertrand 1874, p. 138; Laborde 1936–38, pp. 52, 53; Shishmariov Fund 1965, p. 42.

114. F. 5r: MINIATURE (150 x 130 mm).
This is the illustration to the first part of the treatise about the clashes and sufferings caused by the Western Schism which divided the Roman Catholic Church. The artist's depiction of a bloody battle around the Tree is executed with a great deal of energy and inventiveness. On the right and left he shows the figures of Popes wearing tiaras and holding crosses. The one on the right wearing a blue cope is blessing the fighting men, while the one on the left in a purple cope has his cross turned upside down. Here is Bonet's description: "...above the tree one can see dignitaries of the Church who are taking part in all tribulations, dissensions and wars." The style of painting is similar to that of the Master of the Apocalypse of Jean Berry (see notice for n° 136-138).

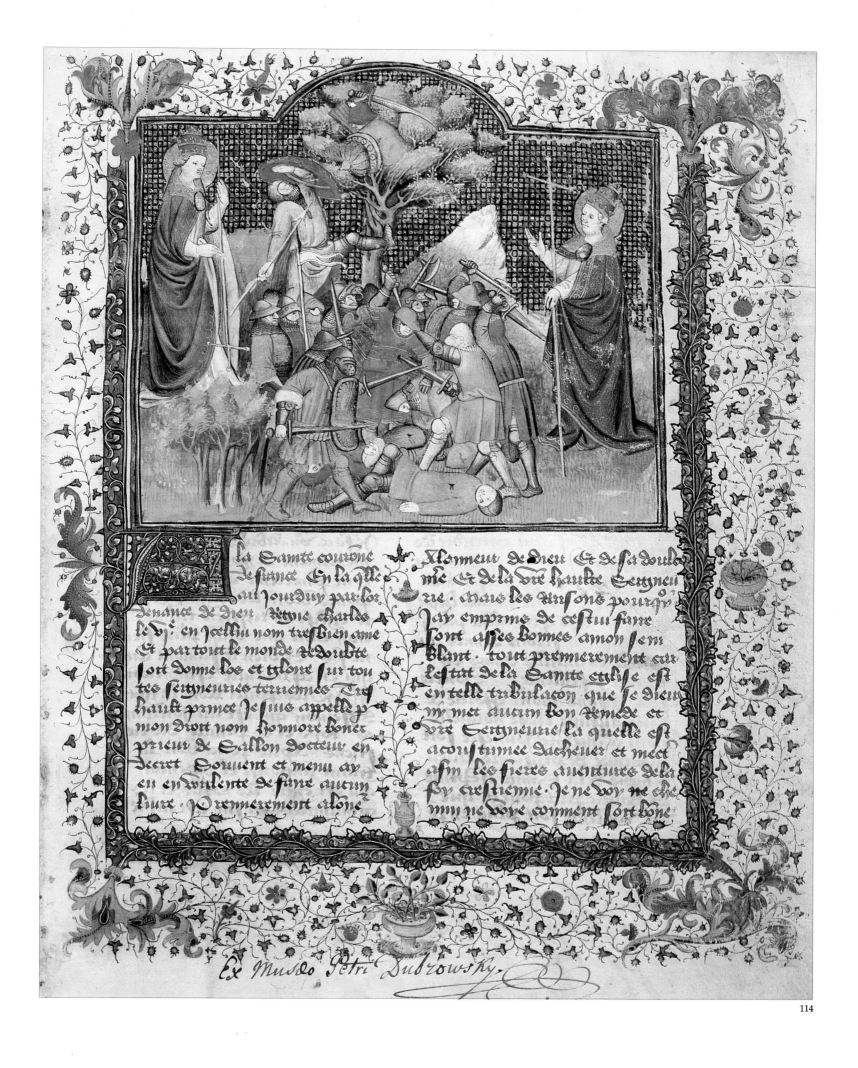

la sainte couronne
de france En la ville
aui jourduy par lor
denance de dieu Royne chardo
le vj; en jcellui nom tresbien ame
Et partout le monde redoubte
sort dome los et gloire sur tou
tes seigneuries terriennes Tres
hault prince Je suis appelle p
mon droit nom honnore bonet
prieur de Sallon docteur en
decret Souvent et menu ay
eu en voulente de faire aucun
liure. Premierement alone

Alonneur de dieu Et de sa doulo
me Et de la tre haulte seigneu
rie. Et aus les raisons pourgr
jay emprise de cestui faire
sont asses bonnes amon sem
blant. tout premierement aur
lestat de la sainte eglise est
en telle tribulacon que se dieu
ny met aucun bon remede et
tre seigneurie la quelle est
acoustumee dachever et meet
asm les fieres aventures de la
foy crestienne. Je ne voy ne che
mm ne voye comment sort bone

115-117
LES GRANDES CHRONIQUES DE FRANCE
France (Paris). Early 15th century.
In three volumes: 122, 219, and 190 ff., 410 x 293 mm (text 295 x 190 mm). Parchment. French.
The first volume has 39 miniatures (7 of them large, 185 x 85 or 185 x 125 mm;
32 miniatures are small, 80 x 90 mm). The second volume has 32 miniatures, 15 large and
17 small. The third volume has 22 miniatures, 5 large and 17 small. Each miniature
is accompanied by a coloured initial (14 of them with the arms of the house of Sanguin de
Meudon and a frame or half-frame of grapevine); numerous small coloured initials.
Binding (each volume): 16th century. Leather over cardboard;
corners decorated with golden fleurs-de-lis; gilt-edged.
Fr.F.v.IV.1/1–3.

The manuscript contains a history of the kings of France compiled at the Abbey of Saint-Denis and translated into French in the second half of the 13th century by Primat, a monk of the abbey. The translation was extremely popular and often copied. Later the monks of Saint-Denis began adding to the text on a regular basis, bringing it up to the reign of Philip VI. The *chronicle* was continued during the reign of Charles V by Chancellor Pierre d'Orgemont, but ends with 1380, the year of Charles's death.

The three volumes end with the reigns of Charlemagne, Philip the Bold and Charles V respectively. The chronicle was illuminated by several artists, all of whom adhered to the archaic trend in Parisian art of the early 15th century, as is indicated by, among other things, the ornamental background.

The St Petersburg manuscript belonged to the rich Parisian Sanguin de Meudon family, which was elevated to the nobility by Charles VI. It was purchased by Piotr Dubrovsky at the end of the 18th century.

ENTERED THE PUBLIC LIBRARY IN 1805 (1849–61 THE HERMITAGE, 6.3.33).

LITERATURE: Gille 1860, pp. 54, 370 (suppl.); Bertrand 1874, p. 107; Laborde 1936–38, pp. 50–52; S. Reinach, Un manuscrit de la bibliothèque de Philippe de Bon de la Bibliothèque à St Pétersbourg, Paris, 1904, pl. XLI; Nikolayev 1904, p. 96 (3 miniatures reproduced: vol. 1-r, ff. 3, 4v, 19v) ; le Monde de l'Art, p. 96.

115. Volume One, f. 4v: MINIATURE TO CHAPTER ONE OF BOOK ONE.
This miniature illustrates the idea of the French being descended from Françion, son of Hector and grandson of Priam, King of Troy. Thus, beneath the quatrefoil with the siege of Troy is a scene of the foundation of Paris. The border of acanthus leaves and vines includes many drolleries drawn with great skill and vividness. The Sanguin de Meudon arms are inserted into the initial Q. Text of the heading : le premier chapitre parle comment les françois sont de Troye La Grant, de la lignie au Roye priant descendus.

Page 106
116. Volume One, f. 19v: MINIATURE TO CHAPTER ONE OF BOOK TWO.
The miniature illustrates the division of the Frankish kingdom between the four sons of Clovis. (Le premier chapitre parle comment le royaume fut départi aux IIII filz du roy Clovis et de la mort Clodomire).
The refined colour scheme and drawing suggest that this miniature, as well as other illustrations at the beginning of the second volume, was painted by one of the leading Parisian illuminators of the early 15th century.

Page 107
117. Volume 2 - F. 2: VISIT OF EDWARD I OF ENGLAND TO PHILIPPE IV THE FAIR.
On the left, Edward entering Paris ; on the right, the King of England goes down on one knee in homage to the enthroned King of France.

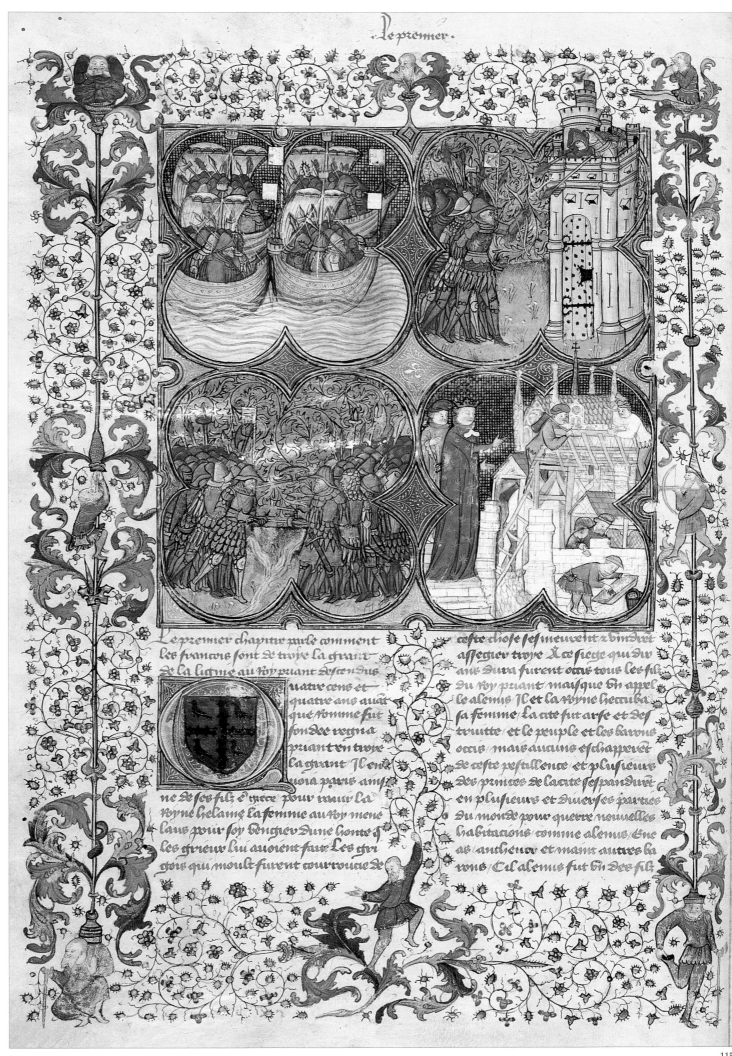

Le premier chapitre parle comment
les françois sont de troye la grant
de la ligune au roy priant descendus
quatre cens et
quatre ans auant
que romme fut
fondee regna
priant en troye
la grant. Il enuoia paris amy
ne de ses filz en grece pour rauir la
ryne helaine la femme au roy mene
laus pour soy venchier dune honte q̃
les grieux lui auoient fait Les grie
gois qui moult furent courrouciet de

ceste chose sesmeurent z vindrent
assegier troye A ce siege qui dix
ans dura furent occis tous les filz
du roy priant maisque vng appel
le alenis Il et la ryne hecruba
sa femme la cite fut arse et des
truitte et le peuple et les barons
occis mais aucains eschappent
de ceste pestillence et plusieurs
des princes de lacite sespandirent
en plusieurs et diuerses parties
du monde pour querir nouuelles
habitacions comme alenis, Ene
as antheuor et maint autres ba
rons, Cil alenis fut vng des filz

Le premier chapitre parle comment
le royaume fut departi aux .iiii. filz a
roy clouis et de la mort clodoinires

e fort roy clouis
ot quatre filz de
la royne auoit de
Clodomires Chil
debert Theodo
rich et Clothaire
tous ces quatre
furent roys et deuiserent le royaume
en quatre parties Theodrich fist le
siege de son royaume ametis Clodoui
res a orliens Clotaire a soissons, et
Childebert a paris comme le pere Ja
soit ce que en france ait eu plusieurs
roys en diuers sieges et en diuerses
parties du royaume nous ne mettos
en nombre des roys de france fors
ceulx tant seulement qui furent roys
du siege de paris Quant le royaume
fut ainsi deuise en quatre parties vn
pou de temps fu que guerres ne sour
doient de mille part mais damois
qui sont vne gent qui ne puent estre
en paix ariuerent par eaue en la
terre du roy theodrich, en partie la
prindrent et gasterent Le roy enuoia
contre eulx vn sien filz theodebert
pour son ost conduire et guier Alen
contre leur vint a eulx se combati des
confis furent et chaciez du pais, et
aucuns pris et retenuz Quant theo
debert ot ainsi exploittie il retourna

a son pere Entre ces choses la roy
ne trouble manda ses autres troir
filz le roy childebert le roy clodo
mires et le roy clothaire pour leur
dist en telle maniere le tout puis
sant dieu createur et gouuerneur
de tout le monde voult que vous
feussiez roys du regne biau pere
pour la quelle chose beaux doulz
filz se ay deserui merites Je vous
prie que vous vengiez la mort de
mon pere et de ma mere se me
doy esiouir de ce que jay enfante et
nourry enffans qui doiuent estre
vengeurs de ma douleur mais
ie me doy douloir de la mort de le
pere mon maris qui leur fist grant
honneur Si requier orendroit
vous ne deuez pas desprir ne despri
ser la cause de ma complainte par
la quelle vous estes orphelins de lai
de de si grans amis que trayson et
enuie vous ont tolu auant q vous
feussiez nez Aduertissez vous qlle
esperance vous poues auoir en celu
qui ce vous ont fait Cuidiez vous
quilz esparuient aux nepueux q
par ne se sparuirent aux freres, et
certes ilz les occistrent pour petite
partie du regne Cuidiez vous qlz
vous soient plus debonnaires se
vous estiez mors Ilz auroient grant
esperance quilz eussent voz royau
mes Certes se vous ne prenez la

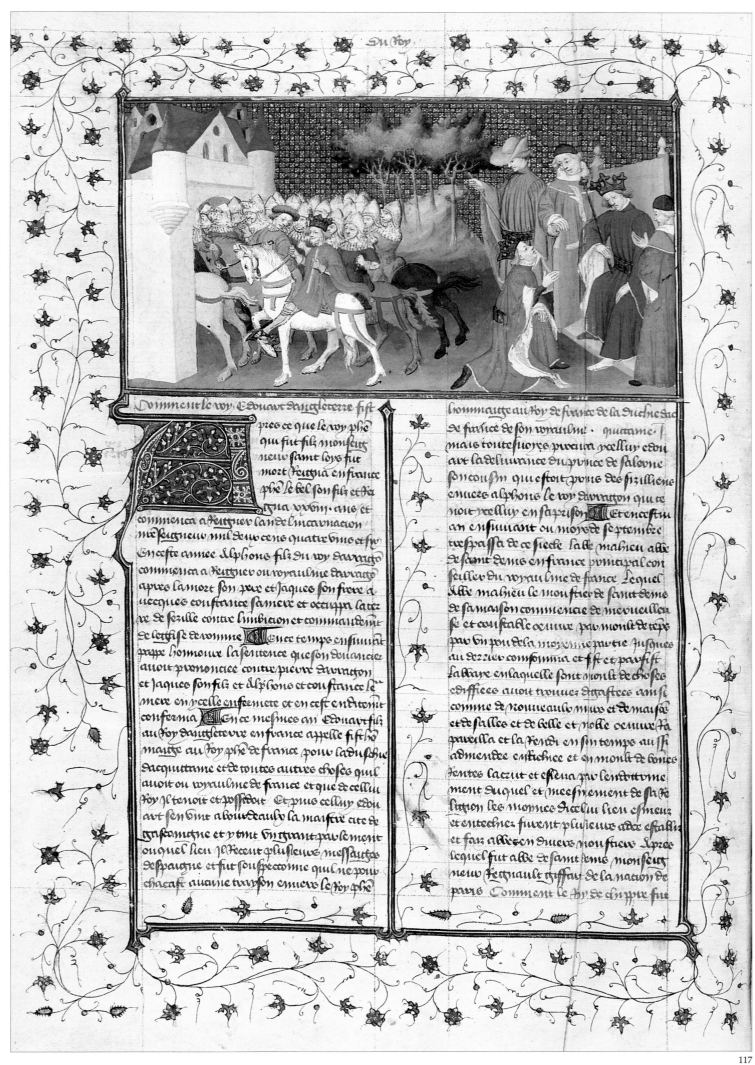

Comment le roy Edouart dangleterre fist hommauge au roy de france de la duchie dacquitaine de france de son royaulme · quittame

Apres ce que le roy phe qui fut filz monseigneur saint loys fut mort regna en france phe le bel son filz et regna xxix· ans et commenca a regner lande de lincarnacion nre seigneur mil deux cens quatre vins et sis En ceste annee Alphons filz du roy darragon commenca a regner ou royaulme darragon apres la mort son pere et Jaques son frere avecques constance samere et occuppa la terre de sezille contre lambicion et commandement de leglise de romme ¶ En ce temps ensuiuant pape honnour la sentence que son deuancier auoit prononcee contre pierre darragon et Jaques son filz et alphons et constance le mere en ycelle ensemente et en cest endiroit conferma ¶ En ce mesmes an Edouart filz au roy dangleterre en france appelle fist hommauge au roy phe de france pour la duchie dacquitaine et de toutes autres choses quil auoit ou royaulme de france et que de cellui Roy il tenoit et possedoit ¶ Pius cellui Edouart sen vint a bourdeaux la maistre cite de guisomtne et y tint vn grant parlement ouquel lieu il recent plusieurs messaiges despaigne et fut souspeconne quil ne pour chacast aucune traison enuers le roy phe

mais toutesfoiez procura icellui Edouart la deliurance du prince de saloune son cousin qui estoit pris des sizilliens enuers alphons le roy darragon qui tenoit icellui en sa prison ¶ Et en cestui an ensuiuant ou moys de septembre trespassa de ce siecle salle mahieu abbe de saint denis en france principal conseiller du royaulme de france lequel abbe mahieu le moustier de saint denis de samaison commencie de meruellerse et constable oeuure par moult de temps vn peu dela moyenne partie Jusques au derrier consumma et fist et parfist labbaye enlaquelle sont moult de choses edifficiees auoit trouuez degastees ainsi comme de nouueaulx murs et de maisons et de salles et de belle et nolle oeuure fa pareilla et la rendi en son temps auffi admendee ensichnee et en moult de bonnes rentes laccrut et esleua par lendroitement auquel et mesmement de stre solution les monnee de celui lieu esmeuz et entechez furent plusieurs adex establi et fax abbe en diuers moustiers Apres lequel fut abbe de saint denis monseigneur neur regnault giffart de la nacion de paris ¶ Comment le roy de chippre fut

118-122
GUIDO DELLE COLONNE (DE COLUMNA)
The History of the Destruction of Troy
Guido delle Colonne. Historia Destructionis Troiae
France. Early 15th century.
151 ff. 288 x 222 mm (text 190 x 155 mm). Parchment. Latin.
35 miniatures; 35 large colourful initials decorated with gold and with vinestem border.
Binding: 18th century. Olive-coloured morocco over cardboard; gold-tooled design on the spine;
gilt-edged. The first protective leaf ot the binding has the date 1742 and filigree decoration.
Lat.F.v.IV.5

Between 1270 and 1287 Guido de Columna, an Italian lawyer, historian and poet, wrote a 35-book Latin prose version (abbreviated) of Benoît de Sainte-Maure's famous romance covering the legendary *history of Troy* from the expedition of the Argonauts to the death of Ulysses. Born in 1220 in Messina, Guido de Columna served at the Neapolitan court of Frederick II, as well as that of his son Manfred. The popularity of Columna's work in Europe, especially in the latter part of the 14th and in the 15th centuries, by far exceeded that of the cumbersome poem by Benoît de Sainte-Maure. It was translated into Italian, Spanish, French, English and Dutch, and the Latin version was published in Cologne in 1477.

The style of the large illustration preceding each of the 35 books is somewhat archaic. The chequered *(quadrillé)* backgrounds of the miniatures and the borders that appear on the pages with initials bear a resemblance to

14th-century illumination. In the "peaceful" subjects the size of the figures is occasionally out of proportion and their gestures awkward. The large dimensions of the compositions, the artist's inclination towards broad areas of a single colour, the serenity of the parallel folds of the vestments, and the facial types place these scenes close to Italian art. If the miniaturist himself was not from Italy, it may be that he had an Italian manuscript which he took as a model. The numerous battle scenes are executed by a more skilful hand, probably another artist.

The manuscript's early history is obscure. In the first half of the 18th century it belonged to Jean-Louis Gaignat, a French bibliophile, as is indicated by the inscription on the protective leaf of the binding. It is known that Catherine the Great thought of buying the whole of the Gaignat collection in 1769 when it came up for sale in Paris. Possibly, it was at that time that one of the Stroganovs bought it.

ENTERED THE PUBLIC LIBRARY IN 1889 WITH THE COUNT A. STROGANOV COLLECTION.

LITERATURE: Catalogue des livres du cabinet du feu M. Louis-Jean Gaignat. Disposé et mis en ordre par G.F. de Bure le Jeune, vol. 2, *Paris, 1769, p. 81, No 2851;* Otchot Imperatorskoi Publichnoi biblioteki za 1889 god, *St Petersburg, 1890, p. 12;* Golenishchev-Kutuzov 1972, pp. 50, 232–234 (3 miniatures reproduced).

118

118. EX-LIBRIS DE COMTE STROGANOV.

119. F. 2v: BEGINNING OF BOOK ONE.
Peleus, King of Thessaly, and Queen Thetis at a banquet table receive Jason and his companions and entrust them with obtaining the Golden Fleece.

120. F. 88v: THIRD BATTLE BETWEEN THE GREEKS AND THE TROJANS.
The more gentle use of colours is common in the painting of battles. The favourite colours are lilac, dark green, with light blue for armour. This explains the effect produced by the splashes of vermilion. One is struck by the careful and calculated use of gold in the armour of the knights in command; the finish of the breast-plates, the spurs and the bugle.

121. F. 134r: DESTRUCTION OF THE GREEK FLEET LURED BY FALSE SHORE FIRES ONTO THE CLIFFS NEAR NAUPLIOS.
The shipwreck is inventively depicted: the collapsing masts break across the white network of the ropes, the sails quiver in the wind, and the warriors raise their arms to the sky in despair as they sink into the deep in their heavy armour.

120. F. 143r: KINGS PELEUS AND ACASTUS PRESENT THE CROWN OF THESSALY TO PYRRHUS, HAVING DRESSED HIM IN ROYAL VESTMENTS.

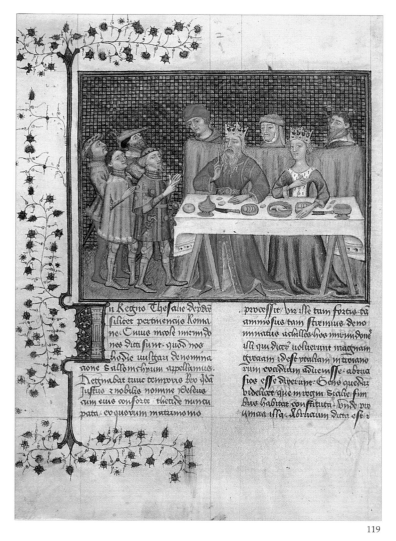

In Regno Thesalie depdce
silicet permenerio Rома
ne. Cuius moris intermid
nes dicta sunt quod noc
hodie uultari denomi
none Salsomchrum appellamus.
Dettinabat tunc temporis Rex Ada
Justus z nobilis nomine Peleus
rum eius consorte thetide nuncu
pata eo quorum matrimonio

processit/ un iste tum fortis tu
animosus tam stremius deno
minatus achilles hoc intum dne
iste qui dicunt voluerunt magnam
turiaam Adest pralium in troiano
rum euadium aduenisse abdura
sios esse diverunt Seus quedam
videlicet que in regno Sialie sm
tibus habitat constituta und pro
utma ista Abrituum dicta est:

119

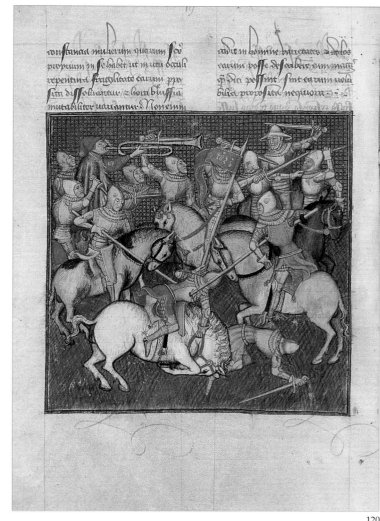

constanaa mulierum quarum seo
proprium in se habet ut inita oculi
repentia fragilitate earum pro
sim dissoluantur z hora bluffia
mutabiliter uariantur: Non enim

radit in nomine intricatues. Po
carum posse describere unminde
qp dia possint sint earum uola
bile proposit nequioura :

120

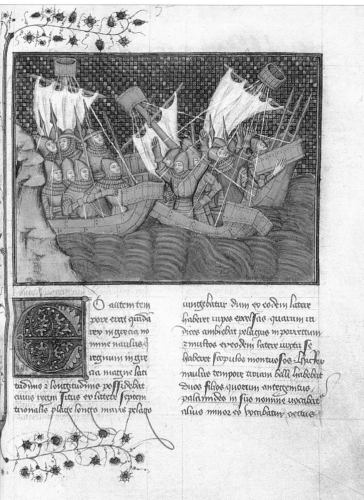

O autem tem
pore erat quida
rex in grecia no
mine naulus in
regnum in gir
ra matine sati
tudinu z souctitudine possidebat
cuius regni situs ex latere septen
trionaste plage souto maris pelago

untebatur dum eo eodem latere
haберет rupes excelsse quarum in
dices ambiebat pelagus in porrettum
z multos eo dem latere rupta se
haberet scopulos montuosos Hucten
naulus tempore troiani belli habebat
duos filios quorum antergemuus
palamides in suo nomine vocabit
alius minor eo vombatur vetices

121

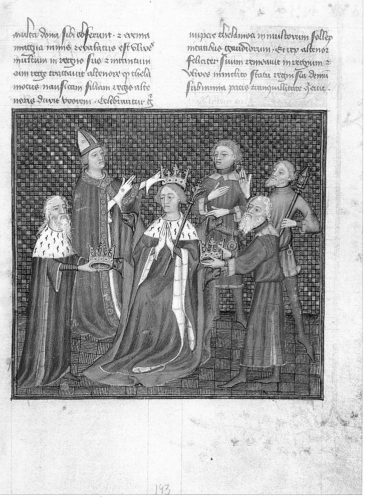

multa doma sibi obferunt z exenia
matiqia imme rebasatus est Vlixes
multum in regno suo z imtantum
am rege tractauit alteno qp theld
motue nausicam filiam regis iste
nonis durie vouem. celebrintur tt

mipace thelamoa in multorum sollep
mtatitue grauidorum: Se irp altenor
feliciter suum remeauit in regnum z
Vlixes inmelior statu regni sui dem
subimtia pace tranquillitate heuit.

122

123-127
GERBERT DE MONTREUIL. Violette, or Gérart, Count of Nevers
NICOLE DE MARGIVAL. The Tale of the Panther of Love
Gerbert de Montreuil. Roman de la Violette ou de Girart Comte de Nevers.
Nicole de Margival. Le Dit de la Panthère d'Amours
France (Paris). Early 15th century.
64 ff. 290 x 210 mm (text 195 x 130 mm). Parchment. French.
16 pages with miniatures, initials and half-frames; 2 half-page miniatures enclosed in frames of vine-stems preceding each novel; numerous gold and red-and-blue initials filled with tendrils.
Binding: 18th or early 19th century (commissioned by Piotr Dubrovsky). Bright-yellow morocco over cardboard; gold-tooled borders on the front and back covers; designs stamped in gold on the spine; gilt-edged; purple paper fly-leaves. Fr.Q.v.XIV.3.

The first part of the manuscript (ff. 1r–45v) contains the *Romance of Violette*, written between 1227 and 1229 by Gerbert de Montreuil, a 13th-century French poet. It is devoted to a woman whose reputation was slandered and then restored. Gérart, Count of Nevers, believes the calumny of a treacherous seducer and is cruel to his wife Oriana. On the verge of killing her with his sword in a thick forest, he instead almost dies himself, but is saved by a warning from his wife. The second part of the manuscript contains an allegorical novel by Nicole de Margival, another 13th-century poet. Two copies have survived, one in St. Petersburg and the other, an earlier manuscript without miniatures, now in the Bibliothèque Nationale in Paris (MS.fr.24432). Seeking the love of a beautiful lady, the poet tells her his dream: wandering in a forest inhabited by animals and singing birds he encountered the God of Love and Venus, who showed him the Panther of Love, a wonderful animal which was a symbol of his lady and helped him to win her favour. When he woke up, however, he realized the dream was not true. He composes ballads and songs about loyalty, love and sorrow before his beloved.

Laborde correctly ascribed the illumination to the school of Paris, but was apparently mistaken over the connection with the Boucicaut Master which he postulated. According to Millard Meiss, the illumination was done by the Luçon Master, who decorated a Missal commissioned by Etienne Loypeau, Bishop of Luçon. Meiss's attribution can be accepted with one reservation: not all the miniatures of the St Petersburg manuscript were painted by the master himself — some, the more primitive ones, were probably executed by assistants. The Luçon Master, active between 1390 and the 1400s, was one of the most prolific artists of the early 15th century. He decorated numerous Books of Hours, the most famous of which is *Térence des duce* (ca 1412; Paris, Bibliothèque de l'Arsenal, MS.664). His style is marked by elegant, lithe and slender figures and exquisite colour compositions. Meiss called the Luçon Master the most typical artist of the International style in early 15th-century Parisian illumination. The type of border seen here, in which dragons (usually in the upper part of the page) are incorporated into the design of vinestalks with golden leaves, was widely used in Parisian illumination during the late 14th and early 15th centuries.

The manuscript used also to include the *Roman d'Athis et Prophilias* (n°5 128-135 ; Fr. Q. v. XIV, 4) (see 38), and belonged to the collection of the Dukes of Burgundy (it is mentioned in the inventory of 1420). In the 17th century, the manuscript belonged to Pierre Séguier and in 1735 went to Saint-Germain-des-Prés (f. 2 has the inventory number n.18312). Piotr Dubrovsky probably purchased the whole manuscript, but unbound, which prompted him to separate it into two parts and give them separate, but identical bindings.

ENTERED THE PUBLIC LIBRARY IN 1805 (1849–61 THE HERMITAGE, 5.2.53).

LITERATURE: Montfaucon 1739, 2, pp. 763, 1108; Gille 1860, p. 52; Bertrand 1874, p. 175; Nicole Margival, Le Dit de la Panthère d'amour. Poème du XIIIe siècle publié d'après les manuscrits de Paris et de Saint-Pétersbourg par Henry A. Todd, Paris, 1883; Nikolayev, le Monde de l'Art, 1904, p. 101; Doutrepont 1906, p. 67, No 107; Yaremich 1914, p. 39, ill. between pp. 36 and 37; Gerbert de Montreuil, Le Roman de la Violette, ou de Gérard de Nevers (ed. by D.L. Buffum), Paris, 1928; Laborde 1936–38, 1, pp. 53–55, pl. XXVI; Shishmariov Fund 1965, pp. 42, 43, 79, 80; Meiss 1968–74, pp. 317, 355, 358; Meiss 1974, the Limbourgs, pp. 395, 419.

123. F. 2r: INTRODUCTORY MINIATURE TO THE ROMAN DE LA VIOLETTE. (115 x 135 mm).
In the garden near the tent a sovereign wearing a crown decorated with fleurs-de-lis (the manuscript was executed for the Duke of Burgundy) is sitting in an armchair surrounded by courtiers. Behind the wall are musicians entertaining the guests. The bright colours, the slender and dainty figures, their stylish costumes and the flowers in the garden help to create both the conventional atmosphere of a romance and that of the chivalrous life style of the French nobility under Charles VI.

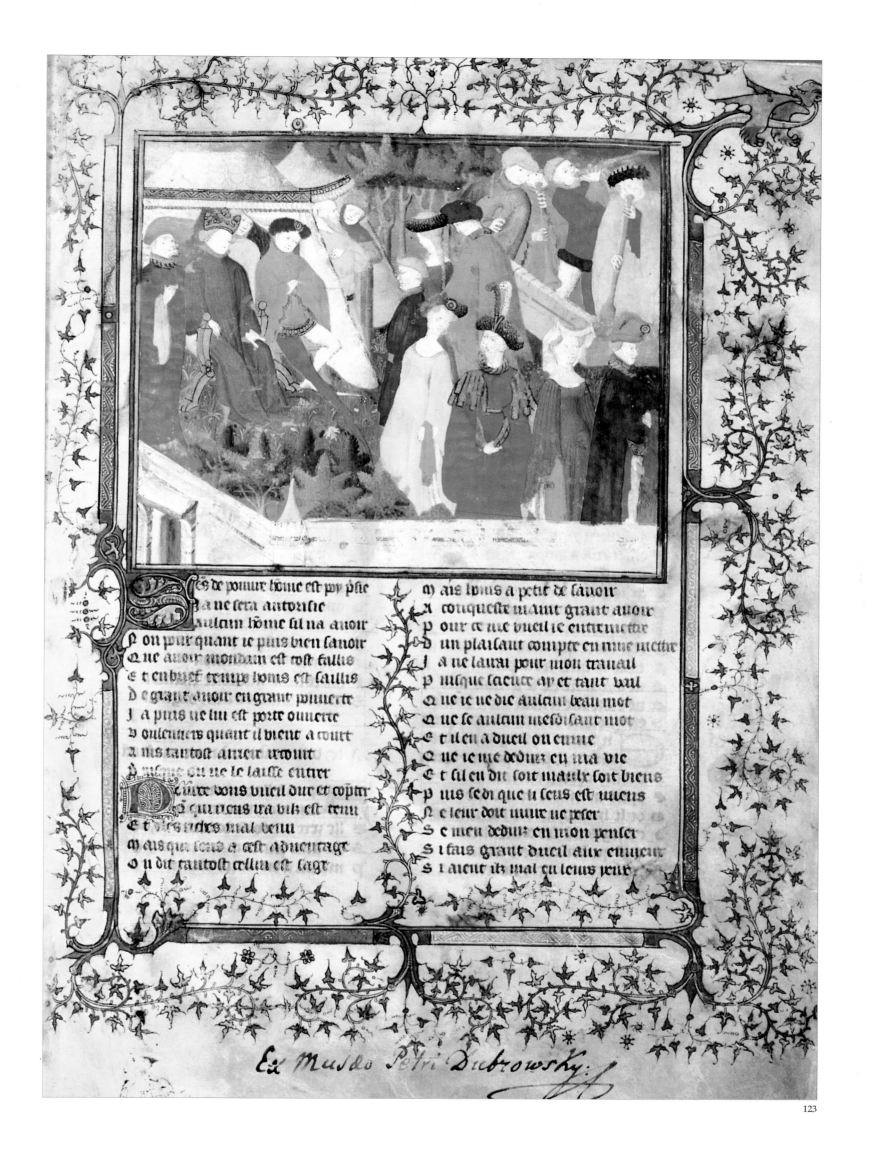

tes de pouur home est pu psie
a ne sera autorisie
autam home sil na auoir
Pon pur quant ie puis bien sauoir
Que auoir mondain est tost fallis
et en buef temps tons est saillis
De grant auoir en grant pouuerte
Ja puis ne lui est porte ouuerte
Dóulciners quant il vient a court
a ms tantost ameir troiut
Jusque on ne le laisse entrer
Dutre tous vueil dire et compter
es qui tens tra vils est tenu
et tres ordres mal uenu
aus qui sens a cest aduentage
on dit tantost cellui est sage

ais tous a petit de sauoir
conqueste maint grant auoir
Pour ce me vueil ie entremettre
Dun plaisant compte en rime mettre
Ja ne lauai pour mon trauail
Puisque saueir ay et tant vail
Que ie ne die autem beau mot
a ne se autem mesdisant mot
et ilen a dueil ou enuie
Que ie me dedutz en ma vie
et sil en dit soit mauls soit biens
Puis se di que li sens est miens
Se leur doit nuire ne peser
Se men dedutz en mon penser
Si fais grant dueil aire enuieut
Si aient ils mal en leurs peur

123

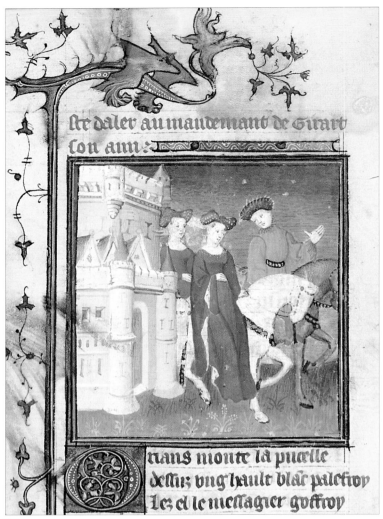

ſte daler au mandemant de Girart
ſon ami ꝫ

nans monte la puelle
deſſus ung hault blac paleſroy
les et le meſſagier gosſroy

124

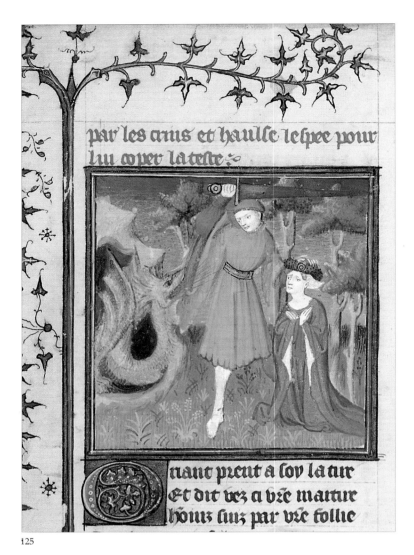

par les crins et haulſe leſpee pour
lui couper la teste ꝫ

nant prent a ſoy la tur
Et dit vez a vre martir
hōm ſuz par vre follie

125

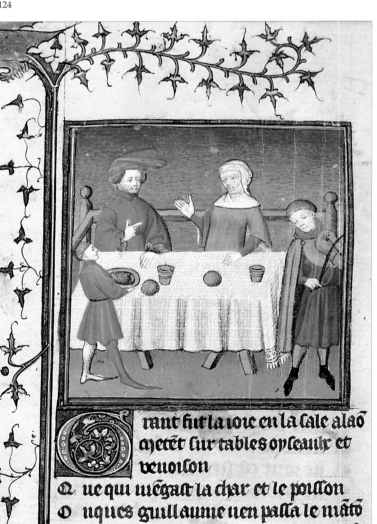

nant fut la ioie en la ſale alaõ
ajetēt ſur tables oyſeaulx et
venoiſon

Que qui meigaſt la char et le poiſſon
Onques guillaume nen paſſa le matõ

126

124. F. 7r: "HOW THE BEAUTIFUL ORIANA
PREPARED TO SET OUT ON HER WAY AS
ORDERED BY GIRART" (63 x 60 mm).

125. F. 9r: "HOW GIRART SEIZED
ORIANA BY HER HAIR AND LIFTED HIS
SWORD IN ORDER TO CUT OFF HER
HEAD" (63 x 60 mm).
At the moment Girart is going to kill her, his own life is
threatened by a dragon emerging from a cave. The green grass
and trees, blue sky, the characters' fragile elegance and the
naive, toy-like, fire-breathing dragon give the scene a charming
fairytale quality.

126. F. 12r: "HOW GIRART ARRIVED IN
NEVERS DISGUISED AS A JUGGLER AND
PLAYED THE VIOL BEFORE THE COUNT
AND THE OLD LADY WHO, UNAWARE
THAT GIRART AND THE JUGGLER
ARE ONE AND THE SAME PERSON,
REPROACHED HIM OF HAVING
CONQUERED THE COUNTY OF NEVERS"
THANKS TO HER. (63 x 60 mm).

127. F. 48v: "HOW THE GOD OF LOVE
BROUGHT THE INFATUATED MAN TO A
VALLEY IN ORDER TO SHOW HIM THE
PANTHER". (57 x 60 mm).

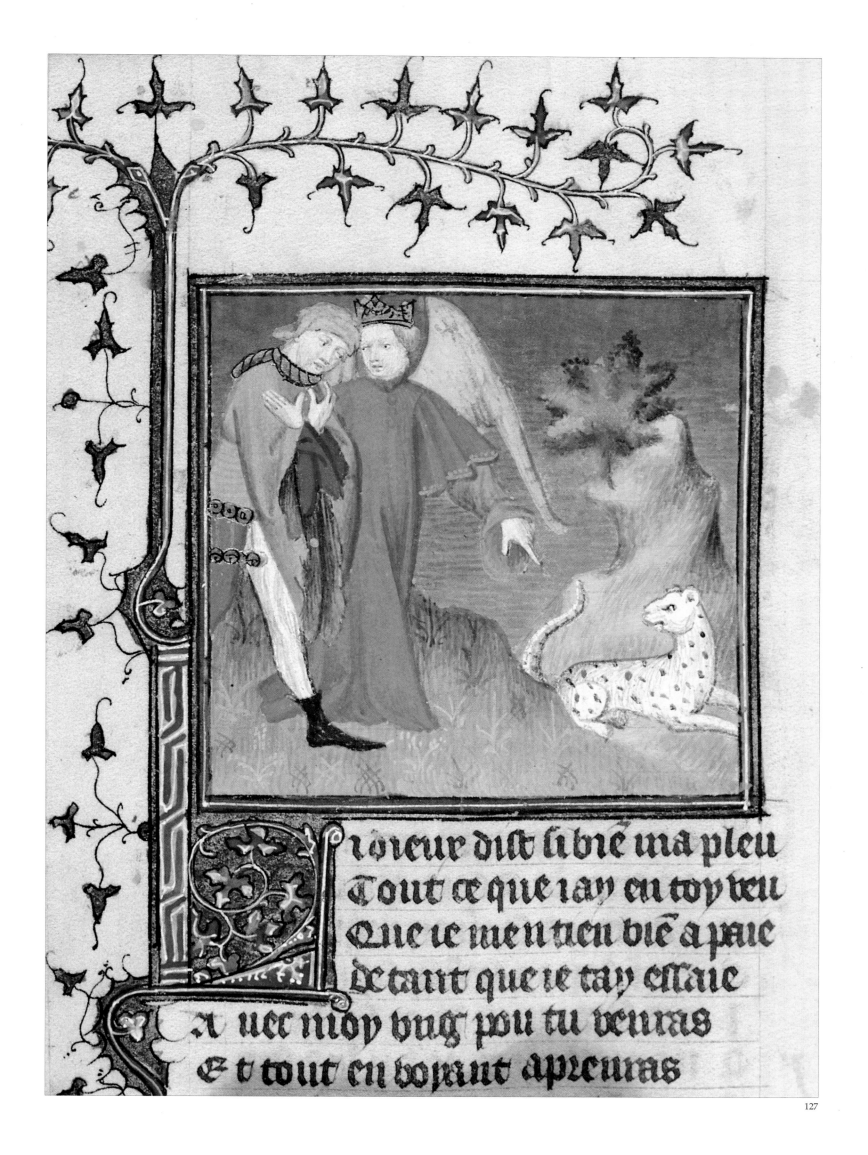

ioieur dist li biē ma pleu

Tout ce que iay en toy veu

Que ie men tien biē a paie

detant que ie tay essaie

A uec moy vng pou tu venras

E t tout en boiaut appcuras

128-135
ALEXANDRE DE BERNAY
ATHIS AND PROPHILIAS OR THE SIEGE OF ATHENS
Roman d'Athis et Prophilias ou Le siège d'Athènes
France (Paris). Early 15th century.

133 ff. 290 x 210 mm (195 x 130 mm). Parchment. French. 26 miniatures, each as wide as the column of text (60 mm) and of a height ranging from 50 to 70 mm; every page with a miniature is decorated with a colourful initial and has vine-stem ornamentation between the columns or in the margin; small initials alternately in red and blue, and gold and blue. Binding: 18th or early 19th century (commissioned by Piotr Dubrovsky). Yellow morocco over cardboard; gold-tooled frame on the cover and designs on the spine; gilt-edged. Fr.Q.v.XIV.4.

Alexandre de Bernay was a French poet of the second half of the 12th century widely known as the author of the continuation of the famous *Romance about Alexander the Great*. De Bernay was probably the first poet to write in lines of 12 syllables, a metre called Alexandrine verse. The *Roman d'Athis et Prophilias* is considered to be his earliest work. It tells the long and elaborate story of the friendship between Athis from Athens and Prophilias from Rome. Athis gives his wife to Prophilias, who is in love with her. Not long after that, Prophilias saves his friend's life. Athis falls in love with Prophilias's sister Gaiete, who has already been promised to Billas, King of Sicily. The marriage of Athis and Gaiete provokes a war between Theseus, Duke of Athens, on the one hand, and King Billas and Thelamon, Duke of Corinth, on the other. The author gives a detailed and colourful description of the action and the siege of Athens. During an armistice Billas meets Sabine, the sister of Athis, and falls in love with her. Their love and marriage reconciles the parties and the romance ends with the lifting of the siege and a feast in honour of the newly married couple.

The decoration of the manuscript, which is marked by an intense colour scheme, skilful drawing and ingenious composition, reminded Laborde of the illumination of the two existing copies of the French translation of Boccaccio's tale (*Des Cleres et Nobles Femmes*), produced in the early 15th century for Jean de Berry (Paris, Bibliothèque Nationale, MS.fr.598) and Philip the Bold, Duke of Burgundy (Paris, Bibliothèque Nationale, MS.fr.12420). It was earlier considered that the manuscripts were illustrated by the same miniaturist, conventionally named the Master of 1402. Millard Meiss, however, attributed the miniatures to different artists. The illustrations in the St Petersburg manuscript, particularly those close to the Burgundian copy of Boccaccio, are ascribed to the miniaturist called the Master of the Coronation of the Virgin (on the basis of the subject on the frontispiece of a copy of the Golden Legend dating from 1403; Paris, Bibliothèque Nationale, MS.fr.242). This miniaturist came from Flanders (probably Bruges) to Paris at the very end of the 14th century and became one of the most remarkable representatives of the Parisian school. He must only have worked for a short time, however, as all of his known works are dated before 1404. Incidentally, during his last period (1402–4) he worked not only for Jean de Berry, but also for Philip the Bold. The St Petersburg manuscript, which was executed for the Duke of Burgundy, probably dates from the same period (it used to form a whole with the Roman de la Violette and Le Dit de la Panthère d'Amour, see 37) (Fr. Q. v. XIV, 3).

ENTERED THE PUBLIC LIBRARY IN 1805 (1849–61 THE HERMITAGE, 5.2.54).

LITERATURE: Montfaucon 1739, 2, p. 1108, No 763; Gille 1860, p. 55; Bertrand 1874, p. 175; Doutrepont 1906, p. 67, No 107; Li Romanz d'Athis et Prophilias (L'Estoire d'Athenes) (publ. by Alfons Hilka), 2 vols, Dresden, 1912–16; Laborde 1936–38, p. 55, pl. XXVI; Dobias-Rozdestvenskaïa, Liublinskaya 1939, pp. 861–864; Shishmariov Fund 1965, pp. 42, 43, 79, 80; Meiss 1968–74, p. 355; The late 14th century ; Meiss 1974, The Limbourgs, pp. 383, 419; Fourteenth Century French Miniatures: Le Roman d'Athis et Prophilias ou le Siège d'Athènes by Alexandre de Bernay (publ. by T.P. Voronova), Leningrad, 1983.

130. F. 71v: A MESSENGER ARRIVES TO ANNOUNCE TO THE DUKE OF ATHENS THAT THELAMON, DUKE OF CORINTH, HAS DECLARED WAR ON HIM.
Its colours still as bright as if they had been applied yesterday, this miniature is particularly close to the illumination of the famous Burgundian manuscript of Boccaccio produced for Philip the Bold.

131. F. 68r: THESEUS, DUKE OF ATHENS, AND HIS SON PREPARE TO RECEIVE ATHIS AND PROPHILIAS.
Such scenes, in which the characters are so tightly packed into the room that their heads almost touch the ceiling, are typical of the Master of the Coronation of the Virgin.

128. F. 62v: ATHIS AND PROPHILIAS WITH THEIR WIVES ON THE WAY TO ATHENS.
The artist chose to show his characters inside the ships and, in order to treat the space freely, he boldly foreshortened the stern of the third ship, raised by a steep wave.

129. F. 46v: GAIETE, THE SISTER OF PROPHILIAS, SETS OFF TO MEET BILLAS, KING OF SICILY.
The horses are represented with a degree of skill unusual for that time.

La ot gette mait grat soupir
Dam bedeuv pars au departir
Cilz de hors pleurent grat deul fot
Et eulz dedans grat pitie ont

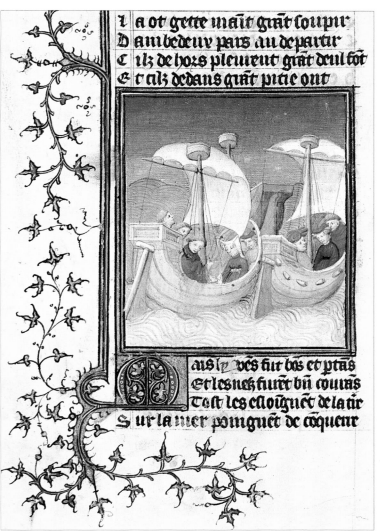

aus ly ves fut bos et ptas
Et les nes furet bn courans
Tost les esloignet de la tir
Sur la mer poinguet de coquerre

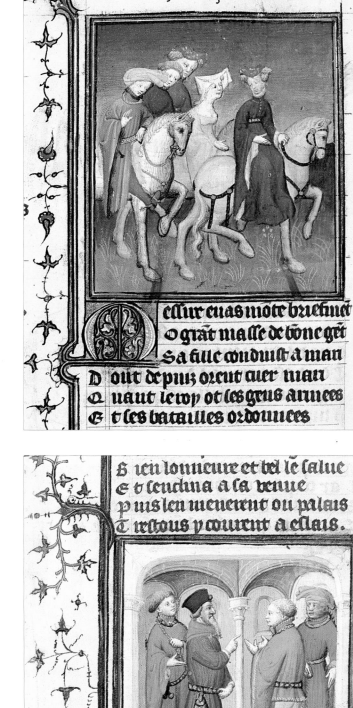

essur euas mote briefuet
O grat masse de bone get
Sa fille conduist a man
Dout de puis oreut auer man
Quaut le roy ot les greus armees
Et les batailles ordounees

Grat teste auoit dedas corpe
Tout le pais sone et retint
Des menestriers de maite guile
Dont ne vous vueil faire deuise
Car le duc auoit celebre
Ic iour de sa natiuite
Tous les homes cemos auoir
Car mlt larges et preur estoit

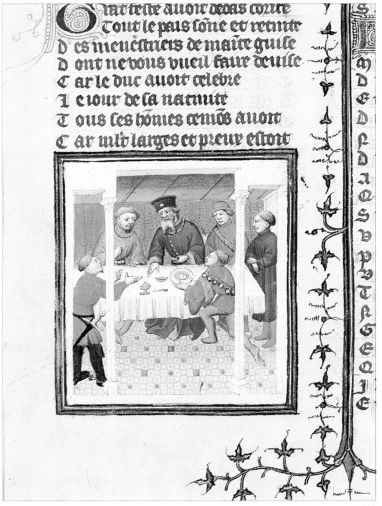

Bien lonnieure et bel le salue
Et lenclina a sa venue
Puis len menerent ou palais
Trestous y courent a eslais.

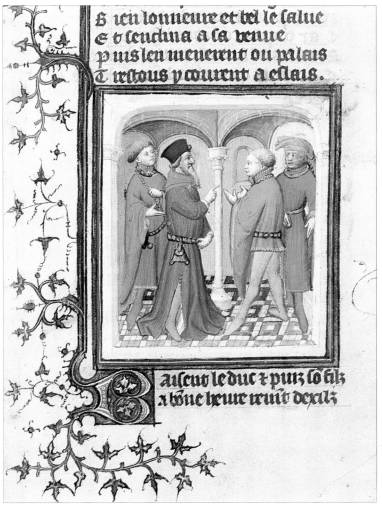

Aiseur le duc z puis son filz
a bone heure truit deulz

ff eult par trestoute la contree.

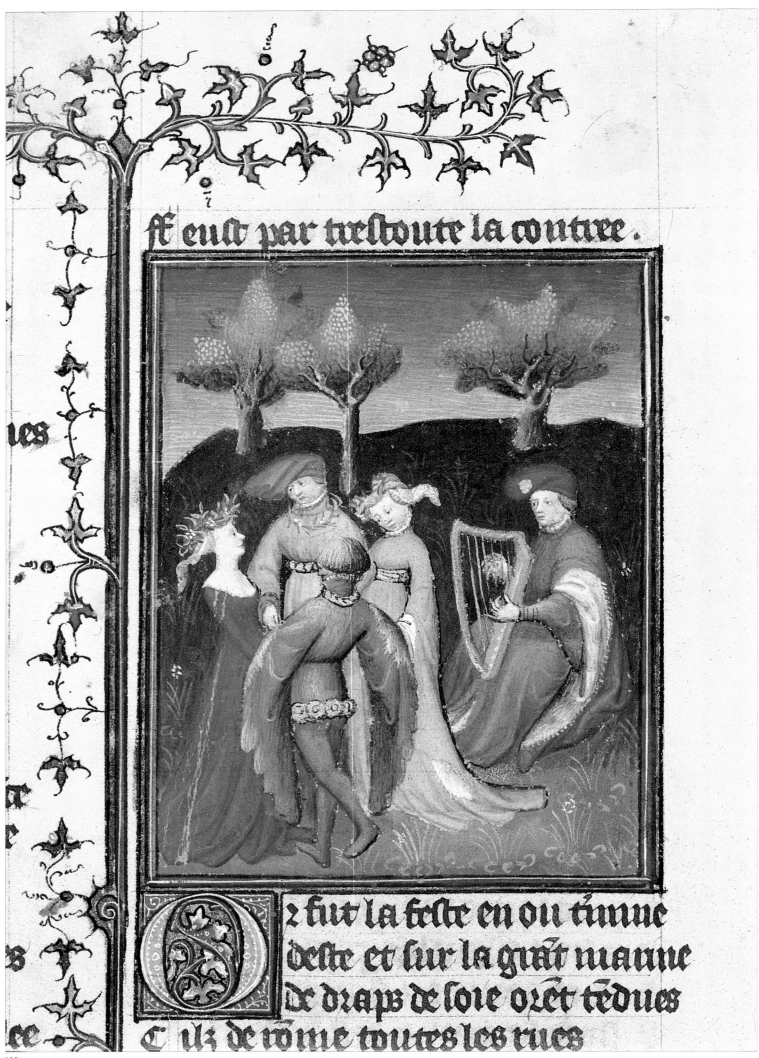

Oz fut la feste en ou tímue
deste et fur la gnat mamue
de draps de foie ozét tédues
Cilz de rome toutes les rues

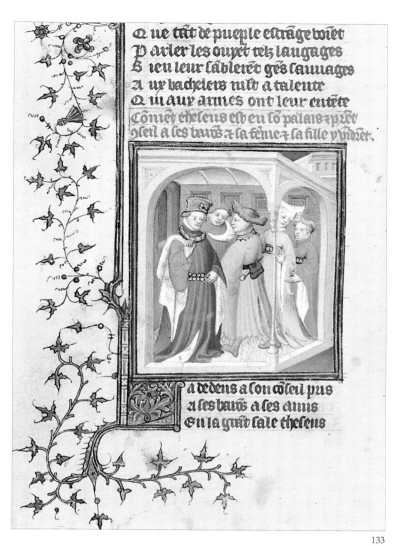

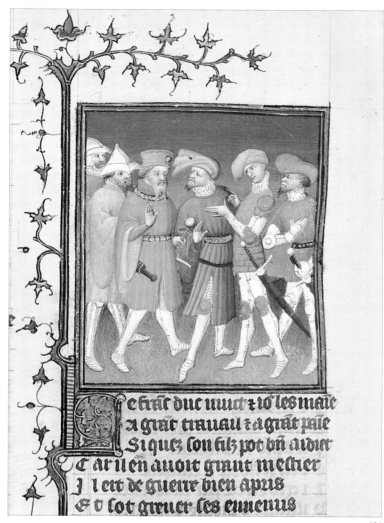

132. F. 17v: THE FESTIVAL OF THE ROMANS AND THE SABINES.
The miniature depicts the Roman festivities which, according to legend, ended in the rape of the Sabine women. Men and women in rich mediaeval costumes decorated with gold are dancing to the sounds of a lute in a meadow filled with flowers. The bold juxtaposition of bright colours and the composition's rhythm create the atmosphere of a joyful festival.

133. F. 83v: THE DUKE OF ATHENS CONSULTS THE BARONS, HIS WIFE AND DAUGHTER IN HIS PALACE.

134. F. 93v: THE DUKE OF ATHENS CONSULTS HIS KNIGHTS ON GIVING ASSISTANCE TO HIS SON.

135. F. 132r: THE ENGAGEMENT OF BILLAS AND SABINE.

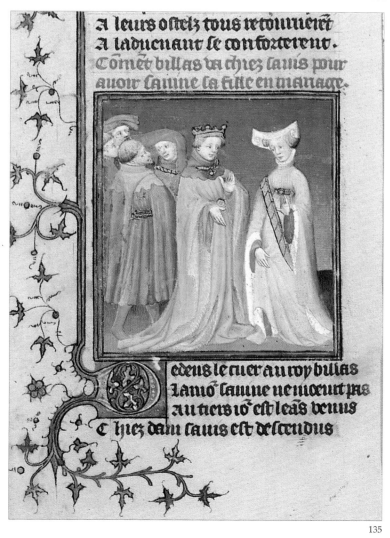

136-138
COLLECTION OF SAYINGS BY DIFFERENT PHILOSOPHERS
Les Ditz Moraux de Philosophes
France. Early 15th century.
90 ff. 265 x 190 mm (text 150 x 110 mm). Parchment. French.
15 miniatures; colourful initials with gold and grape-leaf tracery.
Binding: 18th century (commissioned by Piotr Dubrovsky). Blind-stamped turquoise velvet over
cardboard; doublures on the front and back covers; fly-leaves of gold brocade.
Fr.Q.v.III.4.

The collection was compiled and translated into French before 1402 by Guillaume de Tignonville (d. 1414), chamberlain to King Charles VI of France, and also a poet, translator and political figure. The collection consists of sixteen chapters that include sayings by various philosophers of the past (Hermas, Pythagoras, Socrates, Plato, Aristotle, Alexander the Great, Ptolemy, and others).

Referring to the miniatures as a good example of the "grisaille of the time of Charles VI", Laborde dated them around 1395. Meiss, however, thinks they were executed later, in the 1400s, by the artist he termed the Master of the Apocalypse after his main work, a copy of the Apocalypse (New York, Pierpont Morgan Library, MS.133), who worked from 1407 to 1418 or 1420. The style of this miniaturist follows that of the Boucicaut Master; it is distinguished by a limited and delicate palette showing a preference for light, even pale green, blue, beige and grey hues. The Master of the Apocalypse, whose colour scheme continued the traditions of 14th-century grisaille, also employed quick, spontaneous drawing, rendering figures somewhat two-dimensionally and creating simple compositions usually featuring several characters arranged into groups.

This work by Guillaume de Tignonville gained wide popularity in the 15th century. Its contents were not always the same and it was more often than not included as part of a volume containing several texts. The St Petersburg manuscript most likely was also part of such a collection (this is supported by an entry in Montfaucon's catalogue noted by Shishmariov, and an inscription on the first blank page made by Piotr Dubrovsky according to which the manuscript had belonged to King René). The manuscript changed hands many times during the 16th century, and on its last blank pages are the signatures, quatrains and sayings of its numerous owners (Pierre Gilbert, Françoise Gilbert, Claude Roger, Roger Bontemps, P. Boulle and André Boulle). In the 17th century, it formed part of Pierre Séguier's collection, which was inherited by his grandson, the Duke of Coislin, and bequeathed by him to Saint-Germain-des-Prés in 1735. Piotr Dubrovsky purchased the manuscript some time before 1792.

ENTERED THE PUBLIC LIBRARY IN 1805 (1849–61 THE HERMITAGE, 2.5.44).

LITERATURE: Cat. Séguier 1686, *inv. des Miniatures*, p. 5; Montfaucon 1739, 2, p. 1805, No 782; Gille 1860, pp. 51, 52; Delisle 1868–81, 2, p. 58; Bertrand 1874, pp. 96, 97; Shishmariov 1927, *vestiges de la Bibliothèque de René d'Anjou*, pp. 189–192; Laborde 1936–38, pp. 26–28; M. Meiss, *French Painting in the Time of Jean de Berry. The Boucicaut Master*, London, 1968, p. 71, fig. 480; Meiss 1968–74, p. 354; Meiss 1974, *The Limbourgs*, p. 379.

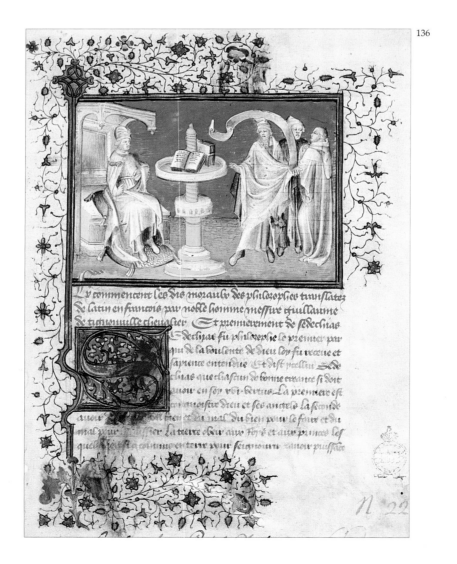

136

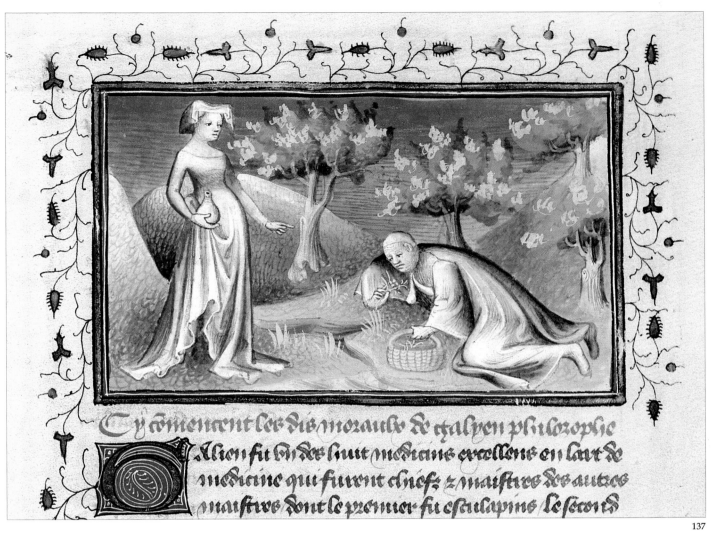

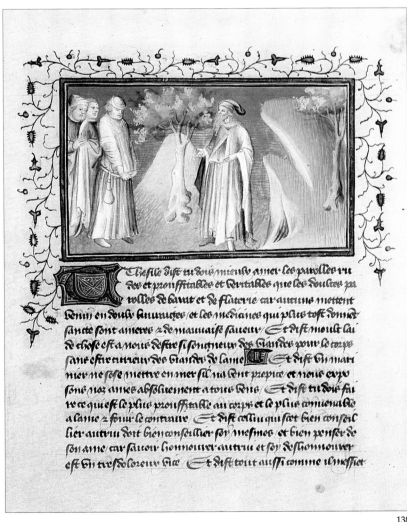

136. F. 2r: THREE WISE MEN AND ZEDEKIAH.
Three wise men are shown engaged in a discussion in front of Zedekiah, King of Judah, whom the author calls the "first philosopher". The King sits under a canopy.

137. F. 77r: ILLUSTRATION TO THE SAYINGS OF GALEN.
Galen, or Claudius Galenus (131 – ca 200), the famous physician of antiquity and the author of works on natural philosophy, is shown picking medicinal herbs.

138. F. 75v: ILLUSTRATION TO THE SAYINGS OF PHESSAL.
Phessal, a philosopher and physician of antiquity, was a follower of Hippocrates. The colour scheme of this miniature, especially the pale green and beige of the hills, is typical of the Master of the Apocalypse.

BOOK OF HOURS OF MARY STUART

Heures Dites de Marie Stuart

France. Second quarter of the 15th century.

229 ff. 250 x 175 mm (text 110 x 75 mm). Parchment. French and Latin.
22 miniatures; rich foliated borders touched with gold on each page; calendar
headings in gold, blue or red; initials in red and blue with gold; decorative bands.
Binding: 18th century. Purple velvet over wooden boards; blind-stamped frame;
two silver-gilt clasps; banded spine; doublures of gold brocade; fly-leaves of red moire;
gilt-edged. Lat.Q.v.I.112.

This is the most famous Book of Hours in the St Petersburg collection. It includes a Calendar in French, extracts from the Gospels, the Hours of the Virgin, the Penitential Psalms, the Litany, the Hours of the Cross, the Hours of the Holy Ghost, the Office of the Dead, two prayers to the Virgin (*Obsecro te and O Intermerata*) in Latin; *the Fifteen Joys of the Virgin, Seven Requests to the Saviour, a Prayer* to St Peter of Luxembourg in French verse and various prayers at the end of the manuscript.

The broad, ornate borders framing the miniatures attract most attention in the illumination. The acanthus design also includes palmettes and flowerpots. At the bottom of the pages are botanically accurate depictions of plants, something very rare in manuscript illumination. This kind of marginal decoration is dated to around 1430 and connected with the so-called Bedford Master, who gets his name from a Breviary and a Book of Hours associated with the English Regent of France, the Duke of Bedford. Laborde linked the illumination of the St Petersburg volume with the style of the so-called Bedford Breviary (ca 1433; Paris, Bibliothèque Nationale, MS.lat.17294) and considered its miniatures to be imitations of earlier models at the artist's disposal. The archaic traits of the illumination are obvious, especially in the iconography of subjects and in the treatment of backgrounds (landscapes with hills and groups of trees, and the occasional use of coloured or chequered pattern backgrounds. The fresh and vivid colours have not faded at all over the centuries. Judging by the surviving coat of arms (a silver shield with a lion) on f. 167v, the manuscript was commissioned by somebody from the house of Luxembourg. This coat of arms was carefully erased from all the other leaves. The Book of Hours was given to Mary Stuart by her uncle Francis, Duke of Guise. The inscriptions and quatrains written by Mary Stuart at different times are still to be found on many leaves of the manuscript.

The manuscript was in England before 1615 and probably belonged, according to Andrei Lobanov-Rostovsky, to somebody at the court of James I. Its owner gathered a collection of the autographs of noble figures in the book, among them the Earl of Nottingham, Lady Arabella Seymour, Elizabeth Talbot, the Countess of Shrewsbury, the Earl of Essex, the Earl of Sussex and Sir Francis Walsingham. There is no information on the manuscript's further history until its purchase by Piotr Dubrovsky in France at the end of the 18th century.

ENTERED THE PUBLIC LIBRARY IN 1805 (1849–61 THE HERMITAGE, 5.2.11).

LITERATURE: Gille 1860, pp. 65, 66; A. Labanoff, Lettres, instructions et mémoires de Marie Stuart, reine d'Ecosse, publiés sur originaux et les manuscrits du State Paper Office de Londres et des principales archives et bibliothèque de l'Europe, vol. 7, London, 1844, pp. 245 (No 1), 346–352; O. Dobias-Rozdestvenskaïa, "Livres d'heures de la Bibliothèque Publique", in: L'Académie des Inscriptions et Belles-Lettres. Comptes-rendus des séances de l'année 1925. Paris, 1925, pp. 183–187, 2 figs.; Dobiash-Rozhdestvenskaya 1927, pp. 15, 16; Laborde 1936–38, pp. 63–66, pl. XXVII.

139

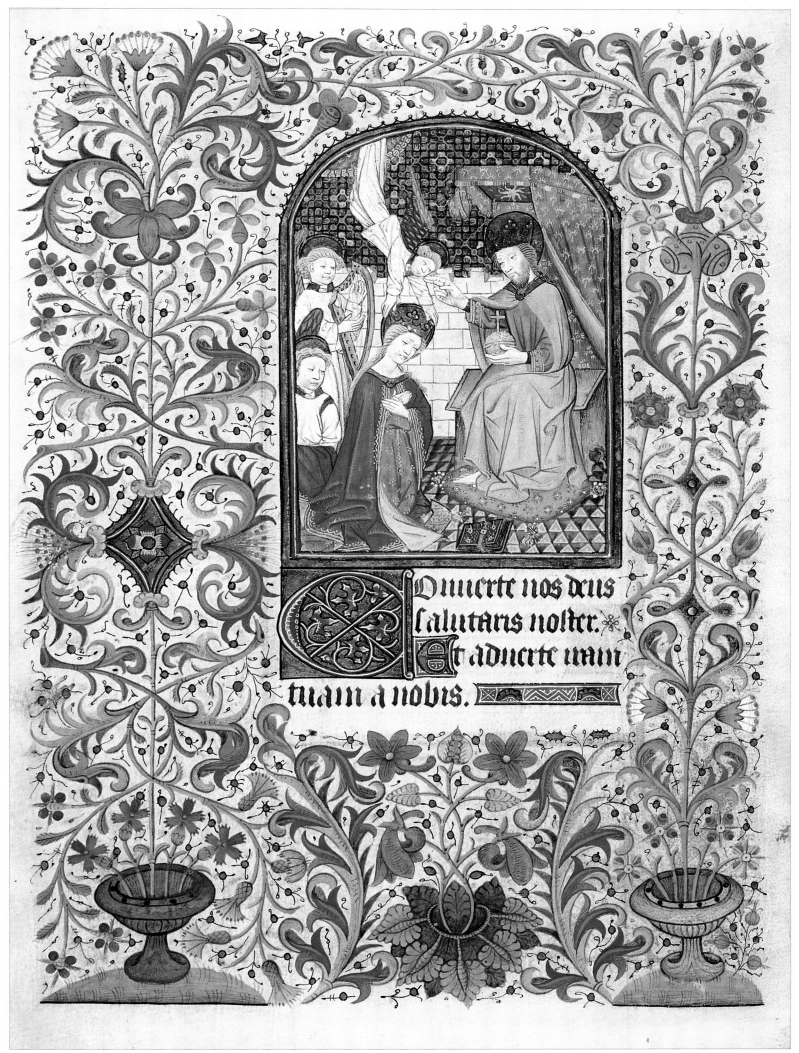

Onuerte nos deus
salutaris noster.
Et aduerte uram
tuam a nobis.

141

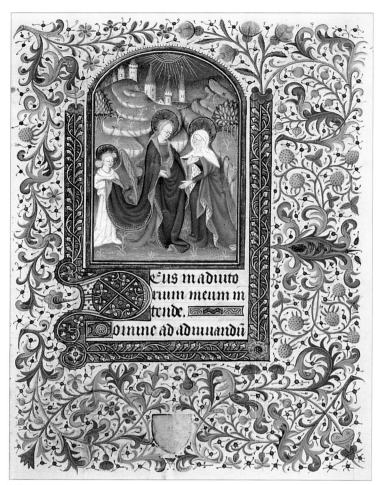

142

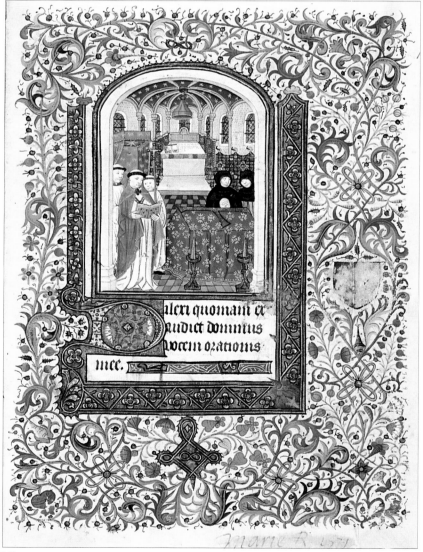

143

Page 120
139. F. 129v. QUATRAN :
AUTOGRAPH OF MARIE STUART.

Page 121
140. F. 77v:
THE CORONATION OF THE VIRGIN.

141, 142. F. 40r: THE VISITATION.

143. F. 110r: MINIATURE TO THE OFFICE
OF THE DEAD.

144. F. 167v: MINIATURE TO THE PRAYER
OF ST PETER OF LUXEMBOURG.
St Peter sees a vision of an angel descending from the starry
sky wearing a cardinal's hat. A coat of arms with a lion against
a silver background is attached to it. Laborde mentions
a similar miniature in the Vie de Saint Pierre de Luxembourg
(Paris, Bibliothèque Nationale, MS.fr.7392).

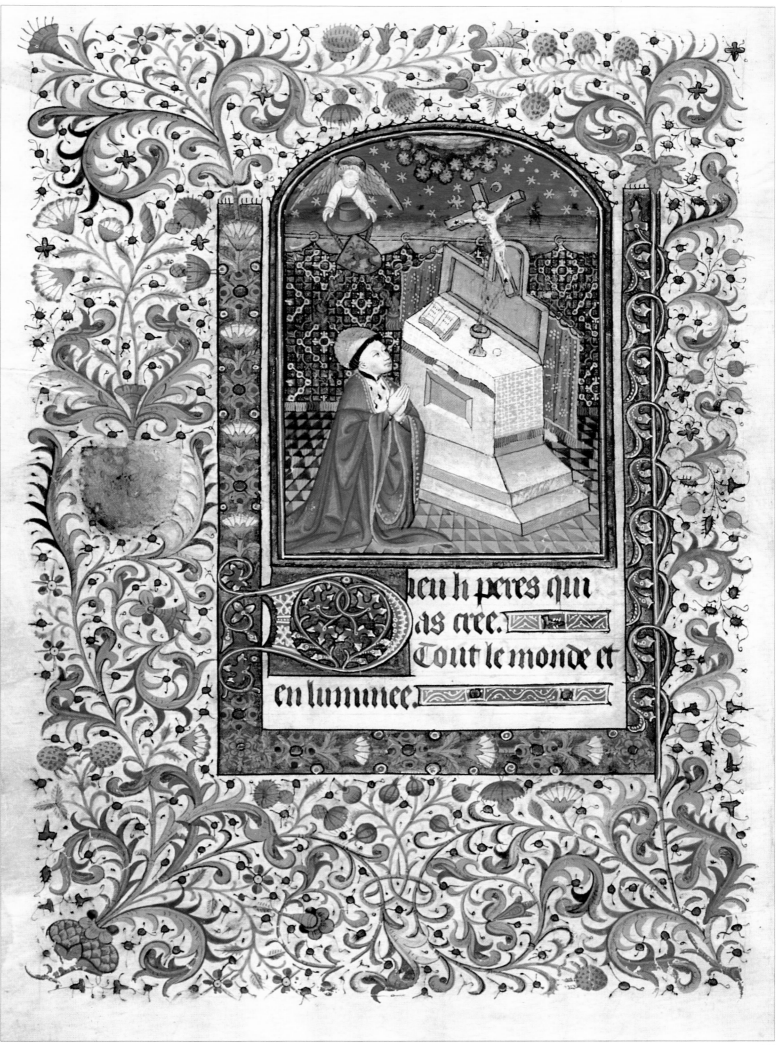

145, 146
BOOK OF HOURS OF FRANCIS II, DUKE OF BRITTANY, OF THE USE OF PARIS

Heures Dites de François II Duc de Bretagne à l'Usage de Paris
France (Paris?). Second quarter of the 15th century.
157 ff. 168 x 120 mm (text 95 x 68 mm). Parchment. Latin and French.
15 pages with miniatures framed by vine-stems, with acanthus leaves in various colours and gold and large coloured initials; other pages have borders of golden vine leaves with red and blue flowers in the outer margins; numerous small golden initials on red or blue backgrounds.
Binding: 17th century. Dark purple velvet over cardboard; traces of two clasps; gilt-edged.
Lat.O.v.I.65.

The composition of the Book of Hours is standard: it includes a Calendar, readings from the Gospels, the prayers *Obsecro te and O Intemerata*, the Hours of the Virgin, the Hours of the Cross, the Hours of the Holy Ghost, the Penitential Psalms, the Office of the Dead, and prayers in Latin; *the Fifteen Joys of the Virgin*, Les *cinq plaies de Notre Seigneur* are in French, as are all of the headings. Missing are a reading from the Gospel according to St Mark, part of the text of the Hours of the Virgin starting from the Annunciation and part of the Hours of the Cross.

The miniatures reflect the impact of the Parisian school of the first decades of the 15th century. Laborde placed them at the very beginning of the century. But the fact that the composition is definitely based on earlier models and the type of the marginal decoration indicate that the miniatures were produced in the second quarter of the 15th century. The manuscript was adorned by at least two masters who were stylistically linked by their realistic treatment of movements, their calm, harmonious draperies and awareness of the compositional devices of the artists of the Duke of Berry. The illustrations to the Hours of the Virgin are reserved and poetic, and show the artist's preference for blues, greens and violets blended with white; he likes to depict silver-coloured clouds floating in a dark-blue sky. The style of this artist indicates that this could be a late work of the master of the "Cité des Douves". The other master, whose illumination of the *Office of the Dead* is reproduced herein, favoured striking combinations of contrasting colours and gold.

In the 15th century, the manuscript belonged to Francis II, last Duke of Brittany and father of Queen Anne of Brittany; his signature appears on the last page (f. 157v). In the 16th century, it was acquired by Duke François de la Trémoille (1510–1541), whose signature appears on f. 143 and f. 157. The later history of this Book of Hours is unknown until it was purchased by Piotr Dubrovsky at the end of the 18th century.

LITERATURE: Gille 1860, p. 46; Yaremich 1914, pp. 38, 39; Laborde 1936–38, pp. 60, 61.

145

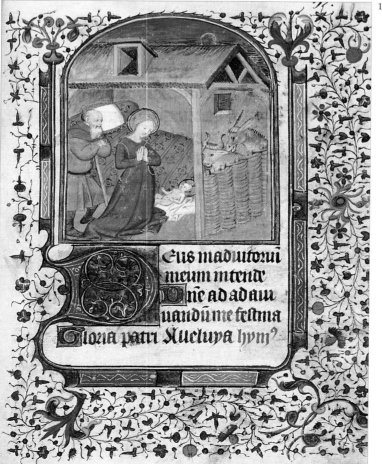

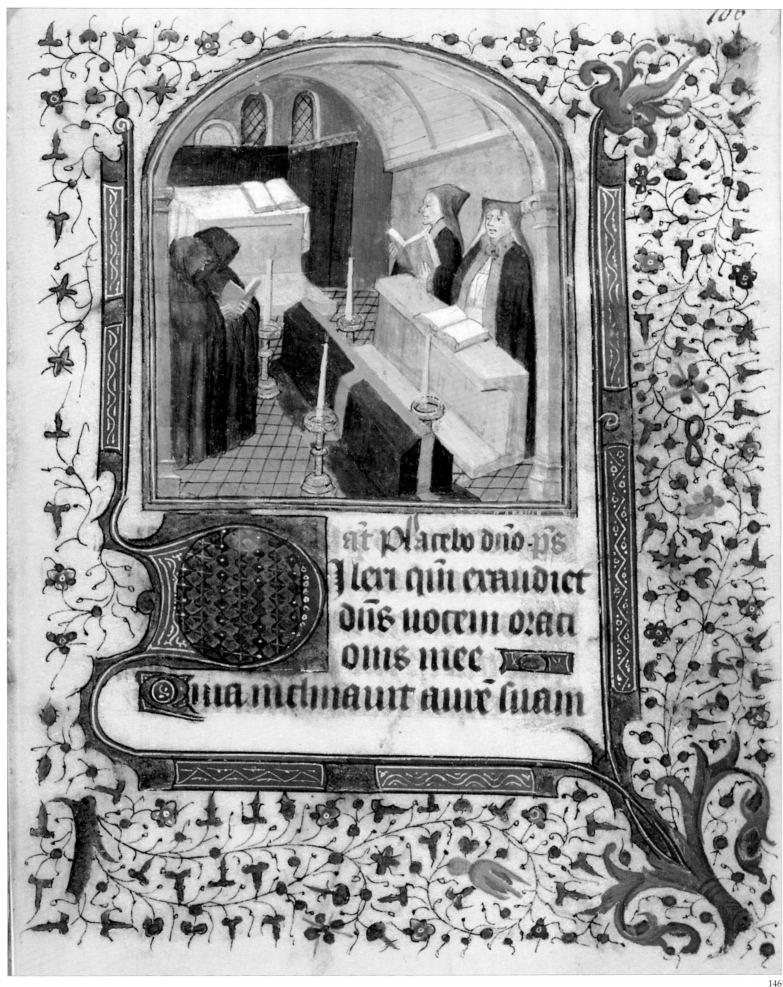

146

145. F. 57r: THE NATIVITY.

146. F. 106r: MINIATURE TO THE OFFICE OF
THE DEAD.

147-157
LUXEMBOURG BOOK OF HOURS OF THE USE OF ROME
Heures Dites de Luxembourg à l'Usage de Rome
Flandre (Bruges). First half of the 15th century.
156 ff. 157 x 120 mm (text 90 x 60 mm). Parchment. Latin.
39 miniatures; 39 large initials against golden backgrounds; 39 ornamental frames;
vertical border on each page.
Binding: 19th century. Light-red velvet over cardboard; ormolu corners;
star-shaped bosses in the centre; eagle-shaped agraffe holding 15th-century miniatures
of the Virgin and Child and St John the Baptist; doublures
and fly-leaves of green moire; gilt-edged.
Rasn.O.v.I.6.

The Book of Hours includes readings from the Gospels (the calendar is lost), the Hours of the Virgin, the Penitential Psalms, the Litany, the Hours of the Passion, the Hours of the Holy Ghost, the Office of the Dead and prayers to various saints including St Peter of Luxembourg. The character of the prayers in the Hours of the Virgin indicates that the manuscript was executed in the Netherlands. According to Olga Dobias-Rozhdestvenskaïa, it was commissioned shortly after the death of Peter of Luxembourg by one of his relatives, as is proved by the coats of arms of the house of Luxembourg (ff. 111r–112v). Dobias-Rozhdestvenskaïa also holds that the French inscription on the last leaf referring to the earthquake of 2 February 1418 places the manuscript before 1419. It is possible that the manuscript was produced in several stages, with the illumination being executed at a later date. On seeing photographs of two miniatures from the St Petersburg manuscript, Durrieu assessed them as being of exceptionally high quality. Dobias-Rozdestvenskaïa's supposition that the illuminator was Jacques Coene, the artist usually identified with the Boucicaut Master, seems erroneous. The type of the borders and the style of miniatures, which combines the refined, aristocratic and calligraphic manner of the Parisian school of the early 15th century, the architectural devices introduced by the Boucicaut Master and an unquestionable knowledge of the discoveries of the great Netherlandish artists, suggest that the illumination dates from the second quarter of the 15th century. Several hands can be distinguished, three according to François Avril, who also considered that the manuscript was produced in southern (French) Flanders or Hainaut, which does not contradict its Luxembourg character.

The early history of the manuscript is a mystery. According to Fiodor Berenstam, director of the Peterhof Museums in 1924, it belonged to the Empress Alexandra Fiodorovna.

ENTERED THE PUBLIC LIBRARY FROM THE PETERHOF PALACE IN 1924.

LITERATURE: O. Dobias-Rozdestvenskaïa, *"Livres d'heures de la Bibliothèque Publique",* L'Académie des Inscriptions et Belles-Lettres. Comptes-rendus des séances de l'année 1925, *Paris, 1925, pp. 183, 186, 2 figs;* Dobias-Rozdestvenskaïa *1927, pp. 7, 8, 10, 14, 15.*

147. F. 7r: ST MARK THE EVANGELIST.
The cell of the Evangelist, who is writing at a lectern, and a still life motif of books and bottles resting on the shelf, are reminiscent of the devices worked out by the Boucicaut Master. The intimate, spiritual atmosphere of this scene is matched by the soft light, an indication, perhaps, of the miniaturist's knowledge of the interiors painted by Robert Campin and Jan van Eyck. Pointing out the similarity of the artist's manner to that of the Maître aux rinceaux d'or, François Avril suggests an analogy with a similar composition in a Book of Hours illuminated by the Master of Guillebert de Mets around 1440–50 (New York, H.P. Kraus collection).

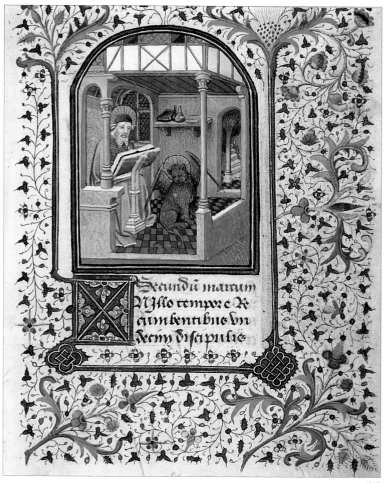

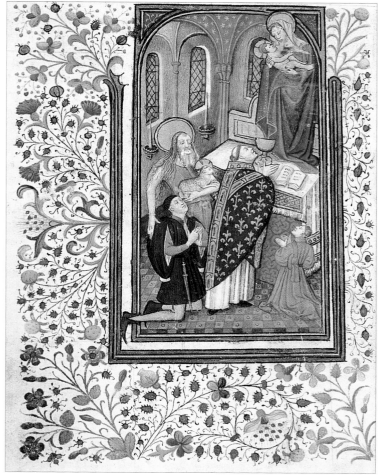

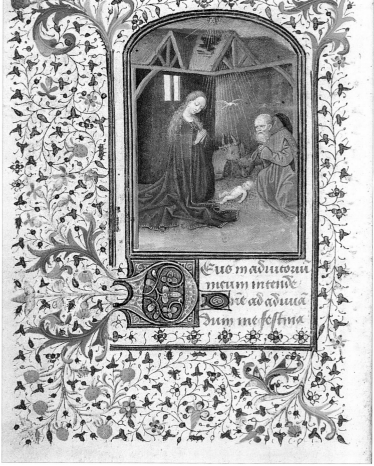

148. F. 10v: THE APPARITION OF THE VIRGIN AND CHILD TO ST PETER OF LUXEMBOURG.

The man who commissioned the Book of Hours, his patron saint John the Baptist and a smaller figure of a kneeling man are shown near the praying St Peter. A man with the facial features of the commission-giver appears once more on f. 111v - 112. The two-dimensional, linear character of this miniature, as well as many other ones in the manuscript, is, in Avril's opinion, close to the style of Perroné Lamy, a miniaturist from Savoy. This miniature is also characterized by the use of archaic devices, such as chequered backgrounds.

149. F. 47v: THE NATIVITY.

This poetic scene was painted by the same artist as the Annunciation. Avril suggests that it served as a pattern for the Nativity from the Book of Hours belonging to Guillaume de Montfort (1450s; Vienna, Österreichische Nationalbibliothek, S.n.12878, f. 44v) that was illuminated by Guillaume Vrelant, a famous Burgundian miniaturist.

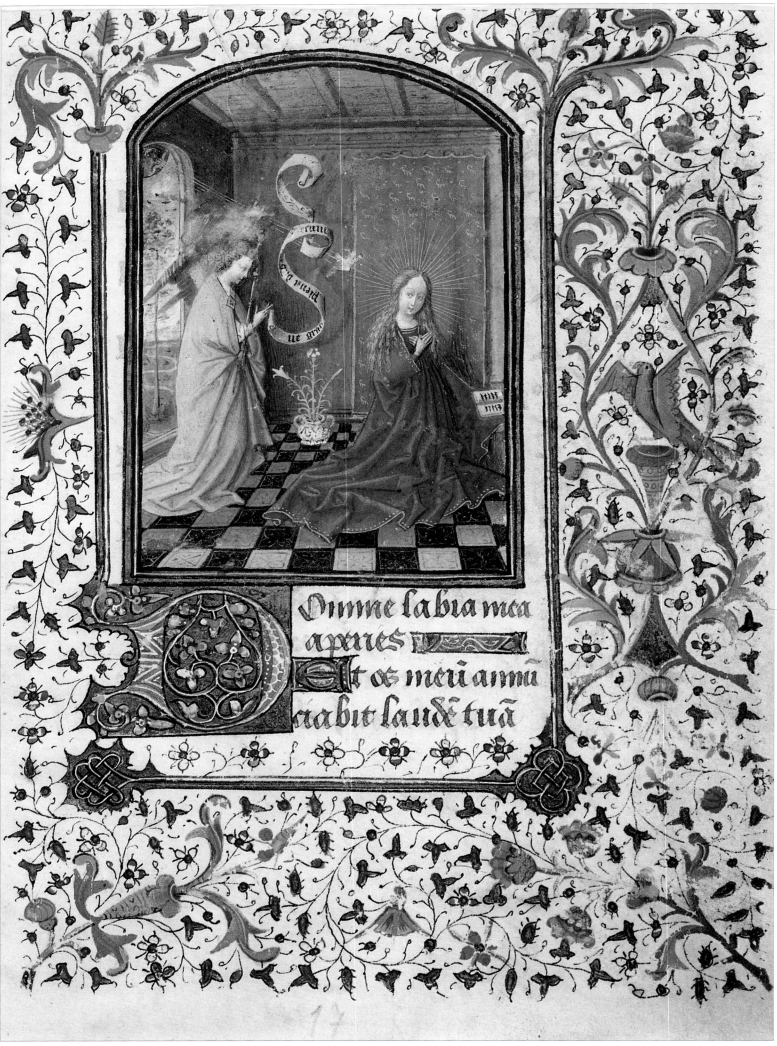

Omne labia mea
aperies

Et os meu ann̄
tabit laudē tuā

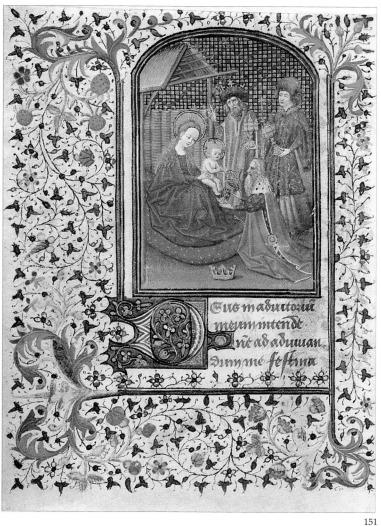

151

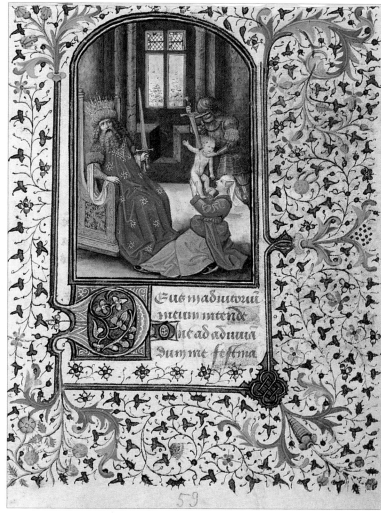

152

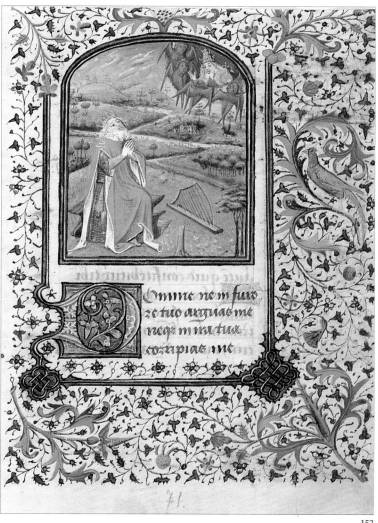

153

150. F. 17r: THE ANNUNCIATION.

This miniature, which unfortunately is slightly damaged, was painted by the most progressive of the artists engaged in the illumination of this Book of Hours. Having learned the lessons of the great Netherlandish masters very well, the artist gave a realistic rendering of space, which is filled with light and air. The landscape fades into a haze and the whole scene is permeated with a sense of serene joy. The fine drawing, the elegant treatment of the drapery, the colour harmony and the lyrical images of the archangel and the Virgin, which are particularly close to the Virgins of Campin and van Eyck, speak of talent of the highest order.

151. F. 55v: THE ADORATION OF THE MAGI.

This subject is painted by the author of the Annunciation (f. 17r).

152. F. 59r: THE MASSACRE OF THE INNOCENTS.

153. F. 71r: KING DAVID PRAYING.

This is a miniature to the Penitential Psalms.

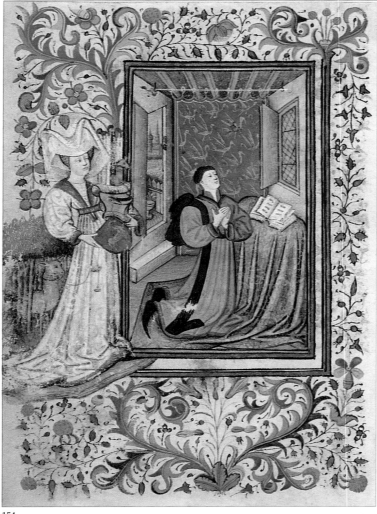

154

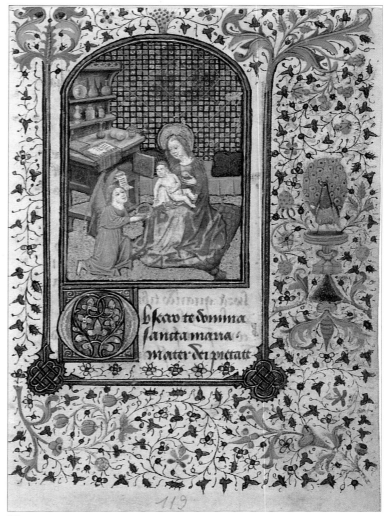

155

156

154, 155. FF. 111v–112r: PRAYER TO THE VIRGIN.

154, 155. FF. 111v–112r: PRAYER TO THE VIRGIN.
The two-page composition shows the patron who commissioned the manuscript (left) praying to the Virgin and Child (right). The main scene in the left part of the composition is accompanied by a marginal depiction of a lady wearing courtly dress. She is leading a fallow-deer from the woods, holding the helmet of the patron and a shield decorated with his arms.

156. F. 147v: ALL SAINTS.

157. F. 142r: ST ANTONY.
St Antony is depicted in the desert with wild pigs. He holds the Holy Scriptures, a crutch and a bell. The bottom part of the border bears episodes from the life of the saintly hermit.

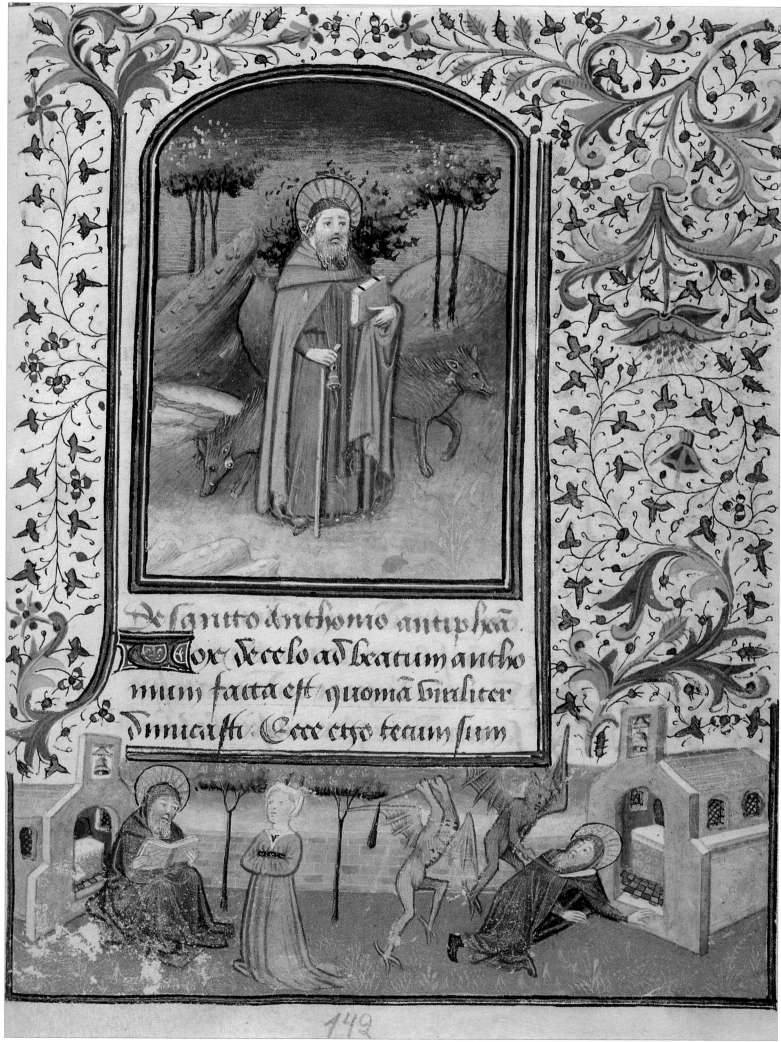

De sancto Anthonio antiphona
Lux de celo ad beatum antho
nium facta est quoniam viriliter
dimicasti. Ecce ego tecum sum

158-161
POETRY DESCRIPTION OF A TOURNAMENT OF 1446
Description en vers français d'un tournoi fait en 1446, ou Récit du tournoi du roi René à Saumur (Launay) en 1446 nommé "Pas du Perron"
France. Ca 1470 - 1480.

48 ff. 360 x 270 mm (text 230 x 210 mm). French. Paper.
89 miniatures (pen and watercolour); numerous coloured initials.
Binding: 18th century. Cardboard.
Fr.F.p.XIV.4.

According to Shishmariov, the description of this famous 15th-century tournament was written by the abbot of the Conilly family or by Grandin de Mansigny (judging by the coats of arms on the first leaf) rather than by Seneschal de Beauvau, as Laborde thought. The manuscript is devoted to two tournaments in which King René I took part: *Emprise de la Gueule du dragon*, which is described briefly, and *Pas du Perron*, forming the main part of the text. Both tournaments were held in 1446, the second one lasting 40 days, from June 27 to August 8; it took place near a wooden castle specially built at Saumur for the occasion. The festival was very flamboyant and extravagant and attracted a lot of people. King René naturally wanted to have a description of the tournament, but for a long time his biographers considered the work lost. The St Petersburg manuscript is the only existing copy of the description.

In addition to festive processions of knights, the miniatures depict jousts between 91 participants, who were divided into two groups; those on the defensive (*tenants*) and those on the offensive (*assaillants*). The sketchy illustrations were probably intended to be used as patterns for another, more ornate copy. The style of clothing indicates a period later than 1470 ; notably the lady on horseback with a long pointed hennin. Despite their fluent and seemingly casual manner, these pen drawings, touched with coloured wash, are arranged freely and are full of movement, their bright colours rendering the atmosphere of sunny summer days quite effectively. The artist managed to convey the rhythmic tread of the knights' strong horses and their heavy gallop. The artist's ability to depict the horses almost full face prompted Pächt to speak of an imitation of Italian models, such as drawings by Antonio Pisanello. Pächt suggests that the St Petersburg miniatures were an early work by the famous artist working for King René termed the Master of the Heart after his masterpiece, the illumination of *Cœur d'Amours Espris* (Vienna, Österreichische Nationalbibliothek, MS.2597). Durrieu identified this mysterious artist as Barthelemy d'Eyck, who served at René's court from 1447 to 1470, a hypothesis recently revived by Charles Sterling. If this is true, the tournament drawings might have been among the first works produced by Barthelemy d'Eyck for King René I. In this early series of illustrations the artist was working out the types of representations of horses and riders, of processions and cylindrical towers flanking the draw-bridges which he later employed in the illumination of the famous books about the tournaments held by King René. The manuscript belonged to King René; in the 17th century, it was in the library of Pierre Séguier; in 1735, it entered Saint-Germain-des-Prés with the collection of Séguier's grandson the Duke of Coislin; in the 18th century, it was purchased by Piotr Dubrovsky.

ENTERED THE PUBLIC LIBRARY IN 1805.

LITERATURE: M. Wilson de la Colombière, Le vray théâtre d'honneur et de chevalerie, *vol. 1, Paris, 1648, pp. 81–106; Montfaucon 1739, 2, p. 1108, No 749; Th. de Quatrebarbes*, Oeuvres complètes du Roi René d'Anjou, *vol. 1, vestiges de la Bibliothèque de René d'Anjou, 1844, pp. LXXV–LXXXIII; Bertrand 1874, p. 173; Shishmariov 1927, pp. 162–167; Laborde 1936–38, p. 71, pl. XXIX; O. Pächt, "René d'Anjou", Jahrbuch der Kunsthistorischen Sammlungen in Wien, 73 (N.F. 37), 1977, pp. 37, 38, 42, 64–66, ills. 73–75.*

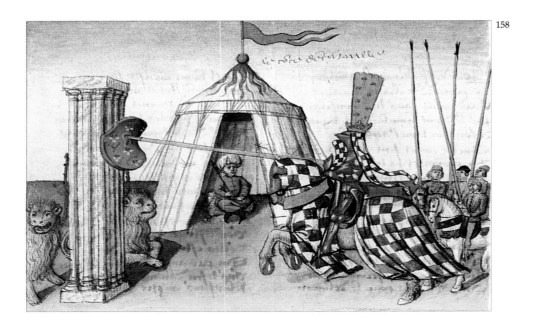

158

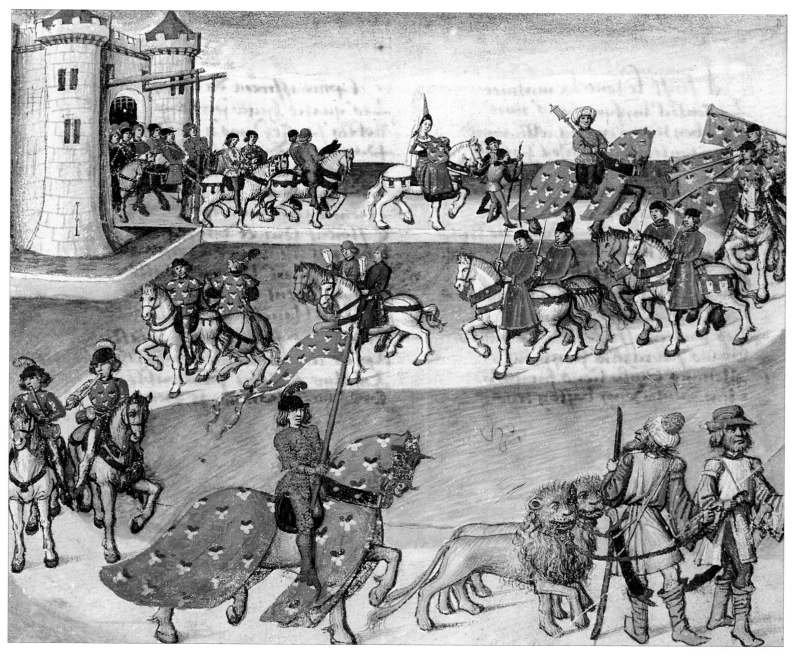

**158. F. 9r: THE COUNT OF TANCARVILLE
CHALLENGING THE DEFENDERS.**
One of the assaulting party hits the shield of the defending
party attached to a pillar and guarded by lions, signalling a
challenge. The herald sits in a tent nearby. The streamers
attached to the knight's helmet and the horse-cloth are painted
with black-and-white checks, the colours of the offenders.

**159. F. 6r: THE FESTIVE PROCESSION OF
THE DEFENDERS LEAVING THE CASTLE.**
The procession is headed by two figures wearing Oriental
costumes who are leading two lions depicted in conventional
heraldic fashion. Then follows a rider whose streamer and
horse-cloth are decorated with the colours of the defenders:
small violet and white pansy-like flowers on a red background.
The warriors and trumpeters are followed by a herald wearing
a turban and holding a baton, after which comes a white horse
being led by the bridle carrying the Lady to be "protected".
Last come the knights, leaving the castle in pairs and talking.

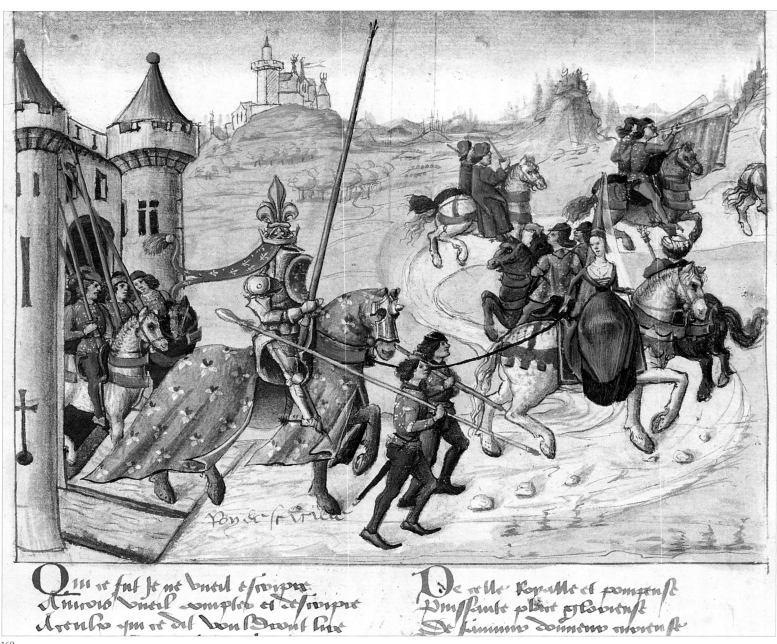

Qui ce fut je ne vueil escripre
Amours vueil comptes et descripre
Arentis qui ce dit von front lire

De celle royalle et pompeuse
Duissant plait gloricuse
De femmes dommene monteuse

160

160. F. 24r: KING RENÉ LEAVES FOR THE
JOUST WITH THE DUKE OF ALENÇON.
King René I, who participated in the tournament on the side
of the defenders, is being symbolically led by the Lady. The
background shows a meticulously detailed landscape.

161. F. 22v: JOUST BETWEEN COUNT
FERRY OF LORRAINE AND THE COUNT
OF EU FROM THE HOUSE OF VALOIS.
The wooden partition prevents the knights from clashing yet
allows them to reach each other with their lances. Count Ferry
of Lorraine is named the best defender and receives a gold
award decorated with diamonds and rubies.

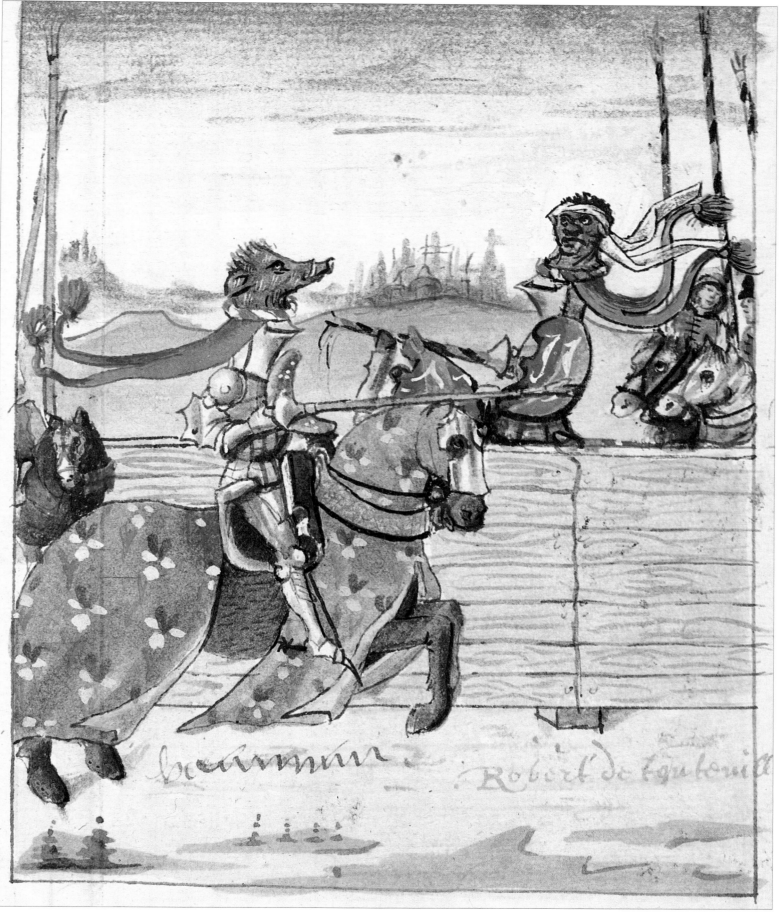

beaumont　　　　　　Robert de torbouill

162-171
MATTHAEUS PLATEARIUS. BOOK OF SIMPLE MEDICINE
Matthaeus Platearius. Le Livre des Simples Medecines
France. Mid-15th century

221 ff. 290 x 200 mm (text 205 x 140 mm). Parchment. French.
10 quarter-page miniatures; 420 illustrations in the text; 2 pages with multicoloured initials
(one, f.2r, with a vertical border, and the other, f.26r, with a full frame); numerous smaller gold,
blue and red initials. Binding: 17th century. Red morocco over cardboard; gold-tooled
ornamental border on the front and back covers; gold-tooled heraldic lions and fleurs-de-lis on
the spine; marbled paper fly-leaves. The inside of the back cover has a paper bookplate
with the ex libris of the Stroganovs. The manuscript is contained in a cardboard box covered
with the same gold-tooled red morocco as the binding.
Fr.F.v.VI.2.

The manuscript is a French translation of *Circa instans*, one of the most famous mediaeval books on medicine so named after the words beginning the prologue. Written in the 12th century by Matthaeus Platearius, a physician from Salerno, the text contains descriptions of the pharmaceutical properties of plants, minerals and extracts prepared from animal organs. The material is organized strictly alphabetically and is preceded by an index which classifies plants according to their medicinal effects. The pharmaceutical description of each plant is accompanied by a picture of it. There are also several miniatures showing the methods of extracting some of the most valuable components of medicines. In fact, this encyclopaedic type of illustration was uniform in all Western European scientific books. Italian masters contributed a great deal to the elaboration of this type of illumination, though in every case the manner of the artist remained individual. The style of the illuminator of the St Petersburg manuscript is free and unconstrained, and shows a preference for light cheerful colours. Both his narrative miniatures and the illustrations to the text are devoid of frames, unpainted parchment serving as the background. The figures are filled with life, their movements are natural and their faces are fine and delicate. The artist managed to render the soft petals of flowers, the velvety fur of animals and the transparent wings of insects with great economy of means.

The main text of the manuscript starts with the initial E, in which, according to François Avril, the coat of arms of Charles du Maine, a nephew of King René, is inscribed. An obvious conjecture is that the manuscript was commissioned by Charles du Maine and then, when he inherited King René's library, became part of it. It may be this manuscript which is listed in the inventory of 1471, where it is registered as *Liber dictus Herbolista, avec la reproduction peinte de différentes herbes*. Later the manuscript belonged to Charles VIII of France. The history of the manuscript in the 16th and 17th centuries is unknown.

ENTERED THE PUBLIC LIBRARY WITH THE COUNT STROGANOV COLLECTION IN 1889.

LITERATURE: A. Lecoy de la Marche, Le Roi René, sa vie, son administration, ses travaux artistiques et littéraires, *vol. 2, Paris, 1875, p. 188; Report of the Imperial Public Library for 1889, St Petersburg, 1891, pp. 12, 13; Avril : M. Platearius, Livre des simples médicines. French translation of Platearius' Liber de simplici medicina, ed. by P. Dorveaux), Paris, 1913; Laborde 1936–38, pp. 164, 165.*

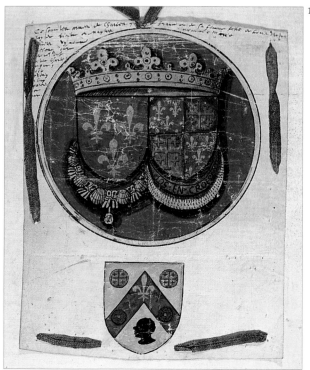

162

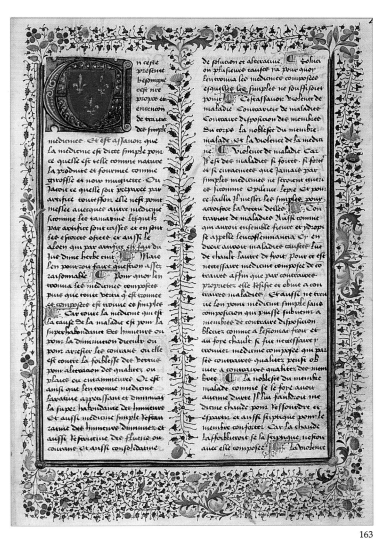

par la tandeur du fleuue ce boys
aloe est admene ⟨ les autres di
ent que ce copiaulx des hauttes m̄

162. F. 1r: COATS OF ARMS.
The first blank page of the manuscript has a piece of
parchment (170 x 130 mm) attached to it by a silk ribbon. A
royal crown surmounts two emblems: the royal coat of arms
with fleurs-de-lis and the sign of the Order of St Michael
on the left, and, on the right, the Order of the Crescent. This
combination indicates that the manuscript belonged to Charles
VIII of France. Below is an unidentified coat of arms, probably
of Pierre Morel, the physician and counsellor of Charles du
Maine, to whom he left the medical books from his library.

**163. F. 26: FIRST PAGE OF
THE PRINCIPAL TEXT OF PLATEARIUS,
WITH THE INITIAL "E".**
The light and elegant border with golden vine leaves, flowers,
berries and acanthus leaves is typical of French book
decorations in the mid or second half of the 15th century.
The arms of Charles du Maine are inscribed in the initial.

**164. F. 28r: EXTRACTION OF ALOE
(100 x 60 mm).**
The miniature illustrates a method of extracting aloe, which,
according to Platearius, was a tree growing in the "wood of
Babylonia". A grey-haired man uses a net to catch the branches
of this miraculous plant that are floating down a river.

165. F. 33v: EXTRACTION OF ANTIMONY.

et bne tante omtt de ceste confiture .
soit mise on partut de la fistule ⟨ en
pouldre mise sur chancre corrosif ou

espart attrait et mondefie Il est
deup mamere dorpigment Cest
affanour le rouge et le Jaune Et
et Jaune est mis en vsauge de medi
eine Contre empeschement de

166

lequel est tresbon pource que
fait est

Ici est chaut ou premier
liure et sur vn second le
miel est fait par lactefier de

167

fandius du fort si onst auer
lerte Raomes de fenoul et ache
et que len praingne aut opiate

Cis du cuer du serf est de
froide et seule complexion
len tienut ou auer du serf bien es

168

166. F. 43r: EXTRACTION OF
AURIPIGMENT (ORPIMENT, YELLOW
CRYSTALLINE MINERAL).

167. F. 149r: BEEHIVE.
This miniature exemplifies the artist's eye for such details as the
shadows of the bees on the hive.

167. F. 165r: DEER.
The deer is a favourite "character" in all mediaeval manus-
cripts, including those on the natural sciences. This is not just
because of the medicinal use of its horns, but also because of the
animal's noble beauty and its symbolic role in knightly cul-
ture. Though this type of a deer is repeated in many manus-
cripts, this particular example is one of the best representa-
tions, both for the delicacy of its painting and its impeccable
drawing.

169. F. 183v: ROSE.
The depiction of plants where the leaves, stalks, branches
and roots are shown flat on the surface of the page as if in a
herbarium is common to illustrations in mediaeval herbals.
The flower itself is executed in fine brushwork.

170. F. 192v: EXTRACTION OF SULPHUR.
The scenery looks like the crater of a volcano.

**171. F. 212v: OBTAINING TURPENTINE -
RESIN COLLECTES FROM TREES.**

172
MARTIN LE FRANC
ARGUMENT BETWEEN VIRTUE AND FORTUNE
L'Estrif de Vertu et de Fortune
France. Mid-15th century.
101 ff. 285 x 205 mm (text 195 x 135 mm). Parchment. French.
Frontispiece miniature framed with an ornamental border; 4 multicoloured initials touched
with gold and framed with a vine-stem border with golden leaves and flowers; numerous smaller
golden initials on blue or red backgrounds. Binding: red velvet over old wooden boards.
Traces of 5 metal knobs on each cover and of two clasps; banded spine; gilt-edged.
Fr.F.v.XV.6.

This didactic treatise in prose and verse was compiled in 1447 by Martin le Franc (1410–1461), a well-known French poet and rhetorician, provost of the Lausanne capitulary and secretary to Popes Felix V and Nicholas V. It was commissioned by Philip the Good, Duke of Burgundy, and has three books in which Virtue and Fortune each present their own advantages to Reason. The dispute is ultimately won by Virtue. A. Bayot, who studied the text of the manuscript, noted that the St Petersburg copy mentions Pope Nicholas V (died 24 March 1455) and thus dated it before 1456. Paul Durrieu attributed the frontispiece miniature to Jean Fouquet, an opinion which was later supported by Ph. Lauer, K.G. Perls, and others. Recently, however, Fouquet's authorship has been disputed. C. Schaefer, for example, placed the miniature between 1453 and 1456 and suggested the authorship of either Fouquet or his assistant, whom he termed the Boccaccio Master. The same doubts are shared by N. Reynaud. S. Lombardi, on the contrary, dates the miniature to 1456–59 and considers it to be one of Fouquet's masterpieces. It is true that the harmonious and reserved colour scheme of the frontispiece is different from the bright and intense colours in the *Hours of Etienne Chevalier* illuminated by Fouquet. Minute brushstrokes of light colours combined with very fine gold hatching create a remarkably radiant and airy atmosphere. Fouquet's style, however, also developed in exactly this direction. His decisive contribution to the miniature is proved not only by its author's virtuoso skill, but by a rare clarity of thought and compositional balance typical of the master. There are also a number of direct analogies with Fouquet's other works: for example, one can note a certain affinity between the figure of Virtue from the St Petersburg manuscript and the maid in the *Visitation* and *St Anne* (both from the *Hours of Etienne Chevalier*); there is a resemblance to f. 81 of the Vienna Boccaccio; and the shape of the armchair in the St Petersburg manuscript is identical to that in the Antwerp *Madonna*.

In the 17th century, the manuscript belonged to Pierre Séguier. From 1735 it was housed at Saint-Germain-des-Prés. Piotr Dubrovsky purchased it at the end of the 18th century.

ENTERED THE PUBLIC LIBRARY IN 1805 (1849–61 THE HERMITAGE, 5.3.53).

LITERATURE: Cat. Séguier 1686, Inv. des des miniatures, p. 12; Montfaucon 1739, 2, p. 1109, No 814; Gille 1860, p. 80; Bertrand 1874, p. 190; S. Reinach, "Un manuscrit de la bibliothèque de Philippe le Bon de la Bibliothèque à Saint-Pétersbourg", Monuments et Mémoires publiés par l'Académie des Inscriptions et Belles-Lettres, 11, Paris, 1904, le Monde de l'Art, p. 10; Nikolayev 1904, inset; P. Durrieu, "Le Manuscrit de l'Estrif de Vertu et de Fortune de Martin le Franc, avec des peintures de Jean Fouquet", in: Académie des Inscriptions et Belles-Lettres. Comptes-rendus des séances de l'année 1913, Paris, 1913, p. 268; Yaremich 1914, pp. 39, 40, ill. between pp. 38 and 39; A. Laborde, "De quelques manuscrits à peintures des Bibliothèques de Petrograd", in: Comptes-rendus des séances de l'Académie des Inscriptions et Belles-Lettres, Paris, 1917, p. 13; A. Blum, Ph. Lauer, La Miniature française au XVe et XVIe siècles, Paris, Brussels, 1930, p. 66, pl. XVII; Laborde 1936–38, pp. 88–90, pl. XL; K.G. Perls, Jean Fouquet, London, Paris, New York, 1940, pl. 267; C. Schaefer, Recherches sur l'iconologie et la stilistique de l'art de Jean Fouquet, vol. 2, Lille, 1972, pp. 305–307; S. Lombardi, Jean Fouquet, Florence, 1983, pp. 123, 124, fig. 124.

172. F. 1v: FRONTISPIECE.
Reason, the arbiter in the dispute, is seen as an elderly wise woman wearing a nun's habit, seated on a curule chair under a canopy in the centre of a perfectly balanced composition. On the right before her is Fortune, who wears a dress sparkling with all the colours of the rainbow, a symbol of inconstancy. At Fortune's feet is an owl, here a sign of death, and in the background is a cliff topped with sombre ruins, a hint of the sad destiny of those who give themselves up to the mercy of Fortune. Fortune holds the handle of her wheel with one hand and points at her rival with the other, as if threatening her with her baton. Virtue, wearing a tall headdress and a robe of noble colours, has a peacock, the symbol of eternity and revival, at her feet. Behind her is a beautiful castle crowning the cliff. Reason listens attentively to the rivals and indicates by the slight tilt of her head that she favours Virtue. This dispute over human destiny versus morality takes place in a beautiful, peaceful and serene landscape. The background in this miniature, as in many other of Fouquet's works, was inspired by the bright landscapes of the Loire valley.

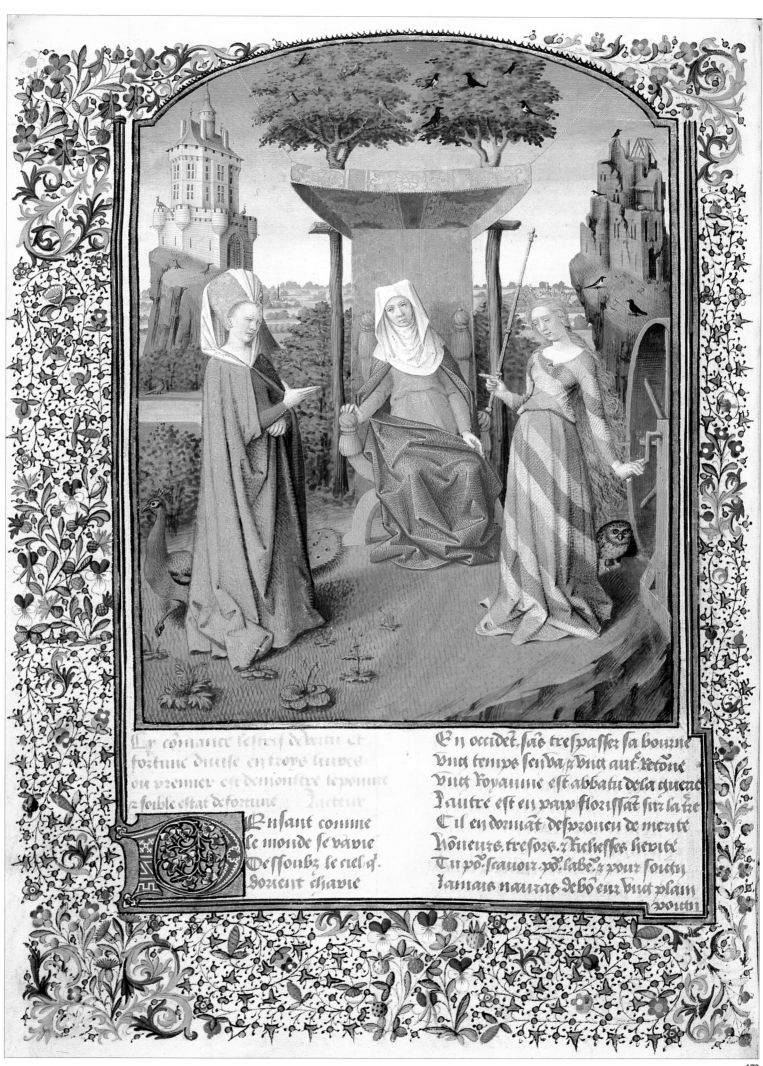

Ly commance lescript de vertu et
fortune divise en troys livres
ou premier est demonstre le povrre
z foible estat de fortune Lacteur

Enfant comme
le monde se varie
Dessoubz le ciel si.
doivent chavie

En occidet fais trespasser sa bourne
Vng temps sen va z vng aut retoue
Vng royaume est abbatu dela queac
Lautre est en paix florissat sur la tie
Cil en dormat desprouen de merite
Honeurs tresors z richesses herite
Tu po scauoir po labez z pour soustn
Iamais nauras debo eur vng plain
vo liii

173
GUIDO PARATI CREMENSIS (GUY PARAT).
THREE TREATISES ON THE PRESERVATION OF HEALTH
Trois Traitiez de la Conservation et Garde de la Santé
Burgundy. Mid-15th century (1450s)

132 ff. 225 x 170 mm (text 145 x 102 mm). Parchment. French.
1 miniature on f. 2v with richly ornamented borders; on f. 4v (beginning of the first treatise)
is an initial with Philip the Good's arms and an ornamental frame with his motto, heraldic
motifs and a monkey; the opening pages of the second and third treatises,
as well as of some of their sections, have a floral border on the right (sometimes also on the left);
golden initials with tendrils on a red or blue background at the beginning of each chapter.
Binding: 15th century. Green patterned brocade over brown leather;
a restored spine of brown leather with gold tooling between five bands;
fly-leaves of white parchment; gilt-edged.
Fr.Q.v.VI.1.

The manuscript is a French translation (done in 1448) of three Latin treatises by Guido Parat Cremensis, an Italian humanist and professor of medicine at the University of Pavia who served at the court of the Duke of Milan. Since the manuscript was to be a gift to Philip the Good, Duke of Burgundy, its illumination must have been entrusted to an artist of high standing. The composition of this miniature and particularly the treatment of the image of "the Great Duke of the West" show an affinity to the well-known miniature ascribed to Rogier van der Weyden (Brussels, Bibliothèque Royale, MS.9241, f. 1) which depicts Jean Wauquelin, head of the Mons atelier in the 1440s–1450s and translator of the Chroniques du Hainaut, presenting his work to Philip the Good. The refined drawing, delicate harmony of reserved tones, elegant silhouettes and somewhat mannered postures of the figures, and the artist's ability to endow his characters with marked individuality all indicate that this is a good example of the aristocratic art that flourished at the Burgundian court. The device of "breaking through" to the outer world or disconnecting the space of the miniature, which was elaborated with great detail by Netherlandish masters in the 15th century, is of particular interest. The viewer's eye travels through a large hall to a stained-glass window and sees a landscape and a lady and gentleman conversing.

These motifs bring to mind some interiors depicted on the altar wings with scenes from the life of St Bertin from the Abbey of Saint-Omer (now in Berlin, Staatliche Museen). The altar was painted in 1459 by Simon Marmion.

Laborde and Durrieu attributed the miniatures to Jean Hennecart from Lille, but it is now thought that the author was Simon Marmion.

The manuscript was part of the library of the Dukes of Burgundy and retained its original binding described in the old inventories as "*Livre couvert de drap damas vert*". The history of the manuscript in the 16th and 17th centuries is unknown. In the 18th century, it belonged to the Counts Zaluski.

ENTERED THE PUBLIC LIBRARY IN 1795 (THE HERMITAGE, 5.2.51).

LITERATURE: Barrois 1830, pp. 294, 2069; Gille 1860, p. 79; Bertrand 1874, p. 163; Nikolayev 1904, inset; Yaremich 1914, p. 40; Laborde 1936–38, pp. 99–101, pl. XLIII; La Librairie de Philippe le Bon (catalogue compiled by G. Dogaer et M. Debae), Brussels, 1967, p. 89; O. Pächt, U. Jenni, D. Thoss, Die illuminierten Handschriften und J. Inkunabeln der Österreichischen Nationalbibliothek, vol. 6: Flämische Schule I, Vienna, 1983, pp. 31, 32, fig. 28. Vorona, 1984 ; Avril, Reynaud, p. 87, n° 38.

173. F. 2 : PHILIP THE GOOD, DUKE OF BURGUNDY, BEING PRESENTED WITH THE MANUSCRIPT.

The Duke's motto, Aultre n'auray, and his coat of arms decorated with a chain of the Order of the Golden Fleece are inscribed in the border at the top. A bear, another emblem of the House of Burgundy, stands out among the birds and animals scattered among the flowers, acanthus leaves and vine-stems of the border. The catalogue of the Nationalbibliothek in Vienna compares this splendid border with the illumination of MS.2583 (dated after 1453), yet the style of the miniatures from Vienna painted by the Maître des Privilèges is different from Marmion's. The authors of the catalogue suggest that the borders of these two manuscripts were done by the same artist (enlumineur), while the miniatures belong to different masters (historieurs). Below the miniature is the text of Parat's dedication to the Duke of Burgundy. A character decorated with the Chain of the Golden Fleece is shown next to Philip the Good. The manuscript being presented to the Duke has the same green binding as that retained by the present manuscript. Below the miniature is the following dedication : A tres hault tres noble et tre excellent prince monsr le duc de Bourgogne Guy Parat chevalier et phisicien de monsr le duc de Milan. The features of the Duc de Bourgogne and the translator (Jean Wauquelin ?) are faithfully reproduced, whereas the other characters are generalized, and therefore impossible to identify.

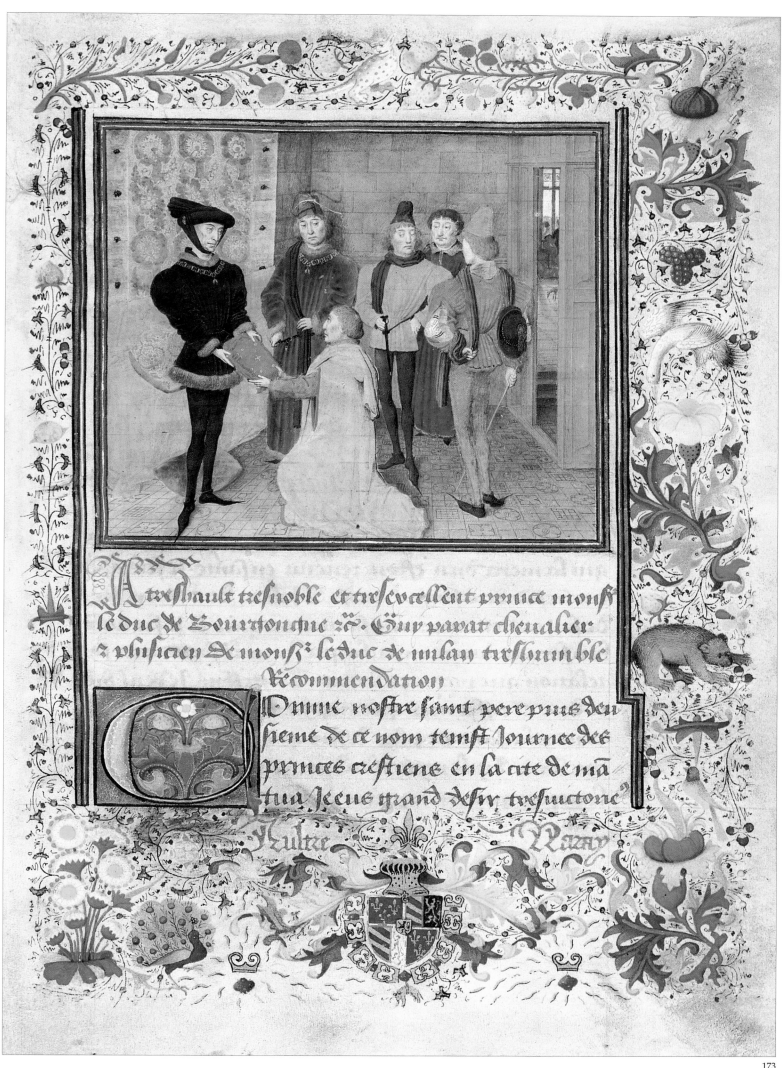

A tr̃shault tr̃snoble et tr̃seuellent prince mõns
le duc ꝛ Bourtonenc ꝛc. Guy parat cheualier
z plusicien ꝛe mõns le duc ꝛe inlan tr̃shumble
Recõmendation

Õnune noſtre ſaint pere pius deu
fiene ꝛe ce nom tenſt Iournee ꝛes
prmces crestiene en la cite ꝛe mã
tua ſe eus grand ꝛesir tr̃ ſuctone

Multce Nazay

173

174-189
LES GRANDES CHRONIQUES
DE FRANCE
Burgundy (Saint-Bertin). Mid-15th century.

441 ff. 465 x 325 mm (text 325 x 230 mm). Parchment. French.
25 miniatures (215 x 258 mm), 65 miniatures (from 65 to 110 x 165 mm,
as well as 100 x 140 mm and 105 x 120 or 110 mm); the borders framing
the main multicoloured miniatures are decorated with thin curved branches with golden leaves
and stylized flowers, as well as with thistle blossoms entwined in the ornamentation;
the borders framing other pages with miniatures are more modest and copy the pattern typical
of the workshop; multicoloured initials correspond to the illumination of the whole text.
Binding: 20th century. Black velvet over cardboard.
Erm.fr.88.

The manuscript contains the history of France from ancient times up to the 14th century. The text does not completely coincide with the official version of *Les Grandes Chroniques de France* compiled in the monastery of St Denis near Paris. While following the official version up to the year 1226, the manuscript's compiler, when describing the period from 1226 to 1327, adhered to the *Chronicon* by Guillaume de Nangis, a monk of the monastery. The final part of the manuscript is based on the Flemish *Chronicles* written in the monastery of St Bertin at St Omer. The structure of this final part was determined by the political views of the man who commissioned it, Abbot Guillaume Fillastre, who was guided by Burgundian interests and was trying to substantiate the claim of Philip the Good, "the Great Duke of the West", to the French throne.

The "pro-Burgundian" bias, as G. Chernova has shown in her study, is characteristic not just of the text, but also of the illustrations. The illumination of this splendid manuscript is dominated by 14 multicoloured miniatures that are remarkable for their skilful drawing, harmonious coloration and unsurpassed narrative quality. Other miniatures are executed in a manner close to grisaille. Salomon Reinach, who saw the manuscript in 1901, identified the main master with the major Burgundian miniaturist Simon Marmion, who came from Picardy

(1420–1489). At the beginning of the century the lack of information about the artist caused doubt concerning Marmion's authorship (Paul Durrieu, for example, thought that Philip de Mazerolles was the main author). However, now that the knowledge of 15th-century art has increased greatly, it cannot be disputed that the St Petersburg manuscript is Marmion's masterpiece, created at the peak of his career.

Written at the monastery of St Bertin during Guillaume Fillastre's abbotship and intended for Philip the Good, the manuscript became part of the Duke's collection. In the second half of the 16th century and in the following century, it was mentioned in all the extant inventories of the collection which the Burgundian dukes kept in Brussels. The manuscript disappeared in the mid-18th century during the Seven Years' War. It was stolen by Courchetel d'Esnaus, then commissar of the French government, in 1748. Later, in order to sell the manuscript, his heirs changed the binding and removed the first and last pages on which there were notes indicating that the manuscript had come from the Burgundian collection. In 1807, the manuscript was purchased by the French book dealer de Bure, from whom it was bought by Count F. Pototsky; in 1838, the latter sold it to Nicholas I and it became part of the Hermitage collection (4.2.13).

ENTERED THE PUBLIC LIBRARY IN 1861.

LITERATURE: Barrois 1830, p. 234, No 1638; S. Reinach, "Un manuscrit de la bibliothèque de Philippe le Bon de la Bibliothèque à Saint-Pétersbourg", Gazette des Beaux-Arts, 29, 1903, pp. 265–279; Idem., Paris, 1904, 79 pp., 41 tabls; le Monde de l'Art Nikolayev 1904, pp. 101, 102, 110; A Bayot, "Sur l'exemplaire des Grandes Chroniques offert par Guillaume Fillastre à Philippe le Bon", Mélanges Godefroid Kurth, 2, Liège, Paris, 1908, pp. 183–190; Yaremich 1914, p. 41; G.A. Chernova, Miniatiury Bolshykh Frantsuzskikh khronik, Moscow, 1960; E. Warren Hoffman, "The Simon Marmion Reconsidered", Scriptorium, 23, 1969, No 2, pp. 243–272, pls. 83, 84a, b; E. Warren Hoffman, "Simon Marmion or The Master of the Altarpiece of Saint-Bertin", Scriptorium, 27, 1973, pp. 263–290; Durricer, la miniature flamande au temps de la cour de Bourgogne, 1921, p. 62 T.P. Voronova, Les Grandes Chroniques de France. Enluminures du XVe siècle, Leningrad, 1980. Dogaer, Flemish miniature paintig in the 15th and 16th century, Amsterdam, 1987, p. 51, 53, 55, 185, fig. 24 and 26 ; Avril, Reynaud, pp. 82 - 84, notice 36.

174. F. 1r: PHILIP THE GOOD, DUKE OF BURGUNDY, RECEIVING THE MANUSCRIPT FROM ABBOT GUILLAUME FILLASTRE ON 1 JANUARY 1457.
Chancellor Rolin is on Philip's left, and the Count of Charolais (the future Charles the Bold, Duke of Burgundy), Jean Chevrot, Bishop of Tournai, and Antoine of Burgundy are on his right. This miniature shows that Marmion was an outstanding portraitist able to render emotional states as well as individual features.

Page 146
175. F. 36v: THE DIVISION IN 561 OF THE FRANKISH KINGDOM OF THE MEROVINGIANS BETWEEN THE FOUR SONS OF CLOVIS.
The scene on the left shows the sons holding a council and the expulsion of Chilperic from Paris. In the centre St Germanus accuses Chilperic of treachery. The upper right depicts Crocus, King of the Huns, crossing the bridge at Mainz and his destruction of Metz. At the bottom is an episode from the legend of the vision of Gontran, King of Burgundy and Orleans.

Page 147
176. F. 120v: THE CORONATION OF CHARLEMAGNE.
On the right Charlemagne is crowned Emperor in St Peter's in Rome, in the year 800. At the bottom left Charlemagne receives gifts from Aaron, King of Persia, and the Saracen Emir Abraham. In the upper left : the troops of Charlemagne's son Pepin lay siege to Venice.

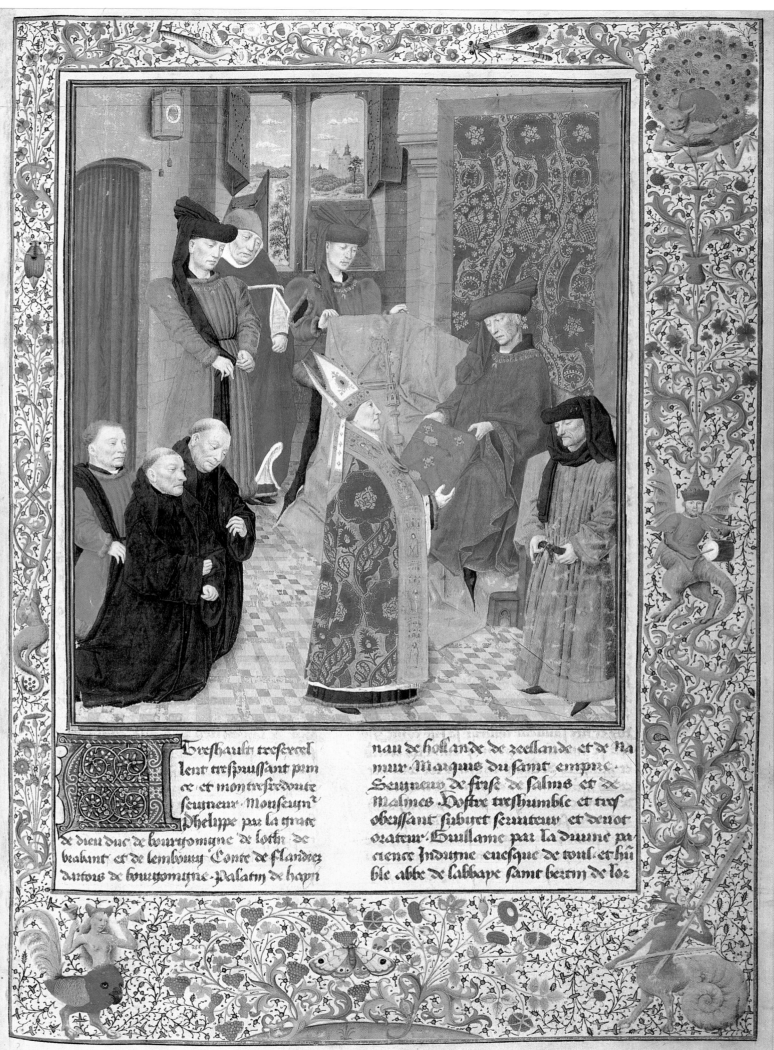

Treshault: treserel
lent: trespuissant prin
ce: et mon tresredoute
seigneur: Monseigneur
Phelippe: par la grace
de dieu duc de bourgoingne: de loth: de
brabant: et de lembourg: Conte de flandres:
dartois: de bourgoingne: Palatin de hay-

nau: de hollande: de zeellande: et de Na
mur: Marquis du saint empire:
Seigneur de frise: de salms: et de
Malines: Vostre treshumble: et tres
obeissant subiet: serviteur: et devot
orateur: Guillame: par la divine pa-
cience: Indigne: euesque de toul: et hu-
ble abbe de labbaye: saint bertin de loz

174

norablement mis en sepulture en
labie s. maart si come il auoit p
auant deuise · Il y auoit · xxv · milez
de la ou il trespassa · iusques la il fu
portes · Ses · iiii · fieur estoient pnt
qui moult honorablement le fixent
porter toute la voie · a grans pressi
ons de gens de religion · qui lame
recomandexent a mess · et faisoient

le seruice et office diuin selone ce
que a noblece de roy doit apptenir
Ceste hystoire demoustre et enseigne co
ment les · iiii · filz clotaire partirent le
royalme · et boutexent hors de paris chil
pic leur frere qui lor auoit kaue ·
Item coment kocus passa le pont de maience
et destruist la cite et celle de mes · Item
du castoy que fist s. germain au roy cildebt
De la vision le roy trouva en dormat a la cache

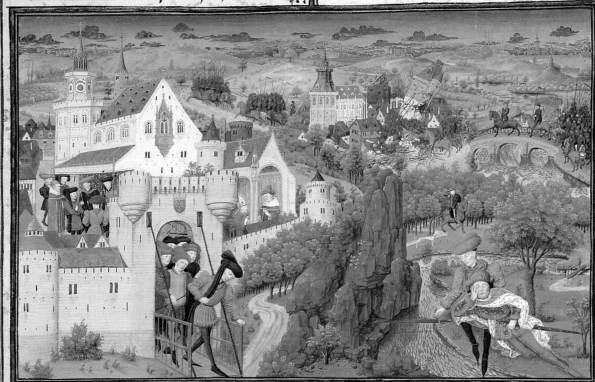

pez le mort le roy
clotaire · fu li roia
me; departis as
iiii · fieres · mais
chilpis qui plus
sages et plus malicieus estoit que
nuls des aultres a qui ne souffisoit
pas tel partie que il deuoit auoir
par droit sort · alla a paris saisir
les tresors son pere au plus tost
qui pot · Les poissans franchois ma
da · et acquist lor amour par dons
et par promesses · en tel maniexe
se mist en possession du roialme ·

mais les aultres fixres qui pas ne
sacordexent a ce · sassemblexent et
entrexent en la cite soudainement
que chilz nen scent mot qui estoit
despourueus contre lor venue · hors le
boutexent · puis lui mandexent que
sil se voloit assantir que tout le roi
alme qui fu leur pere · fust partiz en
iiii · parties eguaus · il; le rapeleroi
ent · Rapeles fu donques en tel ma
nexe · Lors partirent le roialme en
iiii · Childebers qui aisnes estoit · ot
le roialme de paris · qui ot este son
onde childebert · troutans ot le roi

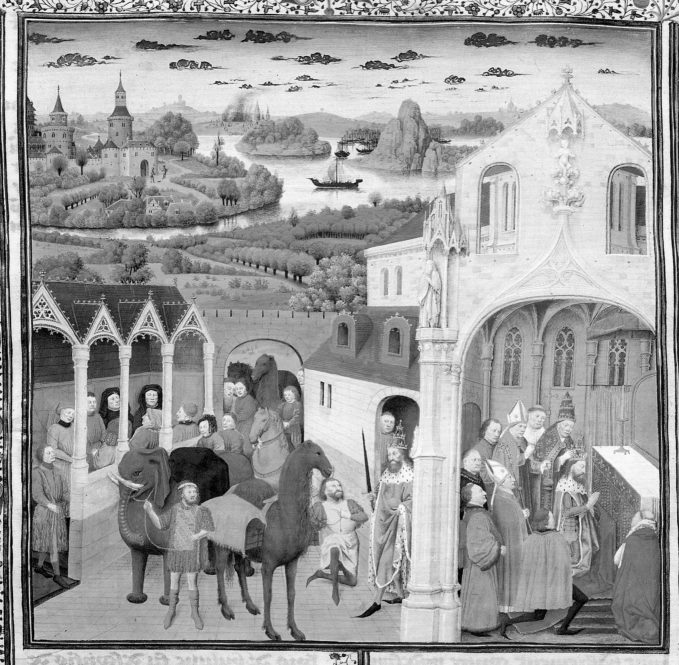

E lour de la
natiuite entra
li rois en leeli
se saint piere
droit en ce poit
que on deburoit celebrer la grant
messe ainsi comme il se fu encli
nez deuant lautel li apostoles le
ons li assist la corone impial
sour le chef Lors commanca li
peuples a cryer en tel maniere
au grant charlemaine auguste

corone de dieu paisible empeor
des romains soit vie et victoire
apres les loenges de peuple li papes
le corona et vesti des garnimens
impiaus selonc la coustume des
anciens princes et fu apeles dilluec
en auant emperes auguftes Pou
de iours fu apres que il manda q
ceulx qui lapostole leon auoient
depose fussent deuant lui amenez
et puis furent iugies selonc les
lois de romme des ciefs pdre

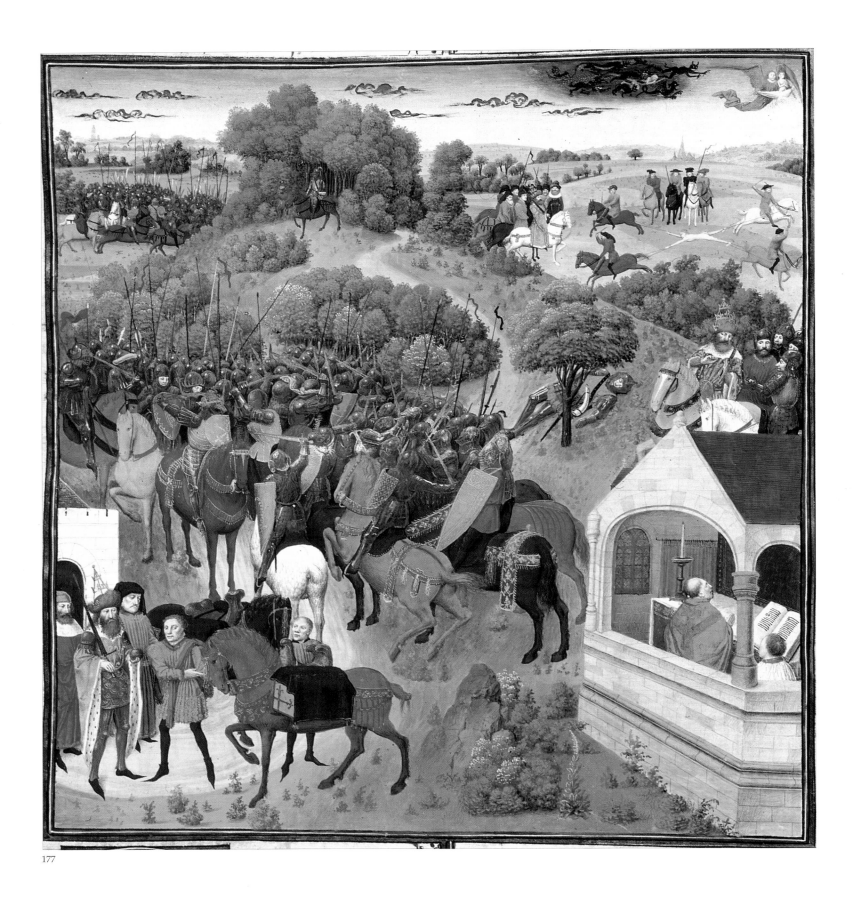

177

177. F. 154v: THE STORY OF ROLAND.

At the bottom left Charlemagne receives gifts from the Saracen
Kings Marsile and Baligant brought by the traitor Ganelon. In
the centre is the battle of Roncesvalles (Roncevaux). The upper
left shows the duel between Roland and Marsile; under the tree
on the right Roland lies wounded with a horn at his waist;
further to the right Ganelon dissuades Charlemagne from
hurrying to Roland's assistance. Below, and at the top right and
left is the vision of Turpin (Tilpinus), archbishop of Rheims:
the Archangel Michael carries away Roland's soul, while devils
drag the souls of Saracens into Hell. Beneath is the scene of
Ganelon being drawn and quartered.

178. F. 39r: THE STORY OF CHILPERIC.

The left part of the miniature depicts the story of Chilperic
marrying Galeswintha, a daughter of the King of Visigoths, and
then, at the instigation of his mistress Fredegund, strangling her.
At the bottom right we see the relations between Chilperic and
his second wife Audovère, falsely accused by the treacherous
Fredegund, who became queen as a result. The scene in the
upper right shows the siege of Tournai by Chilperic's brother
King Sigebert, and the assassination of Sigebert by men sent by
Fredegund.

les huns baptisier · et cōment il haioit
le roy youtran

E vbiȷ· Cōment les ·ij· rois murēt
tuewe contre le tiers et cōment ilȝ fi
rent paix

E rbiȷ· cōment firedewonde fist
iustice des sorcieres · et cōment li kois
chilpis emoia sa fille en espaingne

E rir· cōmeut firedewonde nust lui
et son filȝ en le garde le roy youtran

E rr· cōment firedewonde fist oci
re le roy chilpic son seigneur

E rriȷ· cōment grodoalȝ fu nes et
cōment il fu fais rois

E rrij· cōment li kois youtrans
traita bilainement les messages le
roy childebert son neueu

E rriiȷ· cōment pretertes fu rape
leȝ dexil · et cōment firedewonde cuida
faire ocime brunehaut

E rriiiȷ· comment li kois youtrans
fist ocime obenulphe eue en latre
saint martin de tours

E rrbȷ· comment grodoalȝ tra
nust ses messages au roy youtran
et comment il saisist vne partie
du koialme ·

Cōment li rois sigebers fu ocis en son tref p̄sid

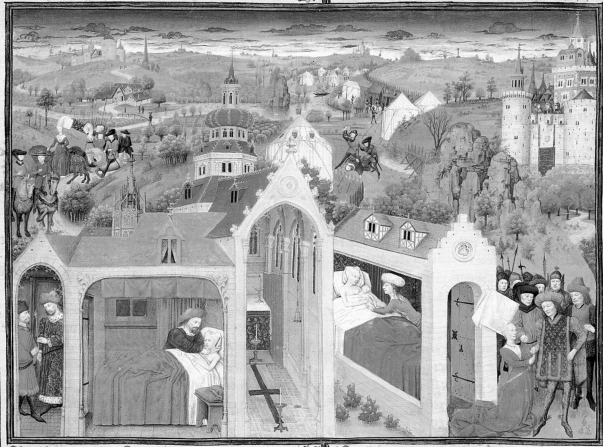

Cōment le roy chilpic mādi tarlfode en espaigne et

hilpeus li kois de
soissons estoit si ha
bandonneȝ a luruxe
que tout adies me
noit il graus tour

cōment il lestrula · et cōment il laissā la vij· p̄ fredri
bes de femmes aucuns lui contre
lonnestete de son estat · plus le ser
noient pour se biaute · que elles ne
faisoient pour se noblece · ne pour
talens · volaute lui prist de faire

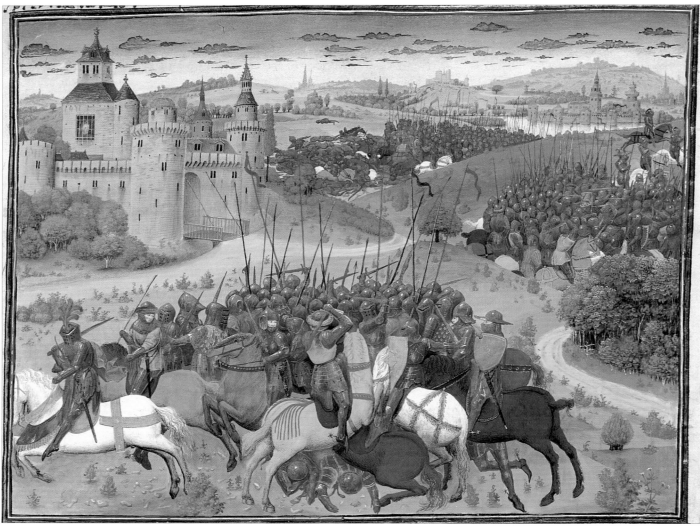

179

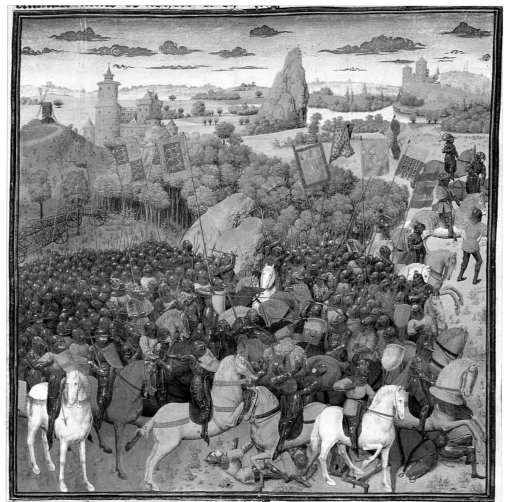

179. F. 102r: HOW CHARLES MARTEL ESCAPED FROM HIS STEPMOTHER'S PRISON AND BECAME THE KING OF TWO REALMS.
The miniature shows three battles as a result of which Charles Martel conquered Alemannia, Swabia and Bavaria. In the upper left he is depicted imprisoned in Cologne.

180. F. 422r: THE BATTLE OF CRECY.
In 1346, at Crecy the English army, led by Edward III, achieved complete victory over the French. At the bottom in the centre is the fallen Duke of Alençon; above is the King of Bohemia, Jean de Luxembourg, a French ally, battling with a two-handed sword. On the right the defeated Philip VI escapes to Amiens.

181. F. 373r: THE UPRISING OF THE COUNTS OF FLANDERS.
In the upper right, on top of the hill, are the fortifications of Cassel. The famous "Battle of the Golden Spurs" at the walls of Courtrai in 1302, where the French knights were completely defeated by the burghers of the town, is the main subject. Robert d'Artois, the French leader, is shown falling from his horse in the centre.

180

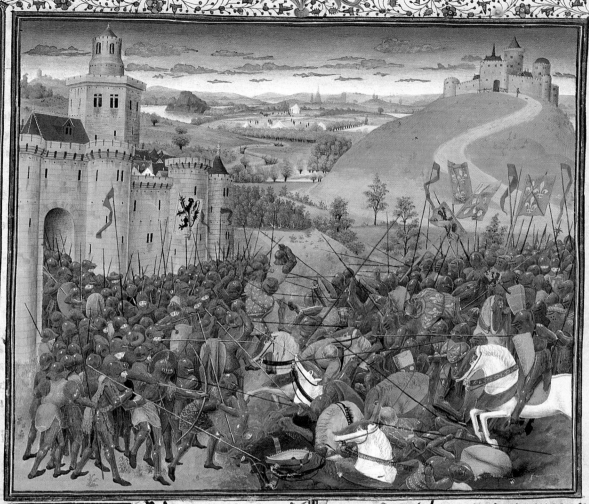

ke lous dirons de
ceulr de brumes q
pur droit auoient
fourfait corps et
auoir et pensoi
ent bien que la aisse ne pooit mie
ensi demourer si enuoierent querir
tuillame de sulers et lui requisent
que pour dieu il venist vers eulx et
empresist la guerre a la deliurance
du comte truy son oncle qui en puson
estoit et lui offrirent or et artect
a truant foison Tantost tuillame;
ot conseil si y vint a tout lesfort
quil y pooit auoir Apres mande
rent le comte iehan de namur et
monsitneur truy et monsitneur
henry son fixre les quelz tantost

emprendirent la guerre auecques
eulz Puis assambla truillame de
sulers son ost et prinst auec lui
vne partie de ceulx de brures et
sen vint a diesmue a ypre et puis
a furnes les quelz se rendirent to
a lui puis se trinst vers berithes
a tentes et a pauillons et quant
monsitneur wale par ele leutendi
qui de par le comte dartois y estoit
et sceut quil auoit ia enuoiet a
lencontre pour eulx rendre si fist
armer ses tiens et se parti de la
ville et sen vint a cassel Illuecquez
trouua le castel tout vuit et y fist
entrer de par le roy monsitnt iehan
de haueskerke et monsitneur tril
lon son fixre et puis le fist garnir

Cōment par ꝛeuelation diuine demoustree
a vng ꝛeligieur deuot et digne · et a vng
clerc sages et soubtis que le corps du ꝛoy
charle le chauf fust nportes et mus · en le

ecluse monsigneur saint denis de france
Item coment lespit audit ꝛoy charle le chauf
issy de son corps auant son trespas · et par vng
espit fu menes es tormens de purgatoure ·

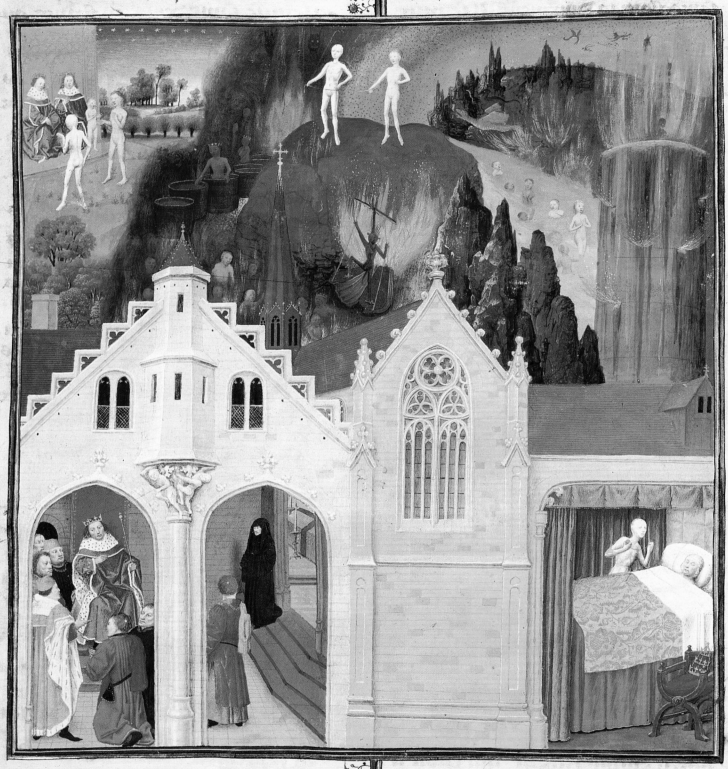

In endroit vo
lons ꝛetraire
lauision que
nous auons
promise · vu
ans apres er

que le corps charle le chauf ot
veu a vermaus en leuuse saint
eusebe le martir aparut par la
voulente nresingneur a vnit
moisne de saint denis en france
qui par nuit nardoit leuuse aus

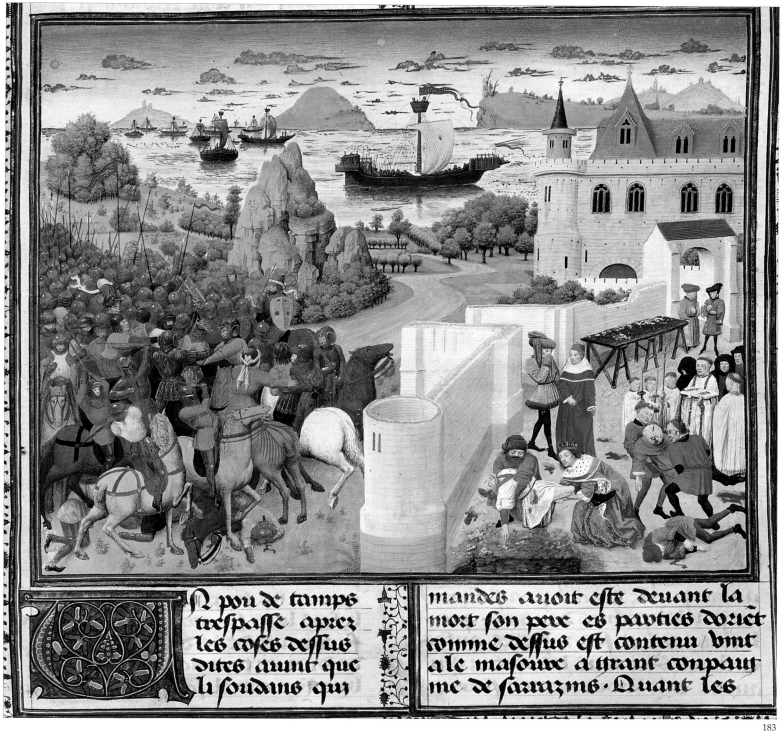

NOU pou de tamps
trespasse aprez
les cofes deffus
dites auint que
li soudans qui

mandes auoit efte deuant la
mort fon pere es parties doriet
comme deffus eft contenu vint
ale mafoure a tirant conpaui
me de farrazins · Quant les

183

182. F. 208v: THE DREAM OF CHARLES
THE BALD.
The King is depicted in the bottom right corner travelling in
the other world with some mysterious creature. At the bottom
left King Louis II the Stammerer listens to the story of the
apparition of the ghost of Charles the Bald, which ordered that
his remains be transferred to the monastery of St Denis.

183. F. 338r: LOUIS IX, KNOWN AS SAINT
LOUIS, DURING THE SEVENTH CRUSADE
OF 1248–54.
At the top Louis IX's ships sail down the Nile. On the left is a
battle with Saracens. To the right the King himself buries dead
warriors, massacred by the Saracens while trying to defend
Acre, Sidon and Jaffa.

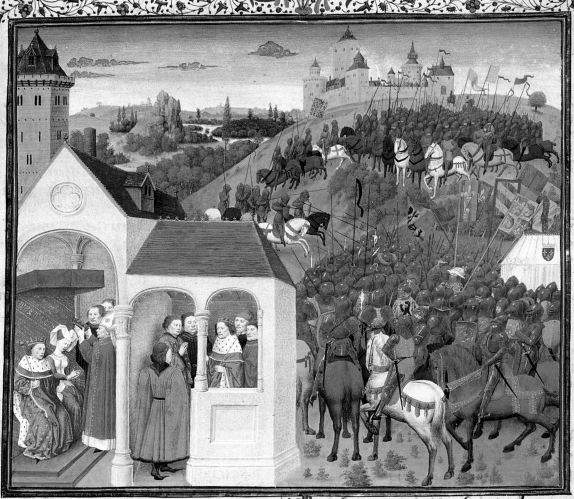

Comment phelippes de valois fu
couronnes a Roy de france · et com
ment a le requeste du conte loys
li Rois mist le pais de fland en sbras

A l'an de grace
en EEE xxviii.
que li Roialmes
de france estoit
aussi comme vanches · et que les ba
rons n'estoient pas d'acort de faire
Roy · mais toutesfoies par le pour
cach de monsseigneur Robert d'artois
fu la cose tant demenee que monss̄
phes qui fu fieulx monsseigneur charle
de france et quens de valois fu es
leus a Roy de france · mais en ce
tamps s'estoient les flamens nouue
lement reueles contre leur conte

et l'auoient cachiet hors de la terre
de flandres · non contrestant la paix
qui fu faite a arkes · Maintenant
fist li Rois adiourner tous ses ba
rons quil fussent a son couronne
ment a Rains · Le iour de la trini
te fu sacres aueuc la Roine sa fe
me · la quelle estoit seruur au duc
de bourbourgne · Illueaques fu fais
cheualiers le comte loys de flandres
et illuec requist au Roy que pour
dieu il vausist auoir pitie de lui
car ses tiens lui estoient si Rebelles
quil ne le voloient obeir · Tantost
fist mander ses barons qui la estoi
ent et lor Requist que p la foy
que ilz leur lui deuoient que tous
fussent en armes as octibres de

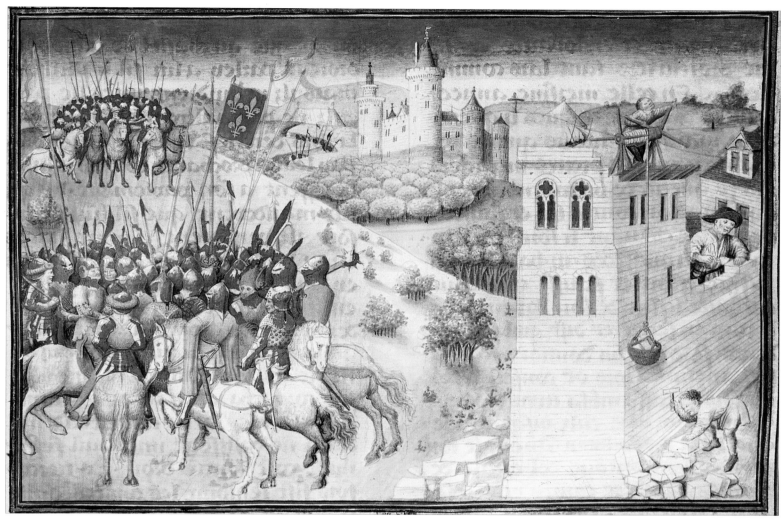

**184. F. 398r: THE CORONATION
OF PHILIP VI.**
On the left in the foreground is the coronation of Philip VI and
his wife, the sister of the Duke of Burgundy, at Rheims in
1328. The battle depicted is that of Cassel in which the
Flemings were defeated by the French.

**185. BEGINNING OF THE REIGN
OF LOUIS IX. F° 322**
This miniature was executed by one of Marmion's assistants.
On the left, the meeting of the King's army with rebel
detachements of the counts of Marche, Brittany and Champagne.
In the centre, Louis lays siège to the castle of Bellême;
on the right, the building of the Royaumont abbey, founded
by the King.

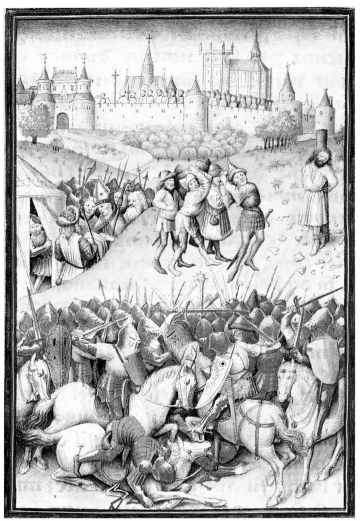

186

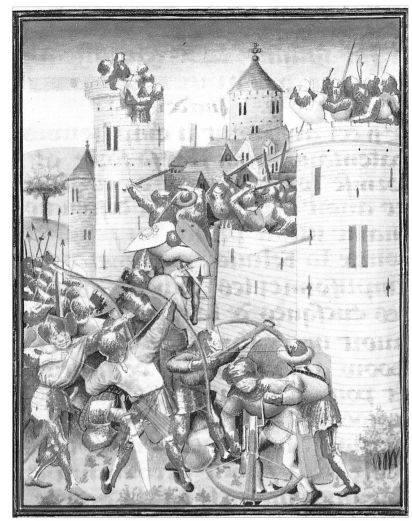

187

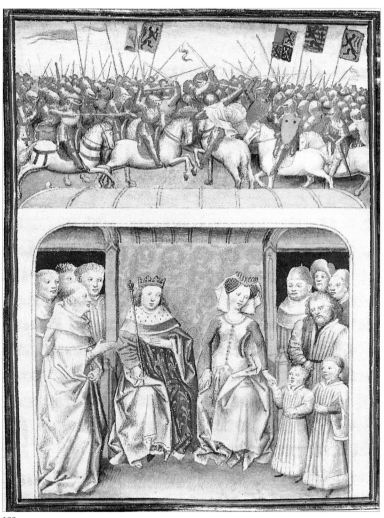

188

186. F. 29v: ON HOW KINGS CHILDEBERT AND LOTHAIR BESIEGED SARAGOSSA, HOW VELISERIUS, THE ROMAN PRINCE, WAS KILLED BY THE FRANKS, AND HOW PARTHEMIE WAS STONED.

187. F. 301r: HOW KING PHILIP II OF FRANCE DESTROYED THE AUBEMALLE CASTLE AND DROVE OUT KING RICHARD I OF ENGLAND WHO HAD SUDDENLY ATTACKED HIS ARMY.

188. F. 361r: PHILIP, SON OF LOUIS IX, IS CROWNED AT RHEIMS.
At the top the Dukes of Brabant and Luxembourg are battling for Limbourg.

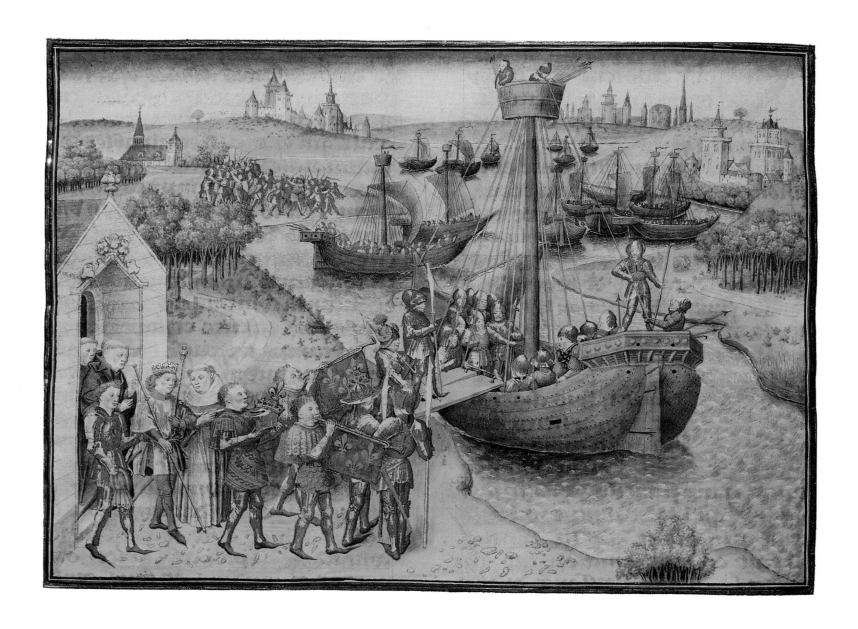

189. F. 354v: DEPARTURE OF LOUIS XI ON HIS 8TH CRUSADE IN THE YEAR 1270.
Below left, solemn exit of Louis XI from the church, accompanied by priests and the archbishop. Right, vessels ready to leave for Tunis.

190, 191
GERVAIS DU BUS. FAUVEL
Le Roman de Fauvel
France. Mid-15th century
51 ff. 230 x 160 mm (text 165 x 60 mm). Parchment. French.
2 half-page framed miniatures with a border carrying the motto va, Hativité m'a brulé.
At the end of the text is the signature — Demanne — considered by Gille to be that of the scribe.
Binding: 17th century. Violet velvet over cardboard.
Fr.O.v.XVI.1.

Le *Roman de Fauvel* is a satirical and didactic poem in two parts written in the early 18th century by Gervais Du Bus, a cleric from Normandy and a royal notary under Philip IV the Fair. The author chastises the morals of the clergy and contemporary society represented by the Pope, the monastic orders and the royal government. Fauvel, an imaginary creature, personifies mendacity, vanity and earthly bustle, his name being an acronym of human vices: Flattery, Avarice, Vileness, Inconsistency, Envy, Meanness. The style of the miniatures and the characters' costumes suggest a date in the mid-15th century. Laborde linked the miniatures with the hand of Jean Fouquet or Maître François. The artist's style, however, does not give sufficient grounds to ascribe the illumination to the great master from Tours, although the broad generalized treatment of landscape, the compact groups of characters and certain facial types indicate that the manuscript was produced in the Loire valley where illumination developed under the strong influence of Fouquet.

The illumination of this manuscript has recently been connected with the so-called "group of the Master of Jouvenel des Ursins", i.e., with a mid-15th-century style widespread in the workshops of Tours, Nantes, Angers and Saumur. In the opinion of J. Plummer the centre most likely to have produced *Le Roman de Fauvel* and some other very similar manuscripts was Angers.

Laborde managed to decipher the anagram contained in the motto and determined that in the 15th century the manuscript belonged to Mathieu Beauvarlet, a retainer of Louis XI. The manuscript, according to Laborde, was housed at Saint-Germain-des-Prés, though there is no record of this in the book itself. Dubrovsky purchased the manuscript at the end of the 18th century.

ENTERED THE PUBLIC LIBRARY IN 1805 (1849–61 THE HERMITAGE, 5.2.101).

LITERATURE: Montfaucon 1739, 2, p. 1109, No 811; Gille 1860, p. 79; Bertrand 1874, p. 184; Yaremich 1914, p. 40, ill. between pp. 38 and 39; Le Roman de Fauvel de Gervais du Bus, publié d'après tous les manuscrits connus par A. Längfors, Paris, 1914–19; Laborde 1936–38, pp. 104–106, pls XLII, XLV; J. Plummer (with the ass. of Gr. Clark), The Last Flowering: French Painting in Manuscripts (1420–1530) from American Collections, New York, London, 1982, p. 33.

190

190. F. 1r: MINIATURE TO PART ONE.
The miniature shows representatives of different social strata, from peasants to townsmen, monks and priests to high officials, bishops and cardinals, including the king and the Pope. All of them are diligently cleaning, combing and wiping Fauvel, depicted as a rust-coloured (fauve, another pun) horse that symbolizes vanity. Armfuls of hay are being brought for Fauvel through an open door. In the margin, besides the ribbons bearing the motto, there is a monkey, also a symbol of vice.

191. F. 20r: MINIATURE TO PART TWO.
The second part of the manuscript narrates Fauvel's unsuccessful attempt to marry Fortune. Fortune is on the left with her usual attribute, a wheel. She is surrounded by ladies who symbolize the bustle of society. On the right Fauvel's procession is setting off to meet Fortune. A landscape with a river and a city makes up the background.

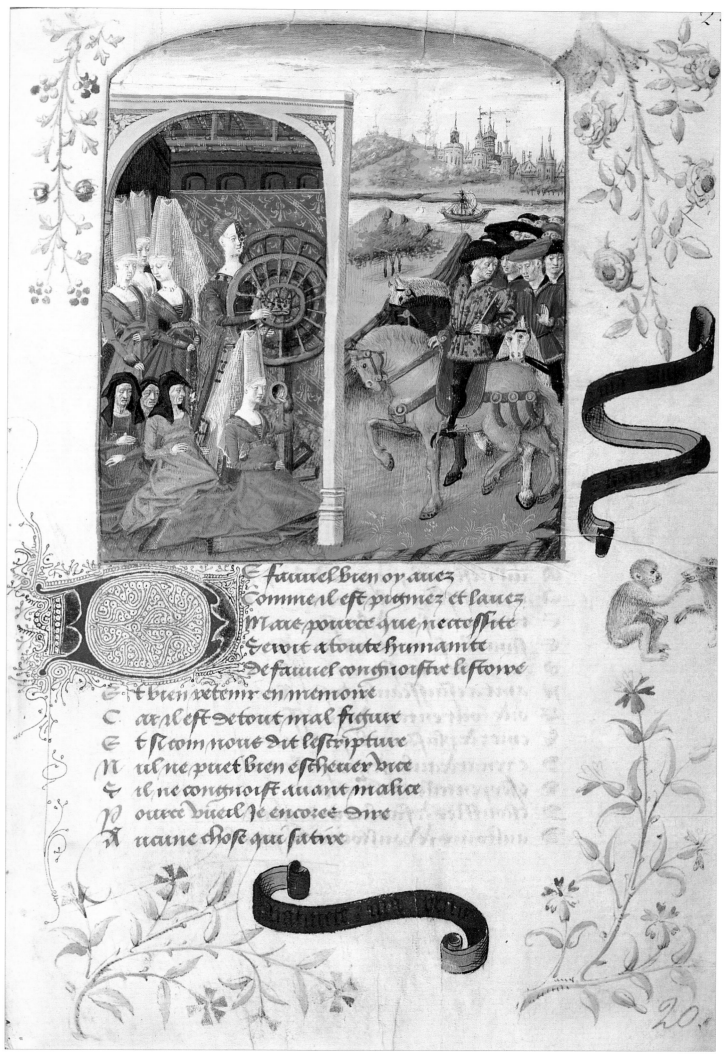

E fauuel bien oy auez
Comme il est prisinez et lauez
Mais pource que necessite
Deuoit a toute humanite
De fauuel cognoistre listoire
E t bien retenir en memoire
C ar il est de tout mal figure
E t si com nous dit lescripture
N ul ne puet bien eschener vice
Q il ne congnoist auant malice
P ource vueil ie encorec dire
A uaine chose qui sature

192, 193
THOMAS D'AQUIN
Summa Theologiae
France (Paris?). Mid-15th century.

228 ff. 300 x 205 mm (text 180 x 120 mm). Parchment. Latin.
1 miniature framed with a floral border: numerous colourful D initials
on golden backgrounds at the beginning of the sections of the text are enclosed in half-frames;
smaller golden A initials with floral ornament.
Binding: 18th century (restored). Dark-brown leather over cardboard; gold tooling
on the front cover and spine; gilt-edged; ex libris of Piotr Suchtelen.
Lat.Q.v.I.137.

The manuscript contains the text of one part (*prima secundae*) of *Summae Theologiae* by the great scholastic philosopher of the Middle Ages, Thomas Aquinas (1225/26–1274). The end of the text (articuli 4–10) is missing. The catalogues of Gille and Laborde mistakenly identified the manuscript as a treatise by St John of Damascus. Shishmariov stated the correct authorship.

The entire construction of the manuscript, with its economical, tight script, strict hierarchy of standard initials with various meaning and running titles, presents a typical example of a well-organized, practical, yet at the same time refined French manuscript of the 15th century. It may have been produced at the university workshop in Paris.

The coat of arms, in guise of a frame, are wrongly identified as those of René d'Anjou, and are in fact those worn by certain members of the Aragonaise dynasty from Naples, in particular Alphose, Duke de Calabre, son of Ferdinand d'Aragon.

Its history after that is unknown until the 19th century when it was part of Piotr Suchtelen's collection.

**ENTERED THE PUBLIC LIBRARY IN 1836 WITH THE SUCHTELEN COLLECTION
(1849–61 THE HERMITAGE, 5.2.24).**

LITERATURE: Gille 1860, p. 75; Laborde 1936–38, p. 86, pl. XXXVIII; Shishmariov 1927, vestiges de la Bibliothèque de René d'Anjou, pp. 182–184.

192

193. F. 1r: OPENING PAGE.
The rich yet elegant border framing the text like lace is dominated by blue, red and gold, typical colours of French illumination. The design incorporates strawberries and golden nuts, bachelor's buttons and other flowers. At the bottom of the page is the coat of arms of King René. The miniature St Thomas d'Aquin sitting in a chair upholstered in precious fabric before a bookrest with a manuscript. He is surrounded by people dressed like clergymen and monks of different orders listening to him. The Holy Ghost, a dove with golden rays, a symbol of the divine source of the theologian's inspiration, is descending from above.

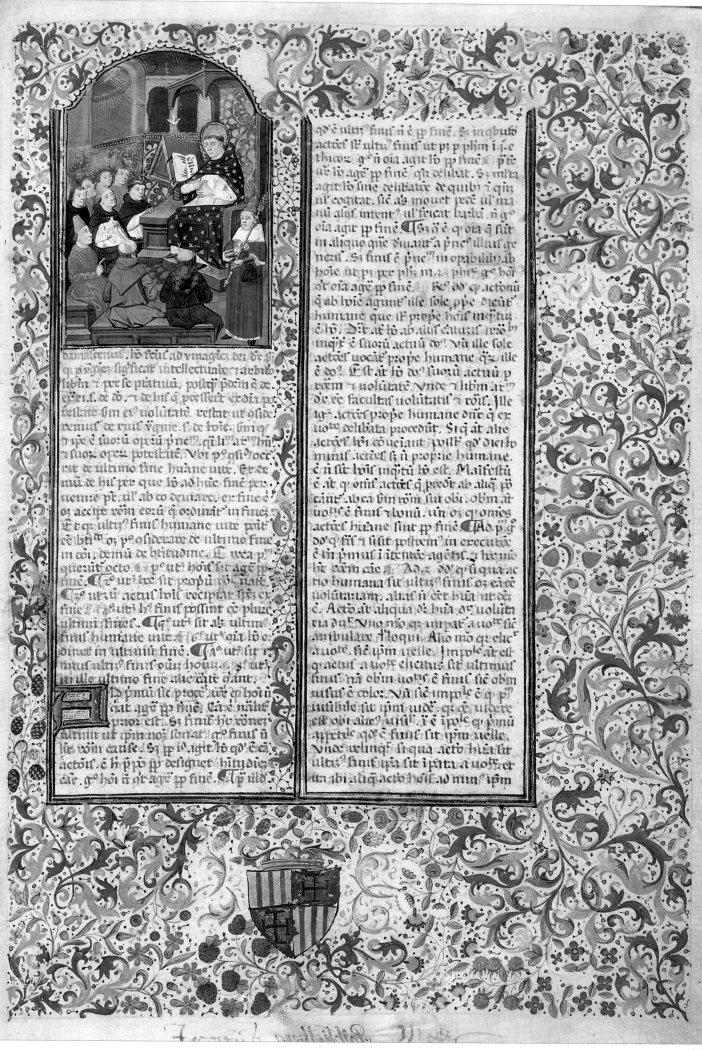

194-196
MARTIN DE BRAGA (PSEUDO-SENECA)
ON THE FOUR CARDINAL VIRTUES
CICERO. ON OLD AGE. ON FRIENDSHIP

Martin de Braga (pseudo-sénèque). Formulae Honestae Vitae
Cicéron. La Vieillesse. L'Amitié
France, Bourges. Mid-15th century.

109 ff. 295 x 200 mm (text 195 x 190 mm). Parchment. French.
3 miniatures preceding each treatise; numerous coloured and golden initials.
*Binding: 16th century. Light-brown leather over cardboard; gold-tooled ornate boss on the front
and back covers; 5 bands on the spine; gilt-edged.*
Fr.F.v.III.1.

The manuscript contains French versions of three Latin philosophical treatises, the first one translated by Jean Courtecuisse and the other two by Laurent de Premierfait.

Unlike the ornamental borders made up of acanthus leaves, grapevines and flowers, which are typical of French 15th-century illumination, the miniatures bespeak an unusual and independent artist. His style is characterized by the simple and logical placement of figures, the quiet rhythm of silhouettes and draperies, the fine graphic treatment of architectural details, and a predilection for the Netherlandish device of open doors and windows, which form a united whole of interiors and landscapes. On the basis of the virtuoso and delicate brushwork and the facial expressiveness, Laborde compared the artist's manner with that of the Master of the Hours of Coetivy. Nowadays experts are convinced that the illumination was executed by the Maître de Charles de France (Duke of Berry, brother of Louis XI) who worked in the 1460s in Bourges or one of the cities in the Loire valley. The name of the artist was coined on the basis of the Book of Hours of Charles of France from the Mazarin library in Paris (MS.473). Its illumination is close to that of the St Petersburg manuscript. A later (1470–80) copy of the text was in the Philips collection before being sold at auction at Sotheby's in 1966 (29 nov. lot 73). Gille thought that the St Petersburg copy was made for Louis of France, the uncle of Charles VI. Laborde insists that it was kept at Saint-Germain-des-Prés, where Dubrowsky acquired it. However, the manuscript has no Saint-Germain catalogue number. It is possible that the St Petersburg manuscript is described in the auction catalogue of the *Louis-Jean Gaignat collection (Catalogue des livres du cabinet du feu M. Louis-Jean Gaignat. Disposé et mis en ordre par G.F. de Bure le Jeune*, vol. 1, Paris, 1769, p. 219, No 840). Written in pencil on the front cover of the St Petersburg manuscript are the numbers 51497 0 75000 35.

ENTERED THE PUBLIC LIBRARY IN 1805 (1849–61 THE HERMITAGE, 5.2.41).

LITERATURE: Gille 1860, p. 73; Bertrand 1874, p. 93; Laborde 1936–38, pp. 66–68, pl. XXVIII; H. Haselbach, Sénèque des IIII vertus. La Formulae honestae vitae de Martin de Braga (pseudo-Sénèque), traduite et glosée par Jean Courtecuisse (1403). Etude et édition critique, *Berne, Frankfurt, 1975; J. Plummer (with the ass. of Gr. Clark), The Last Flowering: French Painting in Manuscripts (1420–1530) from American Collections, New York, London, 1982, pp. 47, 48. Vorona, 1984, 2 plates ; Avril, Reynaud, n° 82, n. 162-163.*

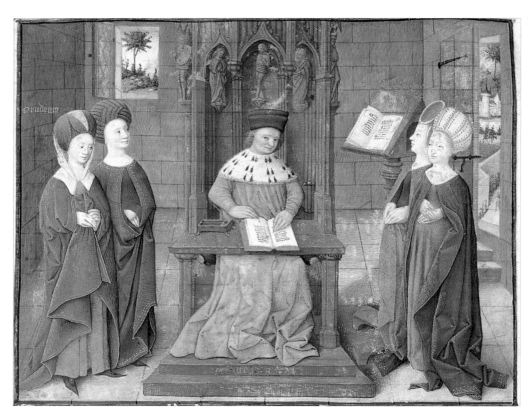

194

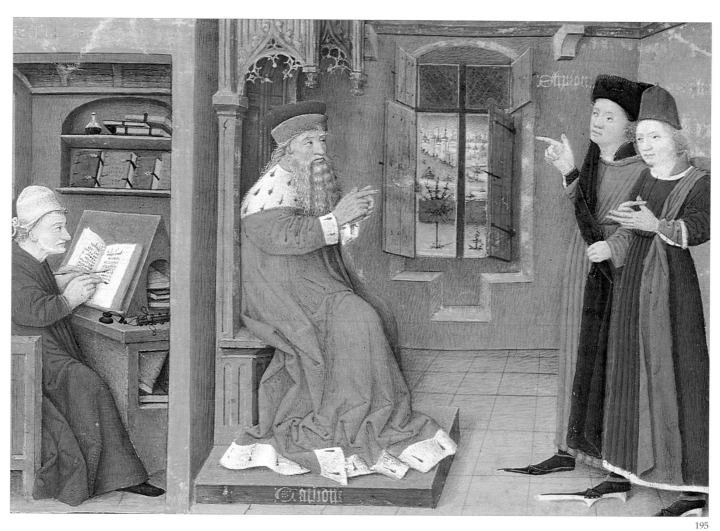

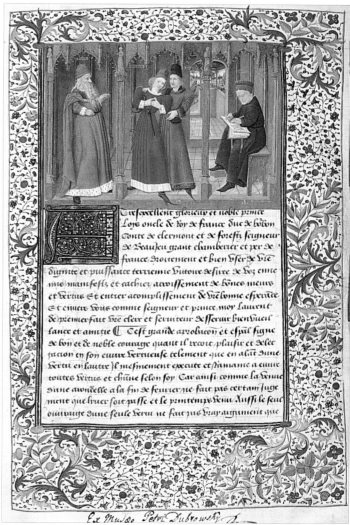

194. F. 1r: MINIATURE TO THE FIRST TREATISE.
A scholar (the author) sits at a reading-desk facing four women wearing turbans who symbolize virtues: Reason and Justice on the left and Temperance and Chastity on the right.

195. F. 19r: MINIATURE TO THE SECOND TREATISE. CATO FACING SCIPIO AND LAELIUS.
On the left Cicero is shown writing his treatise On Old Age. On the right, Cato, with Scipio and Laelius standing before him.

196. F. 61r: MINIATURE., TO THE THIRD TREATISE.
The miniature depicts Laelius on the left, Ennius and Scaevola in the centre and Cicero composing De amicitia on the right.

197-202
JEAN DE COURCY
THE BOUQUECHARDIÈRE CHRONICLE
Jean de Courcy. Chronique de la Bouquechardière
France (Rouen). 1470s.
Two volumes: 182 and 164 ff., 430 x 310 mm (text 290 x 200 mm). Parchment. French.
6 miniatures in ornamental borders (3 in each volume);
numerous initials in various colours and gold with a small vertical border.
Binding: 16th century. Green velvet over wooden boards; monograms on the front and back
covers; clasps and corner decorations of silver-gilt (in the style of bindings of the
Urfé library, according to Laborde); gilt-edged; the monogram reads O.I.A.P.F.R.
and probably stands for the owner's name.
Fr.F.v.IV.13/1–2.

The manuscript contains a world chronicle written between 1416 and 1422 by Jean de Courcy, a Norman knight and historian, and the Seignior of Bourg Achard (1350–1431). The chronicle consists of six books: the first deals with Greece, the first country to become inhabited after the Flood; the second is devoted to Troy and its destruction by the Greeks; the third is on the formation of other states by the Trojans; the fourth is on the Assyrians and their mighty kingdom; the fifth is on the Macedonians and the feats of Alexander the Great; and the sixth describes the revolt of Mattathias and the Maccabees against Antiochus IV Epiphanes. Both in structure and illumination the manuscript resembles another copy of the text in the Bibliothèque Nationale (MS.fr.20124) originally from the La Vallière collection which is described in detail in the auction catalogue of 1783 (*Catalogue des livres de la bibliothèque de feu M. le duc de La Vallière*, vol. 3, Paris, 1783, p. 58, No 4601; Supplement, p. 77, No 11). O. Pächt and S. Thoss mention a similar copy of the same treatise in Vienna at the Österreichische Nationalbibliothek (Cod.2543) written and illuminated in Normandy around 1470 (O. Pächt, D. Thoss, *Die illuminierten Handschriften und Inkunabeln der Österreichischen Nationalbibliothek. Französische Schule*, vol. 1, Vienna, 1974, pp. 57, 58, pls 100–105). In the 1460s–1470s, the atelier in Rouen produced a number of luxurious copies of large format of Courcy's chronicle. Other copies, besides the ones mentioned above, are in the Paris Bibliothèque Nationale (MSS.fr.329, fr.2685, fr.6183, fr.15429, fr.20130), in the Mazarin library (MS.1556/1557), in the Arsenal library (MS.3689) in Chantilly (Cod.fr.312), at Waddesdon Manor (MS.11), and in the Meermano-Westroenianum Museum in the Hague (MS.10A17).

The miniatures illustrating each book of the St Petersburg Chronicle are better, though probably later examples of this series. The historical subjects in them are treated like battle-scenes or chivalrous episodes of a time contemporary with the artist's; the construction work and siege scenes are painted in great detail. The author of these paintings is an artist from Rouen of the late 15th century who went under the name of Maître de l'Echevinage de Rouen, due to the numerous manuscripts he illustrated, devoted to the Norman capital. The miniaturist had a skilful hand and an ability to render his characters' postures and movements in a lively, realistic manner. The vestments, jewellery, armour and horses are painted boldly, yet the colour scheme, which is typical of the school of Rouen of the third quarter of the 15th century, is somewhat monotonous and dominated by grey. In the borders of all miniatures the shields of the coats of arms were left unpainted in order to personalize them later with the owner's device. The same is true of the manuscript in Vienna.

The St Petersburg manuscript was purchased by Dubrowsky at the end of the 18th century.

ENTERED THE PUBLIC LIBRARY IN 1805 (1849–61 THE HERMITAGE, 5.3.41).

LITERATURE: Gille 1860, p. 75; Bertrand 1874, p. 109; Laborde 1936–38, pp. 85, 86, pl. XXXVII. B. de Chancel. Les manuscrits de la Bouquechardière de Jean de Courcy, Revue d'histoire des textes, XVII, 1987, p. 219 - 290 ; c. Rabel, "Artiste et clientèle à la fin du Moyen Âge : les manuscrits profanes du Maître de l'Echevinage de Rouen", Revue de l'Art, 84, 1989, p.48 - 60.

197. F. 3r: MINIATURE TO BOOK ONE (Volume 1).
At the top Noah and his sons come out of the ark onto the land. The scene at the bottom depicts the founding of Athens, with a builder receiving instructions (on the left) and a battle scene (on the right). The upper part of the miniature depicts the New Testament Trinity.

198. F. 58r: MINIATURE TO BOOK FIVE Volume 2.
The two episodes depicted in this miniature are united by Gothic arches, yet they take place in independent architectural surroundings. On the left is Fortune and her wheel which raised and then dropped Alexander the Great, who is twice represented. On the right under the tent is Eurydice, Queen of Macedonia, enthroned and surrounded by court dignitaries who are poisoning her son-in-law and two elder sons (see O. Pächt and D. Thoss; the same subject in the manuscript from Chantilly is interpreted as the three stages of the poisoning of Alexander the Great).

199. F. 2r: MINIATURE TO BOOK FOUR Volume 2.
Babylon is on the left, depicted as an imaginary Gothic city with elements of Muslim architecture. The giant in the centre is Nimrod. On the right the Tower of Babel is under construction. In the upper part God the Father sends an archangel to the builders of the tower.

200. F. 123r: MINIATURE TO BOOK SIX Volume 2.
Antiochus IV Epiphanes is plundering Jerusalem (not Athens, as was mistakenly stated by Laborde). The temple of Jerusalem rises up on the right behind the walls. Warriors carry sacred vessels out of the temple and place them at the feet of Antiochus IV; the tents of his camp can be seen in the distance.

Page 166
201. F. 138r: MINIATURES TO BOOK THREE (Volume 1).
The Trojans found four cities: Venice, Cycambre, Carthage, and Rome.

Page 167
202. F. 85r: MINIATURE TO BOOK TWO (Volume 1).
Priam, King of Troy, meets Paris and Helen, whom Paris kidnapped, at the gate of the city.

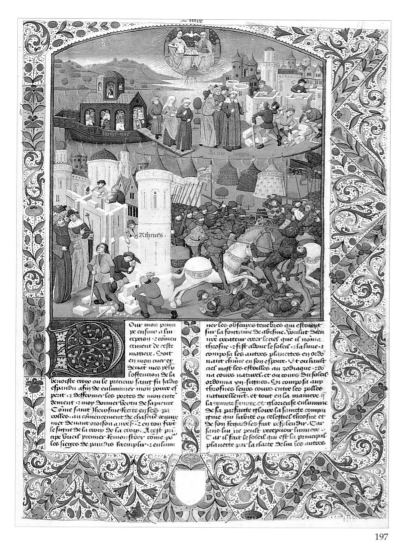

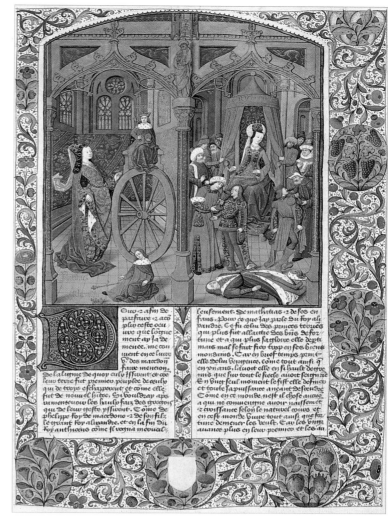

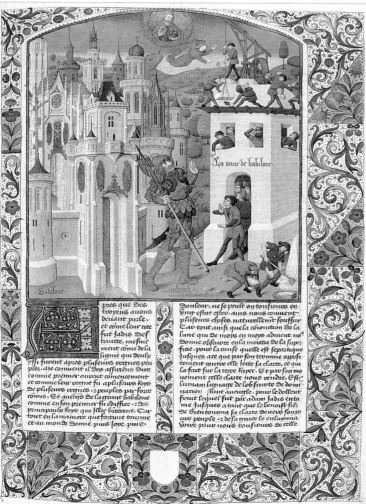

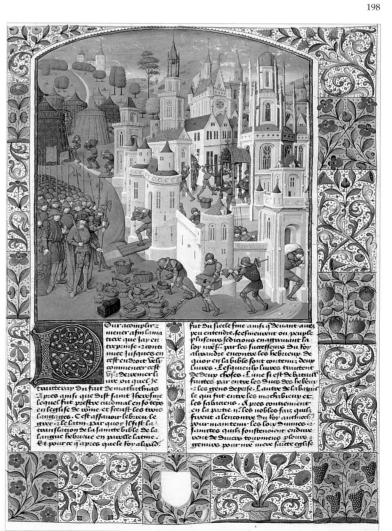

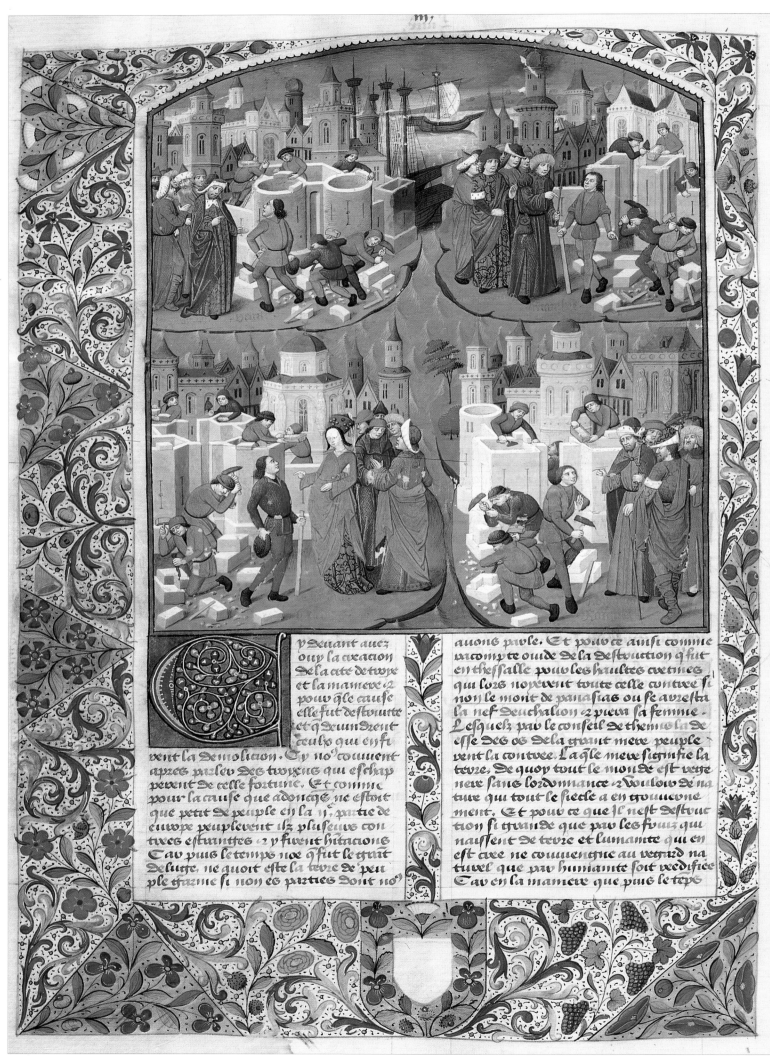

y deuant auez
ouy la creacion
de la cite de turpe
et la maniere Et
pour qle cause
elle fut destruitte
et q deuindrent
ceulx qui en fu
rent la demolicion. Cy no' conuient
apres parler des turpens qui eschap
perent de celle fortune. Et comme
pour la cause que adonqs ne estoit
que petit de peuple en la ij.e partie de
europe peuplerent ilz plusieurs con
trees estrainctes et y furent hitacions
Car puis le temps noe q fut le grant
deluge, ne auoit este la terre de peu
ple fermie si non es parties dont no'

auons parle. Et pour ce ainsi comme
vncompte ouide de la destruction q fut
en thessalle pour les haultes cretines
qui lors noperent toute celle contree si
non le mont de panasias ou se arresta
la nef deuchalion et pirra sa femme.
Lesquelz par le conseil de themis la de
esse des os dela grant mere peuple
rent la contree. La gle mere signifie la
terre, de quoy tout le monde est vetre
nere sans lordonnance et voulour de na
ture qui tout le siecle a en trouuorne
ment. Et pour ce que sl nest destruc
tion si grande que par les fruiz qui
naissent de terre et lumanite qui en
est avec ne commenchte au vetard na
turel que par humanite soit reedifiee
Car en la maniere que puis le tps

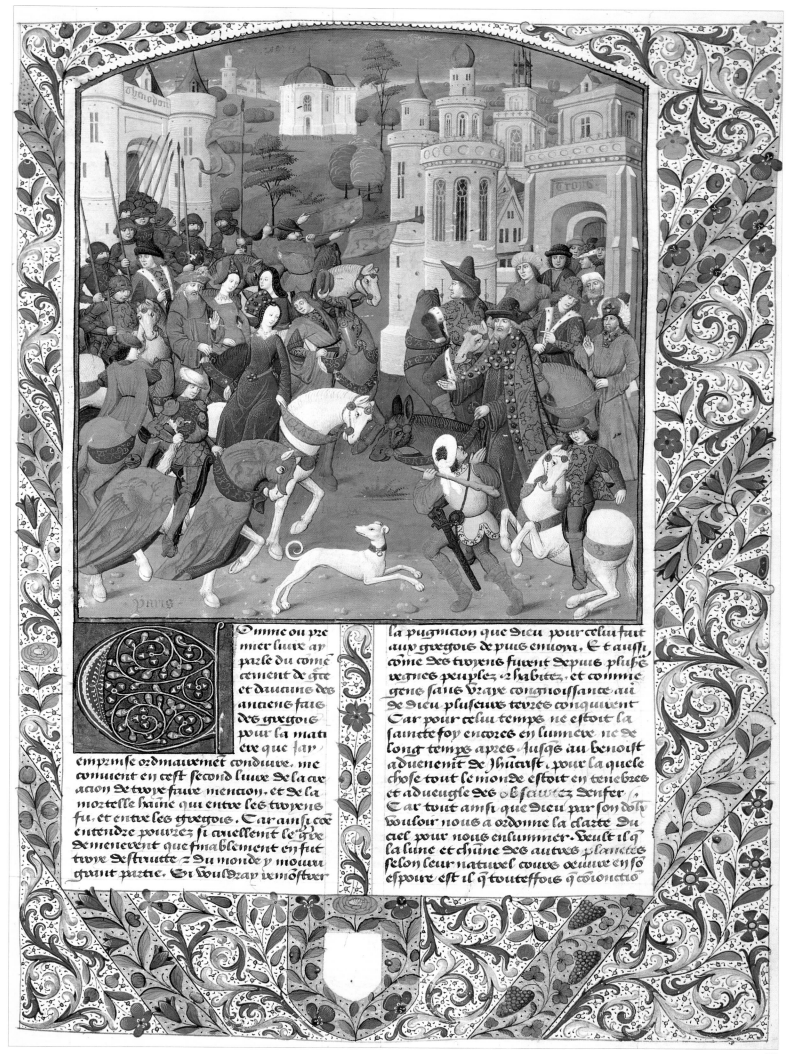

Omme ou pre
mier liuue ay
parle du come
cement de gte
et duuaine des
anciens fais
des gregois
pour la mati
ere que say
emprinse ozdmairemet condiuue. me
conuient en cest second liure de la cre
ation de twyre faire mention. et de la
moztelle haine qui entre les twyens
fu, et entre les gregois. Car ainsi coe
entendre pourrez si aucllemt le tre
demenerent que finablement en fut
twre destruitte z du monde y mouu
grant partie. Si vouldray remostrer

la pugnation que dieu pour celui fait
auy gregois de puis emiom, Et aussi
come des twyens furent depuis plusie
urres peuplez z habitez, et comme
gene sans vraye congnoissance au
de dieu plusours terres conquirent
Car pour celui temps ne estoit la
sainte foy encores en lumiere ne de
long temps apres Iusqs au benoist
aduenemit de Jhucrist. pour la quele
chose tout le monde estoit en tenebres
et adueugle des obscurtez denfer.
Car tout ainsi que dieu par son doly
vouloir nous a ordonne la clarte du
ciel pour nous enlummer. Veult il q
la lune et chune des autres planetes
selon leur naturel cours œuure en so
espoir est il q touteffois q coronetio

203-205
REGNAULT AND JEANNETON
Regnault et Jeanneton
France. After 1480.

37 ff, 265 x 195 mm (text 100 x 80 mm). Paper. French. 74 miniatures (pen and watercolour).
Binding: 18th or early 19th century (commissioned by Piotr Dubrovsky). Red morocco over
cardboard; decorated with green mosaic and gold. Fr.Q.p.XIV.1.

The manuscript contains an idyll composed on the occasion of the marriage of King René to Jeanne de Laval in 1454. The poem tells of the courtship of a shepherd, Regnault (implying King René), and a shepherdess, Jeanneton (Jeanne de Laval). The authorship of the pastoral is still the subject of dispute: Shishmariov considered that it was written by one of René's officials, possibly Pierre de Hurion; other scholars, however, maintain that it is possible that the author was King René himself. Written in or after 1466, this manuscript is the only extant copy of the poem. It is decorated with pen drawings touched with colour wash. The St Petersburg manuscript was part of the library of King René, as is shown by his coat of arms as Duke of Anjou and that of Jeanne de Laval. The depiction of the devices is accompanied by an inscription saying that they are those of the shepherd and shepherdess whose story is related in the poem. The question of the poem's illumination is no less vague and debatable than that of its authorship. The illumination is sketchy and somewhat lacking in confidence, although the free distribution of the text and illustrations, the lyrical depiction of nature and the bucolic quality of the images are of great interest and indicate the artistic value of the lost volume, which, accor-

ding to Durrieu, was probably executed after the initial St Petersburg manuscript. Pächt undertook a comparative study of the miniatures in *Regnault et Jeanneton* and the *Livre des tournois* and concluded that the illumination must be by René's favourite artist, the so-called "Master of the Heart" (Barthelemy d'Eyck?). Charles Sterling, however, questioned this attribution, stressing the more "aristocratic" type of peasants in comparison with Barthelemy's style. Sterling is convinced that René of Anjou himself was the author of the poem and, considering the peculiarities of the illumination mentioned above, puts forward a supposition that the illustrations were also done by the Duke who, if that were case, showed himself to be a gifted though unprofessional artist. The watermark shows this manuscript to be later than 1490. The coat of arms clearly indicates that it was destined for Jeanne de Laval, and not René himself.

In the 15th century, the manuscript was part of the library of King René; in the 17th century, it was in Séguier's collection, then passed into the hands of the Duke of Coislin, his grandson, and finally entered Saint-Germain-des-Prés in keeping with Coislin's will (1735). Sometime before 1792 it was purchased by Piotr Dubrovsky.

ENTERED THE PUBLIC LIBRARY IN 1805.

LITERATURE: Cat. Séguier 1686, Inv. des Miniatures, p. 20; Montfaucon 1739, 2, p. 1109, No 789; Th. de Quatrebarbes, Œuvres complètes du Roi René, vol. 1, Angers, 1844; Bertrand 1874, p. 176; M. Du Bos, Le Roi René. Regnault et Jeanneton (introduction, notes and glossary), Paris, 1923; Shishmariov 1927, Traces de la Bibliothèque de René d'Anjou, pp. 147–162; V. Shishmariov, "Notes sur quelques œuvres attribuée au Roi René", Romania, 55, 1929, pp. 214–250; Laborde 1936–38, pp. 82, 83, pl. XXXIII; V.F. Shishmariov, "Regnault et Jeanneton (frantsuzskaya poema XV veka). Rukopis s akva-reliami iz biblioteki René Anzhuiskogo", Literaturnoye nasledstvo, 33/34, 1939, pp. 870–893; Shishmariov 1955, Livre de lecture, pp. 477, 478; O. Pächt, "René d'Anjou", Jahrbuch der Kunsthistorischen Sammlungen in Wien, 73 (N.F. 37), 1977, pp. 47–64, 78, ills 53–61, 63, 68–70; Ch. Sterling, Enguerrand Quarton. Le Peintre de la Pietà d'Avignon, Paris, 1983, pp. 181–183. A.M. Legaré, "Reassessing women's libraries in late medieval France : The case of Jeanne de Laval" : in Renaissance Studies, vol. 10, 1996, p. 209 - 236 (see in particular : p. 212-213).

203

203. COATS OF ARMS OF RENÉ D'ANJOU AND ANNE DE LAVAL.

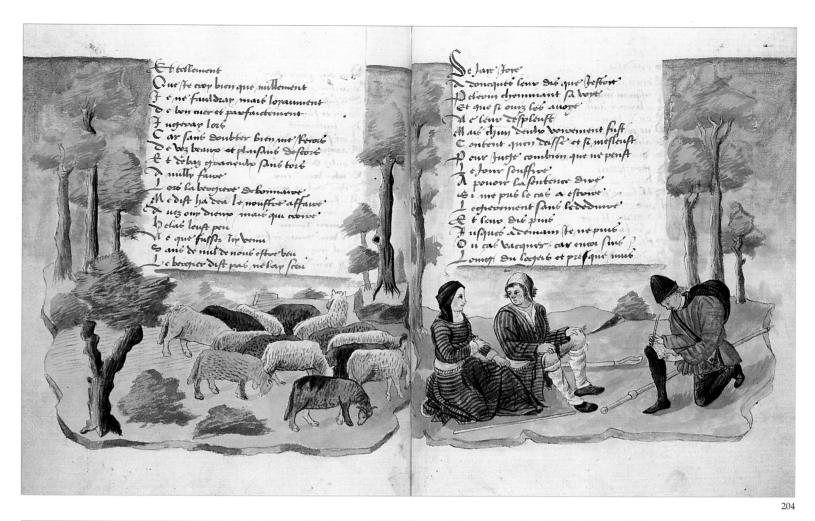

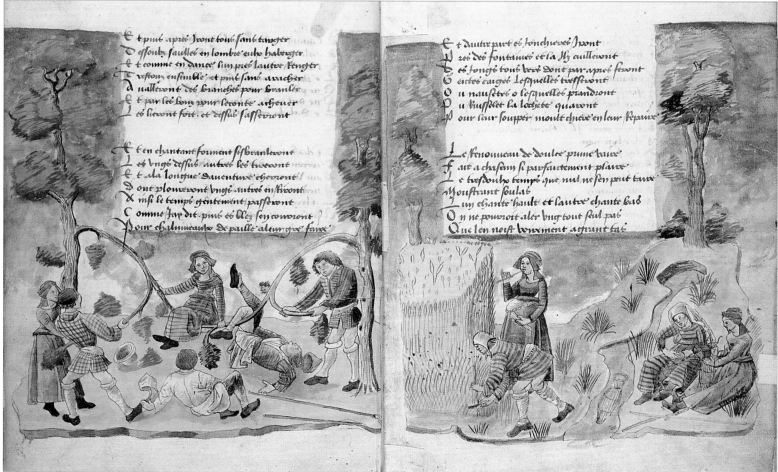

204. FF. 31v–32r: DISPUTE OF A SHEPHERD AND SHEPHERDESS.

A shepherd and shepherdess argue about whose love is stronger, a man's or a woman's. A stranger (perhaps the author) listens and writes down their words. The text tells how the next morning the stranger waited in vain for the young couple: he guessed that the dispute was solved naturally and continued on his way.

205. FF. 6v–7r: PASTORAL SCENE. HARVEST.

206-208
FIFTEEN JOYS OF MARRIED LIFE
Les Quinze Joies de mariage
France. 1485.

126 ff. 279 x 200 mm (text 150 x 102 mm). Paper. French.
16 half-page miniatures (with 1 to 7 scenes each) accompanied by colourful initials featuring
fantastic monsters. Binding: 18th or early 19th century (commissioned by Piotr Dubrovsky).
Pink velvet over cardboard; blindstamped geometric designs on the front and back covers and
on the spine; orange paper fly-leaves. Fr.F.p.XV.4.

The manuscript entitled, ironically, *Fifteen Joys of Married Life*, contains a satire on marriage and women's frailty by an unknown author and was written between 1380 and 1410. The "joys of marriage" are described as the gravest upheavals, sorrows and trials that a human being will ever experience. The text gives an accurate and detailed account of the ways, customs and lifestyle of townspeople and minor provincial landowners. The St Petersburg manuscript is one of the four surviving copies of this work. The style of its illumination suggests that it was produced at the end of the 15th century in the north-west of France. A certain primitiveness in the miniatures can to a great extent be explained by the fact that they are painted on paper. The author of these pen drawings, which are touched, sometimes heavily covered, with watercolour, faithfully followed the text and showed a deep interest in reality and a love of anecdote. As a result, the manuscript gives a pictorial account of people's life at the time in addition to a literary one.

In the 17th century, the manuscript belonged to Pierre Séguier and was transferred to Saint-Germain-des-Prés with his collection in 1735. At the end of the 18th century it was purchased in Paris by Piotr Dubrovsky.

ENTERED THE PUBLIC LIBRARY IN 1805.

LITERATURE: Cat. Séguier, *Inv. des Miniatures*, 1686, p. 9; Montfaucon 1739, 2, p. 1113, No 1041; Bertrand 1874, p. 191; O. Soelter, Beiträge zur Überlieferung der Quinze Joyes de Mariage mit besonderer Berücksichtigung der Handschrift von St. Petersburg, *Greifswald*, 1902; Laborde 1936–38, pp. 119, 120; Shishmariov 1955, *Livre de Lecture*, pp. 485–487; Shishmariov Fund 1965, p. 40; Les XV joies de mariage (ed. by J. Rychner), Geneva, Paris, 1967; Les XV Joyes de Mariage (ed. by J. Crown), Oxford, 1969.

206

206. F. 76v: LETTRINE.

207. F. 104r: THE TWELFTH JOY OF MARRIED LIFE.

At the lower right the husband prepares to go off to war, but his wife will not let him leave for fear of losing the breadwinner. The scene in the upper left follows next in the plot and shows the husband getting out of bed having been awakened by the dog that smells his wife's "friend" climbing through the window. In the centre, behind the couple, somebody is carrying a baby. In the upper right a family hurries to the castle in order to hide from the enemy. The military scene in the lower left is not connected with any definite section of the text, but renders the atmosphere in which the events are taking place. O. Soelter noted that sometimes the content of the miniatures was broader than the text of the manuscript and suggested that the artist could have been illustrating a more complete text or copying illustrations in earlier manuscripts.

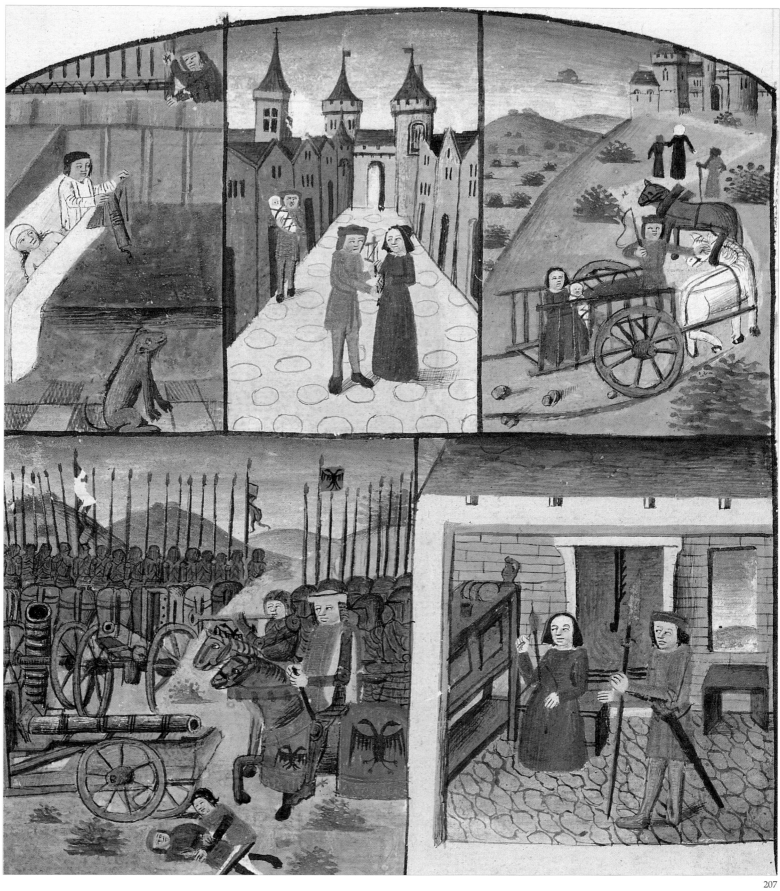

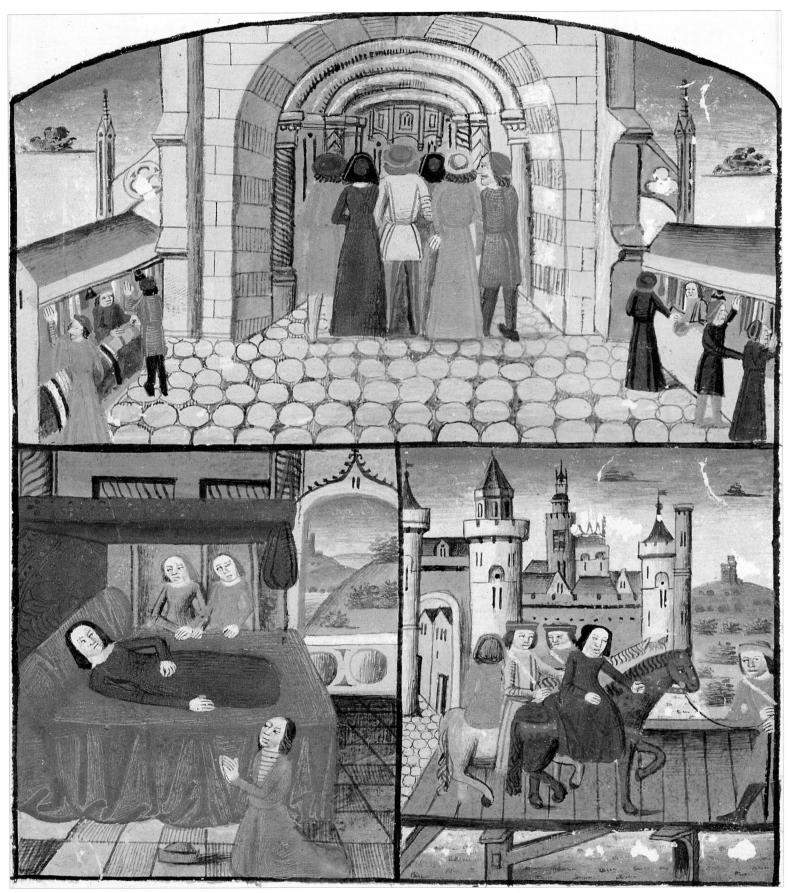

208. F. 76v:
THE EIGHTH JOY OF MARRIED LIFE.
The illustration corresponds to the ironical story of matrimonial
"joys" and must be deciphered starting from the lower left
scene where the husband is worrying over his wife's difficult
labour. On the right the wife, accompanied by a "friend",
leaves on a pilgrimage to fulfil a vow, and the husband leads
her horse by the bridle. At the top the pilgrims have already
reached their destination; on the right and left are shops selling
souvenirs.

209-212
ROLIN-LÉVIS BOOK OF HOURS OF THE USE OF PARIS
Heures de Rolin-Lévis à l'usage de Paris
France. Third quarter of the 15th century.
288 ff. 215 x 150 mm (text 100 x 65 mm). Parchment. Latin and French.
20 miniatures framed with splendid ornamental borders; 4 historiated initials
with the Evangelists on pages with borders on three sides; vertical border on every page;
large initials in gold and various colours, one at the beginning of each section;
numerous initials of average and small size.
Binding: 18th century. Brownish-red morocco over cardboard; gold-tooled frame
and designs on the spine; gilt-edged.
Rasn.Q.v.I.9.

The Book of Hours includes a Calendar in French, readings from the Gospels, the Little Office of the Virgin, the Hours of the Passion, the Hours of the Holy Ghost, the Hours of the Virgin, the Penitential Psalms, the Office of the Dead, the Litany and prayers, all in Latin. The French part includes the *Fifteen Joys of the Virgin, Seven Requests to the Saviour, the Prière à la Vierge dite prière de Théophile.* The prayers obsecro te and o intemerata are written in the feminine gender. Also included is a rare prayer to St Susan (in French), placed at the end of the Latin prayers. The only other existing copy of this prayer is found in a Book of Hours in the National Library in Madrid (Res.149). All headings are written in French. The Litany dedicated to the three saints venerated at Autun (St Lazarus, St Leger and St Symphorian), as well as the coats of arms, suggest that the manuscript might have been executed for some member of this powerful family, probably for Guillaume Rolin, husband of Marie Lévis and brother of Jean Rolin, Bishop of Autun (f.112v and f.151v have the arms of Rolin-Lévis depicted together).

Though not unlike the general trend in French illumination in the third quarter of the 15th century, the style of the miniatures in this luxurious manuscript has some features of its own. The artist preferred vertical elongated miniatures, which corresponded very well to the slender proportions of small-headed figures and the rhythm of beautifully arranged folds. The characters' faces are more interesting than attractive, the treatment of architectural motifs is scrupulous and somewhat dry with gold tastefully introduced into the colour scheme.

This beautiful manuscript is ascribed to the work of the master of Jean Rolin II (as established by Nicole Reynaud in 1993). He was one of the principal artists of Parisian illumination from 1450-1460, and takes his name from Cardinal Jean Rolin, for whom he executed a series of missals destined for the Cathedral of Autun. The influence of this master can also be traced in later manuscripts, of which the Rolin-Lévis Book of Hours may be one.

Though made for the Rolin-Lévis, the Book of Hours belonged to the Bourbons sometime in the 15th or early 16th century – f.248v has the inscription and signature: votre fylle M. de Bourbon. The prayer to St Susan (this was the name of the daughter of Anne Beaujeu, Duchess of Bourbon, the wife of the Constable of Bourbon) is another sign possibly connecting the manuscript with the Bourbons. Later, the Book of Hours probably belonged to the Urfé family (one of them signed f.18v: ma mere pries pour votre fils Urfe). It is known that the library of the Urfés (who, incidentally, got a large share of the confiscated possessions of the Bourbons in 1527) was later almost completely bought by the Duke of La Vallière who often sold his manuscripts (the auction catalogue of his collection compiled after the Duke's death in 1783 makes no mention of the manuscript).

ACQUIRED BY THE PUBLIC LIBRARY IN 1925 FROM THE YUSUPOV COLLECTION.

LITERATURE: Dobias-Rozdestvenskaïa 1927, p. 4; Kratky otchot rukopisnogo otdela za 1914–38 gody, Leningrad, 1940, p. 242; Le Livre au siècle des Rolin. Catalogue de l'exposition. 8 juin – 28 septembre 1985, Autun, 1985, p. 54,1; T. Voronova, Avril, Reynaud, p. 42-43, n° 11

Page 174
209. F 57v: THE CRUCIFIXION.
The Rolin coat of arms is included in the border at the bottom. A peacock in the border on the left is a frequently encountered Christian symbol of immortality and of Christ's Resurrection.

Page 175
210. F .91v: THE FLIGHT INTO EGYPT.

Page 176
211. F. 140v: THE VIRGIN AND CHILD AND SINGING ANGELS IN A TEMPLE.

Page 177
212. F. 222v: THE RAISING OF LAZARUS.

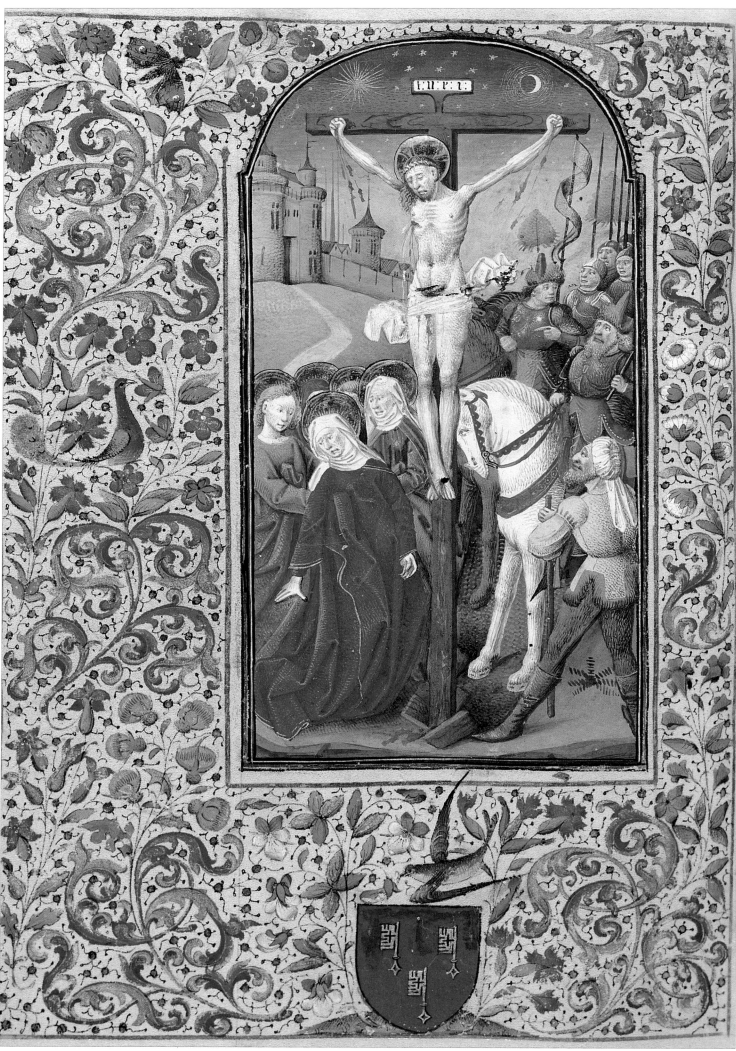

209

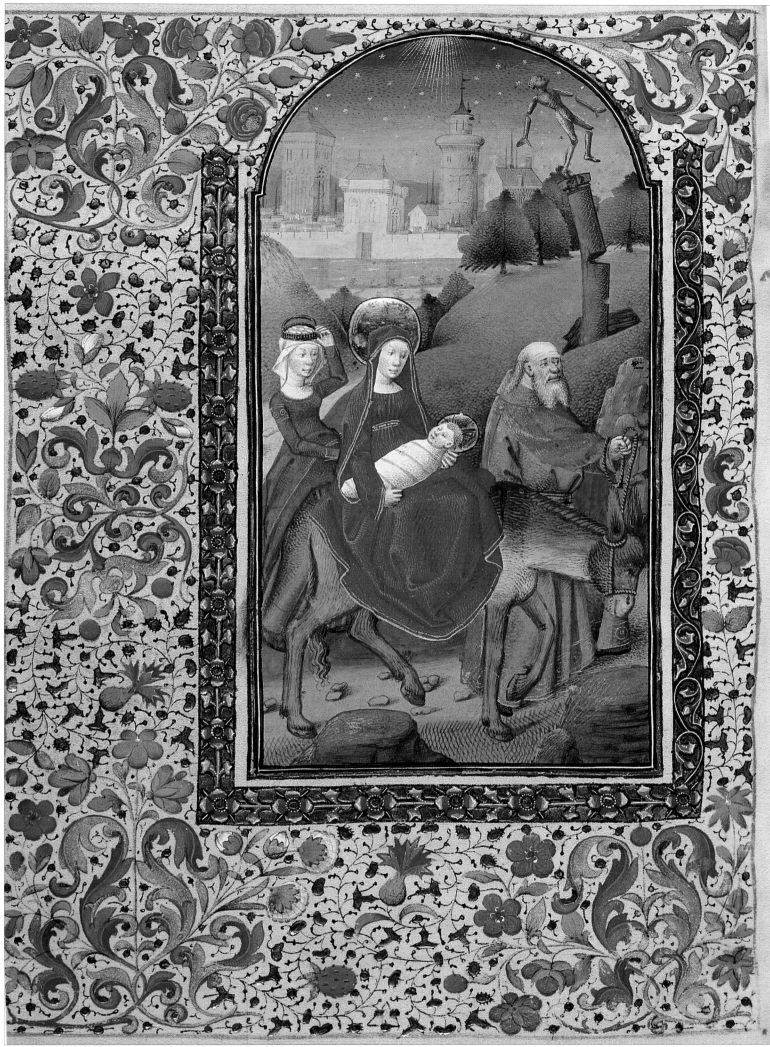

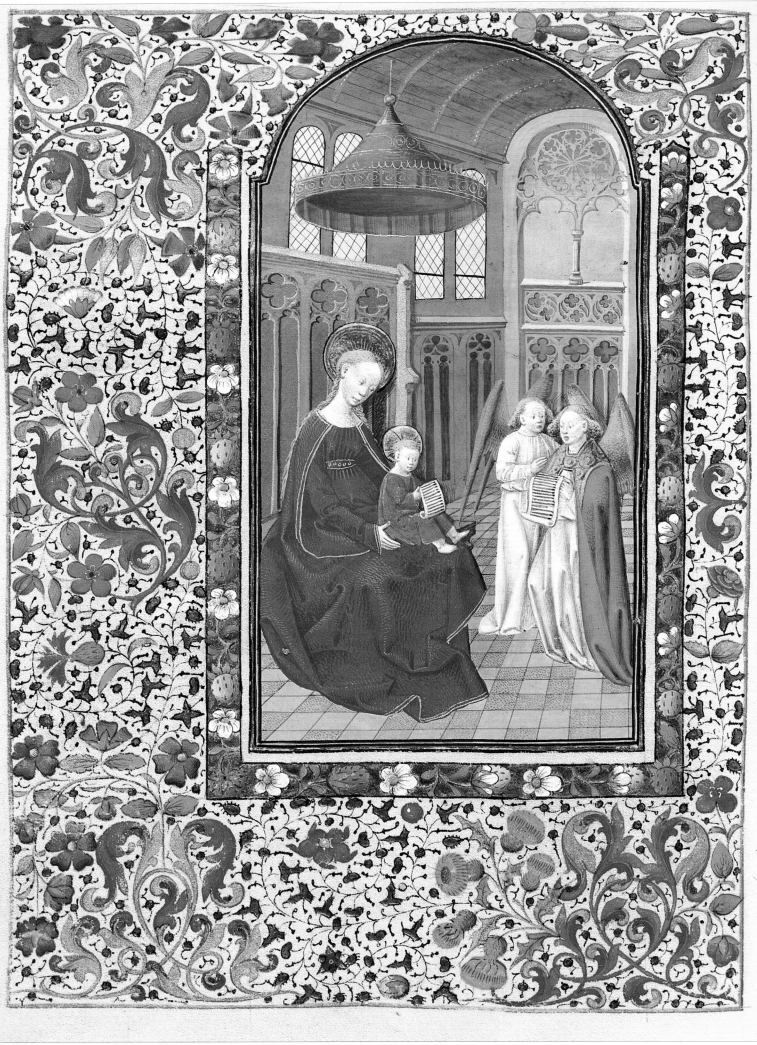

211

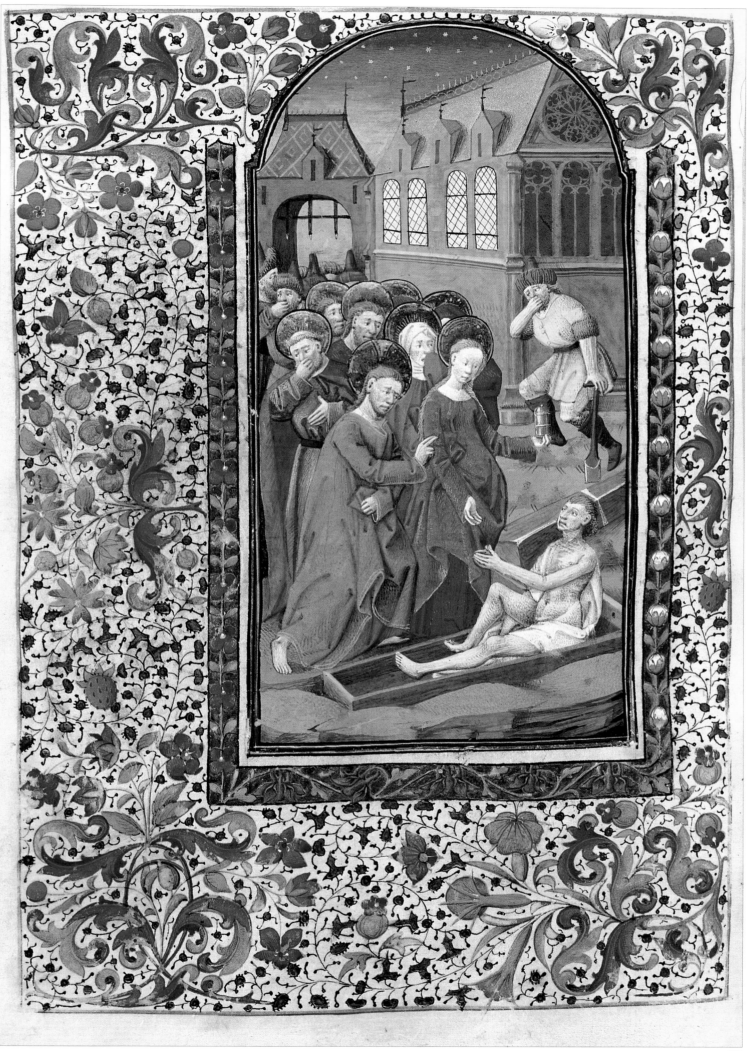

213-216
JEAN D'ORRONVILLE (CABARET).
Chronicle of Louis II, Duke of Bourbon
Jean d'Orronville. Chronique de Louis de Bourbon

France. Last quarter of the 15th century.
176 ff. 265 x 180 mm (text 160 x 115 mm). Parchment. France.
14 miniatures; numerous colourful initials and borders.
Binding: 18th century (commissioned by Piotr Dubrovsky). Pink velvet over cardboard;
doublures of gold brocade on the covers; gilt-edged. Fr.Q.v.IV.2.

The text describes the life of Louis II, Duke of Bourbon (1337–1410), as told by the Duke's comrade-in-arms Jean de Châteaumorand and written by the Duke's secretary Jean d'Orronville (nicknamed Cabaret) in 1429. The life of Louis II, maternal uncle of the King of France, who, together with the Duke of Burgundy, performed the duty of a regent for Charles VI, was full of military campaigns and battles. Thus Cabaret's *Chronicle* contains valuable data on the history (primarily the military history) of France at the time of the Hundred Years' War. The style of the miniatures and the marginal decoration are typical of the illumination of Tours and Bourges of the last quarter of the 15th century when it still bore the imprint of the art of Jean Fouquet. In particular, we can see the influence of his "historic battle illustrations" in which masses of warriors were treated in a generalized way against peaceful landscape backgrounds, his Italianate architectural motifs (columns) introduced into the setting, and his gold hatching. In connection with the same features of the Chronicle's illumination, Durrieu mentioned Jean Colombe, though there are not sufficient grounds for ascribing the authorship to this leading master of Bourges. Furthermore, unlike Jean Colombe, the illustrator of the Chronicle favoured different shades of lilac in his palette. The manuscript was executed for the daughter of Louis XI, Anne de Beaujeu, Duchess of Bourbon, sister and regent for the infant Charles VIII. The Chronicle was housed in the library of the Dukes of Bourbon in Moulins which was confiscated by Francis I in 1523. Gille suggested that the number 2193 still discernable in the manuscript could be considered as a reference from Colbert's library. In Montfaucon's inventory this number is missing (see Montfaucon 1739, 1, p. 955). The manuscript was purchased by Piotr Dubrovsky at the end of the 18th century, sometime before 1792.

ENTERED THE PUBLIC LIBRARY IN 1805 (1849–61 THE HERMITAGE, 5.2.46).

LITERATURE: Gille 1860, pp. 78, 79; Bertrand 1874, pp. 138, 139; Delisle 1868–81, 1, p. 171; La Chronique du bon duc Loys de Bourbon *(publ. by A.-M. Chazaud), Paris, 1876; "Inventaire des Livres qui sont en la librairie du chasteau de Molins", in:* Les Enseignements d'Anne de France, duchess de Bourbonnois et d'Auvergne à sa fille Susanne de Bourbon *(publ. by A.-M. Chazaud), Moulins, 1878, p. 241, No 127; Nikolayev 1904, le Monde de l'Art, pp. 116–119; Yaremich 1914, p. 41, ill. between pp. 38 and 39; Laborde 1936–38, pp. 2, 134–137, pl. LV.*

213. F. 79v: SIEGE OF A FORTRESS.
Troops commanded by Louis de Bourbon take the fortress with the aid of tunnels. The artist depicted the fortress on a high hill surrounded by the assaulting troops led by Louis II, Duke of Bourbon, who is mounted on a white horse and holding a commander's baton. In spite of its originality, the marginal decoration is typical of late 15th-century French illumination: it employs traditional "French" devices (such as floral ornamentation featuring drolleries) along with columns, a fashionable motif imitating antique decorations. Various animals and fantastic beasts are depicted in the capitals of the columns, but their bases always rest on heraldic bears wearing collars.

214. F. 85r: THE FORTRESS AND THE ENGLISH FLEET.
The text preceded by this miniature describes how, in 1382, the King of France and his uncles, the Dukes of Burgundy and Bourbon, gathered an army in the town of Sluis in the Netherlands so as to counter the English. The English landed there in order to capture the town and the fortress, but they were beaten off and had to retreat. The ribbon wrapped around the column in the border carries the motto of the Bourbons: Esperance.

215. F. 92r: THE BATTLE OF ROOSEBEKE.
This miniature, one of the best in the manuscript, depicts the famous battle of Roosebeke (1382), in which a French army defeated the Flemish. The riders' lances, which can be glimpsed in the tumult of the battle, look like bolts of lightning; the foreground features a striking encounter between cavalry. A fallen knight, the Flemish leader Philippe Artevelde, killed in action, lies on the green grass covered with blood, his golden locks escaping from his helmet. The depiction of this cruel human clash is made more dramatic by the sombre colour range dominated by various shades of lilac.

216. F.109v: BATAILLE DU BORDELAIS, THE RETURN OF THE ARMY LED BY LOUIS II, DUKE OF BOURBON, TO FRANCE.
In Bordelais, the French army encountered the English. The view of the city in the background is of particular interest.

ms aduenir lexs luy. il eust tant fait qu'il ne seu
faisoit mye deux Jours que la mine ne fut pre-
achance. Comment le duc debourbon se combatit
en la mine a kerneith. et coment le chastel se
rendit

213

Pres la prise de kerneith que lan de grace
couroit mille. CCC. lxxvn. estoit le roy de
france a lescluse ensemble ses oncles. les
ducs debourt-ne et de bourbon. pour obuier a lencontre
de larmee des anglois. qui estoit en terre en celle
partie descendue. a conquester le chastel de lescluze
et la ville. de laquelle estoit maistre et capi-ne

214

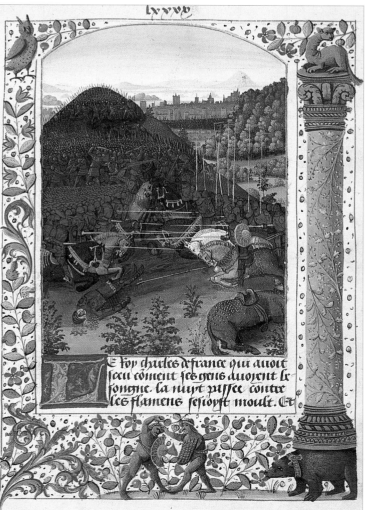

Le roy charles de france qui auoit
seu coment ses gens deuoient le
songne. la nuyt passee contre
les flamens se joyst moult. Et

215

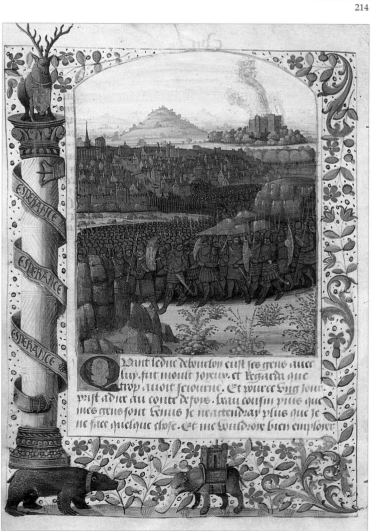

Quant le duc debourbon eust ses gens auec
luy. fut moult joyeux. et regarda que
trop auoit seiourne. Et pource sur jour
prist adire au conte de fois. beau cousin prie que
mes gens sont venus je nattenderay plus que je
ne face quelque chose. Et me vouldroy bien emploier

216

THE HOURS OF LOUIS OF ORLÉANS
Livre d'Heures de Louis d'Orléans : Horae ad usum romanu
France (Toulouse and Bourges). 1490.
112 ff. 215 x 148 mm (text 127 x 68 mm). Parchment. Latin.
90 miniatures with richly ornamented borders; numerous small multicoloured initials
and headings in red. Binding: 18th century. Dark-lilac velvet over cardboard.
Lat.Q.v.I.126.

The Book of Hours contains a Calendar of the Augustinian type which mentions the manuscript's date of execution – 1490. It also has the Hours of the Virgin, the Penitential Psalms, the Litany, the Office of the Dead, the Hours of the Cross, the Hours of the Holy Ghost, the Hours of the Trinity, prayers, readings from the Gospels, and the Seven Requests to the Saviour. The mention of St Louis, the autograph of Louis of Orléans, the future King Louis XII, and his portrait on f.11v seems to indicate that the manuscript was owned by him for a certain time.But it was certainly not commissioned for him. The portrait of F.11v does not correspond with what is known of his physionomy, and is more likely to represent the person whose emblem, a burning tree, with the motto "A prier me lie" are painted at the beginning of the book. He is evidently from Toulouse, due to the decoration in the margin, which is partly the work of an illuminator from that town, who in 1492 worked on the missal of Jean de Foix, bishop of Comminges. (Paris, Bibliothèque Nationale, Lak 16827). It is not known why he was called upon to finish the manuscript in Bourges, in an atelier near to that of Jean Colombe.

The illumination of this small manuscript is remarkable for its elaborate illustrative concept (especially in the series of Biblical subjects), something rarely encountered in Books of Hours, and its sumptuous floral borders. The borders are often divided into sections and feature grotesques birds and animals and various mottos. Durrieu and Laborde connected the illumination of the manuscript with many artists, such as Jean Bourdichon, Jean Colombe, and the towns of Besançon and Montluçon. According to Sterligov, the Book of Hours was decorated in the workshop of Jean Colombe in. This attribution was supported by Schaefer who also suggested that Colombe's son Philibert as well as Jacquelin Raoul de Montluçon and the artist conventionally called Coularti took part in the work.

The manuscript belonged to Louis XII. Its history is unknown until the 17th century when it formed part of the collection of Pierre Séguier (proved by his code – *d953* – in the manuscript). It was then transferred to Saint-Germain-des-Prés along with the rest of Séguier's collection and subsequently purchased by Piotr Dubrovsky.

ENTERED THE PUBLIC LIBRARY IN 1805 (1849–61 THE HERMITAGE, 5.2.87).

LITERATURE: Gille 1860, p. 66; Cat. Séguier 1868, p. 12; Delisle 1868–81, 1, p. 121, note 4; 2, p. 56; Laborde 1936–38, pp. 122–126, pl. L; Das Stundenbuch Ludwigs von Orléans (facsimile edition; commentary by Andrei Sterligow), Leipzig, 1980; C. Schaefer, "Le Livre d'Heures de Louis d'Orléans", Gazette des Beaux-Arts, 1982, December, pp. 240, 241, Avril, Reynaud, p. 400.

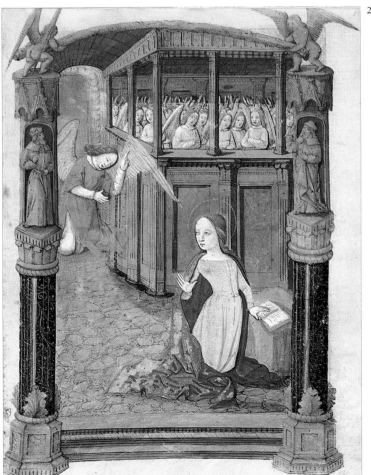

217

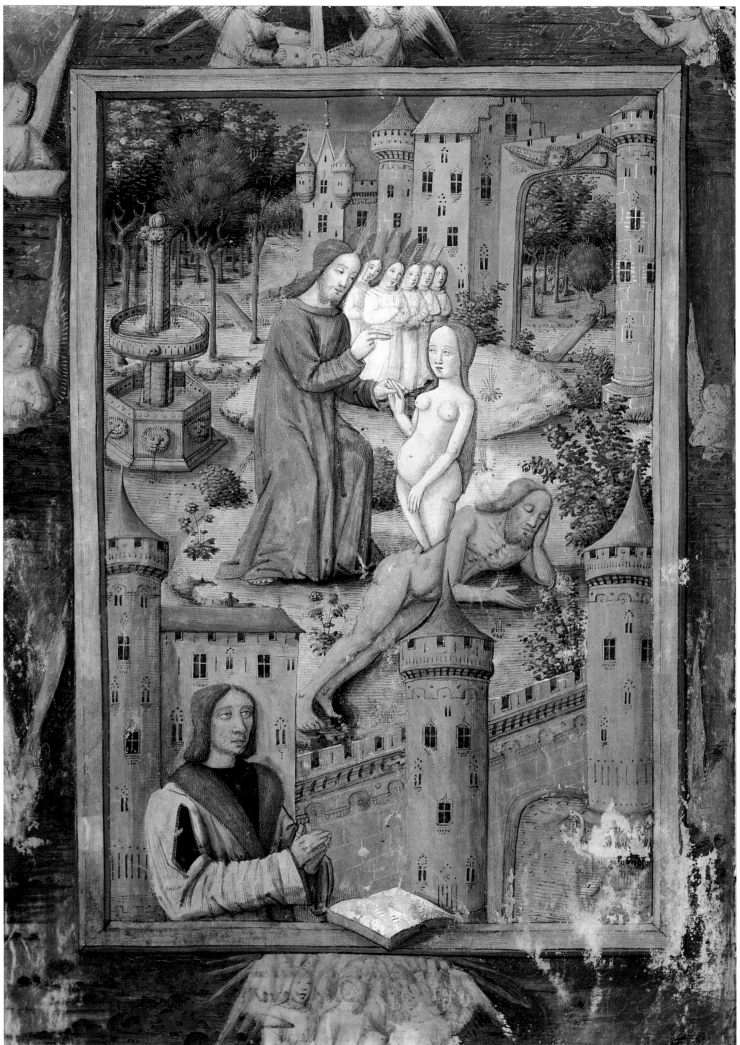

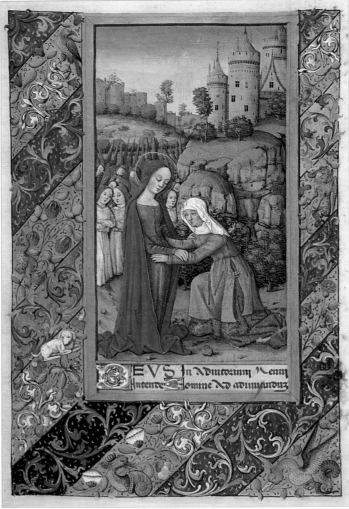

219

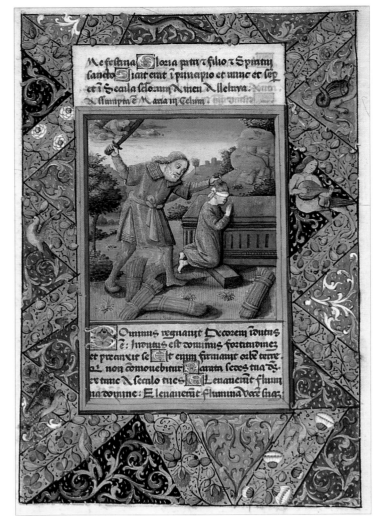

220

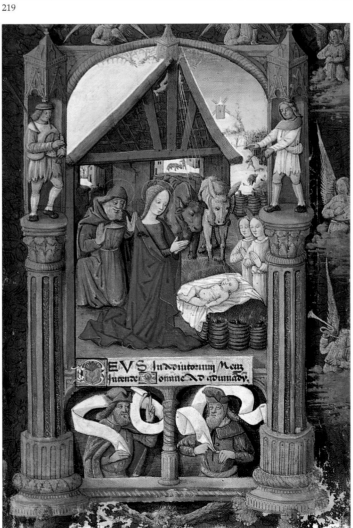

221

Page 180
217. F. 12r: THE ANNUNCIATION.
This type of border, with Gothic and Italianized motifs combined and the figures of prophets in tabernacles, was popular with French artists, including Jean Colombe, who continued Fouquet's traditions.

Page 181
218. F. 11v: THE CREATION OF EVE.
The miniature opens the series of biblical themes. Its main subject is surrounded by an imitation of a wooden frame, giving the impression that it is being viewed through a window. This effect is further enhanced by an open book lying on the frame. The owner is seen in front of the book praying. Behind the wall of the celestial Jerusalem is the Garden of Eden with a fountain – the source of the four rivers. God the Father is creating Eve in the presence of a chorus of angels.

219. F. 18v: THE VISITATION.
The sectional division of borders seen here appeared in French illuminated manuscripts in the 1480s and 1490s.

220. F. 19r: THE SACRIFICE OF ISAAC.
The colour pattern of this illustration, which is dominated by gold and unites the miniature and the border into a single whole, is typical of the biblical series.

221. F. 25r: THE NATIVITY.
One of the best compositions in this Book of Hours, the miniature shows the prophets on the bottom and angels playing musical instruments in the background. The winter landscape seen behind the manger where Christ was born is of special interest. Perhaps the idea for the landscape was suggested by the famous winter scene in the Très Riches Heures du Duc de Berry, the illumination of which was completed by Colombe.

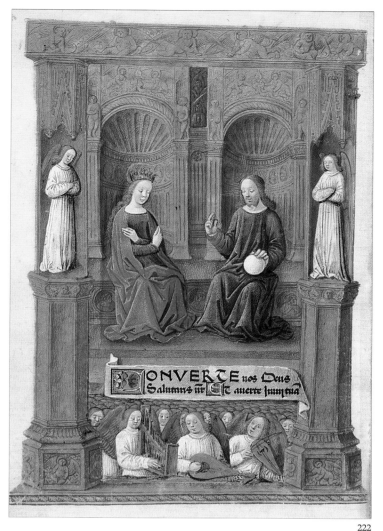

222

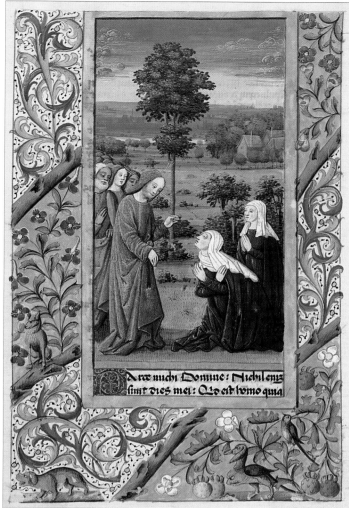

223

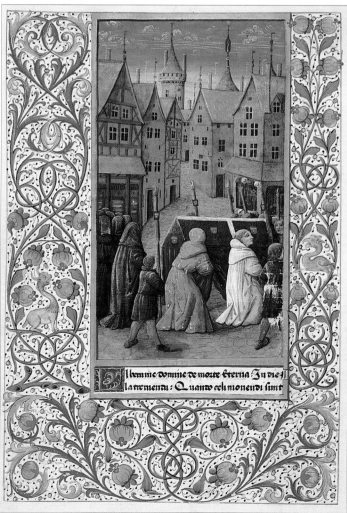

224

222. F. 40v: THE CORONATION OF THE VIRGIN.

This iconographic pattern was used by Colombe in his main works: the Très Riches Heures du Duc de Berry and the Book of Hours of Louis de Lavale. The Virgin and Christ sit on a throne, which is the author's interpretation of Italian Renaissance motifs.

223. F. 69v: CHRIST MEETING MARTHA AND MARY.

The miniature introduces a group of illustrations devoted to Lazarus. The landscape in the background is the best in the manuscript and is reminiscent of the views of the Loire valley by Jean Fouquet. Its three-dimensional effect is enhanced by the hazy air throbbing with light, the alternating planes receding into the blue mass of a forest on the horizon, and the shadows of clouds moving across the valley. The border with floral ornamentation and green stems is typical of the second part of the manuscript.

224. F. 79v: FUNERARY PROCESSION.

The miniature shows a cityscape. The sombre hues of grey and violet and the balanced use of gold helped the artist to create a believable view of the city, rich in realistic detail such as the timber-framed houses, a great number of steeples rising above their roofs, and the shops on the ground floors displaying hats and fabrics for sale, the border is painted by one of the Toulouse artists who worked on the missel of Jean de Foix.

MISSAL
Missale
France. 1490.

451 ff. 375 x 275 mm (text 234 x 152 mm). Parchment. Latin.
3 miniatures; 17 large historiated initials framed with borders; numerous small and large
multicoloured initials against golden backgrounds with flowers; grotesque figures and fantastic
beasts. Binding: 15th century. Leather over wooden boards; 2 metal clasps; traces of 5 knobs on
the covers; the corner decorations are missing. Erm.lat.19.

The complete text of the Missal includes: a Calendar of the Use of Paris, readings from the Old Testament, the Gospels and the Epistles and some prayers with musical notation. Gille referred to this rich manuscript as "one of the most beautiful and wonderfully preserved French Missals". The style of the illumination, which is typical of ateliers of the Loire valley, Bourges and Paris in the last two decades of the 15th century, is characterized by airy landscapes, meticulous penwork, a skilful use of gold hatching, a light colour scheme and various types of borders. However, the angularity of the figures and the primitive treatment of faces rule out the possibility that the illumination was executed by an artist of the rank of Jean Colombe or Jean Bourdichon.

The monograms in the decoration prompted Gille to think that the manuscript had been produced for a lady close to Anne of Brittany, the founder of a branch of the Franciscan Order (Cordeliers) for women. The later history of the manuscript is unknown. At the beginning of the 19th century it belonged to Count Felix Pototski (whose *ex libris* is still preserved on the fly-leaf). The Missal was purchased for the Hermitage Library in 1860 (5.3.60).

ENTERED THE PUBLIC LIBRARY IN 1861.

LITERATURE: Gille 1860, pp. 58–60; Laborde 1936–38, pp. 171–173, pl. LXXIV.

225

225. PAGE WITH HISTORIATED INITIAL REPRESENTING THE RESURRECTION AND A COUNTRYSIDE TYPICAL OF THE LOIRE. F° 235.
The large size of the notes, the blue lettrines and the luxurious border with a monster in the right-hand margin produces a solemn ensemble. Below, two angels show the letters "J" and "M" (Jésus Marie) reunited by a "lacs d'amour" — symbol of the order of the cordelières. We also find this monogram on f°s 38 and 302 ; numerous historiated initials represent benedictines.

226,227. FF.222v–223r: THE CRUCIFIXION WITH THE VIRGIN, ST JOHN AND THE HOLY WOMEN (LEFT). THE LAST JUDGEMENT (RIGHT).
These two miniatures facing each other mark the climax of the Missal's illumination. Laborde compared them with altarpieces, yet this comparison was based on the miniatures' scale, rather than their style. The landscape background in the Crucifixion with distant blue hills topped with castles is painted in the manner of the school of the Loire valley. Christ the Judge in glory surrounded by angels is flanked on the left by the group of the Virgin and the holy women (with St Catherine in the foreground) and on the right by the apostles (with St John and St Peter in the foreground). The border framing this page is divided into sections and carries the motto Ave Maria gratia plena. The border of the left page is different, its floral ornament being lighter; the cross in the lower margin is an unusual detail. Such a combination of different types of borders in one manuscript is typical of French illumination of the late 1480s and 1490s.

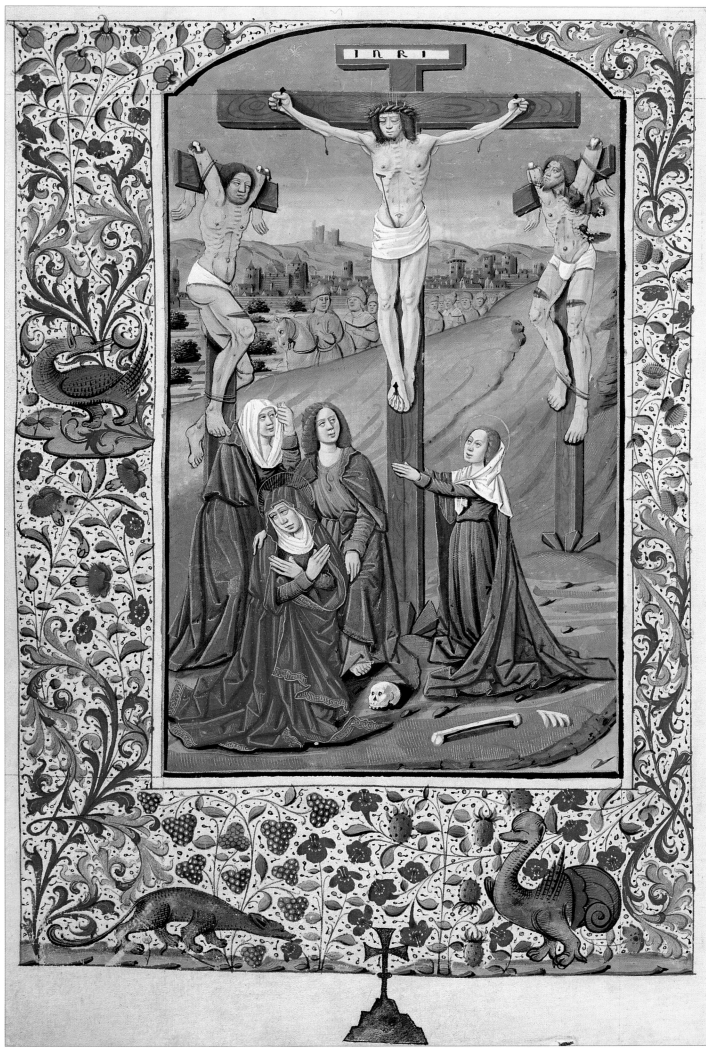

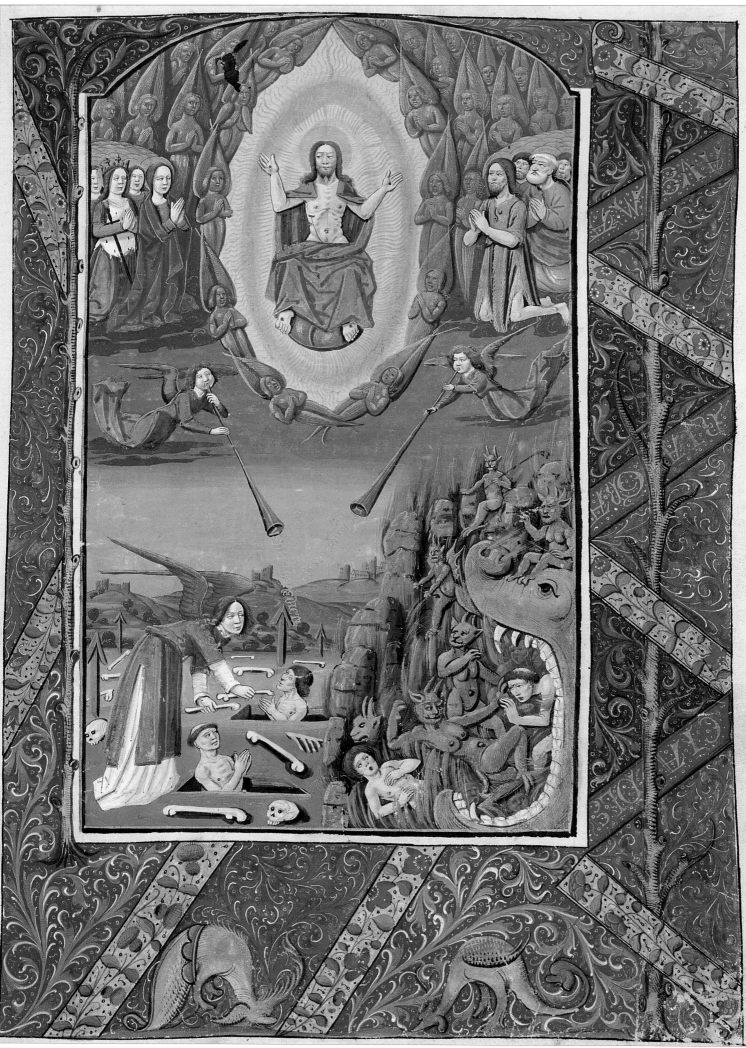

228, 229
THE AMBOISE CHRONICLE
Chronique d'Amboise
France. Late 15th century.

36 ff. 298 x 200 mm (text 180 x 100 mm). Parchment. French.
1 miniature; 1 sheet with the arms of France; coloured initials on golden backgrounds.
Binding: 18th or early 19th century (commissioned by Piotr Dubrovsky). Green velvet over
cardboard; blind-stamped frame; doublures of gold brocade;
fly-leaves on one side of grey and violet striped silk; gilt-edged. Fr.F.v.IV.7.

This is probably the only surviving copy of the unpublished chronicle containing the history of Amboise from Caesar to Clovis. The author of the chronicle (possibly Pierre Sala) wrote it specially for the king, for he espoused the idea that every seignior who had owned Amboise and taken part in its construction later became a great monarch or an emperor and contributed to the strengthening of France. The almost grotesque rendering of the characters' features reveals the miniaturist's outstanding gift for portraiture. The king depicted in the chronicle is undoubtedly Charles VIII and not Louis XII, as Laborde maintained (for comparison see another portrait of Charles VIII: Paris, Bibliothèque Nationale, MS.lat.1190). The artist handles the vestments and the texture of the gold brocade and fur with ease and skill, and renders the view of Amboise Castle surmounting the hill across the Loire very accurately. In spite of the formal similarities with Bourdichon's manner, such as the use of a large format and the imitation of a wooden frame, there are no grounds for postulating a connection between the miniature and his school, as Laborde did. François Avril suggested that the illumination was executed in the atelier of Jean Perréal.
In the 17th century, the Missal belonged to Pierre Séguier; in 1735, it entered Saint-Germain-des-Prés whence it was obtained by Piotr Dubrovsky at the end of the 18th century.

ENTERED THE PUBLIC LIBRARY IN 1805 (1849–61 THE HERMITAGE, 5.3.37).

LITERATURE: Cat. Séguier 1686, Inv. des Miniatures, p. 15; Montfaucon 1739, 2, p. 1073, No 301; Gille 1860, pp. 84, 85; Bertrand 1874, p. 108; Laborde 1936–38, pp. 131, 132, pl. LIII; Shishmariov Fund 1965, pp. 37, 89, 90.

228

Page 188
228. F. 3r: THE ARMS OF FRANCE.
The coat of arms is supported by a legist and a warrior.

229. F. 2v: PRESENTATION OF THE MANUSCRIPT TO THE KING.
The author kneels to present his work to Charles VIII who is accompanied by two courtiers, one of them a falconer. In the background is the Loire and a view of Amboise Castle and its environs with a church.

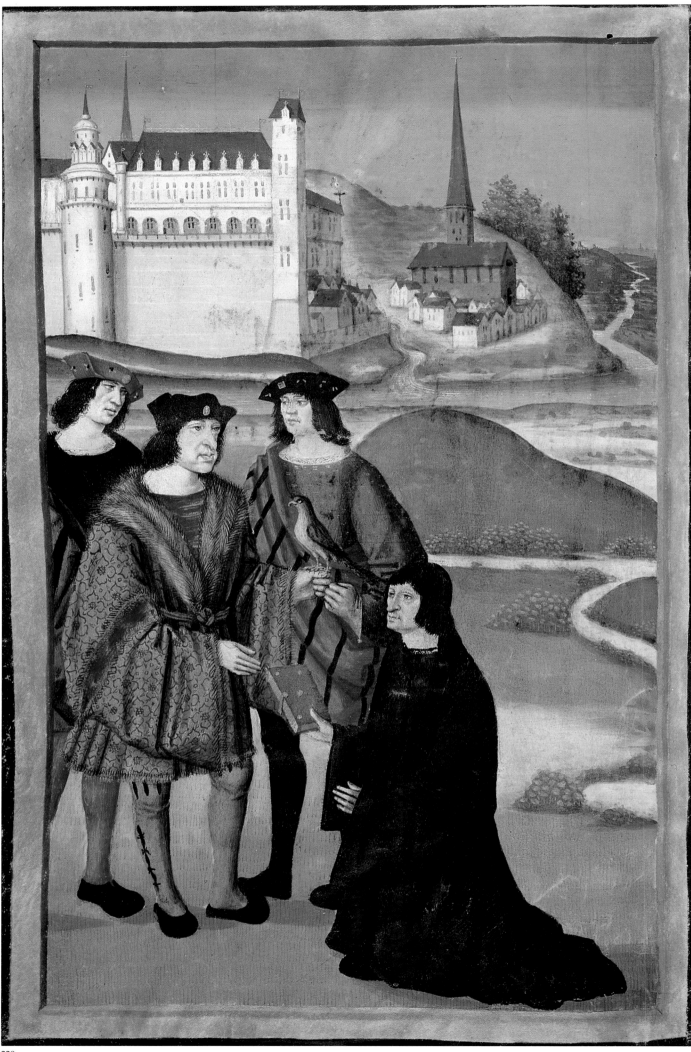

229

230-232
PLUTARCH.
Discourse on the Marriage of Pollion and Eurydice
Plutarque. Discours sur le Mariage de Pollion et d'Eurydice
France. Late 15th or early 16th century.
46 ff. 245 x 165 mm (text 165 x 100 mm). Parchment. French.
12 miniatures; coloured initials.
Binding: 17th century. Light-brown leather with two gold threads over cardboard;
stamped designs on the spine; gilt-edged.
Fr.Q.v.III.3.

This translation of Plutarch's text was produced in 1499 by Jean Laudet on the occasion of the marriage of Louis XII and Anne of Brittany, widow of Charles VIII.

The eleven paintings in this manuscript are part of the prolific work of Jean Pichore, a Parisian illuminator who executed a great number of prestigious commissions for the court during the reign of Louis VII. He also worked for the Cardinal of Amboise and Louise de Vouvre.

Laborde thought that the miniatures were elegant, well-arranged and amusing, though lacking in facial expressiveness. In one way or another, the illumination of Plutarch's *Discourse* is a good example of French illumination of the late 15th and early 16th centuries, when miniaturists developed a taste for decoration combining Gothic and Italianate motifs, as well as for interesting narration and a large format.

The presence of the royal arms united with the arms of Brittany on f.46r proves that the manuscript was destined for Anne of Brittany. In the 17th century, it was owned by Pierre Séguier, and in 1735 was transferred to Saint-Germain-des-Prés; it was purchased by Piotr Dubrovsky before 1792.

ENTERED THE PUBLIC LIBRARY IN 1805 (1849–61 THE HERMITAGE, 5.2.43).

LITERATURE: Cat. Séguier 1686, Inv. des Miniatures, p. 9; Montfaucon 1739, 2, p. 1113, No 1034; Gille 1860, p. 85; Bertrand 1874, p. 96; Yaremich 1914, p. 41; Laborde 1936–38, pp. 132, 133, pl. LIV; D. Aulotte, "Etudes sur l'influence de Plutarque au seizième siècle", Bibliothèque d'Humanisme et Renaissance: Traveaux et documents, 21, Geneva, 1959, pp. 606–612; Shishmariov Fund 1965, pp. 42, 84.

230

230. F. 46: COATS OF ARMS : FRANCE AND BRITTANY.

231. F. 1v: FRONTISPIECE.
This miniature illustrates the main idea of the text in allegorical form: Mercury, messenger of the Gods, explains that a marriage must be based on love (Venus in the centre) accompanied by the Three Graces (women on the left). The woman on the right symbolizes a sense of responsibility, an essential attribute of marriage. The figure of Venus is particularly attractive: tiny white doves fly around her head which is adorned with a wreath, her right hand rests on the harp, and her only accessories are the chain with a medallion and a transparent sash which she holds in a vain attempt to cover her nudity.

Framing the miniature is an imaginary portico, and the expert Late Gothic wood carving shown in the upper part complements the archaic motifs of the interior.

Page 191
232. F. 21v: ON THE MORAL USE OF A MIRROR WHICH REFLECTS BOTH VICES AND VIRTUES.
Pointing at the mirror, the wise author warns children of vices and sins which would disfigure their "very beautiful" faces. Over the fireplace is the royal coat of arms; in the background an elegant lady, "chaste and kind-hearted", is arranging her hair that has escaped from a black cap, such as were worn in Brittany and popularized by Anne of Brittany.

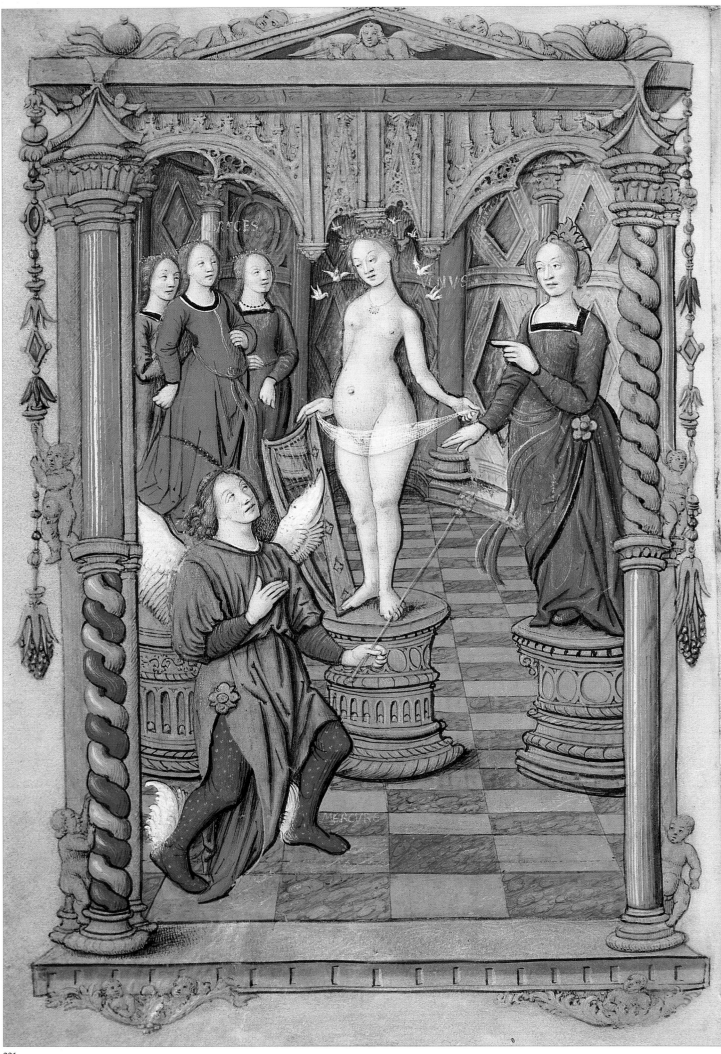

231

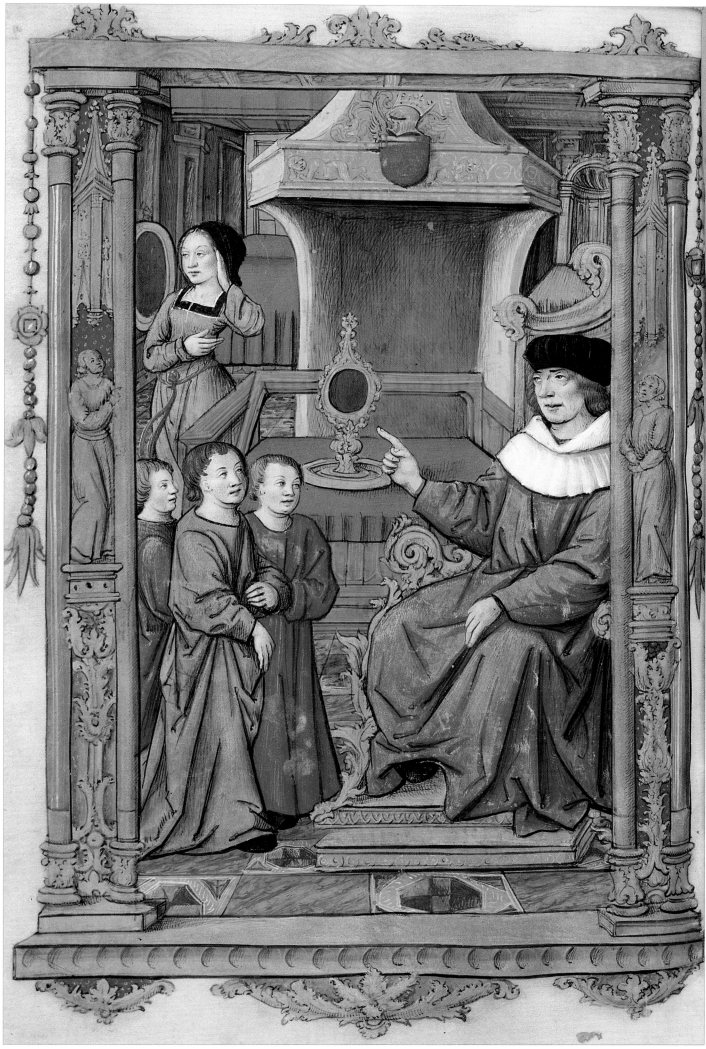

233–242
MATTHAEUS PLATEARIUS. Book of Simple Medicine
Matthaeus Platearius. Le Livre des Simples Medecines

France. Late 15th or early 16th century.

164 ff. 355 x 260 mm (text 240 x 175 mm). Parchment. French.
9 full-page and 2 quarter-page miniatures; 109 illustrations at the end of the manuscript;
ornamental border preceding the index; decorated initial and a vertical border on the opening
page of the prologue; ornamental frame and a coloured initial at the beginning
of the main text; numerous small red or blue initials with gold and silver.
Binding: 16th century. Green morocco over cardboard; gold-tooled border and centrepiece
on the front and back covers; stamped designs on the spine; gilt-edged.
Fr.F.v.VI.1.

The manuscript is a French translation of one of the most famous mediaeval studies on medicine by Matthaeus Platearius. The translation was very popular in the 15th century not only among physicians, but also among surgeons, pharmacists, quack doctors, and all those who could not read Latin and used Platearius' work as a reference-book. It gave a detailed description of each plant and listed its theurapetic effect. The Bibliothèque Nationale in Paris has 15 different copies of the French translation, one of which (MS.12322) was copied from the St Petersburg manuscript.

The illumination is of outstanding richness and quality. It was executed, according to Laborde, by Robinet Testard, who was *valet de chambre et enlumineur* to Charles d'Angoulême. This is one of Testard's later works: the earlier ones date to the 1470s. The illumination is based on the earlier manuscript housed in the Public Library (44), but this time the illuminator must have been set the task of creating a book which was both a practical medical reference-book and a luxury item. Thus the format of the miniatures was enlarged, the narrative compositions were made more elaborate and given new characters, including women. Landscape backgrounds with clouds in the sky and castles in the distance appeared in place of the unpainted parchment surface in the earlier manuscript. Miniatures were given thin gold borders and gold hatching was often employed. The "encyclopaedie" construction of the manuscript, in which pictures of plants accompanied their descriptions, gave way to a more decorative layout, with pictures separated from the text and placed at the end of the manuscript as a kind of "herbarium" arranged in tables. These tables were animated with entertaining motifs, insects and reptiles executed with remarkable skill. This luxury manuscript was produced for a noble lady – in Laborde's opinion for Louise of Savoy, wife of Charles, Count of Angoulême, and mother of Francis I of France.

François Avril suggested that the arms of Orléans-Angoulême at the beginning of the manuscript in the lower margin were painted over and replaced with another coat of arms, probably that of the physician of Charles V (f.2r), a later owner of the manuscript (the autograph of Charles V appears on ff.1r, 68r and 108r). In the 17th century, the volume was part of the library of Pierre Séguier, then in 1735 with his collection it was moved to Saint-Germain-des-Prés; sometime before 1792 it was purchased by Piotr Dubrovsky.

ENTERED THE PUBLIC LIBRARY IN 1805 (1849–61 THE HERMITAGE, 42.5.3).

LITERATURE: Cat. Séguier 1686, p. 19; Montfaucon 1739, 2, p. 1099, no 397; Gille 1860, p. 98; Bertrand 1874, p. 173; Delisle 1868–81, 2, p. 57, No 1817; Nikolayer, le Monde de l'Art, 1904, pp. 104, 108, 114, 120; Laborde 1936–38, pp. 162–164, pl. LXIX; La médicine médievale à travers les manuscrits de la Bibliothèque Nationale: Catalogue de l'Exposition, Paris, 1982, p. 77; J. Plummer (with the ass. of Gr. Clark), The Last Flowering: French Painting in Manuscripts (1420–1530) from American Collections, New York, London, 1982, pp. 46, 47; M.-J. Imbault-Huart, La Médicine au Moyen Age, Paris, 1983, p. 146; Platéarius: Le Livre des simples médecines (ed. by F. Avril), Paris, 1986.

233. F. 1v: THE AUTHOR AT WORK.
The miniature's large format, the fine penmanship seen in the treatment of the stylized Gothic architectural details, the attention paid to the interior (a fireplace with a burning fire and a chest with books piled on top are seen in adjacent rooms), and the use of gold hatching are typical traits of late 15th-century French illumination.

234. F. 2r: OPENING PAGE OF THE TEXT.
The text is framed with a border of flowers featuring a woman with blue wings folded on her back who holds an arrow and pets a dog. The border also contains the above-mentioned coat of arms, probably painted over the earlier one of which the crown and banderoles reading Le Livre des herbes et de tous arbres et les miniraus et métaus les pierres have survived.

235. F. 72v: EXTRACTION OF ALOE.
The miniature shows men catching aloe branches with nets in a river flowing in "Upper Babylonia".
It has more characters than the earlier version, including a woman wearing a stylish turban.

Page 194
236. F. 95v: EXTRACTION OF GOLD.
In addition to realistic movements, the artist also concerned himself with facial expressions.

Page 194
237. F. 109r: ALOE AND TWO KINDS OF CELERY.
Since this page opens the section containing depictions of plants, it is decorated with an elegant border of acanthus scrolls, birds and drolleries.

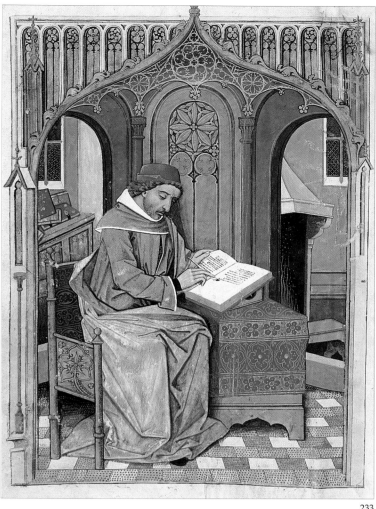

233

234

Page 194
238. F. 159v: OBTAINING TURPENTINE.
The simple scene of the earlier manuscript is turned here into
an idyllic genre picture. The man is a knight with a sword and
gold spurs, and the woman is dressed as a town-dweller.

Page 194
239. F. 160r: LADY AND UNICORN.
This is one of the most popular of all mediaeval motifs. Next to
the Lady is a thistle, which had broad symbolic meaning and
was often depicted by miniaturists. In the background is a
beaver (the castor, or castoreum, secreted by special glands of
this animal was highly valued in medicine) and a rose bush,
which provided bedegars, spongy galls produced by certain
incects and used against mosquito bites.

Page 195
240. F. 140r: EXTRACTION OF ALOE, GOLD,
ALUM AND ANTIMONY.
The miniature summarizes the ways of extracting medicine.
Compositionally, the scenes are close to the miniatures in the
body of the text, yet do not repeat them (cf. ff. 72v, 95v).

Page 196
241. F. 115v: ROSE AND SOLOMON'S-SEAL.
The artist often introduces naturalistic depictions of butterflies,
grasshoppers, frogs, etc. into the illumination, of "herbarium"
sheets.

Page 197
242. F. 163r: "NATURAL PRODUCTS".
The miniature depicts the ingredients of many medicinal
substances: nutmeg, turpentine, musk, sponge, lapis-lazuli,
pearl, vinegar, etc. At the bottom is a furnace, for the making
of glass.

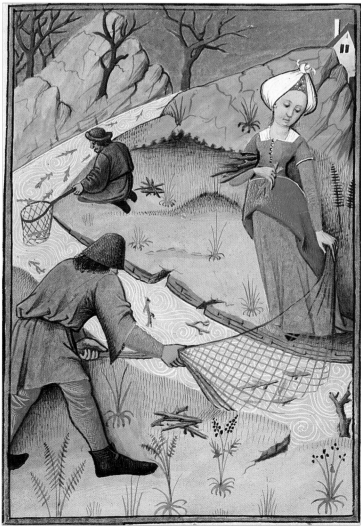

235

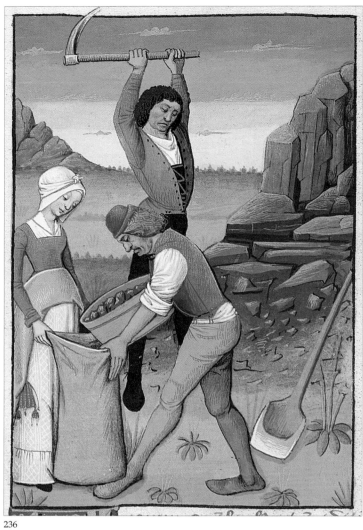

236

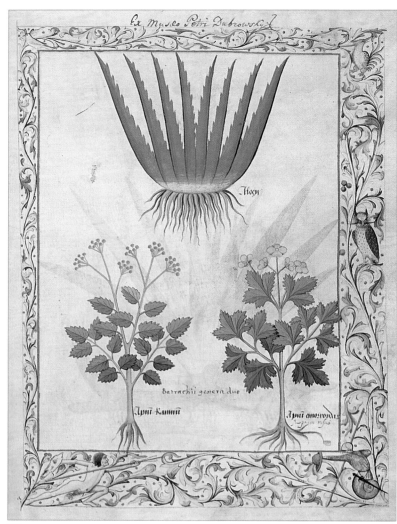

237

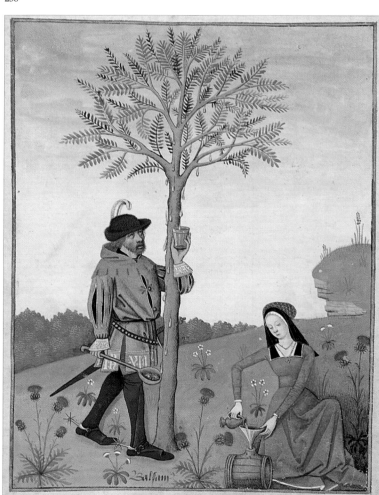

238

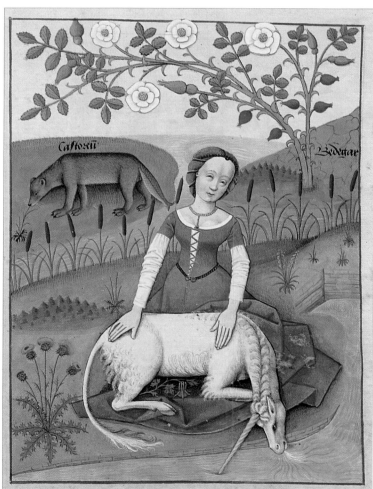

239

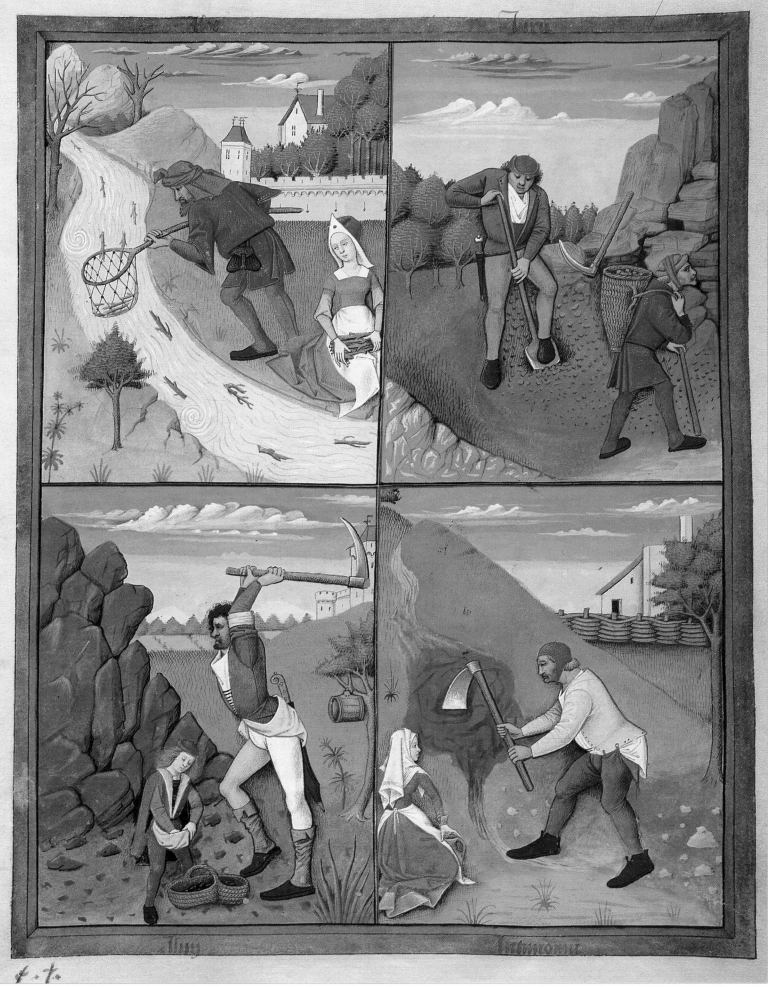

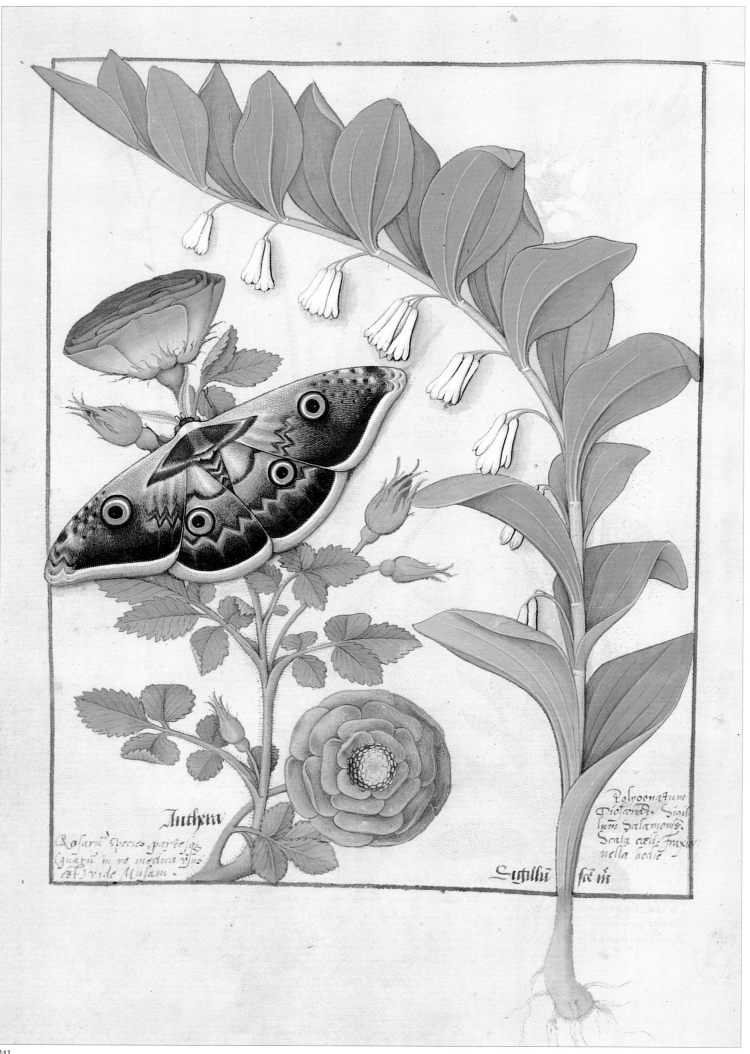

Anthera

Rosarie species, partesæ
quarú in re medica ysus
est. Vide Musam.

Polygonatum
Dioscoridi. Sigil
lum Salamonis.
Scala cæli. Fraxi
nella hodie

Sigillú scti

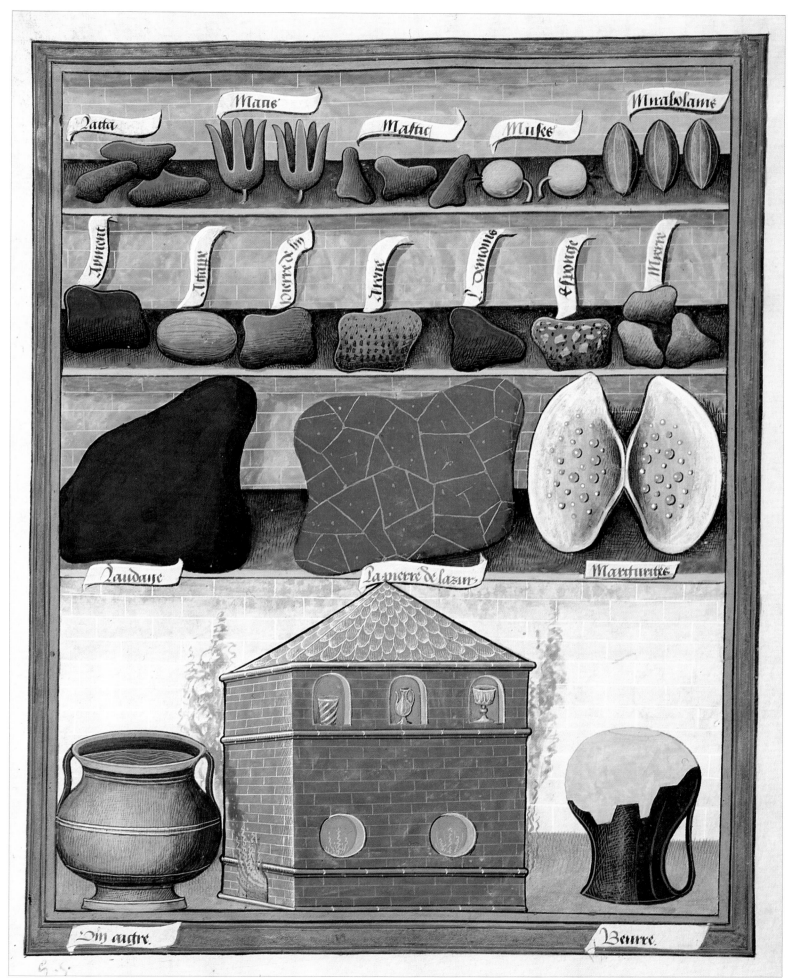

Datta Mane Mastic Musee Mirabolame

Apricut Chaum Pieretir Raque Avne L. Amonie Espouge Mirre

Laudane La pierre de lazur Marturites

Vin aigre Beurre

243
DISPUTE OF THREE LADIES
L'Altercation des Trois Dames
France (Rouen?). Late 15th or early 16th century.

39 ff. 267 x 177 mm (text 165 x 80 mm). Parchment. French
1 miniature opening the manuscript; golden initials on blue and red backgrounds.
Binding: late 15th or early 16th century; brown velvet over wooden boards;
holes and traces of 2 clasps; gilt-edged. Fr.F.v.XIV.11.

This is the only existing copy of a still unpublished didactic poem, *Dispute of Three Ladies about Pleasure, Usefulness and Elegance*, possibly written by Octavien de Saint-Gelais, a 15th-century French poet. Part of the text at the end of the manuscript is lost.

According to Laborde, the miniature belongs to the Parisian school of the time of Louis XII. This dating is quite plausible, although the elegance and a certain mannered quality of the drawing combined with the splendid border rich in such ornamental motifs as cornucopiae, putti, pearls and chandeliers indicate the work of masters from Rouen. François Avril mentions some artists who worked around 1500 for Cardinal Georges d'Amboise,

Archbishop of Rouen and Prime Minister of Louis XII. Furthermore, the names of Robert and Pierre Boyvin and Jean Serpin are known from bills of the Gaillon castle in Normandy owned by Georges d'Amboise. The ornamentation was probably derived from the illumination of Neapolitan manuscripts belonging to the cardinal.

The first page has what may have been the motto of the person who commissioned the work: *si à ton désir force*. In the 17th century, the manuscript was bought by Pierre Séguier, and in 1735 it entered Saint-Germain-des-Prés together with his collection. At the end of the 18th century the manuscript was bought by Piotr Dubrovsky.

ENTERED THE PUBLIC LIBRARY IN 1805 (1849–61 THE HERMITAGE, 5.3.49).

LITERATURE: Montfaucon 1739, 2, p. 1109, No 790; Gille 1860, pp. 81, 82; Delisle 1868–81, 2, p. 58; Bertrand 1874, p. 172; Laborde 1936–38, pp. 137, 138, pl. LVI; Shishmariov Fund 1965, pp. 105, 106, I. Delaunay; Le Manuscrit enluminé à Rouen au temps du cardinal Georges d'Amboise : œuvre de Robert Boyvin et de Jean Serpin dans Annales de Normandie, 45è année - n° 3, p. 211 à 244 (see particularly p. 214-15, 220 and 233).

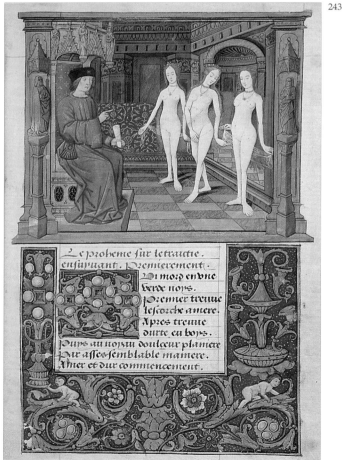

243

243. F. 1r: MINIATURE OPENING THE MANUSCRIPT.
The miniature shows the author sitting on an improvised throne and comparing the merits of Pleasure, Usefulness and Elegance personified by three nude women.

244
PETRARCH. Triumphs
François Petrarque. Les Triomphes
France (Rouen). Ca 1500.

328 ff. 312 x 205 mm (text 230 x 130 mm). Parchment. French.
13 miniatures; large and small initials on red and light blue backgrounds.
Binding: 16th century. Pink velvet with patterned surface over wooden boards; metal clasps.
Fr.F.v.XV.4.

Devoted to the superiority of the spiritual over the mundane, the *Triumphs* was Petrarch's last work. Its allegories were used by many 15th-century artists both in Italy and in France as subjects for frescoes, tapestries, sculptures, faience and, particularly, miniatures. A verse translation of the *Triumphs* was produced at the end of the 15th century by Simon Borgoin (Bourgouyne), *valet de chambre* to Louis XII. The prose translation appeared around the same time. The St Petersburg manuscript contains the prose version of the last three *Triumphs:* of Glory, Time, and Divinity. There are several existing copies of the Triumphs illustrated by masters from Rouen, Paris and the Loire valley, which shows how popular this work was at the court of Louis XII and Anne of Brittany. Some of the miniatures in the St Petersburg copy (e.g., f. 2v) have very close analogies in manuscripts now in the Österreichische Nationalbibliothek in Vienna (MSS.2581/2581) and the Bibliothèque Nationale in Paris (MS.fr.12424).

At the end of the 15th century and the beginning of the 16th, the manuscript appears to have belonged to King Louis XI of France, who also owned another more luxuriously illustrated copy of the work by Petrarch, 594 French, in the Bibliothèque Nationale de Paris. His autograph appears on F.3.

In the 17th century, it belonged to Pierre Séguier and passed to Saint-Germain-des-Prés in 1735. It was purchased by Piotr Dubrovsky at the end of the 18th century.

ENTERED THE PUBLIC LIBRARY IN 1805 (1849–61 THE HERMITAGE, 5.3.63).

LITERATURE: Cat. Séguier 1686, Inv. des Miniatures, p. 20; Montfaucon 1739, 2, p. 1108, No 743; Gille 1860, p. 91; Bertrand 1874, p. 190; Delisle 1868–81, 1, p. 124; Laborde 1936–38, p. 140; Shishmariov Fund 1965, p. 85; E.V. Bernadskaja, "Manoscritti del Petrarca nelle Bibliotheche di Leningrado", Italia medioevale e umanistica, 22, 1974, pp. 550–552; Bernadskaya 1984–85, pp. 201, 202.

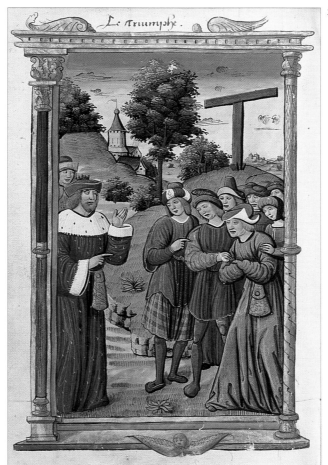

244

244. F. 242v: ILLUSTRATION TO THE TRIUMPH OF GLORY.
The miniature depicts the meeting of Alexander the Great and the philosopher Callisthenes, a disciple of Aristotle, who reprimands the conqueror for adopting Persian ways.

245-251
POETIC EPISTLES OF ANNE OF BRITTANY AND LOUIS XII
Epistres en vers françois dediés
à Anne de Bretagne et Louis XII
France. Early 16th century.

112 ff. 295 x 195 mm (text 165 x 110 mm). Parchment. French and Latin.
11 full-page miniatures with golden borders highlighted in blue;
large and small golden initials on dark red backgrounds.
Binding: 18th century (commissioned by Piotr Dubrovsky). Pink velvet over cardboard;
doublures and fly-leaves of gold brocade; gilt-edged.
Fr.F.v.XIV.8.

The manuscript contains 9 poetic epistles commissioned by Anne of Brittany during Louis XII's Italian campaigns. Epistles 1, 3 and 5 were written in Latin by Publio Fausto Andrelini (1471–1518), Louis XII's favourite poet, and translated into French by Mace de Villebresme, *valet de chambre* to the King (the Latin original of these three verses has been placed in the margin). Epistle 1 contains the Queen's entreaty to Louis to return as victor over the Venetians; epistle 3 expresses her concern over the risings in Venice; and in epistle 5 Anne laments the ungrateful behaviour of Pope Julius II. Epistles 2, 6 and 9 were written by the King's historiographer and poet Jean Dauton, Abbot of Sainte Croix d'Angle (1466–1527). In epistle 2 the three estates address Louis XII with a suggestion to return to peaceful life; epistle 6 is written in the name of Hector of Troy; and epistle 9 includes an elegy devoted to the Church Militant. Jean Dauton also translated from the Latin epistle 4, written by Jehan Francisque Suard of Bergamo, in which Louis XII invited Anne of Brittany to visit Italy. Epistle 7 was written by Jean Lemaire (1473 — ca 1525), a famous Belgian poet and chronicler, and contains Louis's answer to Hector; finally, epistle 8, written in the name of Mars, the god of war, was composed by M. de Mailly. In the 19th century, the illumination was ascribed to Jean Perréal, who was then considered the greatest artist of the late 15th and early 16th centuries (see H. de La Ferrière, F. Gille, E.-M. Bancel). The name of Jean Bourdichon was first mentioned by de Maulde La Clavière, who was supported by D. MacGibbon and Lauer. Laborde also considered Jean Perréal a possible candidate, but now the authorship of Bourdichon, Court Painter to Charles VIII, and Louis XII and Anne of Brittany, is generally accepted. The virtuoso technique displayed in the miniatures is typical of the artist, as are their large format, balanced harmony of composition and successful combination of individual likeness and subtle flattery in the portraits of his high-ranking figures. The St Petersburg manuscript is truly one of the artist's masterpieces.

The manuscript was undoubtedly part of the library of Louis XII and Anne of Brittany. In the 17th century, it belonged to Pierre Séguier and in 1735, together with the collection of his grandson, the Duke of Coislin, it was transferred to Saint-Germain-des-Prés. At the end of the 18th century it was purchased by Piotr Dubrovsky.

ENTERED THE PUBLIC LIBRARY IN 1805 (1849–61 THE HERMITAGE, 5.3.46).

LITERATURE: Cat. Séguier 1686, *Inv. des Miniatures, p. 15; Montfaucon 1739, 2, p. 1072, No 195; Gille 1860, pp. 93–96; Bertrand 1874, p. 172; H. de La Ferrière, Deux annés de mission à Saint-Pétersbourg, Paris, 1865, p. 3; E.-M. Bancel, Jehan Perréal dit Jehan de Paris, Paris, 1885, pp. 135, 136; R.-A.-M. de Maulde La Clavière, Jehan Perréal dit Jehan de Paris, Paris, 1896, pp. 98–100; Laborde 1936–38, pp. 147–149, pls LX–LXII; D. MacGibbon, Jean Bourdichon, a Court Painter of the 15th Century, Glasgow, 1933, pp. 113–115; Shishmariov Fund 1965, pp. 38, 39, 90–98 (epistle 6) Vorona, 1984 ; Avril, Reynaud.*

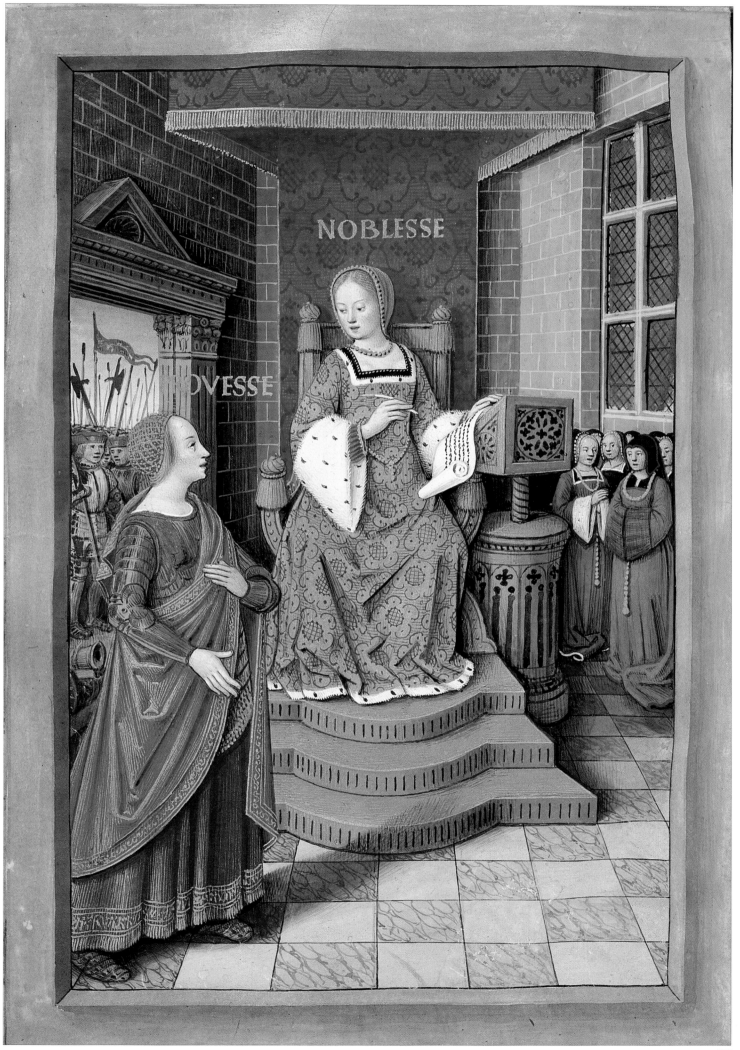

NOBLESSE

OVESSE

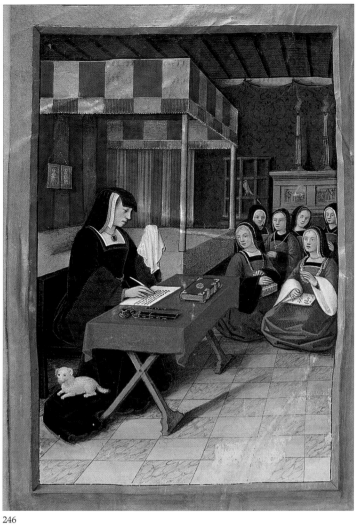

246

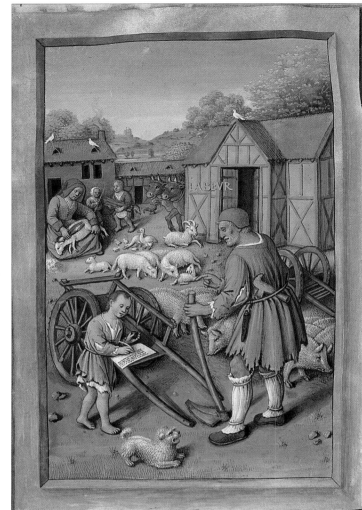

247

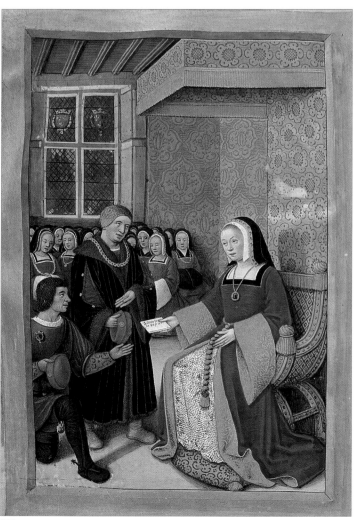

248

Page 204

246. F. 1v: ILLUSTRATION TO EPISTLE 1.
Anne of Brittany, a handkerchief in her hand and eyes red from tears, implores Louis to come back to France. This is one of the best portraits of the Queen. The dog at her feet is a symbol of conjugal fidelity; the diptych in the alcove depicts the Virgin and Child. The ladies of her court wear the traditional Breton caps which Anne popularized.

247. F. 31v: ILLUSTRATION TO EPISTLE 2.
The peasant, a representative of the third estate, is dictating an address to a boy. This is an elaborate country scene (rare for the time) handled in an idyllic manner.

248. F. 40v: ILLUSTRATION TO EPISTLE 3.
Anne gives the messengers a letter to her husband in the presence of her court. The windows are decorated with the royal arms.

249. F. 51v: ILLUSTRATION TO EPISTLE 4.
Louis writes a letter to his wife inviting her to come and visit him in Italy. His valour is symbolized by the armour and swords seen in the depths of the room and by the horse waiting for him at the door. The portrait of the King is not as good a likeness as the depiction of Anne.

Page 204
250. F. 58v: ILLUSTRATION TO EPISTLE 5.
The messengers stand at the door ready to take the letter which Anne is folding seated at her desk in the foreground.

Page 205
251. F. 81v: ILLUSTRATION TO EPISTLE 7.
Enthroned on a chair covered with fabric embroidered with fleurs-de-lis, Louis XII is dictating a reply to Hector of Troy. The messenger, who appears as Borée, ready to deliver the epistle to Elysium, is shown in the foreground.

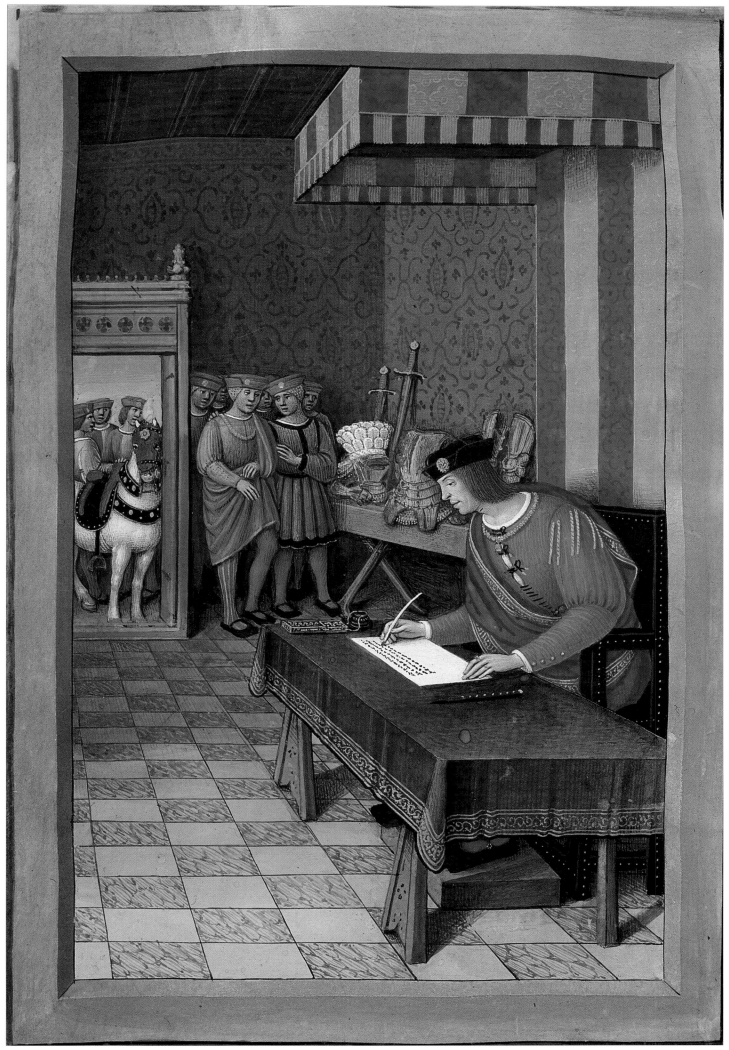

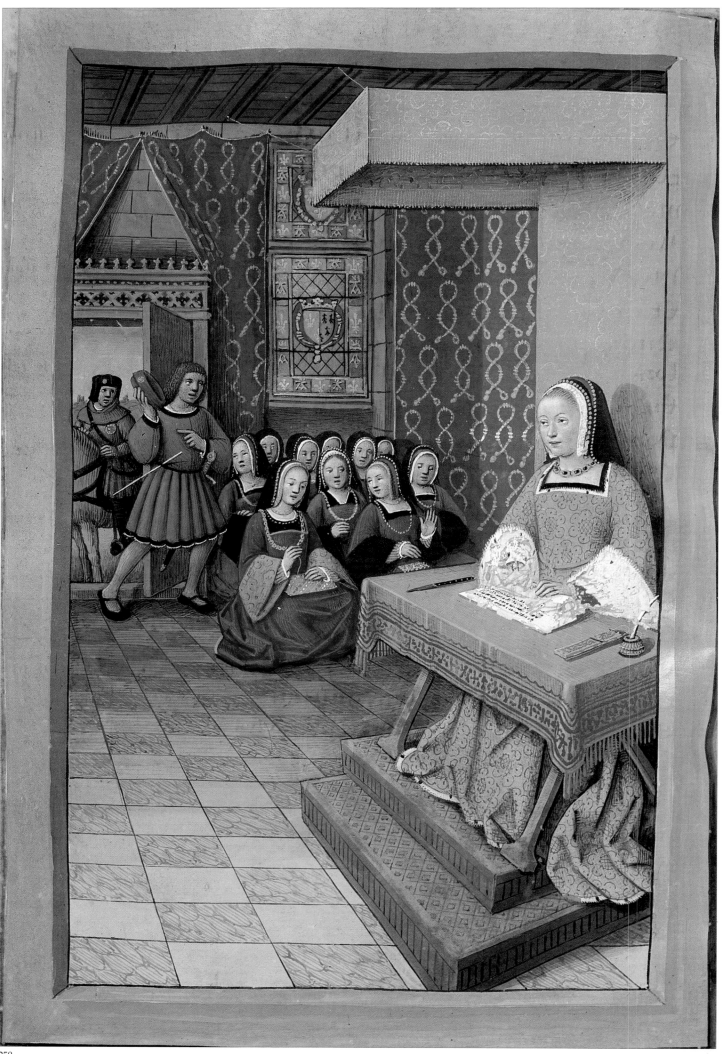

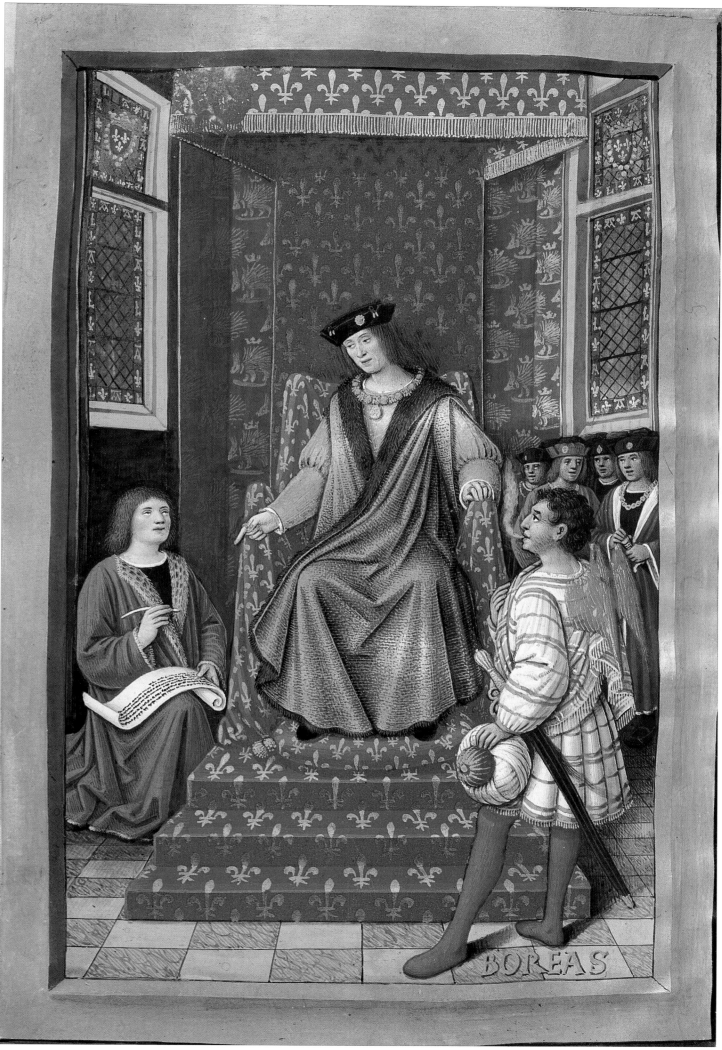

BOREAS

252-257
JEAN THENAUD
The Triumph of Fortitude and Prudence
Livre du Triomphe de la Force et de la Prudence
France. 1522–25.

184 ff. 410 x 290 mm (text 300 x 175 mm). Parchment. French.
19 full-page miniatures; 20 coloured initials on golden backgrounds.
Binding: 16th century. Lilac velvet over brown leather on cardboard; bronze corner decorations
on front and back covers; holes and traces of 2 clasps; 8 bands on the spine; gilt-edged.
Fr.F.v.XV.1.

This is an unpublished work consisting of two allegorical treatises: *On Fortitude and On Prudence*. M. Holban considers it to be a free interpretation of the *Praise of Folly* by Erasmus Desiderius, commissioned for Louise of Savoy by François du Moulin de Rochefort, who invited Erasmus to France in 1517. The supposed author is Jean Thenaud. There is also a second volume "*Les triomphes de justice et de tempérence*", Paris, Bibliothèque Nationale, Français 144). He describes himself as a pilgrim or an explorer leaving for the country of Allegory where he is to witness the triumph of the four cardinal virtues. The first two of these, Prudence and Fortitude, personify Louise of Savoy and her son Francis I of France, and the last two, Justice and Temperance, stand for Claude de France (Claudia), and Marguerite d'Angoulême, the King's sister. Thus in the French court Erasmus's humanist treatise was turned into a moralizing novel full of allegories and miracles. There are two more copies of the same work housed in the Bibliothèque Nationale (MS.fr.443) and the Bibliothèque de l'Arsenal, both in Paris, yet the St Petersburg manuscript, which was made for Louise of Savoy, is distinguished by its marvellous decoration. The illustrators strove to render the treatise's complex symbolic meaning in the clearest possible manner by filling their large-scale miniatures with characters taken from real life, allegories and narrative scenes. The illumination was executed by two different masters, the more interesting of whom is the man who produced the miniatures for the second part of the treatise on Prudence and the treatise on Fortitude. The original style of these tinted grisailles is associated with the Italian artists at the court of Francis I; it is possible that the miniaturist was indeed Italian. The beasts and dragons, depicted expressively and with ease, may have been influenced by drawings of Leonardo and his disciples.

In the 17th century, the manuscript belonged to Pierre Séguier; in 1735, it entered Saint-Germain-des-Prés and in 1792 was purchased by Piotr Dubrowsky in France.

ENTERED THE PUBLIC LIBRARY IN 1805 (1849–61 THE HERMITAGE, 5.3.50).

LITERATURE: Cat. Séguier *1686, p. 21; Montfaucon 1739, 2, p. 1108, No 726; Gille 1860, p. 92; Bertrand 1874, p. 189; Laborde 1936–38, pp. 153, 154, pl. LXIV; M. Holban, Un témoignage inconnu sur le rayonnement érasmien dans l'entourage immédiat de François I, Bucharest, 1955. A.M. Lecoq, "François 1er Imaginaire", Paris, 1987, p. 101-112, 282-301, 468, fig 43-47, 118-127.*

252. F. 9r: ILLUSTRATION TO CHAPTER TWO OF THE TREATISE ON PRUDENCE.
"Comment l'explorateur vient au jardin de Genesse et Naissance ou veoit ceulx qui ont en glorieuse enfance qui sont disposes de parvenir a Prudence. Puis veoit d'un couste les Azemeries et malheureusement nez et de l'aultre les monstrueux perir."
Urania is seated on the portal of the bridge leading to the garden. Pythagoras, who is standing on a column and holding banderoles inscribed with Latin texts in the centre at the bottom, is approached by Louise of Savoy and her court.

Page 208
253. F. 1r: FRONTISPIECE.
Louise of Savoy surrounded by her court receives the manuscript from the author who is wearing a monastic habit (probably Jean Thenaud, an associate of Rochefort, who we know was a monk). Above Louise's throne is her coat of arms.

Page 208
254. F. 32r: ILLUSTRATION TO CHAPTER SEVEN OF THE TREATISE ON PRUDENCE.
"Comment l'explorateur voulant a aller a Providence perd son chemin en la forest de Superstition en laquelle il trouve les astrologues les songeurs auxispices devins et mages en merveilleuses peines, puys il retrouve sondit chemin par lequel il vient a dame Providence qui luy exalte meintes doctrines."
This miniature was painted by the second illuminator.

Page 208
255. F. 162v: ILLUSTRATION TO CHAPTER EIGHT OF THE TREATISE ON FORTITUDE.
"Comment le Monarche des dictatures trouve en allant a Perseverance l'armee de Fantasmes larves et malignes esprit faicte de diverses et execrables bestes nygronantiques qu'il meste en fuyte et neant. Comment Perseverance le recoit et luy donne son anel."
The action starts at the bottom left corner, spirals upwards and culminates at the top edge of the miniature where the monarch, dressed in blue vestments with golden fleurs-de-lis (and easily recognizable as Francis I), is being received by Constancy personified. The royal warriors carry Crusader standards.

Page 208
256. F. 179v: ILLUSTRATION TO CHAPTER NINE OF THE TREATISE ON FORTITUDE.
"Comment l'explorateur fut transporte au paradis terrestre quil descrebe ou il veoit les neuf Preux et les neuf Preues qui portent le dictateur a dame forte qui le faict seoir en ung aultre throsne soubz l'arbre de vie pres la fontaine de paradis terrestre qui arrouse tout le lieu de volupte."

Page 209
257. F. 28v: ILLUSTRATION TO CHAPTER SIX OF THE TREATISE ON PRUDENCE.
"Comment l'explorateur vient au jardin de Intelligence environné du fleuve de Erreur sur lequel est le pont de facetie des troyes filles de Intelligence Simulation, Promptitude et Circonspection."

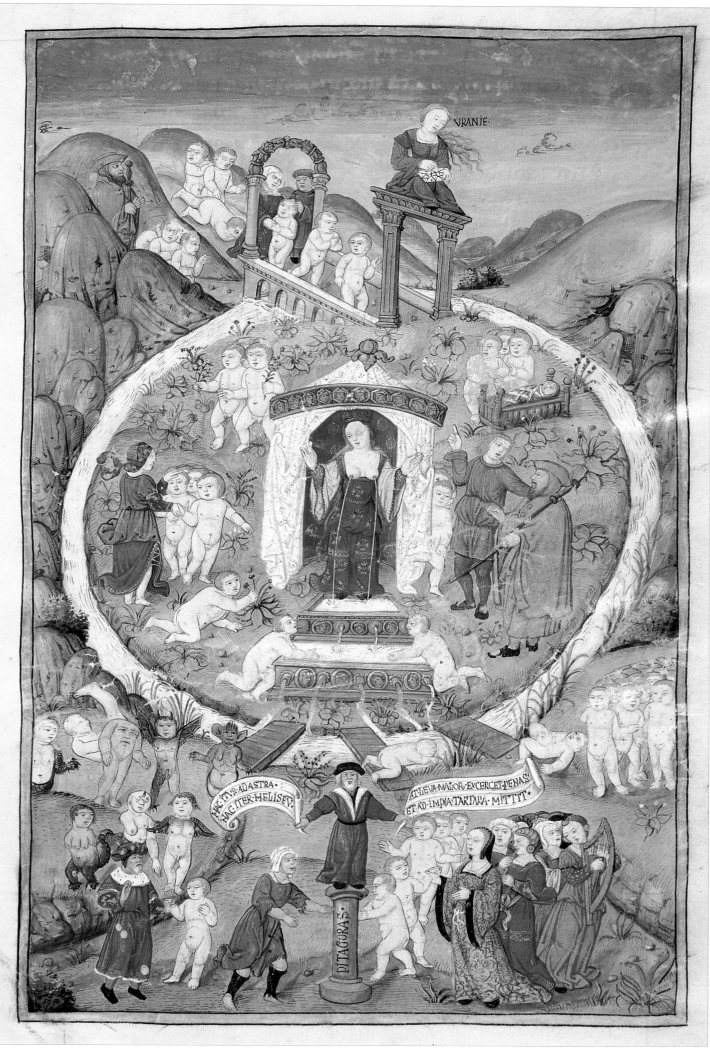

VRANIE·

HAC·ITVR·ADASTRA·
HAC·ITER·MELISEV·

ET·LEVA·MAIOR·EXCERCET·PENAS·
ET·AD·IMPIA·TARTARA·MITTIT·

PITAGORAS·

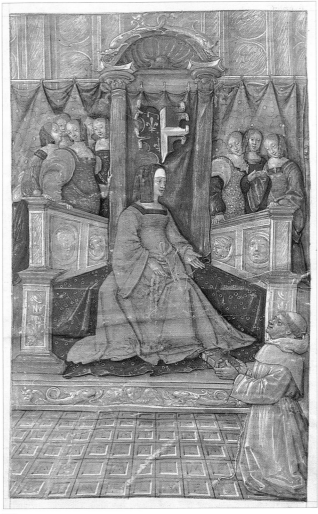

253

254

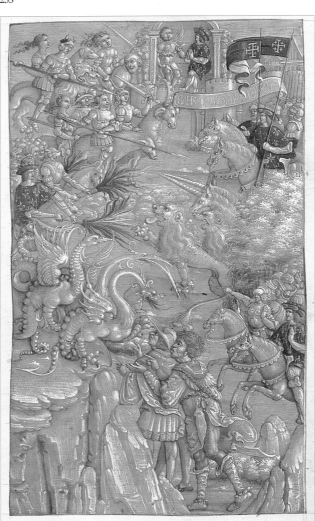

255

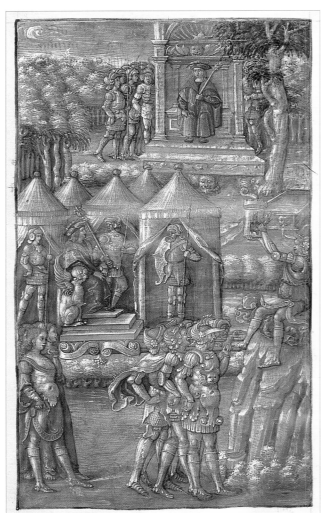

256

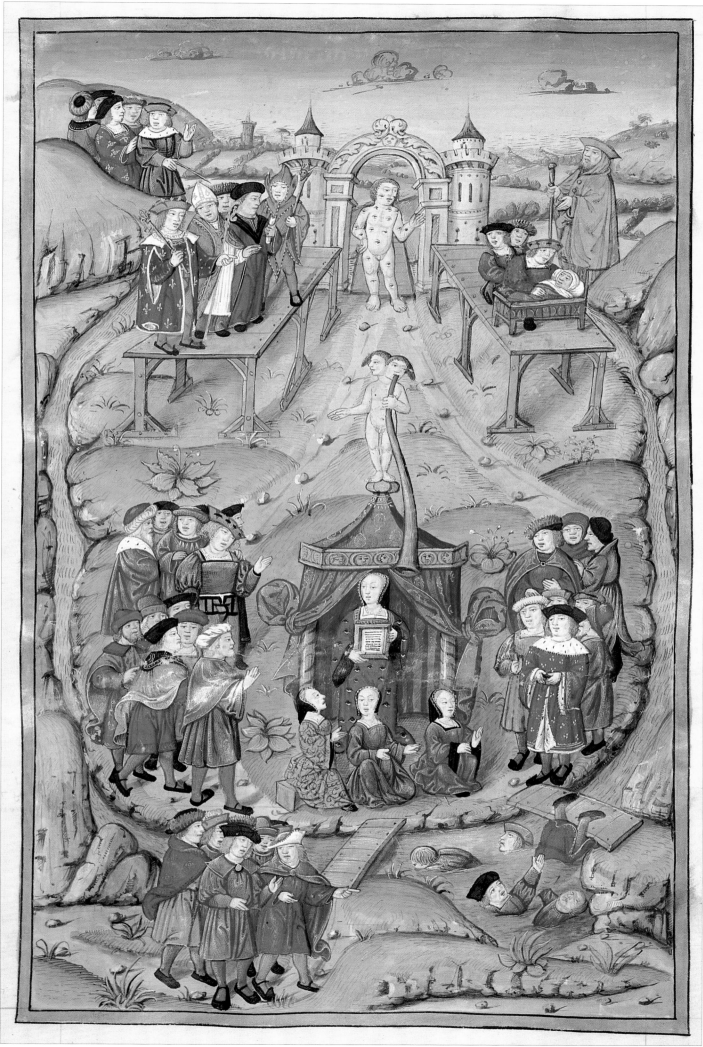

257

258
ORATIONS OF CICERO (translated by Etienne Le Blanc)
Discours de Cicéron
France. Between 1531 and 1538.
101 ff. 325 x 215 mm (text 210 x 130 mm). Parchment. French.
1 miniature (frontispiece); initials in various colours and gold; headings in gold and blue.
Binding: 16th century. Red velvet over wooden boards; borders and the arms of Montmorency
embroidered in silver on the front and back covers; silver clasps; gilt-edged.
Fr.F.v.XV.3.

The manuscript contains a dedication to Anne de Montmorency, Marshal of France, two treatises on the origin of the Romans and on the government of Rome from Romulus to Julius Caesar, and the following orations of Cicero: to the Romans in favour of Pompeii; to Caesar in defence of Marcus Claudius Marcellus, a Roman citizen who joined the Pompeian party (Pro Marcello); in defence of Quintus Ligarius, a Roman citizen who struggled against Caesar; and to the judges on the murder of Publius Clodius by Titus Annius Papianus Milo. The translation was by Etienne Le Blanc, a famous writer and scholar of that time. The clear-cut script, strict division of the text and its proportion relative to the margin reveal the influence of book-printing techniques, while the frontispiece miniature is one of the last masterpieces of manuscript illumination. With the help of a refined colour scheme, the artist managed to combine sparkling precious tableware, golden embroidery, lavish textiles, and jewellery into one harmonious whole. The illustration thus becomes an imposing group portrait produced at the time of the triumph of the Renaissance in France. The miniature's Renaissance-style architectural border suggested to some experts the name of Geoffroy Tory, a famous French typographer and type designer (ca 1480–1533), though such frames were then rather popular. It is certain that the St Petersburg miniature was painted by the same artist who decorated the works by Diodorus Siculus (Musée Condée, Chantilly, MS.fr.1672) with a frontispiece miniature depicting Antoine Macault reading his translation to Francis I.

The manuscript was made for Anne de Montmorency, Marshal of France (subsequently Constable of France); his coat of arms appears in the bottom part of the border framing the miniature. For some time the manuscript belonged to a priest of the Orléans diocese, as is proved by his ex libris on f. 4r: *Ex libris Danielis Degouillons Vinot, presbyteri Aurelianensis.* Piotr Dubrovsky purchased the manuscript at the end of the 18th century.

ENTERED THE PUBLIC LIBRARY IN 1805 (1849–61 THE HERMITAGE, 5.3.62).

LITERATURE: Gille 1860, pp. 90, 91; Bertrand 1874, pp. 189, 190; L. Delisle, "Traductions d'auteurs grecs et latins offertes à François et Anne de Montmorency par Etienne Le Blanc et Antoine Macault", Journal des savants, 1900, August–September, pp. 476–492; Yaremich 1914, p. 41; A. Blum, Ph. Lauer, La Miniature française aux XVe et XVIe siècles, Paris, Brussels, 1930, p. 100, pl. 90; J. Meurgey, Les principaux manuscrits à peintures du Musée Condé à Chantilly, Paris, 1930, p. 198; Laborde 1936–38, pp. 161, 162, pl. LXVIII; Dobias-Rozdestvenskaïa, Liublinskaya 1939, pp. 861–869. Livres du Connétable, la Bibliothèque d'Anne de Montmorency, exposition Château d'Ecouen, 1991, n° 2 (catalogue by T. Crépin-Leblond).

258. F. 3v: FRONTISPIECE.
Anne de Montmorency is the central character, seen full face, wearing the chain and order of St. Michael, and holding a long gold rod, insignia of his function as Marshal of France. He is approached by a bearded man wearing courtly dress, bowing slightly. It is not sure whether this depicts the translator, Etienne le Blanc, who, in spite of his high office in the royal administration, did not move in the court circles. Various other persons, also in courtly dress, surround the two main characters, watching the scene, which is exceptionally well set out.

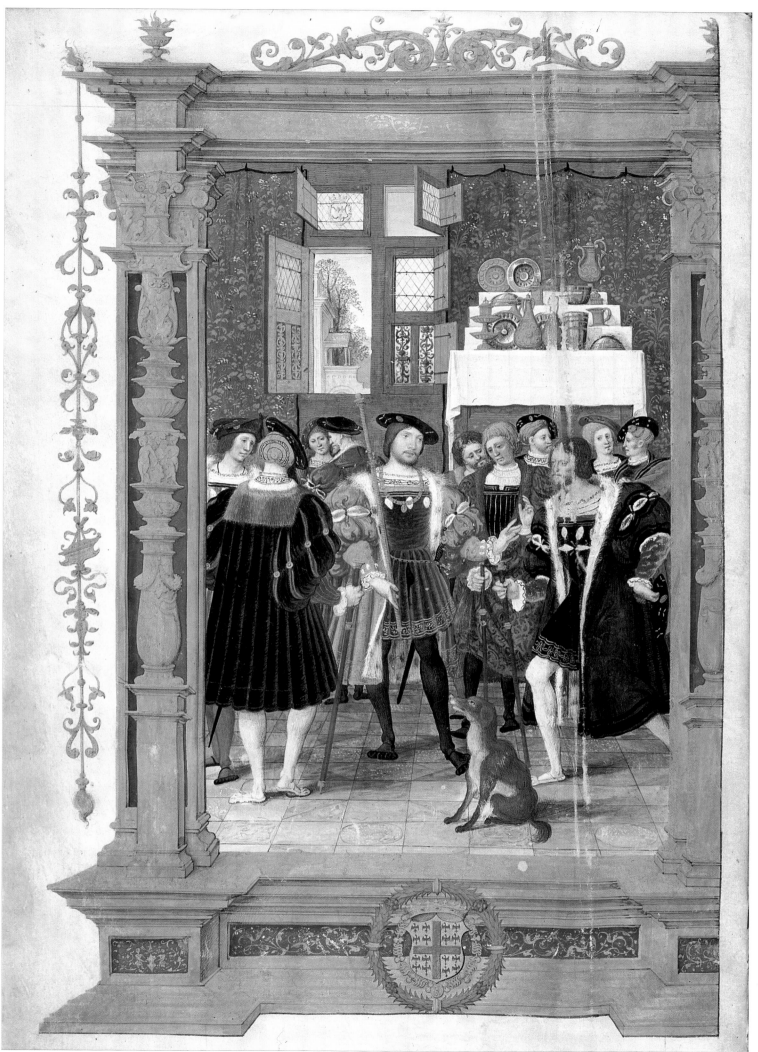

259
STATUTES OF THE ORDER OF ST MICHAEL
Statut de L'Ordre de Saint Michel

France. 16th century.

43 ff. 260 x 180 mm (text 185 x 110 mm). Parchment. French.
1 miniature at the beginning of the manuscript; initials in various colours and gold.
Binding: 16th century. Dark leather over cardboard;
gold-tooled border and centrepiece; banded spine; gilt-edged.
Fr.Q.v.II.2.

Louis XI's ordinance of 1 August 1469 instituting the Order of St Michael, stipulated that two copies of the Order's rules be made when a new member was accepted: one for the new member and one for the king. These copies had to be decorated with a miniature depicting the king and the first knights of the Order, which embraced the highest aristocracy, those closest to the king. The St Petersburg manuscript is one of the regular copies of the rules made for a new member of the Order. On f. 44r is an imitation of the king's signature (Louis). Laborde incorrectly dated the manuscript to 1476 (with a question mark). The style of the miniature, the costumes of the king and the knights are indicative of the 16th century. The somewhat grotesque quality to the faces and the proportions of the short-legged figures standing sturdily on the tiled floor show a resemblance to northern art. Durrieu, who examined the miniature at the beginning of this century, ascribed it to the school of Etienne Collault, Parisian artist who executed, in 1523 and 1528, a series of copies of rules for François I, for knights newly admitted into the order.

The inside of the front cover bears the inscription, *A Roland Hacteus*, which is possibly the name of the manuscript's first owner. In the 17th century, the manuscript belonged to Louis de Machon, a canon at Toul, who presented it to Pierre Séguier. The manuscript was given by Saint-Germain-des-Prés in 1735 by the Duke of Coislin, Séguier's grandson. At the end of the 18th century it was bought by Piotr Dubrovsky.

ENTERED THE PUBLIC LIBRARY IN 1805 (1849–61 THE HERMITAGE, 5.2.40).

LITERATURE: Montfaucon 1739, 2, p. 1029, No 219; Gille 1860, pp. 82, 83; Bertrand 1874, p. 77; Laborde 1936–38, pp. 107, 108, pl. XLVI.

259. F. 9r: KING LOUIS XI ENTHRONED
SURROUNDED BY THE KNIGHTS
OF THE ORDER OF ST MICHAEL.

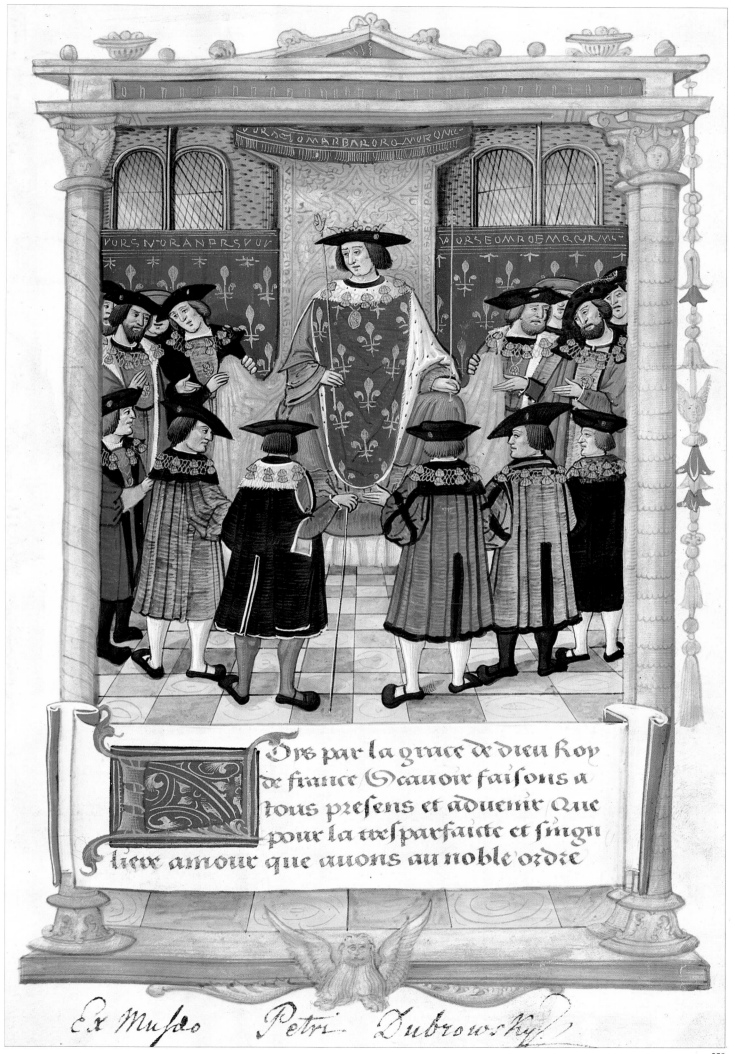

Trs par la grace de dieu Roy
de france Scauoir faisons a
tous presens et aduenir. Que
pour la tresparfaicte et singu
liere amour que auons au noble ordre

260-281
MATFRES ERMENGAUS DE BÉZIERS
The Love Breviary
Matfres Ermengaus de Béziers. Lo Breviari d'amor

Catalonia (Lérida). First half of the 14th century.
252 ff. 350 x 245 mm (text 225 x 170 mm). Parchment. Provençal.
9 full-page and 17 half-page miniatures; 142 miniatures approximately 70 x 60 mm;
31 historiated initials; numerous grotesque coloured initials; 2 frames with medallions.
Binding: 18th or early 19th century (commissioned by Piotr Dubrovsky).
Blind-stamped pink velvet over cardboard; doublures of gold brocade;
fly-leaves of green morocco with gold-tooled border.
Prov.F.v.XIV.1.

Matfres Ermengaus de Béziers (died after 1322) was a Provençal troubadour. Although his poem was quite popular, especially in the 14th century (there are 12 surviving copies, all from that time), little is known about the author. He wrote his poem between 1288 and 1292, when he was a cleric; at the end of his life he joined the Franciscan order. The main text is preceded by two verses, canzone and sirvente, supplied with musical notation composed by Matfres. None of the other existing copies of the poem have these verses: unfortunately, this most complete manuscript was not taken into account at the time when the poem was published (1869–81). All the parts of the poem are connected by the main idea that the world emanates love, of which there are many varieties: love for God, for one's neighbour, for earthly joys, and, finally, for a woman.

Numerous miniatures, which often include text, are a pictorial treatise in themselves. They illustrate all the main themes of the Breviary such as the cosmogonic conceptions dealt with in the first section, theological problems and subjects from the Bible and the Gospels discussed in the second section, and love for a woman and the temptations accompanying it, spoken about in the last section. The abundance of interesting details from day-to-day existence, the clothes and household utensils, make these miniatures an amazing documentary of mediaeval life. The illuminators' range of ornamenting techniques, the organization of the page and the correlation of illumination and text is striking. Despite the variety of ornamental devices, the illumination reveals some traits typical of Western European miniatures of the first half of the 14th century: the sparsely foliated thin tendrils of grape-vines or ivy stalks with marginal drolleries, the diversity of background designs, the graceful gestures of the characters, the draperies of their clothing, their curly hair, and the facial features rendered by delicate strokes of the pen. The peculiarities of the colour scheme and drawing suggest a connection with the art of the south of France and Mediterranean Spain

(mainly Provence and Catalonia), two areas where literature and the arts had had much in common since the 12th century. Olga Dobias-Rozhdestvenskaïa attempted to prove that the illumination had been produced by the Catalan school. Her idea is further supported by the fact that the manuscript was made in Lérida, a centre of Romanesque art in Spain, by the presence of a few Arabic ornamental motifs on the margins and by some specific features of the miniatures' coloration, such as the abundance of deep dark-reds, greens and purples. On the whole, however, the style of the illumination seems much closer to the Provençal school. There are several copies of the Breviary from the 14th and 15th centuries in which the miniatures are almost identical both in terms of their choice of subjects and iconography and these undoubtedly go back to a late-13th-century original with illumination directed by Matfres himself. On the basis of stylistic analysis, K. Laske-Fix also places the St Petersburg codex with the Provençal rather than the Catalan group.

The St Petersburg Breviary, which was produced just two or three decades after the original manuscript, around 1320, is thus one of the earliest existing copies of the poem. Illumination on such a scale certainly involved a number of artists, some of whom had an obvious leaning towards light ochreous tones (the series of miniatures devoted to the months of the year and scenes from the Gospels). The final placing of the manuscript's miniatures and the authorship of each miniature remain to be determined. It should be remembered that in the 14th century Catalan illumination was greatly influenced by the school of Avignon. The scribe himself wrote that he had combined different traditions, for he was born in England and worked in Lérida, yet arrived there from Avignon.

In the 17th century, the manuscript belonged to Pierre Séguier; in 1735, it entered Saint-Germain-des-Prés; at the end of the 18th century it was purchased by Piotr Dubrowsky.

ENTERED THE PUBLIC LIBRARY IN 1805 (1849–61 THE HERMITAGE, 5.3.66).

BIBLIOGRAPHIE : Cat. Séguier 1686, p. 14; Montfaucon 1739, 2, p. 1108, No 757; Gille 1860, pp. 52, 53; Le Breviari d'Amor de Matfrès Ermengaus suivi de sa lettre à sa sœur, publié par la Société Archéologique, Scientifique et Litteraire à Béziers (introduction and glossary by Gabriel Azais), 2 vols, Béziers, 1869–81; Laborde 1936–38, pp. 20–25, pls XIII–XV; O. Dobias-Rozdestvenskaïa, A. Liublinskaya, "Ob odnoi ispanskoi rukopisi", in: Kultura Ispanii, Moscow, 1940, pp. 267–296; K. Laske-Fix, Der Bilderzyklus des Breviari d'Amor, Munich, Zurich, 1973, p. 189, No 31.

260

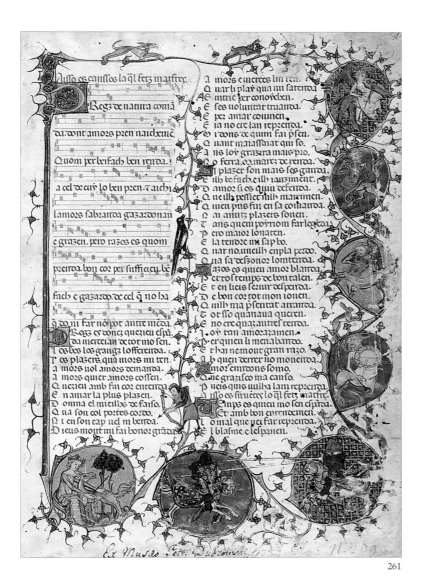

261

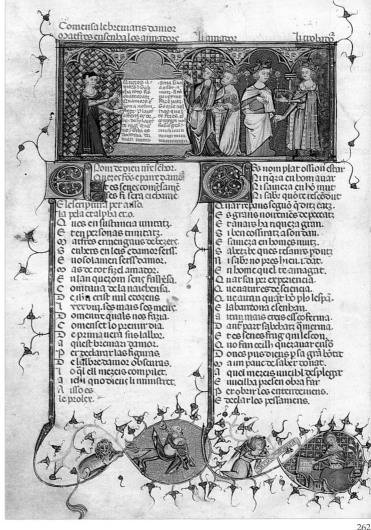

262

260. F. 41v: VENUS.

This is one of the series of miniatures depicting the planets as allegorical figures dating back to classical mythology. Venus's marine origin is rendered with naive ingenuity.

261. F. 1r: CANZONE DREGZ DE NATURA WITH MUSIC AND SIRVENTE COMPOSED BY MATFRES.

On the ivy stalks are an archer, a bird and a dog chasing a hare; in the side medallions are monsters playing musical instruments (viol, lute, domra, tambourine); at the bottom are 3 medallions: in one a lady is saving a fallow-deer wounded by the hunters, and in the other two medallions a pair of knights are fighting, one having a fleur-de-lis emblem on his shield, the other lions.

262. F. 6v: OPENING PAGE OF THE TEXT OF LO BREVIARI D'AMOR.

At the top "Matfres Ermengau of Béziers, a doctor of law and a servant of love", as the author referred to himself, is talking to "lovers" (the couple on the right with lilies) and "troubadours" (the couple in the centre with the book) who are asking him about the nature and origin of love. The insertion into the miniature of a text, i.e. a book with which Matfres is moralizing, is a typical device. At the bottom one can see a lion, a monster playing a bagpipe and a scene of the Annunciation.

263. F. 11v: THE TREE OF LOVE.

This miniature, variations of which are present in all the copies of the Breviary, is a sort of pictorial guide to the treatise. The tree of nature and of the whole universe is interpreted as an emanation of love. The large central figure is an allegory of amors generals. The other figures, as well as circles and leaves with explanatory inscriptions, denote different aspects of love, its flowers and fruit, and also virtues and vices. The devil symbolizes the danger of leaving the path of righteousness, the figures with swords and axes trying to cut the branches stand for gossip, immodesty, greed, etc. In addition to the love of God indicated by the dove at the top — the symbol of the Holy Spirit, parental love which yields fruit, i.e. children, occupies a major place in Matfres's system.

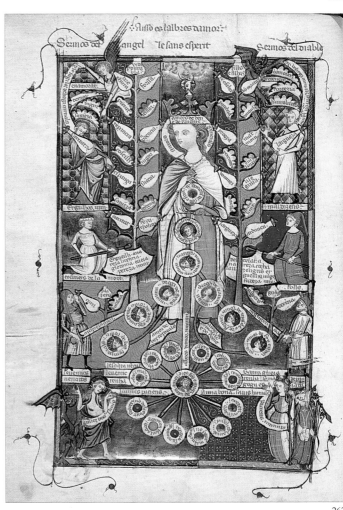

263

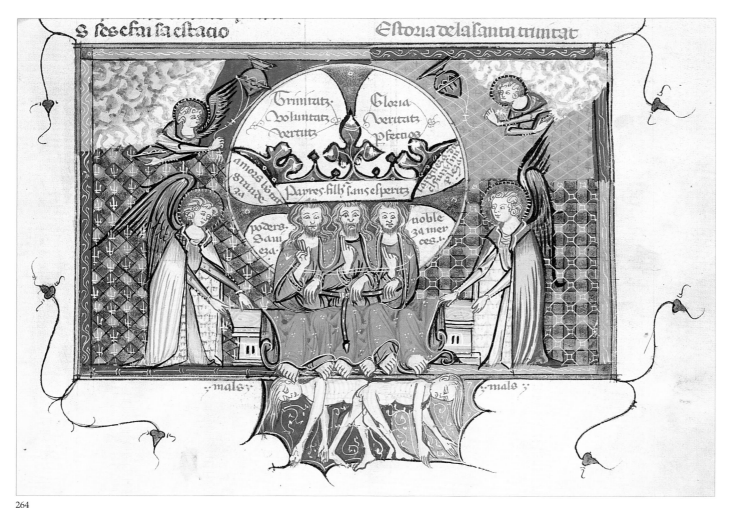

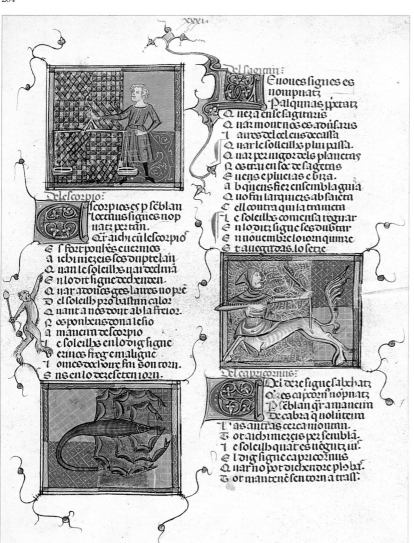

264. F. 16r: THE HOLY TRINITY.
The miniature illustrates the section about God as the Creator of nature and the source of love.

265. F. 36r: SIGNS OF THE ZODIAC (LIBRA, SCORPIO, SAGITTARIUS).
These three miniatures as well as the one that follow illustrate the section on cosmography. It exemplifies the organization of a page with numerous miniatures, initials with stalks spreading onto the margin and drolleries.

266. F. 56v: ILLUSTRATIONS TO THE SECTION ON THE SEASONS OF THE YEAR.
April is represented by nature in full bloom, May by falconry and June by a peasant mowing grass. Dobias-Rozdestvenskaïa sees a reflection of "true Spanish reality" in the specific shape of the long sickle.

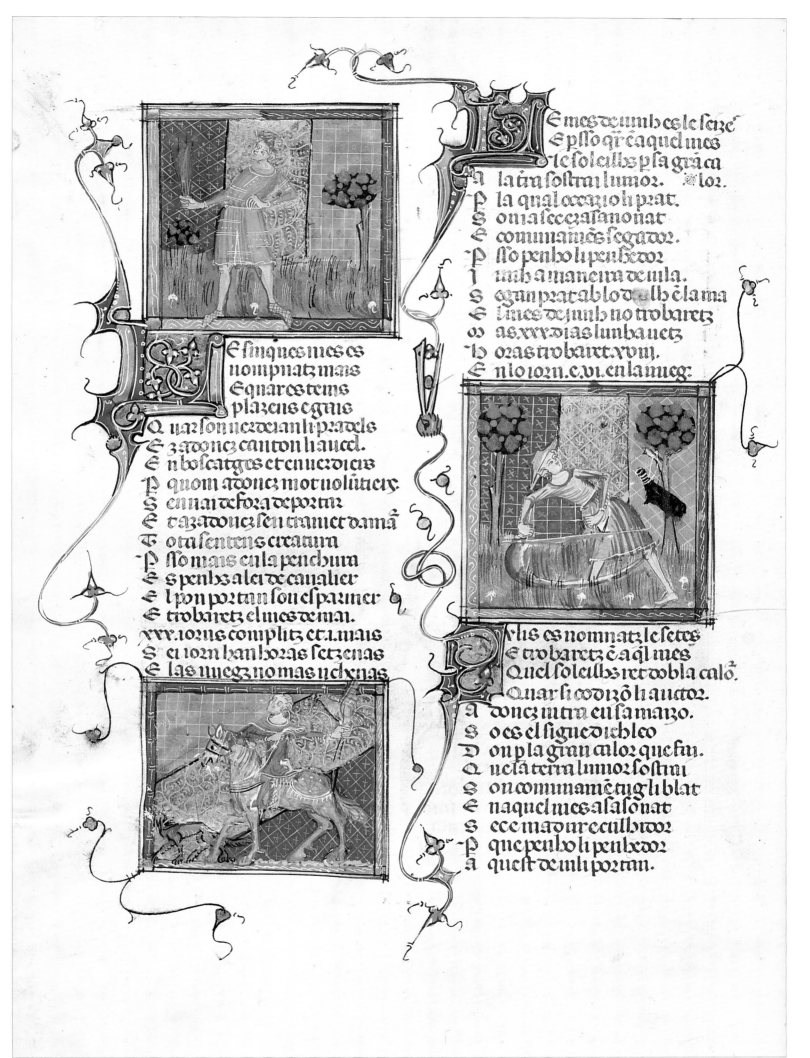

E mes de iunh es le seze
E pso qr ca quel mes
le soleilhs p sa gra ca
la tira sostra lumor. lor.
la qual occaio li prat.
o na secera sa no nat
comunames segador.
pso penho li penhedor
mb a maneira de mla.
e gun pra tab lo d ellh e la ma
lunes de iunh no trobaretz
as xxx dias lunha uetz
oras trobaretz xviii.
En lo 10 211. e. vi. en la mieg.

E sin ques mes es
nompnatz mais
e qnar es tems
plazens e gnie
Quar son uerdei an li prat dels
e za donez canton li aucel.
en boscatges et en uerdicrs
P quom a donez mot no li tueux.
en uai de fora de portar
e taza donez sen tramet da ma
o ta sentens creatura
pso mais en la penchura
s penhs a ler de caualier
el pon portan son esparuer
e trobaretz el mes de mai.
xxx iorns complitz et .i. mais
s eu iorn han horas setzenas
e las mieqz no mas ni denas

rlis es nomnatz le setes
e trobaretz e a ql mes
Quel soleilhs re dobla calo.
Quar si cod izo li auctor.
a donez intra en sa mazo.
o es el sigue dich leo
D on pla gran calor que fin.
Que la terra lumor sostin
on comunamet tug li blat
naquel mes a sa so nat
ecce mad ur e cuilh dor
que penho li penhedor
a quest de iuli portan.

266

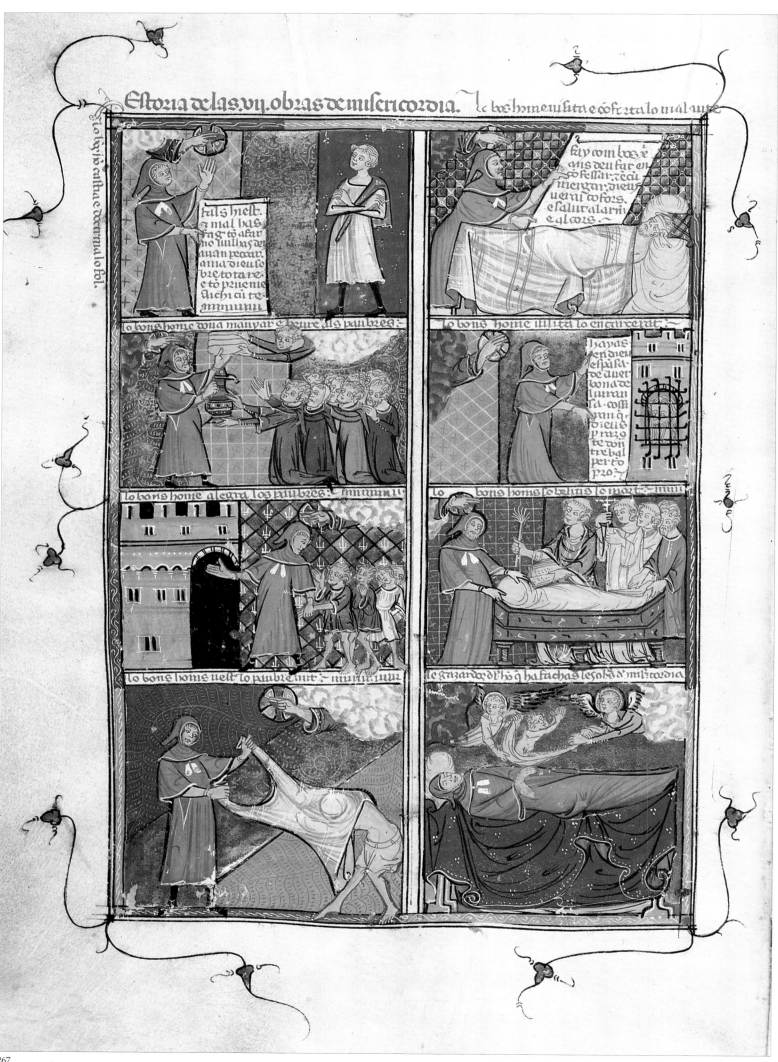

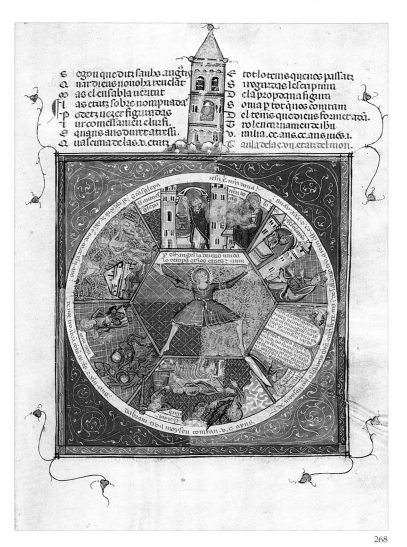

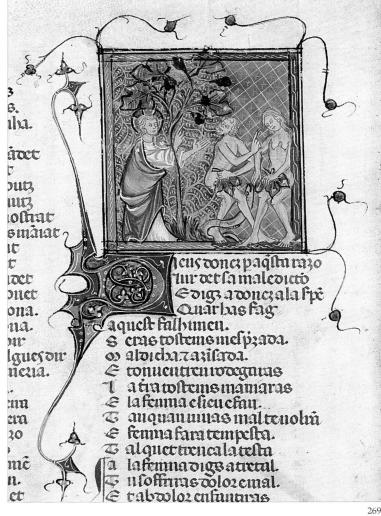

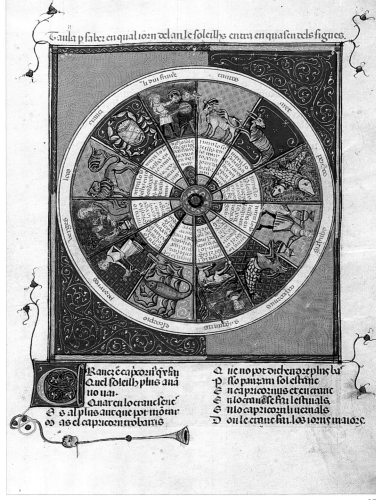

267. F. 80v: SEVEN WORKS OF MERCY.
Depicted are the scenes of feeding the hungry, giving shelter to the homeless, clothing the naked, ministering to the sick, visiting prisoners and burying the dead. The eighth scene depicts how the merciful are rewarded — their souls go to heaven. The hand making the sign of benediction in the upper part of these scenes is a symbol of Divine Providence. Such full-page miniatures, representing different stories, attest to the artist's fine talent for narration.

268. F. 59r: AGES OF THE WORLD.
This is a favourite theme of mediaeval historical symbols, introduced in the West by Isidore of Seville. The miniature shows (counterclockwise) the stages of the Hexaemeron of world history: from Adam to Noah, from Noah to Abraham, from Abraham to Moses, from Moses to Solomon, from Solomon to Jesus Christ, from the Nativity of Christ to the present. The temple tower extending beyond the frame is specific to this miniature.

269. F. 67v: THE EXPULSION. GOD UNMASKING THE SIN OF ADAM AND EVE.
This miniature illustrates the section on the history of man.

270. F. 37r: SIGNS OF THE ZODIAC.
The miniature reflects the idea of the imaginary belt in the heavens, in the middle of which is the ecliptic, or solar path. The text inscribed around the centre is perceived as a component part of the general ornamental composition, in which Olga Dobias-Rozdestvenskaïa detected some affinity with Oriental rugs.

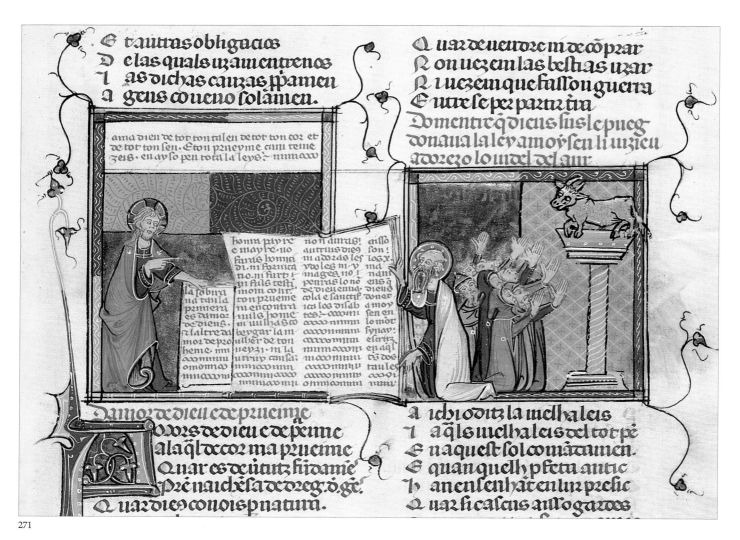

271

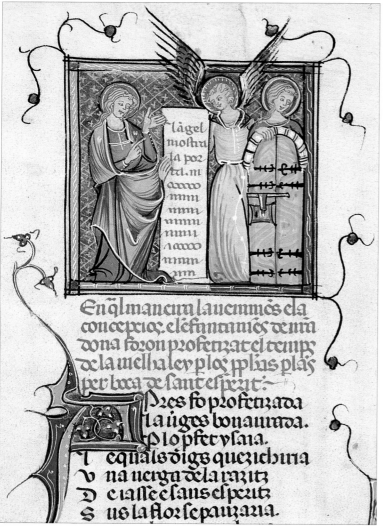

272

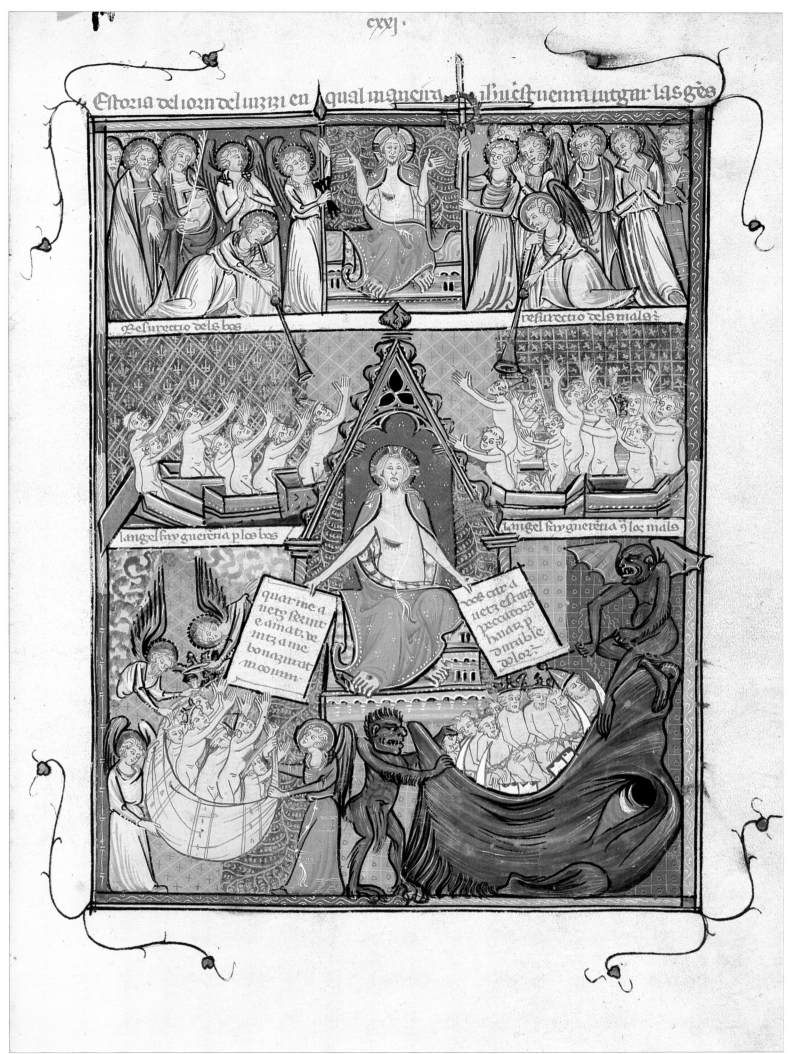

Estoria del iorn del iuizi en qual maneira ihuist uenra iutgar las gens

Resurectio dels bos resurectio dels mals

langel sur guereria p los bos langel sur gueretia q los mals

quar me a uetz fezint e amat. ue nitz a me bonaurat mo uim

uos car d uetz estar peccadors haiatz p durable dolor

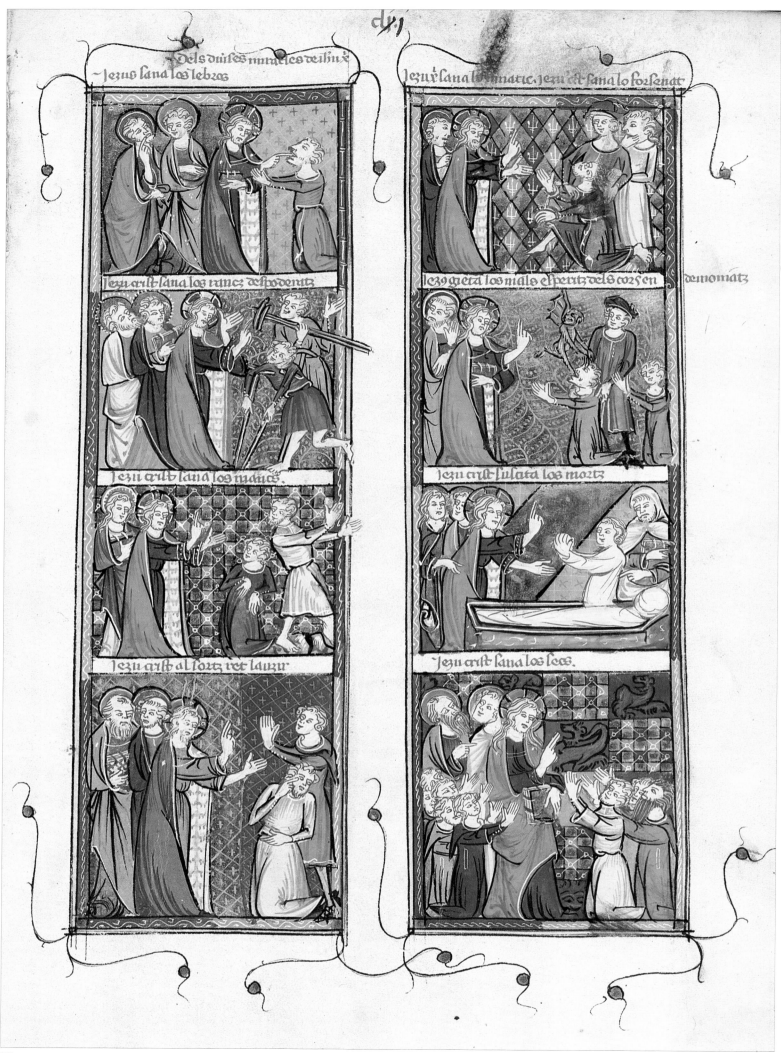

cx/j

Dels diuses miracles de Jhu x

Jezus sana los lebros

Jezu x sana lo linatic. Jezu crist sana lo forsenat

Jezu crist sana los rancs despoderitz

Jezu gieta los mals esperitz dels cors en demoniatz

Jezu crist sana los muditz

Jezu crist suscita los mortz

Jezu crist al sortz ret lauzir

Jezu crist sana los secs.

274

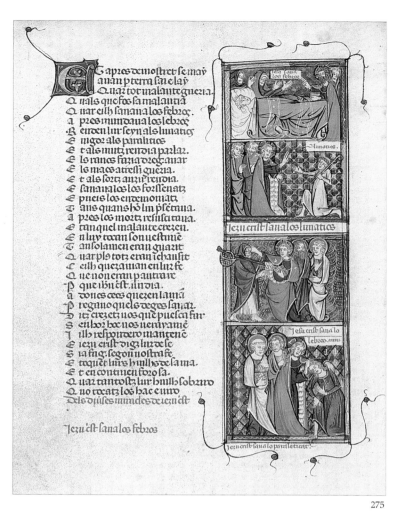

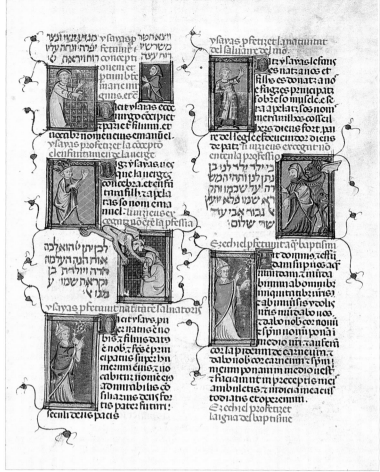

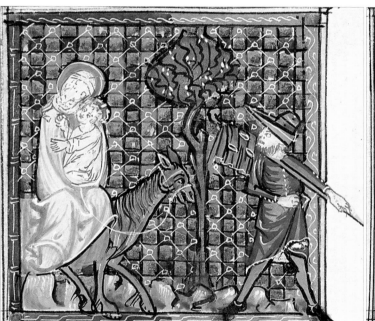

277. F. 162v: THE FLIGHT INTO EGYPT.
This is the illustration to a vast section of the text about love for one's neighbour, which conveys the idea that belief is the most precious flower on the Tree of Love and is devoted to the subjects from the Gospels exemplifying the twelve dogmas of faith.

274, 275. FF. 165v–166r: THE MIRACULOUS HEALINGS BY JESUS CHRIST.
The miniature shows the healing of a man with a fever, the healing of a leper, a lunatic, a paralytic, a lame man, a deformed man, a deaf-and-dumb man, one crazed, and one possessed, the raising from the dead, the healing of bleeding women.

276. F. 95r: THE ISRAELITES DENOUNCING THEIR PROPHETS.
This is one of the group of unusual leaves where the miniaturist and the scribe counterpose true and false belief (depictions of the prophets and the Israelites hindered by the devil from understanding the Old Testament prophecies written there in gold Hebrew script).

278. F. 203v: "BE FRUITFUL AND MULTIPLY!"
This miniature, illustrating a well-known biblical text, opens the third and the last section of the Breviary — The Treatise on the Love for Ladies in Accordance with the Interpretation Given by the Old Troubadours.

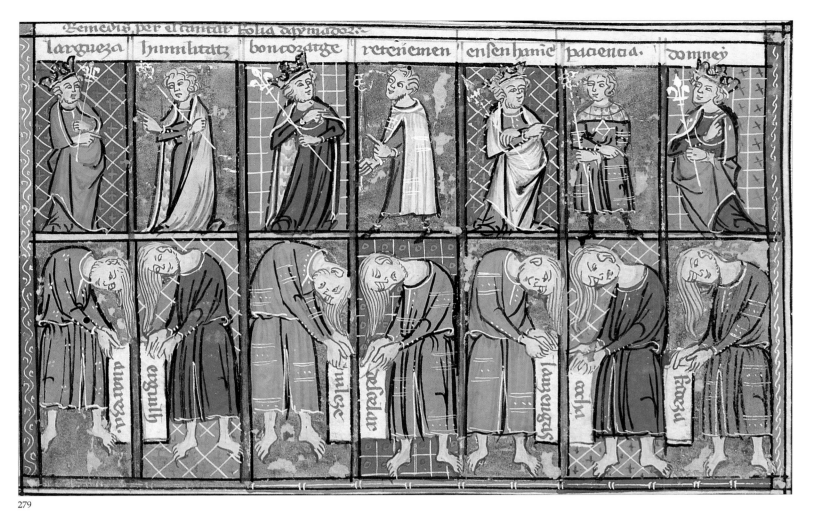

larqueza hmmltatz bontozatge retenemen ensenhame pacenca domnev

279

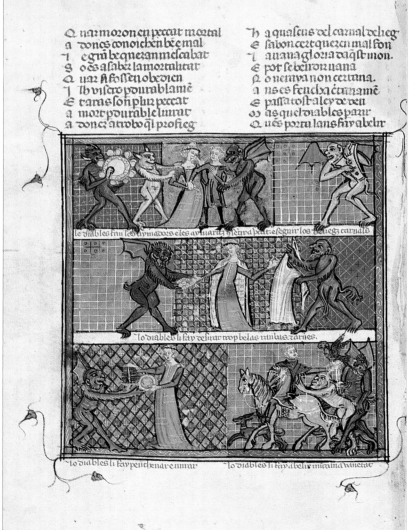

280

279. F. 247r: VIRTUES AND VICES.

This miniature in the manuscript illustrates the section about
the Tree of Knowledge. It is a guide for he who is truly in love:
every virtue to be striven for is opposed here by a vice: charity
— avarice, humility — pride, temperance — garrulity, good
manners — gossiping, patience — wrath. These pairs of
conflicting virtues and vices go back to the Psychomachia, a
popular mediaeval allegorical poem by Prudentius.

280, 281. FF. 205v–206r:
THE DANGERS OF LOVE.

This is one of the most expressive series of miniatures, in which
the artist presents a whole pictorial novel. The demons, shown
as green-winged monsters, make use of the worst instincts of
human nature — profane love, women's fascination with clothes
and jewels, and men's love for rich armour, vanity and fuss,
gluttony and drinking, fighting at tournaments over women,
battles, dancing and their mindless adoration of women. Finally,
the last scene depicts one who has succumbed to the vices and
is now lying on his death-bed with a demon pulling his sinful
soul away.

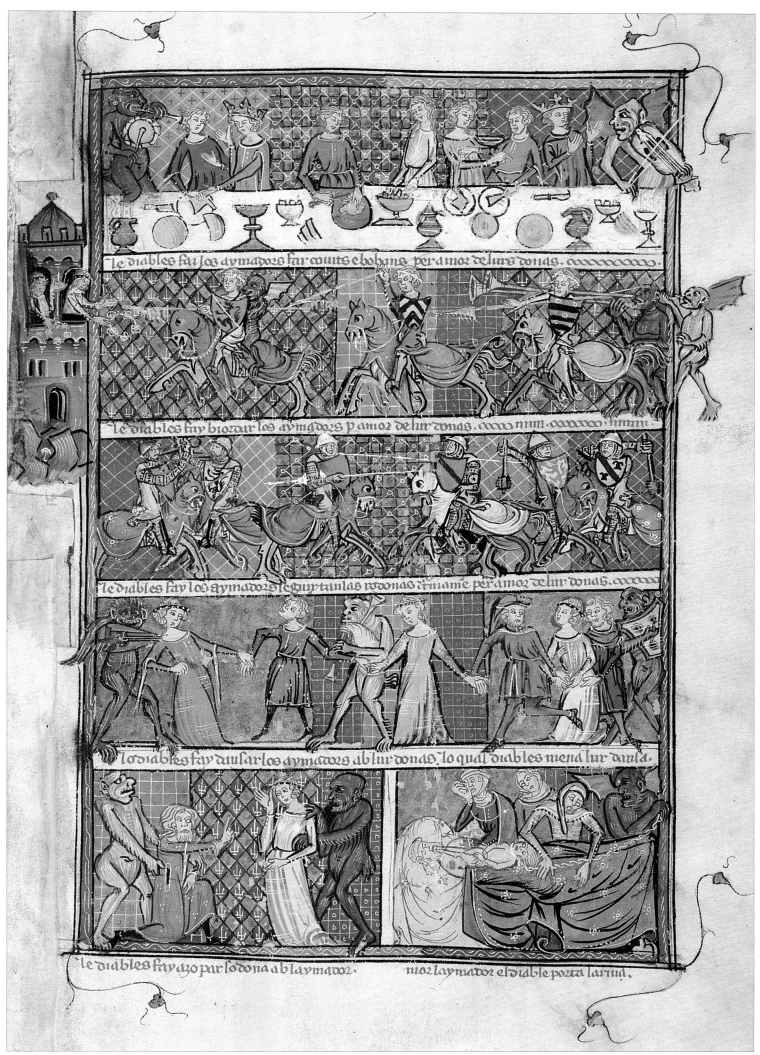

le diables fai los aymadors far couits e bohans per amor de lurs donas. cccccccccc

le diables fay biordar los aymgdors p amor de lur donas. cccc num. cccccccc num

le diables fay los aymadors segur tanlas rodonas reniame per amor de lur donas. cccccc

lo diables fay dausar los aymadors ab lur donas. lo qual diables mena lur dansa.

le diables fay azo par so dona ab laymador. nior laymador el diable porta larina.

THE VENERABLE BEDE
Ecclesiastical History of the English People
Beda Venerabilis. Historia Ecclesiastica Gentis Anglorum

Northumbria (Wearmouth/Jarrow). 746.

162 ff. 270 x 190 mm (text 230 x 160 mm). Parchment.
Latin (f.107r has a hymn by Caedmon in Anglo-Saxon).
2 coloured initials; smaller initials with an ornamental design in pen or highlighted with red.
Binding: 17th century. Brown leather over cardboard. The Harlay arms stamped with gold
on the front and back covers; the spine bears the Harlay monogram stamped with gold.
Lat.Q.v.I.18

This is one of the Library's most precious manuscripts. *Written by Bede* (ca 673–735), a monk at the Northumbrian monastery in Jarrow and the first English historian, the *Ecclesiastical History of the English People* is an important source on the history of England of the 6 th to 8 th centuries. The St Petersburg manuscript is the second oldest surviving copy of Bede's work. The narration begins with Caesar's conquest of Britain and continues to 731. Bede used monastery annals and documents which are now lost, and most of the historic facts of that period are known from his work alone. The manuscript contains one of the earliest records of a hymn by Caedmon, the first Anglo-Saxon poet, who lived in the 7th century. The hymn is essential for the study of the history of English writing and literature.

The St Petersburg copy was written in 746 (this dating is based on a later addition to the original text) in the scriptorium at one of two neighbouring monasteries — St Peter at Wearmouth and St Paul at Jarrow — where copies of Bede's work were made after his death to meet the huge demand for them. In spite of its modest decoration, the manuscript has a prominent place in the history of illumination as a typical example of the Northumbrian school showing traces of the Mediterranean influence on insular miniatures. The initial on f. 26v is the earliest known historiated initial in European illumination.

In the 17th century, the manuscript was in the Harlay collection (Achille III de Harlay, 1639–1712?), France; in 1755, acquired by Saint-Germain-des-Prés with the Harlay collection; after 1791 purchased by Piotr Dubrowsky.

ENTERED THE PUBLIC LIBRARY IN 1805.

LITERATURE : Gillert 1880, p. 260; Staerk 1910, 1, pp. 52, 53, pl. XIV; 2, pl. L; Zimmermann 1916, pp. 145, 309, 310, fig. 332a; The Leningrad Bede: An Eighth Century Manuscript of the Venerable Bede's Historia Ecclesiastica Gentis Anglorum in the Public Library, *Leningrad (complete-facsimile) (ed. by O. Arngart)*, Copenhagen, 1952; N.R. Ker, Catalogue of Manuscripts Containing Anglo-Saxon, Oxford, 1957, No 122; E.A. Lowe, "A Key to Bede's Scriptorium: Some Observations on the Leningrad Manuscript of the Historia Ecclesiastica Gentis Anglorum", Scriptorium, 12, 1958, No 2, pp. 182–190, pls 17, 19, 20, 21, 21c; M. Schapiro, "The Decoration of the Leningrad Manuscript of Bede", Ibid., pp. 191–207, pls 23a, b; P. Dom, "Mayvaert Bede and Gregory the Great", Jarrow Lecture, 1964, pp. 3, 4; Old Latin MSS 1965, pp. 53–57; Codices latini antiquiores (ed. by E.A. Lowe), Oxford, 1966, part 11, p. 12, No 1621; Beda Venerabilis, Historia Ecclesiastica Gentis Anglorum (ed. by B. Colgrave and R. Mynors, Oxford, 1969; J.J.G. Alexander, Insular Manuscripts, 6th to 9th Centuries: A Survey of Manuscripts Illuminated in the British Isles, vol. 1, London, 1978, pp. 47, 48, No 19, ills 83, 84; Latin MSS 1983, p. 19, No 31.

282

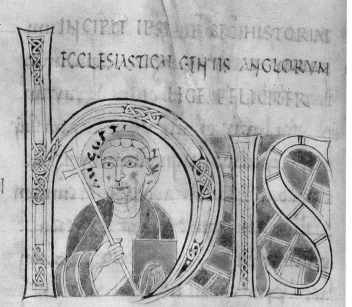

Uto littteras pro hortatus ad
fidem...

Uto coniungam littteras pro chri-
stolam salutis illius sedulam adhor-
tationem monuerit.

Uto eduini prouinctionem quonda
sibi exuli obtentam sit ad credendum
prouocatus.

Quale conuilium idem cum pri-
matib. suis deliberationem de fide christi
habuerit et ut pontifex suus suas
aras profanauerit.

Uto idem eduini cum sua gente
fidelis sit factus et ubi paulinus
baptizauerit. et idem christi uiris explerit.

Uto prouincia orientaliu anglorum...

Uto paulinus in prouincia lindissi
predicauerit et de qualitate regni eduini.

Uto idem ab honorio papa exhortatorias
littteras acceperit. qui etiam paulino
pallium misit. dominibus ecclesiae.

Uto honorius qui iusto in episcopatu
successit ab eodem papa honorio pallium
et littteras acceperit. item littterar.

Uto primo idem honorius. et post iohan
gente scottorum praecipua simul et Pelag
ana heresis miserit. sedibus honoribus.

Uto occisus redeunte paulinus cantiae
ecclesiae presulatum suis explerit.

HIS temporibus idest anno dominicae
Incarnationis DCV beatus papa
Gregorius postquam sedem roma
nae et apostolicae ecclesiae XIII
annos menses VI et dies decem glo
riosissime rexit defunctus est.
atque ad aeternam regni caelestis
sedem translatus. De quo nos con
uenit quia nostram idest anglorum gentem
de potestate satanae ad fidem christi
sua industria conuerttit latius aliqn
in nostra historia ecclesiastica facere
sermonem. Quem recte nostrum appella
re possumus et debemus apostolu
quia cum primum in toto orbe gere
ret pontificatum et con uersus iam
dudum ad fidem ueritatis esset prae
latus ecclesiis. nostram gentem ea
tenus idolis mancipatum christi fecit
ecclesiam. Ita ut apostolicum illu

284-286
EVANGELISTARY
Tetraevangelium

Northumbria (?). Late 8th century.

215 ff. 345 x 245 mm (text 260 x 190 mm). Parchment. Latin.
FF. 213 and 214 have Runic inscriptions.
12 coloured arcades framing the canon tables; four title pages, one at the beginning
of each Gospel; one large coloured initial before the Epistles of St Jerome;
small coloured initials, some patterned.
Binding: 16th century. Red leather over cardboard;
the front cover is missing; the spine is stamped with gold.
Lat.F.v.I.8.

This Evangelistary contains the Gospels of Matthew, Mark, Luke and John, the Epistles of St Jerome, twelve canon tables preceding the text, and a table of contents at the end. The decoration is a good example of mature insular illumination.

The miniaturist employed the devices used in the illumination of the famous Lindisfarne Gospels at the turn of the 8th century; the canon tables were decorated with ornate arcades and the initials, together with the first words of the text of each book *(incipit)*, are made into real title pages. Experts disagree as to the place of execution: H. Zimmermann and C. Nordenfalk refer it to the school of Southern England, while the majority of scholars (T.D. Kendrick, G.L. Micheli, E. Privalova and T.J. Brown) think that it was produced in the North, in Northumbria. E.A. Lowe, while pointing to certain affinities between the manuscript and works produced in Kent, nonetheless maintains that Northumbria is more plausible. The presence of northern traits, which prevail, combined with southern ones, provides good grounds for assuming that it was created at the end of the 8th century.

The manuscript seems have been worked on by three different hands belonging to the same circle. The head artist painted the canon tables and the initial compositions (ff. 1r, 18r and partly 177r), another one decorated ff. 78r and 119r, and a third one — f. 177r. The date when the manuscript arrived in France is not known; for some time it was kept in Saint-Maur des Fossés in Paris; in 1716, it was bought by Saint-Germain-des-Prés, from where it was obtained by Piotr Dubrowsky.

ENTERED THE PUBLIC LIBRARY IN 1805.

LITERATURE : Montfaucon, 2, pp. 1057, 1142, No 35; Giller, p. 247; Facsimiles of the Miniatures and Ornaments of Anglo-Saxon and Irish Manuscripts Executed by J.O. Westwood, *London, 1868, pp. 52, 53, pl. XXV; Staerk, 1, pp. 25, 26; 2, pls XXI–XXIII; Zimmermann, pp. 24, 35, 126, 143–145, 304, 305; figs 321–326, 329a; T.D. Kendrick, Anglo-Saxon Art to A.D. 900, London, 1938, p. 148, pl. LIX; G.L. Micheli, L'Enluminure du haut Moyen Age et les influences irlandaises, Brussels, 1939, pp. 28–30, 32, 34, 49, 62, 139, pls 13, 50, 77; E.L. Privalova, "Irlandskaya srednevekovaya illiuminovannaya rukopis v sobranii Leningradskoi Gosudarstvennoi Publichnoi biblioteki imeni M.E. Saltykova-Shchedrina", Sredniye veka, 21, 1962, pp. 201–211; Old Latin MSS 1965, pp. 77–81; Codices latini antiquiores (ed. by E.A. Lowe), Oxford, 1966, part XI, p. 7, No 1605; T.J. Brown, Northumbria and the Book of Kells. Anglo-Saxon England, 1, 1972, pp. 234, 235; J.J.G. Alexander, Insular Manuscripts, 6th to 9th Centuries:* A Survey of Manuscripts Illuminated in the British Isles, *vol. 1, London, 1978, p. 64, No 39, ills front., 188–195; Latin MSS of the 5 th - 12 th centuries, p. 17, No 23.*

Page 226
282. F. 107: HYMN BY CAEDMON (IN ANGLO-SAXON).

Page 227
283. F. 26v: OPENING PAGE OF BOOK TWO.
The man with a halo, carrying a cross in his right hand and a book in his left, is most probably Pope Gregory the Great, to whose life the first chapter of Book Two is devoted, though a much later hand has added the name Augustinus in the halo. (In 596 Pope Gregory sent forty monks, led by the missionary bishop Augustine, to preach the gospel to pagan England.) As is evident from a description of a portrait of Gregory, commissioned by him and now in the San-Andrea Monastery in Rome, a cross and a Book of Gospels were then considered papal attributes. The figure's counterpoise and the treatment of the face, especially the outline of the nose, show the obvious influence of classical art, while the linear folds of the vestment and the ornamental design of the letters are the typical traits of insular illumination.

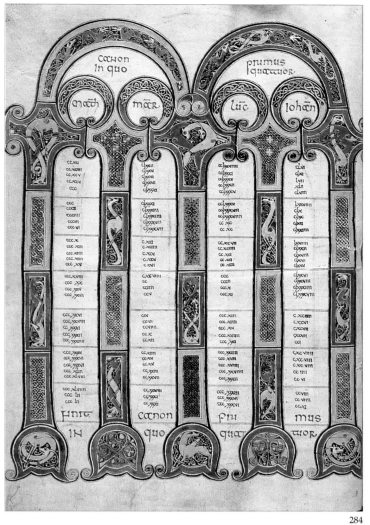

284

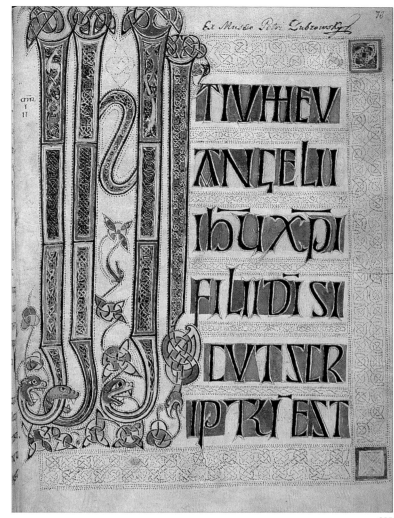

285

**284. F. 12v: PAGE 2 OF THE CANON
TABLES.**
The arcade columns seem to consist of individual elements,
such as bases, shaped as capitals, and panels, both having
alternating geometric patterns and zoomorphic designs (mostly
serpentine bird motifs). This type of composite frame is known
from early 8th-century Northumbrian manuscripts. The
rational character of this two-dimensional composition is typical of the
northern solemn manner of execution. On the other hand,
experts discern southern traits in the treatment of bases with
heraldic beasts.

**285. F. 78r: OPENING PAGE OF THE
GOSPEL ACCORDING TO ST MARK
(INITIUM EVANGELII...).**
The second illuminator of this leaf was a master of compact
composition, in which the bright, parti-coloured mosaic of the
text sharply contrasts with the delicate dotted ornament of the
frame.

**286. F. 177r: OPENING PAGE OF THE
GOSPEL ACCORDING TO ST JOHN (IN
PRINCIPIO...).**
The letters and ornamental borders are executed in a manner
very similar to that of the head illuminator, while the ten lines
of the text filling the page were probably by a third artist.

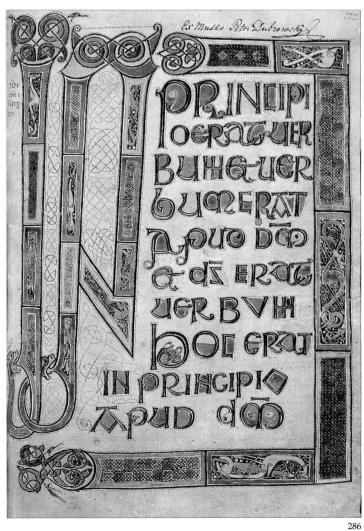

286

287-293
BESTIARY
Bestiarum

England. Late 12th century.
91 ff. 200 x 145 mm (text 140 x 90 mm). Parchment. Latin.
114 miniatures in gold and coloured rectangular frames and medallions;
ne historiated initial; small coloured initials.
Binding: 17th century. Parchment.
Lat.Q.v.V.1.

Bestiaries appeared in the 12th century, their texts based on the *Physiologus*, a Hellenistic religious and allegorical work about animals (2nd or 3rd century AD), and the *Etymologiarum libri* XX by Isidore of Seville (7th century). Informative, moralizing and symbolic, bestiaries describe real and imaginary creatures, their appearance and habits, the origin of their names, and their symbolic meaning. Such works were among the most popular books in mediaeval Europe. Along with the anonymous bestiaries there were also numerous versions, both in prose and verse, in Latin and national languages by famous philosophers, theologians and poets.

The St Petersburg manuscript represents a transitional type between the *Physiologus* and the 13th-century treatises. The introduction comprises fragments from the Bible on the creation of the world, extracts from Isidore of Seville on the naming of the animals and the classification of the animal world, and from a sermon by an unknown author. After that comes the text of the Bestiary itself, which covers wild animals, cattle, small beasts, birds, fish and snakes.

The manuscript was illustrated by several masters (the first four miniatures, for instance, have a very distinctive style), yet the whole of its illumination is typical of English art from the last decades of the 12th century, as is exemplified by the iconography of the miniatures and the colour scheme, which is dominated by gold, red and intense green and yellow colours. The bestiaries from the Pierpont Morgan Library in New York (MS.81) and the British Library (Royal MS.12.CXIX) are, typologically and stylistically, the closest analogies to the St Petersburg manuscript, which help to date it to 1180–90. Experts consider that this group of manuscripts was probably produced in Lincolnshire, although certain stylistic features suggest a connection with the artistic circle of York. Sharp outlines, rich colours and energetic drawing make the Bestiary from the St Petersburg library an excellent example of late Romanesque English art.

The manuscript must have been in France from the 14th to the 16th century, as is indicated by the French inscriptions of that period in the margins and on the miniatures. The Latin inscription on the last leaf, *Hic liber attinet ad Franciscum de la Morliere*, suggests that it was part of the Morliers' library. In the 17th century, the manuscript belonged to Pierre Séguier, and in 1735, along with the rest of his collection, it entered the Saint-Germain-des-Prés library from where it was bought by Piotr Dubrowsky at the end of the 18th century.

ENTERED THE PUBLIC LIBRARY IN 1805 (1849–61 THE HERMITAGE, 5.2.35).

LITERATURE : Cat. Séguier, *p. 18; Montfaucon, 2, p. 1114, No 116; Gille, p. 39; Nikolayev, pp. 90, 91, 93; Yaremich, p. 38, ill. between pp. 34 and 35; N. Garelin, "Dva rukopisnykh bestiariya Rossiyskoi Publichnoi biblioteki", Zbornik Rossiyskoi Publichnoi biblioteki, 2, Petrograd, 1924, pp. 248–276; A. Konstantinowa, Ein englisches Bestiar des XII. Jahrhunderts in der Staatsbibliothek zu Leningrad, Berlin, 1929; T.S.R. Boase, The Oxford History of English Art, vol. 3 (English Art, 1100–1216), Oxford, 1935, p. 295; Laborde 1936–38, p. 9; F. McCulloch, Mediaeval Latin and French Bestiaries, Chapel Hill (North Carolina), 1960, pp. 34, 74; N. Morgan, Early Gothic Manuscripts, 1: 1190–1250. A Survey of Manuscripts Illuminated in British Isles, vol. 4, London, 1982, pp. 56, 57, No 11; Latin MSS of the 5 th and 12 th centuries 1983, p. 58, No 254; K. Muratova, Srednevekovy Bestiary, Moscow, 1984 (facsimile edition).*

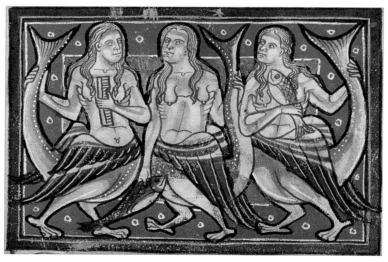

287

287. F. 18r: SIRENS (70 x 100 mm).
Two sirens hold fish, a symbol of the sea, and the third one holds a flute, illustrating Isidore's description of sirens playing and singing. Inscribing this detailed and symmetrical composition within a rectangular frame required a great deal of technical skill.

288. F. 5r: ADAM NAMING THE ANIMALS (130 x 93 mm).
The miniature illustrates the scene of the naming of the animals and birds as described in the Etymologiarum libri XX by Isidore of Seville. The iconography is traditional and it is based on the Book of Genesis, although instead of the figure of God it has that of Adam. The artist probably depicted the animals without much colour in order to stress their novelty and their nameless state.

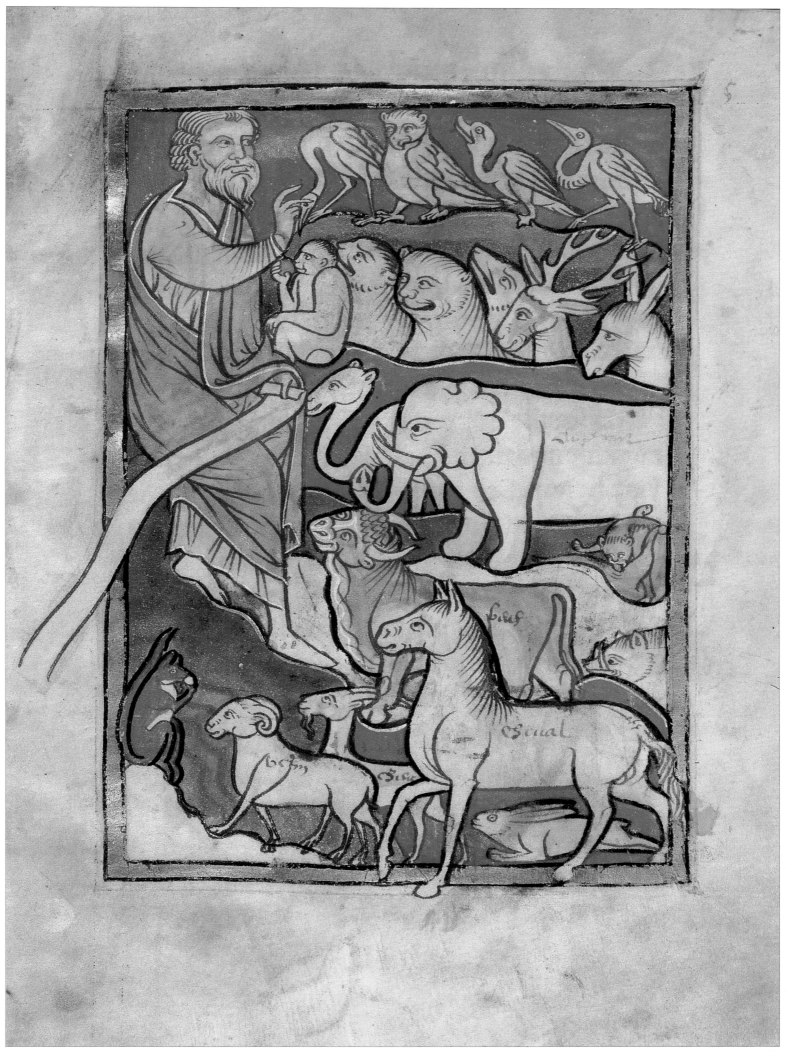

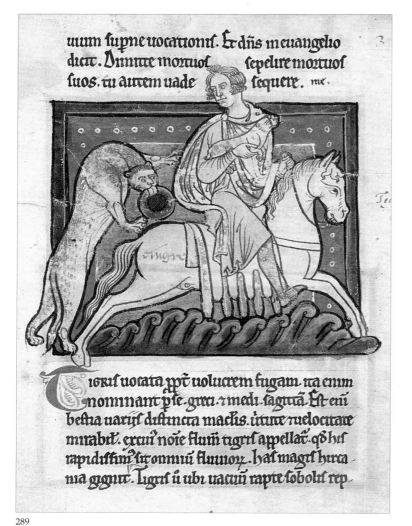

uuum supne uocationis. Et dñs in euangelio
dicit. Dimitte mortuos sepelire mortuos
suos. tu autem uade sequere. mc.

Tigris uocata ppt uolucrem fugam. ita enim
nominant psse. greci ⁊ medi sagittā. Est eni
bestia uarijs distincta maclis. ⁊ uirtute ⁊ uelocitate
mirabilis. ex cui noie flum tigris appellat. qd hrs
rapidissim sit omniū fluuioꝛ. has magis hirca
nia gignit. Tigris ū ubi uacuū rapte sobolis rep

289

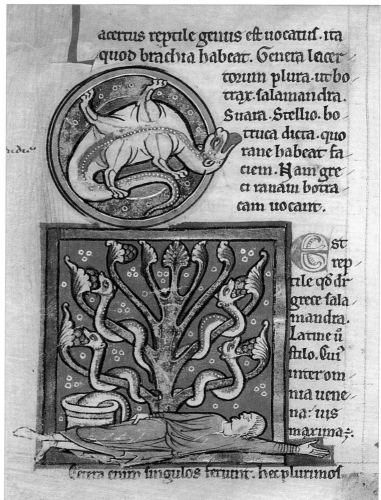

acertus reptile genus est uocatus. ita
quod brachia habeat. Genera lacer
torum plura. ut bo
trax. salamandra.
Suara. Stellio. bo
truca dicta. quo
rane habeat fa
ciem. Ham gre
ci ranam botra
cam uocant.

Est
rep
tile qd dr
grece sala
mandra.
Latine ū
stilo. cui
inter om
nia uene
na: uis
maxima.

Cetera enim singulos feriunt. hec plurimos

290

291

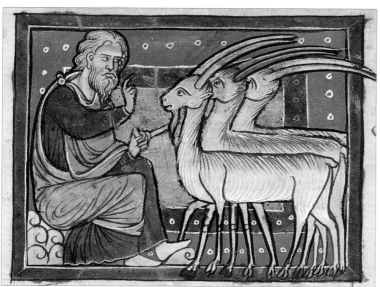

292

289. F. 36ʀ: TIGER (80 x 100 mm).
The miniature is based on old notions concerning different ani-
mals, a tradition which dates back to antiquity. Later it was
employed by Isidore of Seville as well as in various mediaeval
bestiaries in prose and verse. The rider, who has stolen a
tiger cub, throws a mirror to the tigress following him and the
reflection in it deceives and distracts her from the pursuit.

290. F. 85ᴠ: LIZARD. SALAMANDER (50 x 50
mm; 75 x 75 mm).
The stylized depiction of a lizard is skilfully inscribed within a
medallion. The lower miniature, a heraldic emblem,
demonstrates how very venomous a salamander is: the fruit of
the acanthus poisoned by it is lethal for man.

291. F. 50ʀ: STORK (60 x 100 mm).
The stork is usually depicted holding a frog or a snake in its
beak. This is one of the best depictions of a stork in mediaeval
art.

292. F. 69ʀ: AMOS THE PROPHET
(80 x 100 mm).
The subject is based on the Book of Amos: the prophet is
shown as a herdman of Tekoa and a "gatherer of sycamore
fruit". This episode is seldom met in bestiaries.

293. F. 71ʀ: WHALE (Hippocampus)
(134 x 97 mm).
The miniature reflects the fantastic mediaeval idea of a whale as
a sea monster whose colour made it look like a sandy island.
Because sailors often mistakenly made fast to it and were in
danger of being lost in the deep, the whale was often a symbol
of the devil. The ship resembles a Viking boat and the sailors
manning the ropes are depicted with keen observation and skill.

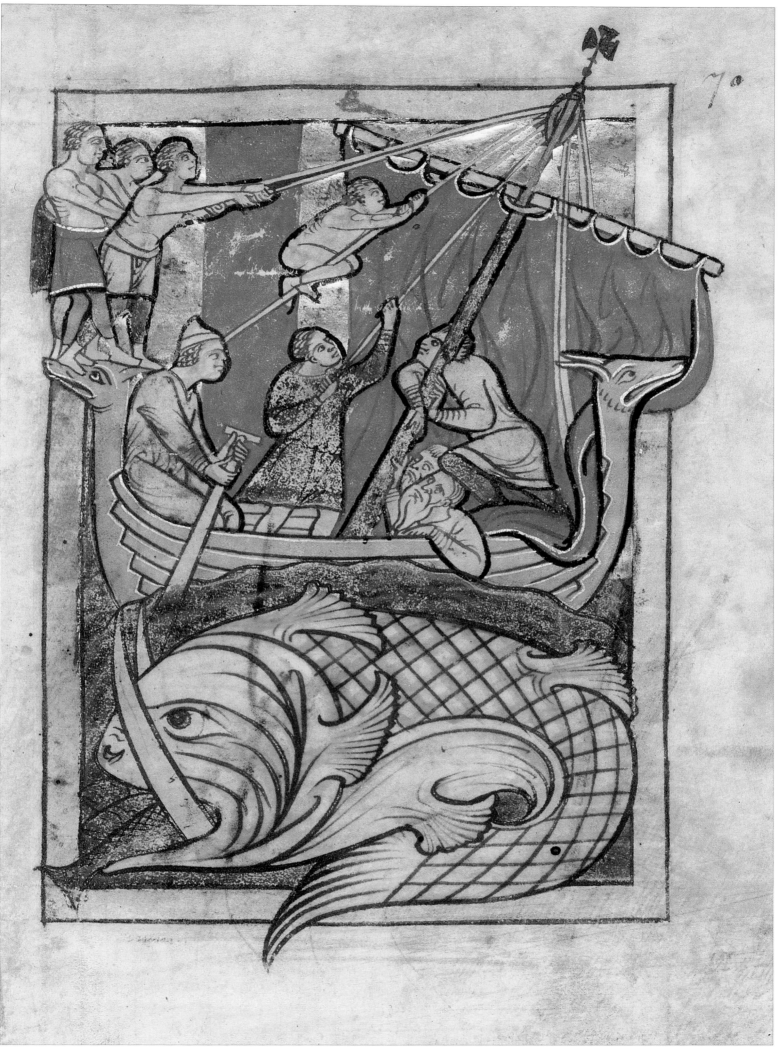

294
BIBLE WITH PROLOGUES
Biblia Sacra cum prologis

Swabia (Weissenau near Ravensburg). Second half of the 12th century.

168 ff. 465 x 330 mm (text 350 x 240 mm). Parchment. Latin.
15 large coloured initials with floral and animal ornament,
one with human figures; small initials in red.
Binding: contemporary with the manuscript. Blind-stamped leather over wooden boards;
headbands and bands on the spine.
Erm.lat.5/2.

The manuscript contains the following books: Jeremiah, Revelations, Epistles, Acts, Kings 1 and 2, Chronicles 1 and 2, Ezra and Nehemiah. The monumental style of decoration is typical of Romanesque monastery Bibles from Swabia.

According to Gille, the manuscripts from Weissenau were purchased for the royal library during the reign of Alexander I (1801–25).

ENTERED THE PUBLIC LIBRARY IN 1861 WITH THE HERMITAGE COLLECTION (4.2.1).

LITERATURE : P. Lehmann, "Verschollene und wiedergefundene Reste der Klosterbibliothek von Weissenau", Zentralblatt für Bibliothekswesen, 1932, January – February; pp. 4, 5; Latin MSS 5 th - 12 th centuries 1983, p. 54, No 224.

294

295-299
BIBLE
Old Testament. Book of Prophets
Biblia
Vetus Testamentum. Libri prophetarum
Swabia (Weingarten). Ca 1220.

203 ff. 479 x 335 mm (text 335 x 205 mm). Parchment. Latin.
1 miniature, 4 historiated initials, 12 large and 11 small initials.
Each book and prologue opens with a large initial in colour and gold,
which can include various animals and birds (eagle, peacock, monkeys and lions);
the miniature featuring a representation of Christ precedes the Book of Hosea.
Binding: 16th century. Undyed leather over wooden boards;
blind-stamped geometric ornamentation; 2 metal clasps;
holes on the covers from missing bosses; banded spine.
Lat.V.v.I.133.

The manuscript includes the Books of the Prophets Ezekiel, Daniel, Hosea, Joel, Amos, Obadiah, Jonah and Micah with prologues by St Jerome.

The manuscript was written in Weingarten, a Benedictine abbey in Swabia, under Abbot Berthold (1200–32). Hans Swarzenski, the author of an extensive study devoted to the artist whom he named the Master of the Berthold Missal (after his main work, now in New York's Pierpont Morgan Library, MS.710), holds that the St Petersburg Bible was produced between 1200 and 1215. The catalogue of the Stuttgart exhibition dates it ca 1220. The Old Testament, or, to be more precise, the Books of the Prophets, was mentioned in the inventory compiled by Berthold. Apparently the manuscript was divided into two volumes when it was rebound in the 16th century, the second being now in the New York Public Library (Spenser Collection, MS.1). The style of the Master of the Berthold Missal was influenced by magnificent Anglo-Saxon and Flemish Gospels from the 11th century given to the Abbey by Judith, Countess of Flanders (1032–1094). His art is considered to be the climax of the so-called high-relief style in German illumination, displaying the development of the techniques and tendencies of the manuscript decoration, jewellery and sculpture which flourished in the 12th century in the Meuse, Rhine and Lorraine regions. Illumination by the Master of the Berthold Missal also has traits in common with the work of the famous monastery scriptoria of Fulda and Saint Omer. The refined skill of the drawing, the glittering gem-like colours and the emotional impact of the images of the prophets make the miniatures by the Master of the Berthold Missal a masterpiece of Romanesque art.

ENTERED THE PUBLIC LIBRARY IN 1885 AS A GIFT
FROM THE HEIRS OF SENATOR A. VENEVITINOV.

LITERATURE : Otchot Imperatorskoi Publichnoi biblioteki za 1885 god, *St Petersburg, 1888, pp. 67, 68; H. Swarzenski,* The Berthold Missal. The Pierpont Morgan Library MS.710 and the Scriptorium of the Weingarten Abbey, *New York, 1943, pp. 102, 103, pls L–LIV.*

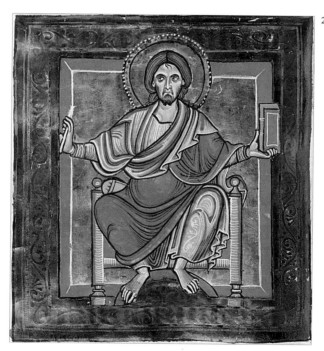

295

294. F. 74v: INITIAL TO 2 KINGS.
The initial displays an ornamental motif typical of Romanesque illumination — a curving white stalk with offshoots in the shape of coloured acanthus leaves against a colourful background. The movements of two men, one old, one young, clinging to the stalk are rendered very naturalistically. The incorporation of such motifs is usually linked with the influence on Swabian illumination of the Anglo-Saxon and Mosan schools. The use of diminuendo, the gradual diminishing of letters, goes back to insular miniatures.

295. F. 150v: INITIAL TO THE BOOK OF HOSEA. THE PROPHET HOSEA.
The initial is filled with a coloured ornament of acanthus scrolls. The frontal position of the prophet, who is shown seated with a book in one hand and a stylus in the other, adds to the hieratic austerity of the image. Experts note that the miniaturist's style also incorporated some Byzantine features.

296

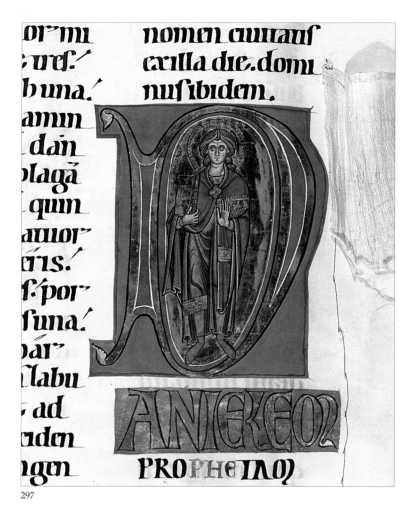

297

298

296. F. 1v: INITIAL TO THE BOOK OF EZEKIEL.

The intricate pattern of the spiral ornaments and the use of gold, silver and deep blue are reminiscent of the best examples of Lorraine enamels and Mosan gold objects. The incorporation of human figures and monsters is usually connected with England and the regions of the Continent adjacent to the English Channel and the River Meuse. The whole of the page, with its large and clear writing, the text in silver letters on a green band under the luxurious initial, and the heading at the bottom left, is a splendid example of the monumental and solemn quality typical of Romanesque illumination.

297. F. 102r: INITIAL FOR THE PROLOGUE TO THE BOOK OF DANIEL.

The golden background, bands on the vestments and the binding of the book in the prophet's hand are embossed, as in a piece of jewellery. The fine penwork of the hair and the modelling of the face are in perfect harmony with the classically serene and dignified posture of the figure and the treatment of the vestments.

298. F. 150v: INITIAL TO THE BOOK OF HOSEA. THE PROPHET HOSEA.

The initial is filled with coloured ornament of acanthus scrolls. The frontal position of the prophet, who is shown seated with a book in one hand and a stylus in the other, adds to the hieratic austerity of the image. Experts note that the miniaturist's style also incorporated some Byzantine features.

299. F. 105r: INITIAL TO THE BOOK OF DANIEL. DANIEL IN THE LIONS' DEN.

The animated initial, which features a zoomorphic design set against a dotted background, bears a similarity to the traditions of insular art.

A seated figure was first introduced in this scene in the 12th or 13th century, and was most often encountered in England. According to Hans Swarzenski, however, such a degree of emotional tension, expressiveness and powerful plasticity of form can only be compared to sculpture, for example, the figures of the phrophets in Bamberg Cathedral.

scribam gra tum
aliquid uobif uo
bif. utile ecclefie
dignum pofterif.
Prefentum quip
pe iudicif non
fauf moueor: q
in utramq, par
tem aut amore
labuntur aut
ódio.

ANNO TERCIO

REGNI IOACHIM
regif iuda uenit
nabuchodono
for rex babylo
nif in hierufalē.
œ obfedit eam.
Et tradidit dnf
in manuf et ioa
chim regem iu
de. œ partem
uaforum dom
dei. œ afportauit
ea in tram fenna
ar in domum
dei fui. œ uafa in

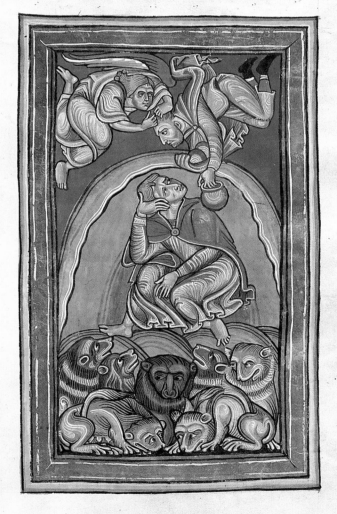

300-311
KUNRAT VON AMMENHAUSEN.
The Book of Chess
Kunrat von Ammenhausen. Das Schachzabelbuch

German Switzerland (Stein am Rhein). Late 14th century.
123 ff. 290 x 210 mm (text 220 x 145 mm). Parchment. New High German.
13 miniatures; large coloured initials with ornamentation in gold, blue and red;
small red initials with ornamentation in blue; headings.
Binding: 18th century. Red morocco over cardboard; stamped in gold along the edges
and on the spine; doublures of dark blue moiré silk.
Deutsch.F.v.XIV.1.

Kunrat von Ammenhausen was a monk and then a priest at the Benedictine monastery of Stein am Rhein. Around 1337 he translated a didactic prose treatise, written ca 1290 by the French theologian Jacques de Cessolis, into German in verse form. The treatise expounded the rules of morality and behaviour of the various groups of mediaeval society, which were symbolized by chess pieces that have to act (move on the board) in accordance with their rights and status. F. Vetter, who published the *Book of Chess* and in doing so made use of the twenty-four existing copies of it, considers the St Petersburg copy to be the oldest. The next chronologically is in the Bibliothèque Nationale in Paris.

In keeping with the composition of the poem, the illustrations show all the chessmen, i.e. the representatives of the social hierarchy, from king to peasant and artisan. Rich in everyday details, the miniatures are a valuable historical source. Pawns symbolizing ordinary city-dwellers and peasants deserve special interest. The instructions for the artist, which precede the illustrations, written in red, are also of interest, though they were not strictly followed by the illustrator. The shining gold, bright greens, white and rich blue merge into a cheerful colour scheme. The ornamented backgrounds, landscape motifs, draperies, the type and modelling of faces, costumes, a certain angular character of the figures and their enlarged proportions suggest that the illumination was executed near the end of the 14th century either in the same place where the poem was copied, or somewhere on the Middle Rhine. In the 17th century, the manuscript belonged to Pierre Séguier; in 1735, it entered the Saint-Germain-des-Prés library. According to F. Adelung, Piotr Dubrovsky bought the collection of the Duke of La Vallière (perhaps this explains why it has none of the old catalogue numbers of Séguier or Saint-Germain-des-Prés).

ENTERED THE PUBLIC LIBRARY IN 1805 (1809–61 THE HERMITAGE, 5.3.38).

LITERATURE : Cat. Séguier 1686, p. 12; Montfaucon 1739, 2, p. 1108, No 752; F. Adelung, "Nachricht von einer Handschrift des altdeutschen Gedichts: von den Schachzabelspel", Neue Deutsche Merkur, 3, Weimar, 1804, pp. 30–74; Gille 1860, p. 57; Delisle 1868–81, 2, p. 58; Das Schachzabelbuch Kunrats von Ammenhausen (ed. by F. Vetter), Frauenfeld, 1892; Laborde 1936–38, pp. 39, 40, pl. XXII.

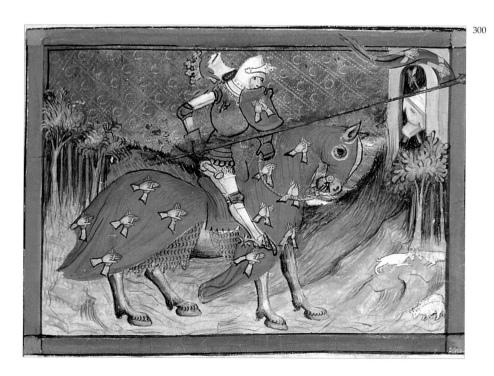

300

300. F. 38r: KNIGHT (114 x 150 mm).
"Let the knight sit on a horse covered with a chain-mail horse-cloth. Let him be a man armed in the best possible way with a helmet, coat of mail, a breastplate, couters (elbow cups), chain-mail gauntlets, greaves, a shield in his right hand, a lance, and a sword on his left side. Let him have everything else necessary. Also two gold spurs, and let the horse have a gold bridle."

Der kunig sol sitzen uf eine guldin sessel Ju eine guldin throne uf
seine houbte ein guldin trone Ju der rehten haut ein zepter Ju d' lurke
haut ein guldin appsel Sin gewant sol sin von purpur Vnd ander
gezrede sol er haben als eine kunige zu gehort

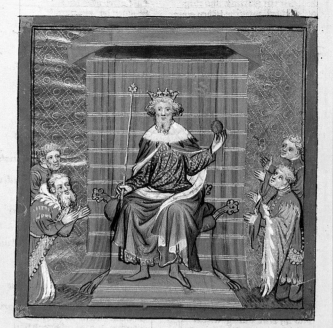

Die guten das durch tuget sint Das den kunigen vmbe di
So mus den argen vorhte dar zu Vnd andern herre entpfelhe ir
Zwingen e d' er rehte tu Gewalt das si zu aller frist
Vndius oderut perrie voi vturs Die guten schir niet vnd dar zu
Auue oderut pitac forumdit peue Die bosen kelugent spote vn fru
Sauc paul' sich als ich e laß Aug' in lib denn xxix q viy c

301

Die kungin sol sitzen uf eine guldin sessel Ju eins kuniges guldin
throne Vnd sol an tragen ein vech vel Vnd dar zu wz ein kunig
inig gezieren

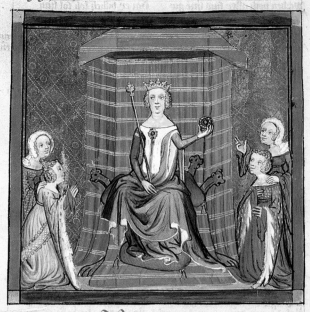

Von der kungin

B
Vnde ich nu fra Das wer wol der wille min
wen loben wol z Zu kan ich des leider niht
Als man si bil Ouch bedarf ich sin an disem diht
lich sol z Nit vil wan ich nit anders han
Vnd sunderlich Zu sagend wan als ich vant ftan
ein kungin Geschriben an disem buchelin

302

Der alte sol sin geschaffen als ein rihter Vnd sol sitzen uf eime rihtstul
vnd sol haun vor im ligen ein uf getan buch Vnd dar zu wz eine
erbern rihter an hort

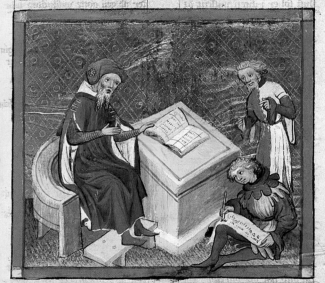

W
We der alte ge Nun horent laut uch fur ich sagen
schaffe wesen Jegelicher sol einen sessel haun
Sol als ich Dar uf er sitze ein buch zeuru
han gelesen Vor an sol ligen dar an sie
Ju disem selbe Daz reht geschriben nu horent me
buchelin Ju sont rihtern sin glich
Das sage ich uch ir sont zwene sin Ju rihter der sol flußen sich
Eiure sol bi dem kunige ftan Ju richter von des kuniges gebotte
Der ander sine dar sol haun Rihte alle sache uf noch gotte
Jnderhalp bi der kungin Vnd noch der gerehtikeit
Vnd sont alsus geschaffen sin Weder durch liep noch durch leit
Als komen sin wol zu ire tagen Dur miete dur vorhte noch dur has

303

Das roch sol haun alle ding Als der ritter Vnd dar zu me Wan es eine laut
vogt beruret so sol er haun ein vech vel vn eine kulhut vnd sin hut sone sin
mit beheim geziert vnd sol haun in siner rehte haun ein kolben do der kuniges
zeichan an si

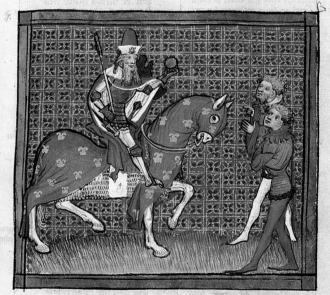

Des lantvogtes anvang

U
Jn disem fch Als auch dis schatzabel buchelin
atzabel fint Bewiset das selbe roch sol sin
Ich aber fur ich Geschaffen als ein ritter wert
sagen wil Der vnder im hab ein stolzes pfert
Das ift der Oder ein ros er sol ouch an
grollen sterne Ein libe im veth vel an han
noch Oder ein gehutze als deme si
z Juwen eine der heillet dz roch Der sitte er sol ouch haun da bi

304

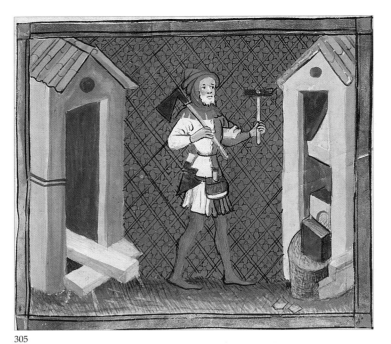

305

306

307

Page 239
301. F. 13v: KING (150 x 145 mm).
The instructions for the artist say: "Let the king sit on a golden armchair, with a gold crown on his head, a sceptre in his right hand, and a gold orb in his left hand. Let his vestments be purple and his other decorations be such as are fit for a king."

Page 239
302. F. 19v: QUEEN (147 x 140 mm).
"Let the queen sit on a golden armchair, on the royal golden throne. And let her wear motley fur, and let her have everything that adorns a queen."

Page 239
303. F. 28r: BISHOP (135 x 150 mm).
"Let the old man be shown as a judge. Let him sit on a judge's chair, and let there be an open book in front of him, and, in addition, let there also be everything that a venerable judge should have."

Page 239
304. F. 51r: CASTLE (140 x 150 mm).
"Let the castle have the same things as the knight, and in addition, if it designates a viceroy, let him have a hat of motley fur, and let the hat have coloured trimming, and let him have in his right hand a mace, which is a symbol of royal power."

308

309

310

305. F. 71r: PAWN (135 x 150 mm).
"Let another pawn be a blacksmith, and a carpenter, and a mason, and let him hold a hammer in his right hand, an axe in his left hand as a carpenter would, and a trowel tucked in his belt." (The painter has obviously made a mistake as the character holds a hammer in his left hand and an axe in the right.)

306. F. 63r: PAWN (119 x 145 mm).
"Let the first pawn be a peasant and a vintner. Let him have a spade in his right hand, a twig in his left hand, and a vintner's knife tucked in his belt."

307. F. 109r: PAWN (127 x 150 mm).
"Let this eighth pawn be [illegible] with curly hair, and let him have a few coins in his right hand, and three dice in his left hand, and a post-bag on his belt."

308. F. 100v: PAWN (130 x 150 mm).
"Let the sixth pawn be the owner of a tavern and let him have a pitcher in his left hand and let him stand so as to invite guests in with his right hand."

309. F. 94r: PAWN (138 x 150 mm).
"Let the fifth pawn be shown as a doctor, and let him sit in an armchair and hold a book in his right hand, and a phial of medicine in his left hand, and let him have many sharp instruments hanging from his belt."

310. F. 73r: PAWN (119 x 148 mm).
"Let the third pawn have scissors in his right hand, a long knife in his left hand, a writing-set hanging from his belt, and a quill sticking out behind his right ear."

311. F. 84r: PAWN (116 x 150 mm).
"Let the fourth pawn have scales in his right hand and a yard-stick in his left hand, and a purse with coins on his belt."

311

312-315
PRAYER-BOOK. BOOK OF SERMONS
Liber precum. Orationes

The Netherlands (Brabant?). 15th or early 16th century.
280 ff. 130 x 95 mm (text 87 x 55 mm). Parchment. Latin.
41 miniatures; 1 historiated initial; 1 large initial on a golden background accompanied by a
richly ornamented frame; 42 red and blue initials with filigree ornament;
1 large and other smaller coloured initials in the second part of the manuscript.
Binding: 16th century. Brown leather over wooden boards;
blind-tooled design on the spine and covers; traces of two clasps; gilt-edged.
Case: 19th century. Black leather over cardboard;
gold-stamped design around the cross; blue velvet lining.
Lat.O.v.I.206.

The volume consists of two separate manuscripts which were bound together in the 16th century. The beginning is missing. The existing first part (ff. 1–106) includes an excerpt from the two initial chapters of the Imitation of Christ by Thomas à Kempis, along with prayers. Each of the prayers opens with a large initial and is preceded by a miniature illustrating a scene from the life of Christ and painted on a separate sheet. The miniatures were probably added when the manuscripts were joined together. At the end of the Prayer-book there is a Litany (which lists the names of German saints and those venerated in the Netherlands: Cilian, Gertrude, Boniface, Lambert, and others) and the Sanctoral. The Book of Sermons is illuminated differently from the Prayer-book and includes a collection of sermons and prayers in verse and prose by Sts Anselm, Gregory, Bernard, Jerome, Thomas and Ambrose, and also by Jean de Gerson and others. The whole manuscript was probably executed in Louvain, as the script and decoration bear a resemblance to three manuscripts in the Bibliothèque Royale in Brussels which are described in the catalogue of manuscripts from Saint-Martin in Louvain (see Willem Lourdaux, Marcel Haverals, Bibliotheca Vallis S. Martini in Lovanio, Louvain, 1978, vol. 1, Nos 17, 20, 21; 1982, vol. 2, pls 4, 5, 22). At the end of the volume is a presentational inscription in Dutch.

TRANSFERRED TO THE PUBLIC LIBRARY IN 1929 FROM THE PAVLOVSK PALACE.

LITERATURE : Kratky Otchot Rukopisnogo Otdela za 1914–38 gody, Leningrad, 1940, p. 244.

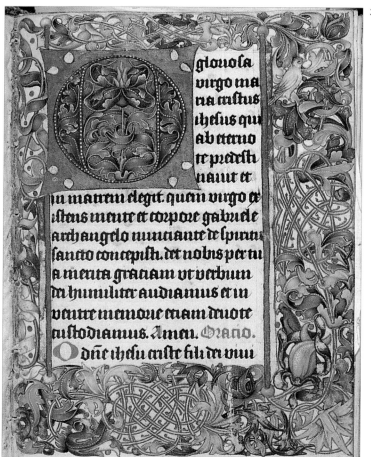

312

313

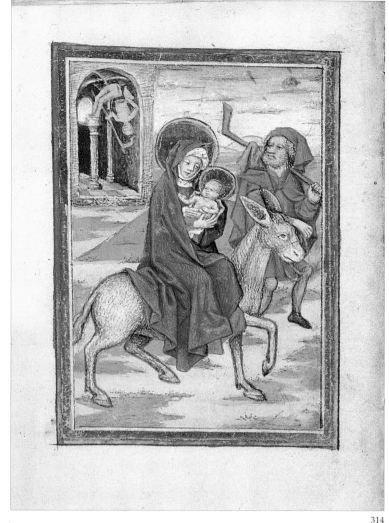

314

312. F. 6r: INITIAL TO THE PRAYER O GLORIOSA VIRGO MARIA.
The rich blue, green, purple and red leaves incorporating golden interlaced pattern and a bird in grisaille make the border on this page quite outstanding. The elegant style of the illumination is completely unlike that of the facing page which carries an Annunciation (f. 5v), which, along with the other miniatures illustrating the life of Jesus Christ, was undoubtedly taken from another manuscript, and added later. The page was cropped at the top and on the right during the rebinding.

313. F. 3r: HISTORIATED INITIAL AT THE BEGINNING OF THE TEXT BY THOMAS À KEMPIS (QUI SEQUITUR ME NON AMBULAT IN TENEBRIS).
A monk (probably Thomas à Kempis) is shown in his cell reading. The miniature is executed in grisaille delicately touched with pink.

314. F. 17v: THE FLIGHT INTO EGYPT.
The motif of a statue of a pagan god with a lance falling from a column and breaking apart which is seen to the left in the background inside the portico is quite rare. The miniatures devoted to Christ's life employ a light colour range.

315. F. 49V: THE CROWNING WITH THORNS.
The expressive faces of Christ's tormentors are a reminder that the miniatures were created in the Netherlands at the time of Hieronymus Bosch.

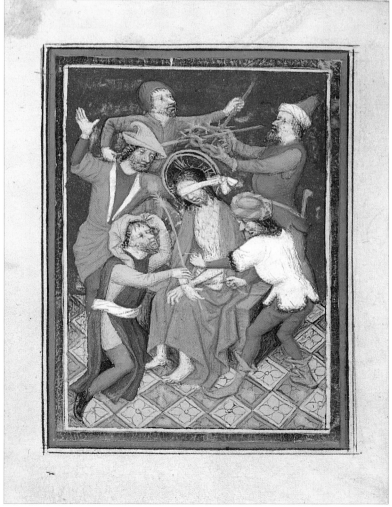

315

316
AVICENNA. CANON (BOOK THREE)
Ibn-Cina (Avicenna)
Canon (Liber Tertius)
Italy. 1343.
176 ff. 420 x 260 mm (text 280 x 160 mm). Parchment. Latin.
20 large ornamented initials in colours and gold, one of which is historiated;
numerous red-and-blue large and small ornamented initials;
catchwords at the end of the quires framed with delicate penwork.
Binding: probably contemporary with the manuscript. Mauve leather over wooden boards;
holes on the covers from square metal corners and bosses;
metal nails and holes from 2 clasps on the edge of the board; 7 bands on the spine.
Lat.F.v.VI.1.

The manuscript contains Book Three of the classical treatise the *Canon of Medicine*, which consists of five books, by Ibn-Cina (980–1037), an Arabian physician, known in Europe as Avicenna. It was translated into Latin by Gerard of Cremona (1114–1187) in Toledo. Having absorbed the ideas of Galen, a famous Greek physician, Avicenna combined and systematized Greek and Arab medical theories to create a work that remained supreme in European medical science for five centuries. The St Petersburg manuscript was copied in 1343 by Gualterus of Heubo (the verso on

f.4 reads: *Huno tercium scripsi ego Gualterus de Heubo* (?) MCCCXLIII; at the end of the manuscript on f.176 are the words: *Me scripsit Gualterus de Heubo*; the reverse of the front cover bears the owner's inscription: *Yste liber est doctoris Jacobi Vachsiis* (?)).

The type and content of the treatise, the monumental style of its illumination, as well as the decoration of the margins with large-scale ornamentation and a design of gold suns suggest that the manuscript was produced in Bologna. The provenance is unknown.

JUDGING BY THE ENTRY IN THE INVENTORY, THE CANON ENTERED THE PUBLIC LIBRARY SOME TIME IN THE FIRST HALF OF THE 19TH CENTURY.

LITERATURE : Golenishchev-Kutuzov 1972, p. 173 (repr.).

316

316. F. 5r: INITIAL TO BOOK THREE.
I. Golenishchev-Kutuzov thought that the characters shown were a university professor demonstrating a vessel and a student listening to him. It is more likely that those depicted are Avicenna and the translator of his work, represented by the small figure of a monk below.

317-328
BENOÎT DE SAINTE-MAURE
Le Roman de la guerre de Troie

Italy (Bologna?). Second half of the 14th century.
168 ff. 415 x 280 mm (text 240 x 165 mm). Parchment. French.
329 pages, starting with f.5 are decorated with miniatures. Though usually placed at the bottom,
they often continue upwards; some pages have miniatures in the middle and at the top.
Every section of the poem is marked by a historiated or ornamental initial, while each page is
framed with a floral ornamental border painted in gold and various colours.
Binding: late 18th or early 19th century (commissioned by Piotr Dubrovwsky). Purple velvet
over cardboard, stamped in blind with geometric design; gilt-edged.
Fr.F.v.XIV.3.

The manuscript contains a French romance written by Benoît de Sainte-Maure, a Benedictine monk who lived in the 12th century and served at the Normandy court of King Henry II of England. The complete text of the romance, which was written around 1160–70, consists of 30,000 verses, while the St Petersburg copy has only 28,000. The author relied on works by Dares Phrygius and Dictys Cretensis who reintroduced Homer's Iliad to the mediaeval world and supplemented it with various legends from antiquity (probably written in the 1st century AD, but known from the Latin translations of the 4th to 6th centuries). The *Roman de la Guerre de Troie* is a major example of this literary genre in France.

The *Roman de la Guerre de Troie* enjoyed great popularity in mediaeval Europe (there are currently seventeen known copies dating from the 13th to 14th centuries). The earliest surviving illustrated copy was produced in France in 1264. The series of illustrations to this work of Benoît de Sainte-Maure were further developed in the 14th century in Italy where it was copied for the courts of Naples and Lombardy. The copies of the *Roman de Troie* produced in the middle of the century in Bologna and now in the Österreichische Nationalbibliothek in Vienna (MS.2571) and the Bibliothèque Nationale in Paris (MS.782) are the closest to the St Petersburg manuscript in terms of the choice of miniatures. However, art historians are unanimous in giving priority to the illumination in the St Petersburg manuscript both from the point of view of quality and artistic originality. F. Saxl wrote that the artistic and historic importance of the manuscript could hardly be overestimated. He also considered it a remarkable document revealing a new concept of human dignity formulated six centuries ago.

Art historians do not agree on the manuscript's date and place of execution. They have put forward various suggestions: Northern Italy in the 1320s (Laborde); the school of Simone Martini (Beer); Siena (Dobias-Rozhdestvenskaïa); Central Italy in the 1340s (Saxl); Bologna with Sienese influence (Saxl, Panofsky); and Bologna in the late 14th century (Buchtal). The style of the manuscript's best miniatures — their monumental impact and large ornamental designs in the margin — shows the influence of fresco decoration, while the treatment of architectural motifs can be traced to Giotto. All these features undoubtedly characterize the school of Bologna, whose masters, starting in the mid-14th century, were often commissioned to work for aristocratic courts in Northern and Southern Italy. Naturally, the adornment of such a voluminous manuscript involved a group of artists. As often happened, the senior masters painted the miniatures in the first part, but afterwards the manner becomes less refined, the colour less radiant, and the drawing stiffer, although that is not to say that the latter miniatures are totally devoid of expressiveness or innovation. The less important miniaturists often treated similar subjects,

especially battle scenes, with understandable monotony. At the same time the manner of the senior master (or masters) is distinguished by the quiet rhythms of the frieze-like compositions, skilful and smooth modelling and a rich colour scheme where the contrasts of gold, deep blue and bright crimson are softened with pistachio-green, lilac and greyish brown.

The depictions are accompanied by the scribes' inscriptions instructing the illustrators as to the subject-matter and the characters to be depicted (several of them were cut off during later binding operations). These inscriptions — a common phenomenon for lavishly illustrated Italian manuscripts — can also serve as an explanation to the readers. The system of illumination used by the miniaturists was elaborated and widely spread in Italy during the whole of the 14th century. Be it in Bologna, where the illumination had an obvious connection with frescoes, in Milan, where it showed the strong influence of French grisaille, or in Naples, where a fascination with the French knightly culture went hand in hand with the popularity of Petrarch and Boccaccio, the general system of illuminating romances and often history books remained alike. The artist used the whole bottom part of the page, on which he presented a detailed pictorial narrative with one episode closely following the other. Architectural forms grew upwards, between the columns of the text and in the margins, sometimes turning into elaborate mediaeval "skyscrapers". Their inhabitants were shown playing musical instruments, feeding birds, or just looking on and witnessing various historical events. As for the choice of subjects, the artists mostly favoured the themes of love and its tragic ways, scenes of courtly etiquette — meetings, receptions, etc., and, most importantly, battle scenes, both on land and at sea. The typical mediaeval preference for war subjects over those of peace was brought about by life itself. Since the illustrators dressed historical characters in a contemporary way and seldom employed the motifs of antiquity, the miniatures in the *Roman de Troie* have become a precious source of information on 14th century life in Italy, its architecture, furniture, clothes, morals and etiquette, military techniques and armour, shipbuilding and navigation.

The early owners of the manuscript are unknown. Gille and Laborde suggested that it belonged to Pierre Séguier in the 17th century and therefore became part of the Saint-Germain-des-Prés library. However, the volume has no races of the catalogue numbers of either Séguier's collection or that of Saint-Germain-des-Prés. The reverse of the upper cover has a later (18th century) inscription in pencil: 51 497 0 30000-35 (cf. Fr.F.v.III.3: 51 496 0 7500-35), which is probably the number and price from some auction catalogue. At the end of the 18th century the manuscript was purchased by Piotr Dubrowsky.

I T A L Y

ENTERED THE PUBLIC LIBRARY IN 1805 (1840–61 THE HERMITAGE, 5.3.44).

246/247

LITERATURE : Cat. Séguier 1686, p. 16; Montfaucon 1739, 2, p. 1108, No 728; Gille 1860, pp. 50, 51; A. Joly; Benoît de Saint-Maure et le Roman de Troie ou les métamorphoses d'Homère et de l'épopée gréco-latine du Moyen Âge, vol. 1, part 2, Paris, 1870, p. 7; Bertrand 1874, p. 171; Benoît de Saint-Maure, Le Roman de Troie (ed. by L. Constans), vol. 6, Paris, 1904–12, pp. 51, 52 (about the St Petersburg copy); R. Beer, "Les principaux manuscrits à peintures de la Bibliothèque impériale de Vienne", Bulletin de la Société française de reproductions des manuscrits à peintures, Paris, 1913, p. 26; E. Panofsky; F. Saxl, "Classical Mythology in Mediaeval Art", Metropolitan Museum Studies, 4 (2), New York, 1933, p. 262, note 40, fig. 49; Laborde 1936–38, pp. 19, 20, pl. XII; Dobias-Rozdestvenskaïa, Liublinskaya 1939, p. 864; F. Saxl, "The Troy Romance in French and Italian Art", Lectures. The Warburg Institute, vol. 1/2, London, 1957, pp. 137, 138, pls 80, 81; H. Buchtal, Historia Troiana. Studies in the History of Mediaeval Secular Illustration, London, Leiden, 1971, p. 14; I.M. Besprozvannaya, "Khudozhestvennoye konstruirovaniye rukopisnoi knigi Roman o Troyanskoi voine", Problemy istochnikovedcheskogo izucheniya rukopisnykh i staropechatnykh fondov, Leningrad, 1979, pp. 155–171. A. Pianosi, il messoli dell'ambrosiana, il tristan di parigi e un capolavoro sconosciuto nella miniatura bombarda trescentes can, in : artechristiana n° 748, p. 9-24.

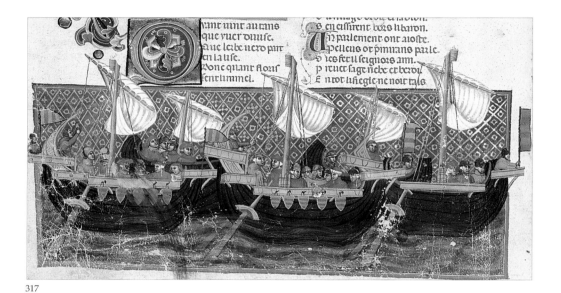

317

318

317. F. 13v: CASTOR, POLLUX AND
HERCULES ON THEIR WAY TO TROY.
There is a separate view of a city similar to that on f. 1r.
The miniatures in this volume are enclosed in thin, rectangular-shaped coloured frames, but the artists often break their constricting rigidity by extending ship masts (as in this case), buildings or trees beyond them.

318. F. 17v: ANTENOR'S MISSION
ARRIVING IN GREECE.
This page presents an example of a more complex organization. The depiction of Antenor's arrival is placed at the bottom of the page, while another narrative scene, showing King Priam and his court, is included in the column of the text. The beginning of the section is marked with an ornamented initial.

319. F. 23v: THE MARRIAGE OF PARIS
AND HELEN.
The ornamental design of this and adjacent leaves is very flamboyant, even to excess. The upper border of the miniature is turned into a fortress wall with towers, the windows of which contain genre scenes.

Page 248
320. F. 86v: BATTLE.
This is one of the numerous battles mentioned in the Roman de Troie and shown in the miniatures. At the bottom of the page Agamemnon and Menelaus are fighting on the Greek side (left) and Troilus and Diomedes on the Trojan side. At the top Hector is shown taking leave of King Priam before going off to battle.

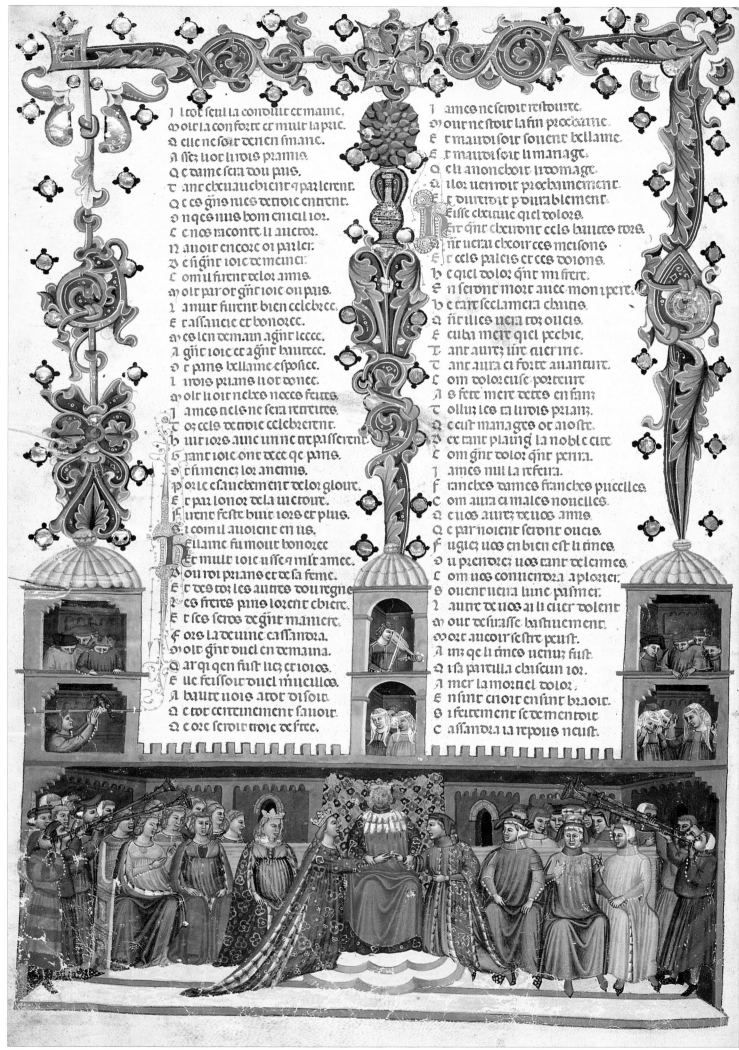

Left column	Right column

l trot seul la conduit et maine,
ou la conforte et mult la prie,
Q elle ne soit de rien en fraine,
A fiz lor li rois priame.
Q e dame sera dou pais.
T ant cheuauchient q parteient.
Q e ces g̃ns nues detroie entrent.
O nqes nus bom en tel lor.
C e nos raconte li auctor.
N auoit encore oi parler.
D e sig̃nr ioie de mener.
C om il furent de lor amis.
ay oit par or g̃nt ioie ou pais.
l anuit furent bien celebrec.
E t assaucie et bonoree.
ay es len demain ag̃nt lecce.
A g̃nt ioie et ag̃nt hautece.
O r pans bellame esposee.
l i rois priame li ot donee.
ay oit li oit nobles noces faites.
l ames nele ne sera retraite.
T oz cels detroie celebreient.
h uit iors ainc un ne trpasserent.
h tant ioie ont dece qe pans.
O r li mene lor anemis.
p or le esaucement de lor glour.
E t par lonor de la uictoire.
f urent feste buit iors et plus.
S i com il auoient en us.
B ellame fu mout bonoree.
E t mult ioie uisse q mlt amee.
D ou roi priame et de sa feme.
E t de toz les autres dou regne.
l es freres pans lorent chiere.
E t ses serors deg̃nt maniere.
f ors la deuine cassandra.
ay oit g̃nt duel en demaina.
Q ar qi qen fust liez et ioios.
E lle feissoit duel miuellos.
A hautte uois atot disoit.
Q e tot certainement sauoit.
Q e ore seroit troie deffite.

l ames ne seroit restourte.
D our ne stoit la fin procheaine.
E t maudisoit souent bellame.
E t maudisoit li mariage.
Q ele anoncheoit ir domage.
Q ilor uenroit prochainement.
E t uiuroit pdurablement.
K isse chetiue qel dolors.
g̃nt cherront cels hautes tors.
nt uerai cheoir ces maisons.
E t cels paleis et ces doions.
h e qiel dolor g̃nt un frere.
E n seront mort auec mon i pere.
h e tant se clamera chaitis.
q sir lles uerrai toz oucis.
E euba mere qiel peebie.
T ant auurz uitt auer ine.
T ant aura ci forte auanture.
C om doloreuse porteure.
A s fere ment detts en fanz.
T olluz les tu li rois priam.
Q ceux manages ot anoste.
D e tant plaing la noble cate.
C om g̃nt dolor g̃nt penra.
l ames nul la referra.
f ranches dames franches pucelles.
C om aura ci males nouelles.
D e uos autrz de uos amis.
Q e par noient seront oucis.
f ugiez uos en bien est li tines.
O u prendrez uos tant de larmes.
C om uos conuendra aplorier.
S ouent uenra hune pasmer.
l autre de uos ail li cuer dolent.
ay our desiraste hastiuement.
ay ort aucour se dire peust.
A inz qe li tines uenir fust.
Q isa partilla chaiscun ior.
A mer la mort el dolor.
E nsint crioit ensint braoit.
S i fierement se dementoit.
C assandra la repous neust.

319

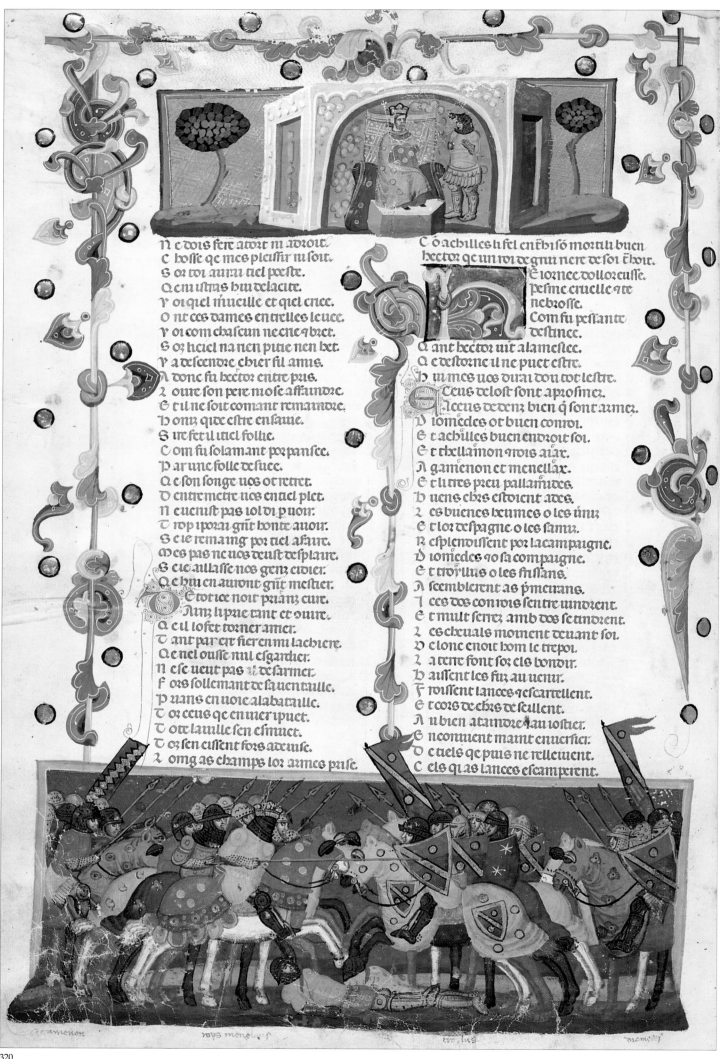

<table>
</table>



N e dois fere atort ni adroit.
c hosse qe mes plessir ni soit.
S or toi aurai tiel poeste.
Q en istras hui delacite.
Y or qiel inuieille et qiel enee.
O nt ces dames entielles leuee.
Y oi com chascun necrie q biet.
S oz heiel na nen pitie nen bet.
Y a descendre chier fil amis.
A done fu hector entre pris.
Q oure son pere niose affaindre.
E t il ne soit comant remaindre.
H onz qide estre ensaiue.
S ir e fer il itiel follie.
C om fu solamant por pansee.
P ar une folle desuee.
Q e son songe uos or retret.
D entremetre uos entel plet.
N euenist pas iol di p uoir.
T rop iporai grit honte auoir.
S e ie remaing por tiel afaut.
M es pas ne uos deust desplaire.
S e ie aillasse nos genz eidier.
Q e hui en auront grit mestier.
E torice noit prianz cuer.
A inz li prie tant et oure.
Q e il lofet torner arrier.
T ant par est fieren mi lachiere.
Q e nel ousse nul esgartier.
N ese ueut pas il desarmer.
F ors sollemant desauentaille.
P uans en uoie alabataille.
T oz ceus qe en iuer i puet.
T oile lauille sen esmuet.
T oz sen eussent fors aduise.
R omg as champs lor armes prise.



C o achilles li fel enfbi so mortli buen
hector qe un roi degnu niere desoi thoir.
E iornee dollor eusse
pesme cruelle rte
nebrosse
Com fu pessante
destince.
Q ant hector uit alameslee.
Q e destorne il ne puet estre.
H u mes uos dirai dou tot lestrit.
C eus delost sont aprosmez.
A ceus dedenz bien q sont armez.
D iomedes ot buen conroi.
E t achilles buen endroit soi.
E t thelamon rois aiar.
A gamenon et menellax.
E t li tres preu pallamides.
H uens chrs estoient ades.
R es buenes beumes o les uirs.
E t lor despagne o les samrz.
R esplendissent por lacampaigne.
D iomedes qo sa compaigne.
E t troilus o les frislans.
A scemblerent as p meirans.
I ces dos conrois sentre uindrent.
E t mult serrez amb dos se tindrent.
R es cheuals moment deuant soi.
D elone enoit hom le trepoi.
L a terre font soz els bondir.
H aussent les fuz au uenir.
F roissent lances qescartellent.
E t cors de chrs de seillent.
A u bien atundre qau iostier.
E ncontuent maint enuersier.
D e tiels qe puis ne relleuient.
C els qi as lances escamperent.

agamenon roys menelax troilus diomedes

321

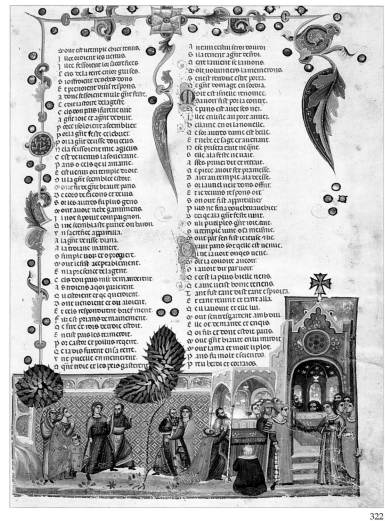

322

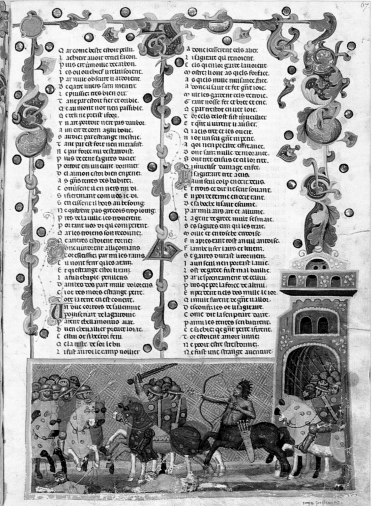

323

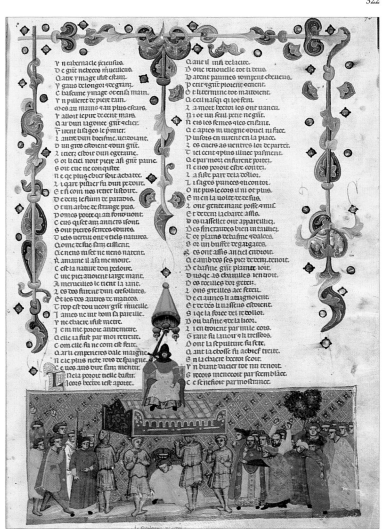

324

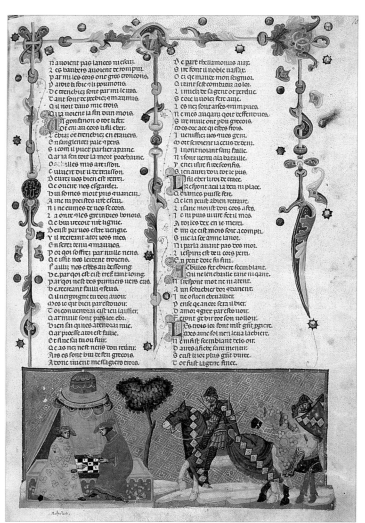

325

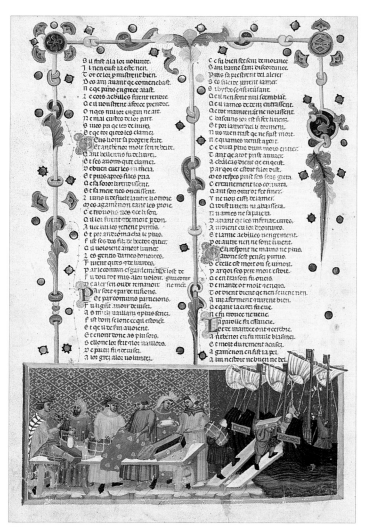

326

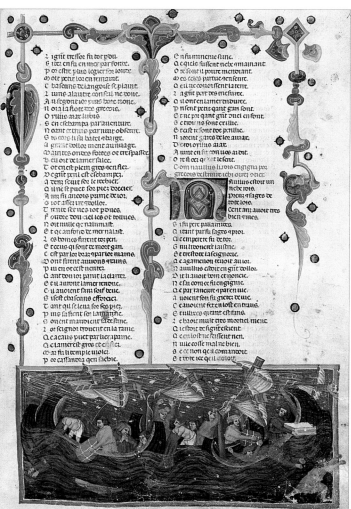

327

Page 249
321. F. 18r: PRIAM SPEAKING BEFORE LAOMEDON.
This scene is reminiscent of university disputes.

Page 249
322. F. 20r: THE MEETING OF PARIS AND HELEN.
Paris sets off to look for Helen and meets her, in accordance with traditional mediaeval iconography, in a temple. The scene is one of the favourite subjects among illustrators of the Trojan romances. This miniature has a greater emotional impact than the previous ones. It demonstrates a sharper contrast of colours, more energetic movements and a different, "Greek" facial type with large eyes and big noses. Perhaps it was this master's individual style that prompted experts to speak of Sienese influence.

Page 249
323. F. 67r: BATTLE.
The king of the Centaurs is fighting on the side of the Trojans, who are appearing from the city gate (their coat of arms features two circles and an oblique stripe, while the Greek coat of arms has a tooth-edged stripe).

Page 249
324. F. 93r: THE LAMENTATION FOR AND INTERMENT OF HECTOR.

325. F. 103r: ACHILLES MEETS THE GREEK ENVOYS.
Three Greek envoys come to Achilles, who is playing chess, and urge him to join the battle.

326. F. 144v: THE GREEKS SHARING THE PLUNDER AND LOADING SHIPS.

327. F. 152r: GREEK SHIPS CAUGHT IN A TEMPEST.
This is a highly expressive scene with the shipwrecked sailors throwing their plunder overboard and ripping off their clothes in order to swim for their lives.

328. F. 142r: THE WOODEN HORSE.
The wooden horse is taken into Troy where it is met by King Priam.

e baleuns ttrt botte 7 en paint.
A mult gnt paine ont lounr traite.
Q e en forme de cheual est faite.
S i est haute si par est gnt.
Q ene lauoit nus hom uiuat.
Q inaut mruelle et qui e die.
C oment fu faite 7 establie.
O sons e strumenr obauz.
E u amenr uisep as portauz.
T roiens tor festiuoient.
Q acmit gnt ioie lospetoient.
O mruellens desdourenz.
E t o gnt sacrehsiemenz.
L aleient encontte bois.
M es tant parauoit grant lecors.
Q e as portes m en ttast por rien.
E t qant ce uirent troien.
C on soull pustrent qe les terrax.
A battoient 7 le portax.
L es biaus les gent qe neptunus.
O t fet mul am auoit 7 plus.
E t qe appollo oit de die.
M olt en est luuois engigniez.
C omunemanr sont deceu.
Q anr li mur furenr abatu.
Y lixes ot parle as suens.
D es or fet il est leus 7 tens.
N l auons mes qe de morer.
U es auous qeste 7 de mander.
D e mentre qen si est li afar.
N elor leisserons mes refaire.
L es murs ne tittr en le cheual.
U cuanr qe tot nre uassal.
A ient lor dons 7 lor loiers.
Q e la nen faudra diuiers.
T ot maintenanr fu ce reqis.
C il q sonr fel 7 entre pris.
O nt tot liure cest duel 7 mal.
A donc fu tttt en li cheual.
A si gnt ueneration.
E t a si gnt precession.
Q e nus m con tteroit la ioie.

Q e de mainenr eil de troie.
E ntte tant dis sont les naues.
T re fettes 7 apparulies.
L i gnt auoir li gnt tteus.
Q e attoie lor est rendus.
E st aportez tes nez mis.
Y n estrange 7 soul ont pris.
Q e heleine pas m p̃oient.
U cuanr qe la cite auroient.
P rise par force et abatue.
Q arse il lauoient recue.
L eit seroit puis bon tte ttort.
S eil lauroient amort.
E t il uoillent qelle soit danee.
E t tresplait molt qde sa gtte.
A menellaus mes sachiez bien.
Q il nen puet estte autte rien.
P oz lui nen fu ne plus ne maint.
M olt en fu uies caus dire plains.
A troue ont fet por tta bison.
A uroi priant qe chendon.
C ondumoient lor epaignies.
T ot lor gent 7 lor naures.
P uis manderont por bellaine.
Q ar ne uoillent li cheuetaine.
Q ele poples comuns la uoie.
N e auul haut ne la ttoie.
Q ar il ont par lui perdu tant.
Q il noit au mont home uiuant.
Q e la peust de mort gant.
S eilla pooient tenir.
C elleement imanderont.
E t en tt post lor ameurront.
C e uielt bien priamz 7 o troie.
Q eil se metent a la uoie.
Q uant orent lor buens a oplus.
Q et lor naues furent gaznir.
S iont les logtes alumees.
Q e ttoie uoient les fumees.
Q ar gnt ieirnt li attait.
Q il lauoient de loing fait.
M olt estoient bien herbergie.

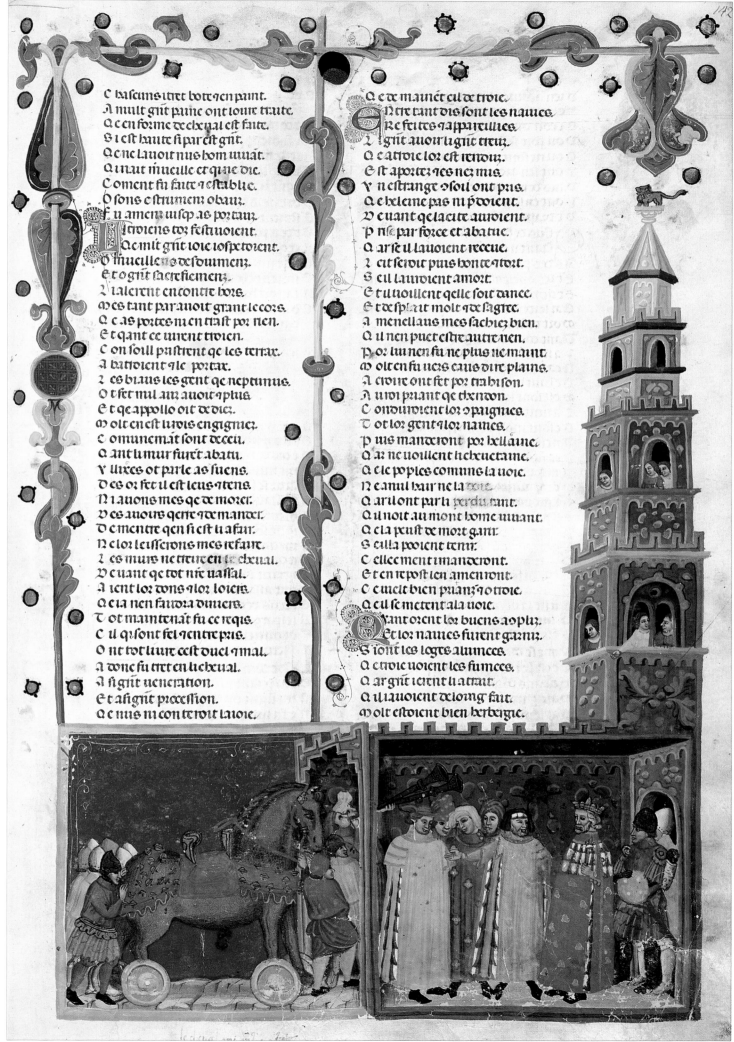

PETRARCH. Remedies Against Both Kinds of Fortune
Francesco Petrarca
De Remediis utriusque Fortunae

Italy(Milan). 1388.

141 ff. 365 x 250 mm (text 230 x 170 mm). Parchment. Latin.
4 historiated initials in gold in frames; ornamental borders of acanthus scrolls in blue,
red and lilac and small golden suns framing the pages; coloured initials
on dark blue backgrounds with floral ornament opening every chapter.
Binding: 18th century. Red morocco with a gold-tooled frame over cardboard.
The inside of the front cover has the ex libris of Piotr Suchtelen.
Lat.F.v.XV.1.

This is one of four dated existing copies of Petrarch's treatise, which was written in 1366. At the end of the treatise (f. 141v) is the scribe's note: *Qui scripsi dego Andreas, prb. ego Madiolanum* 1388, showing that the text was copied in 1388 by Andrea, a priest from Milan, probably for the noble Bolognese family of Ghisilieri, whose coat of arms, according to Gille, appears on two leaves which bear portraits of Petrarch.

The coats of arms prompted Laborde to surmise that the copy had been produced in Bologna. However, they were undoubtedly added after the completion of the illumination. The type of decoration in the margins, with large, resilient acanthus scrolls of various colours and small golden suns was indeed devised in the 14th century in Bologna, but it was already being employed in Padua and Milan in the 1380s. In addition, judging by the scribe's note, the copying of the manuscript was completed in Milan.

The history of the manuscript in the subsequent centuries is not known. At the end of the 18th century it became part of the library of Count MacCarthy. In the early 19th century, that library was sold through the de Bure brothers, French dealers in old books, from whom Piotr Suchtelen bought the manuscript for 400 francs.

ENTERED THE PUBLIC LIBRARY IN 1836 WITH THE SUCHTELEN COLLECTION.

LITERATURE : Catalogue des livres rares et précieux de la Bibliothèque de feu M. le comte de MacCarthy Reagh, *vol. 1, Paris, 1815, p. 239, No 1511; Gille 1860, pp. 49, 50; Yaremich 1914, p. 42; Laborde 1936–38, pp. 44, 45; V. Branca,* "Manoscritti petrarcheschi nelle biblioteche di Leningrado e Stoccolma", *Lettere Italiane, 18, 1966; E. Bernadskaja,* "Manoscritti del Petrarca nelle Biblioteche di Leningrado (USSR)", *Italia mediævale e umanistica, 22, 1979, pp. 547, 548; Bernadskaya 1984–85, pp. 193–195.*

329

329. F. 4r: INITIAL TO BOOK ONE.
The initial shows Petrarch wearing a hooded mantle trimmed with ermine fur.

330. F. 6r: INITIAL AT THE BEGINNING OF A CHAPTER IN BOOK ONE.
The initial shows a portrait of Petrarch.

331. F. 72r: OPENING PAGE OF BOOK TWO.
The miniature shows Petrarch in his study at a lectern. The miniature displays a refined combination of light colours. The delicately modelled faces with a short nose and slightly puffy cheeks are identical in all the portraits of Petrarch in the manuscript. Since there are similar features in other portraits of the poet dating from the 14th century, these elements may reflect Petrarch's true appearance.

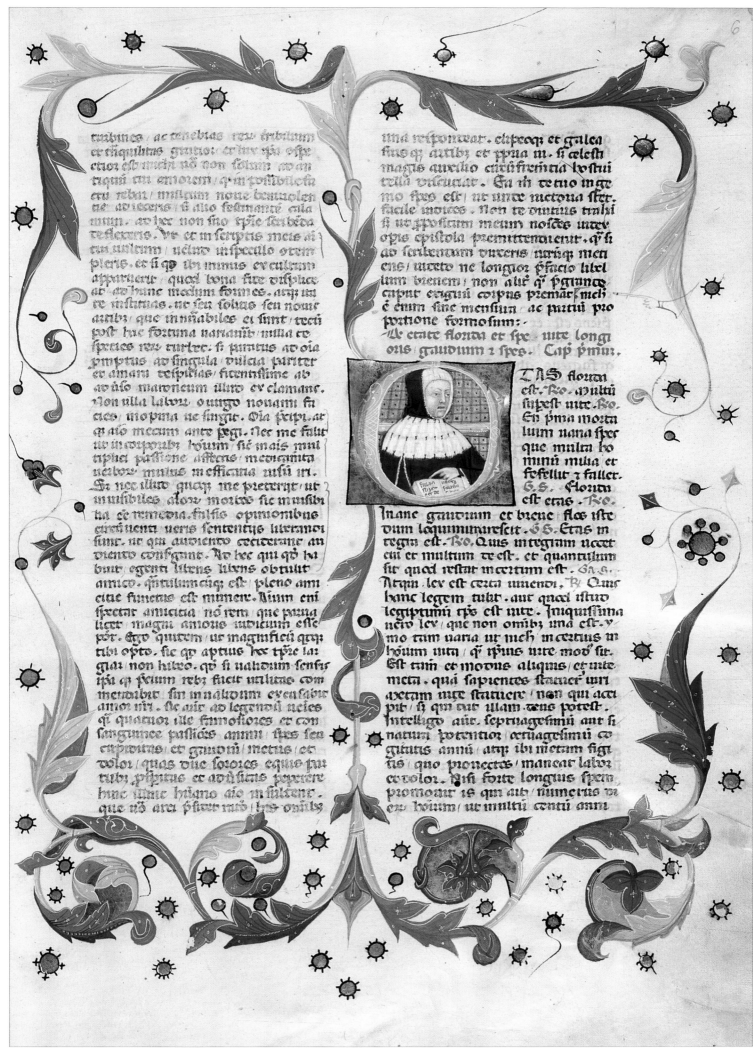

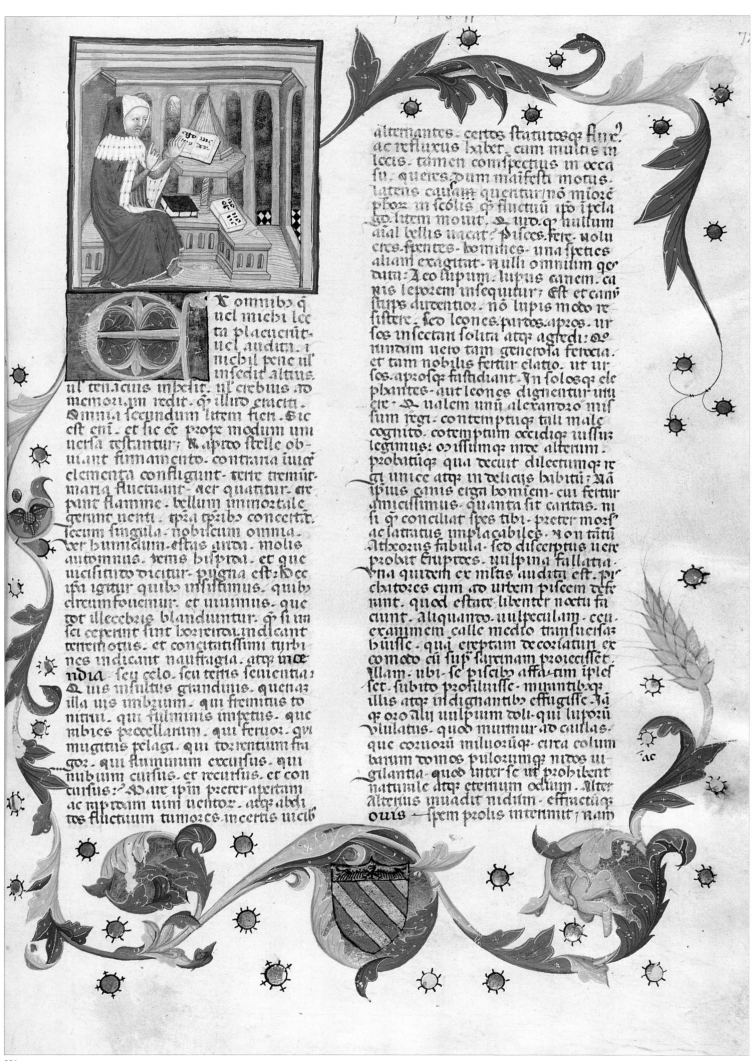

332
PETRARCH. RIME. TRIUMPHS
Francesco Petrarca. Canzoniere. Trionfi
Italy (Florence). 1450–70.
199 ff. 223 x 155 mm (text 150 x 70 mm). Parchment. Italian.
2 title-pages framed with ornamental borders;
a dark-blue initial at the beginning of each poetic piece.
Binding: 16th century. Brown morocco over cardboard; the cold-tooled ornamentation is typical
of the bindings in the collection of Jean Grolier, a bibliophile from Lyon; gilt-edged.
Ital.Q.v.XIV.1.

The volume contains a complete copy of the canzoniere (317 sonnets, 29 canzoni, 9 sestine, 7 ballads and 4 madrigals), the *Triumph* of Love with the chapters in the wrong order, and the first chapters of the *Triumph of Death* and the *Triumph of Glory*.

The title-pages are a splendid example of the style of decorating humanist writings that appeared in Florence at the beginning of the 15th century, although it did not become fully established until the second quarter of that century. This style flourished between 1450 and the 1470s, during which period this manuscript was most probably executed. The illumination has some features in common with the manuscripts produced for Vespasiano da Bisticci (1422–1498), a famous publisher and book dealer, by Florence's leading miniaturist Francesco d'Antonio del Cherico. Vespasiano supplied humanist writings to Louis XI of France, with Cardinal Jean Jouffroy acting as intermediary. It is unclear who commissioned the manuscript, as the coat of arms on the first page has been erased.

In the 17th century, the manuscript belonged to Pierre Séguier: d 795 — a typical number for his collection — appears on the front cover, although that number is not in Montfaucon's catalogue of the books acquired by Saint-Germain-des-Prés from the collection of Séguier's grandson, the Duke of Coislin. However the code n.2373 (f. 1r) proves that it had been part of the library at Saint-Germain-des-Prés. At the end of the 18th century the manuscript passed to Piotr Dubrovsky.

ENTERED THE PUBLIC LIBRARY IN 1805 (1849–61 THE HERMITAGE, 5.2.58).

LITERATURE : Gille 1860, p. 75; Laborde 1936–38, pp. 86, 87; V. Branca, "Manoscritti petrarcheschi nelle biblioteche di Leningrado e Stoccolma", Lettere Italiane, 18, 1966, p. 5; E. Bernadskaja, "Manoscritti del Petrarca nelle Biblioteche di Leningrado (URSS)", Italia mediœvale e umanistica, 22, 1979, pp. 547, 548; Bernadskaya 1984–85, pp. 195, 196.

332

333
BOCCACCIO. FILOCOLO (IN FIVE BOOKS)
Giovanni Boccaccio. Il Philocolo (libri 5)

Italy (Naples?). Middle or second half of the 15th century.
212 ff. 305 x 210 mm (text 205 x 135 mm). Parchment. Italian.
The face of the first page is gilded, and has a historiated initial and a border;
Books Two to Five begin with initials in gold over a white,
blue and red interlace studded with small golden suns; small initials in gold against green,
pink, dark blue and lilac backgrounds with a white design.
Binding: 17th century. Brown leather over cardboard; Séguier's gold-tooled coat of arms
on the front and back covers, and monograms on the spine.
Ital.F.v.XIV.1.

The *Filocolo* is an adapted Italian version of *Floir et Blanchefleur*, a thirteenth-century French novel by an unknown author. The novel narrates the idyllic love story of Floir, a Saracen prince, and Blanchefleur, a Christian captive, who overcome all barriers in their path.

The beautiful decoration of the first page combines the illumination techniques that were elaborated in Florence for humanist literary works in the mid-15th century with the richness of manuscripts commissioned by the high aristocracy. The festive effect of the illumination is further supported by the splendid ornamented initials at the baginning of each book. Laborde calls this style of illumination Neapolitan, while Bernadskaya attributed it to the Florentine school. The combination of the realistic and expressive face of Boccaccio shown as an imaginary old man with eyebrows of unusual form and the beasts in the border suggest a degree of northern influence.

The manuscript was created for King René, whose coat of arms with four shields and the motto Accadera appears at the bottom of the first page. In the border of the manuscript can be seen four coats of arms of Aragon and of Anjou, which was wrongly identified to be that of René of Anjou, and is in fact that of Argonais of Naples. It is not sure that the manuscript was intended for them originally, as the emblem of the palm and the motto Accadera which appears in the medallions on the same leaf, do nor correspond to any of the arms adopted by Napolitan sovereigns.

In the 17th century, the manuscript was owned by Pierre Séguier, and in 1735 it joined the collection at Saint-Germain-des-Prés. At the end of the 18th century it was purchased by Piotr Dubrowsky.

ENTERED THE PUBLIC LIBRARY IN 1805 (1849–61 THE HERMITAGE, 5.42.60).

LITERATURE : Cat. Séguier 1686, p. 102; Montfaucon 1739, 2, p. 1108, No 745; Gille 1860, p. 76; A. Lecoy de La Marche, Le roi René, sa vie, son administration, ses travaux artistiques et littéraires, vol. 2, Paris, 1879, p. 189; Yaremich 1914, p. 42, ill. between pp. 41 and 42; Laborde 1936–38, p. 87; Shishmariov 1927, vestiges de la bibliothèque de René d'Anjou, pp. 184–186; Bernadskaya 1984–85, pp. 206, 207.

Page 255
332. F. 1r: TITLE-PAGE.
The border is filled with typical Florentine humanist ornamentation made up of intricately entwined white vine-stalks (bianchi girari) incorporating birds and putti. This motif, which humanists considered a characteristic feature of classical works, in fact goes back only to ornamented Romanesque initials of the 11th and 12th centuries. The border includes an erased coat of arms and a conventional picture of Petrarch as a grey-haired humanist holding a book, which certainly does not render any of the poet's actual features. The arrangement of the page and its transparent and noble colour scheme based on blue, light green, white and gold against the creamy white surface of fine parchment, its refined penwork and its elegant lettera antica script all testify to the high aesthetic culture of the humanist illumination in the quattrocento.

333. F. 1r: OPENING PAGE OF THE FILOCOLO.
The initial M incorporates a half-length portrait of Boccaccio crowned with a laurel wreath, wearing a red mantle and holding a book. The richly ornamented border has putti, both nude and wearing coloured tunics, deer, hares, a bear, a peacock and medallions with a palm tree and the motto Accadera, as well as the coat of arms of King René. (Aragonaise coat of arms).

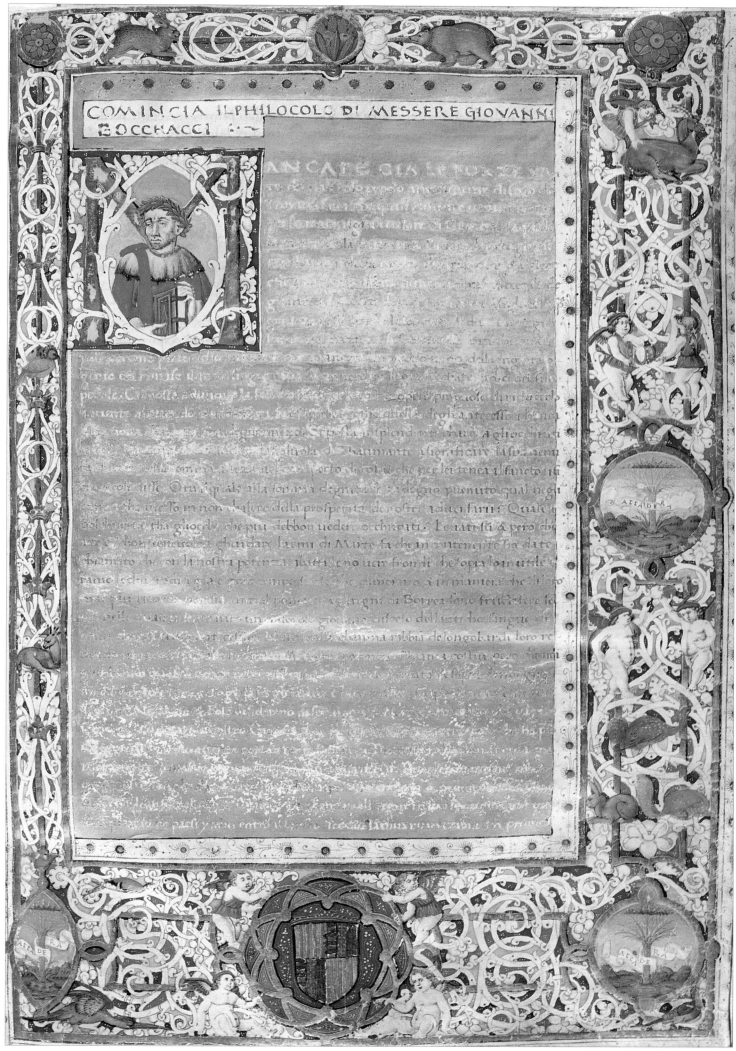

334-347
CATON SACCO. SEMIDEUS.
Book Three: On Military Art
Caton Sacco. Semideus.
Liber tertins: De re militari
Italy (Milan). After 1438.
116 ff. 270 x 190 mm (text 90 x 75 mm). Parchment. Latin.
30 miniatures and drawings.
Binding: early 19th century (commissioned by Piotr Dubrovsky).
Green morocco over cardboard; gold-tooled geometric design; gild-edged.
Lat.Q.v.XVII.2.

Book Three of *Semideus* is an unpublished treatise on military art by Caton Sacco, an Italian lawyer from Pavia (died ca 1463). The treatise was written in 1438 in honour of Duke Giangaleazzo Visconti and dedicated to his son Filippo Maria. The main text is preceded by a genealogical tree of the Dukes of Milan, a dedication to Filippo Maria Visconti and a prayer to the Virgin Mary.

The illumination falls into two parts. The main text of *Semideus* is illustrated, probably by the head miniaturist's assistant, with free pen drawings tinted with wash in the margins. The head miniaturist may have painted the decoration of the first part and the depictions of the Madonna in Glory which appear on a few pages. His style is marked by extremely skilful and minuscule drawing, a particular preference for the colour blue, compact composition and elaborate borders incorporating numerous coats of arms. Laborde's opinion that the master was "un bon artist florentin" is hardly convincing. This is unquestionably a good example of the refined school of illumination of the Lombard court, the development of which was above all connected with the names of Giovannino de' Grassi (died 1398), Michelino da Besozzo (active in Pavia and Milan, 1388–1415) and Luchino Belbello da Pavia (active 1430–62), all of whom carried out commissions for the Visconti family. The assistant's style of drawing and the organization of the page, with the text taking up little space and leaving ample margins for the illumination, also point with certainty to the Lombard origin of the manuscript. Bearing in mind the manuscript's authorship and the fact that it was meant for the Duke of Milan, it seems reasonable to suppose that it was illuminated in Pavia or Milan. The style and type of the miniatures is fairly close to the manner of Belbello.

The manuscript was presented to Francesco Sforza in 1458 and was housed in the Duke's library in the castle of Pavia (it was listed in the inventory of 1459). In 1499, the library of the Dukes of Milan was taken by Louis XII to Blois in France. It is not known when this manuscript was separated from the collection and came into the possession of the Baugencys (or Burgencys), whose seigniory was in the vicinity of Blois and who were connected with the house of Orléans. The first blank page in the book bears numerous inscriptions recording the dates of birth and death of members of the family. At the end of the 16th or in the early 17th century the manuscript belonged to a certain Charles Le Manier, whose signature is also to be found in the manuscript along with an acrostic and sayings in Latin and French. At the end of the 18th century it was bought by Piotr Dubrowsky.

ENTERED THE PUBLIC LIBRARY IN 1805 (1849–61 THE HERMITAGE, 5.2.37).

LITERATURE : *Gille 1860, Le Monde de l'Art, p. 74; Nikolayev 1904, p. 119; V. Liublinsky; "Semideus. Caton Sacco (Neopublikovanny traktat XV veka o voyennom iskusstve, Rukopis Publichnoi biblioteki: Lat.Q.v.XVII.2)", Srednevekovye v rukopisiakh Publichnoi biblioteki (ed. by O.A. Dobiash-Rozhdestvenskaya), 2, Leningrad, 1927, pp. 95–118; Laborde 1936–38, pp. 83, 84, pls XXXV, XXXVI; B. Gallinoni, "Di un trattato militare inedito del sec. XV", Rivista storica italiana, 3, 1938, pp. 87–90; E. Pellegrin, La bibliothèque des Visconti et des Sforza, ducs de Milan, au XVe siècle, Paris, 1955, pp. 57, 317, No 599; Bernadskaya 1984–85, pp. 279, 280.*

334. F. 9r: BEGINNING OF THE PRAYER TO THE VIRGIN (AD LAUDEM VIRGINIS).
The Annunciation is depicted within the initial. The border features the Visconti arms: a stylized sun and a blue snake swallowing a baby, as well as the eagles of the Holy Roman Empire granted to Giangaleazzo in 1395. In terms of the type of ornamentation, the expressive treatment of the Annunciation and the coloration, this beautiful page is very close to the circle of Belbello da Pavia. The dogs and the fallow-deer are also executed in a typically Lombard manner reminiscent of the hand of Giovannino de' Grassi and his illumination of the Visconti Book of Hours (finished in the 1430s by Belbello).

335. F. 39r: THE VIRGIN AND CHILD SURROUNDED BY ANGELS APPEARS TO A KNIGHT.
A knight with the Visconti impresa on his chest looks up at the wonder with veneration. The knight must be Giangaleazzo, as he has the moustache and beard depicted in other sources. It is worth mentioning in connection with this composition that Giangaleazzo was a devout venerator of the Virgin Mary and gave both his sons the second name Maria.

336. F. 59r: CAPTURE OF A CITY.
The soldiers storming the city have shields decorated with the Visconti coat of arms. These vivid pen drawings very accurately render many of the details of contemporary warfare. The attempt to show a wheeled siege tower armed with bombards (quadrum) from above is notable, yet the scenery and architecture are rendered in a fantastic and fairy-tale-like manner in keeping with the traditions of Lombard art.

337. F. 64R: CROSSING THE RIVER.
The upper right corner has the Virgin, the guardian of the Visconti troops, and golden angels. The aureole, or "glory", around the Virgin resembles the Visconti heraldic sun.

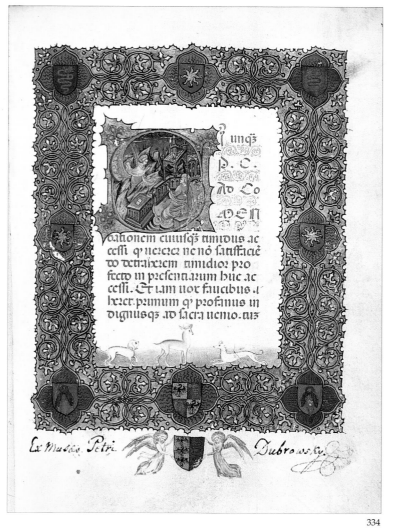

334

335

336

337

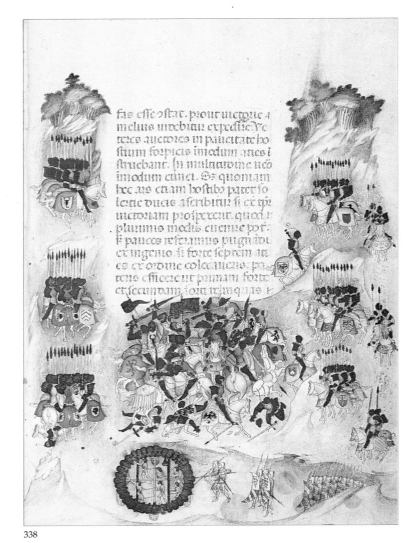

338

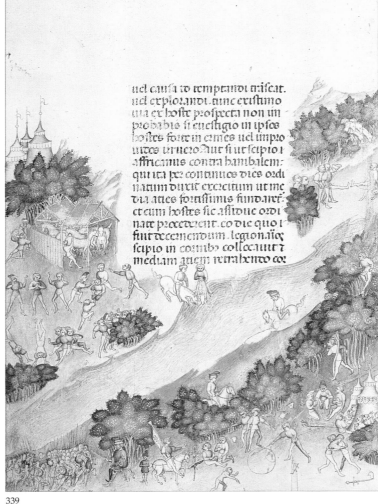

339

340

338. F. 69r: BATTLE SCENE.
The miniature bordering the text on three sides shows the opposing armies marching and the battle itself. The enemy soldiers have scorpions and black heads (symbolizing the Turks) as their coats of arms. The siege tower is equipped with bombards.

339. F. 74v: CAMP ON THE RIVER BANK.
This miniature is replete with true-to-life depictions of everyday episodes: bathing horses, games, wrestling, conversations and acrobatic performances.

340. F. 79v: BATTLE IN THE MOUNTAINS.
The left side of the page is effectively used to show a mountainous road. The rider on the right wearing a plumed helmet is the leader of the Visconti troops.

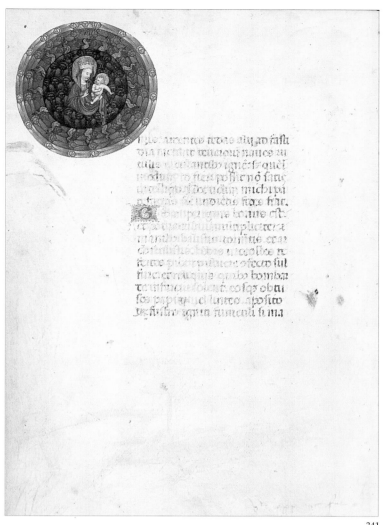

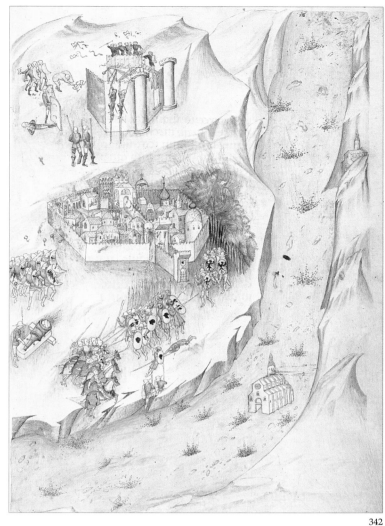

341

342

341, 342. FF. 88v–89r: THE VIRGIN AND
CHILD IN GLORY. SIEGE OF A CITY.
A combination of these subjects on one spread was supposed to
demonstrate again the patronage of the Virgin in the Viscontis'
military campaigns. (Sacco, it should be remembered,
composed the Semideus in order to inspire Filippo Maria for a
crusade.) F. 89r has the only full-page miniature in the
manuscript. The besieged city is Moslem, as is indicated by the
domes topped with a crescent. Interestingly, the city's defenders
use pots filled with snakes.

343. F. 100r: SEA BATTLE.

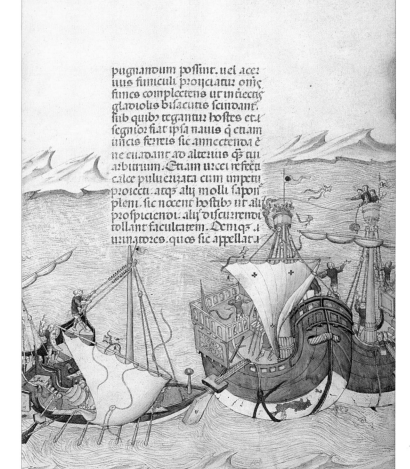

343

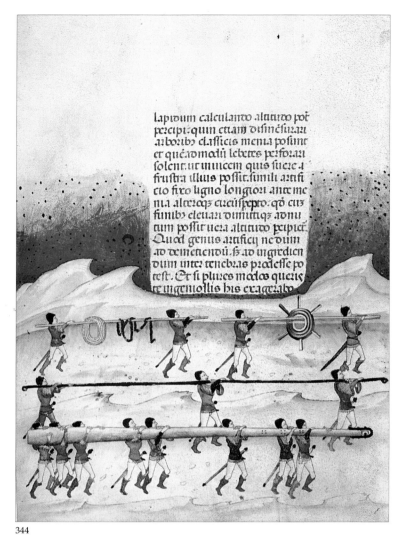

344

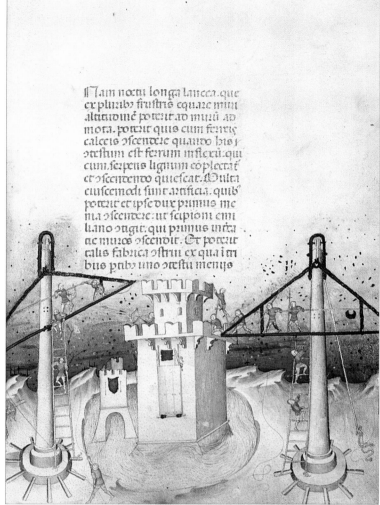

345

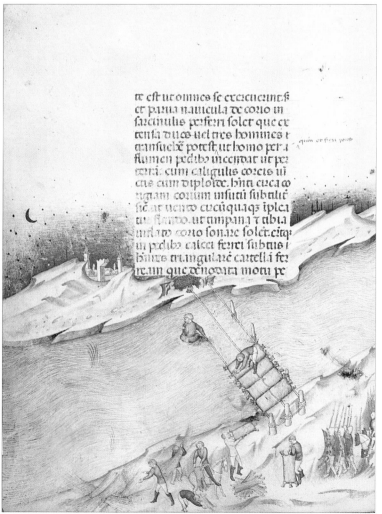

346

344, 345. FF. 91v, 92r:
SIEGE OF A FORTRESS.
This miniature provides interesting pictorial information on military history. F. 91v shows soldiers carrying the parts of siege machines, which can be seen assembled and in operation on the opposite page (f. 92r).

346. F. 106v: CROSSING A RIVER WITH THE HELP OF PONTOONS AND FASCINES.

347. F. 99r: GALLEY FLEET ON A RIVER.
The illustration completely surrounds the text, while the scenery is shown topographically, as if in a bird's eye view. Pots filled with snakes and a kind of "Greek fire" are being used as a means of attack.

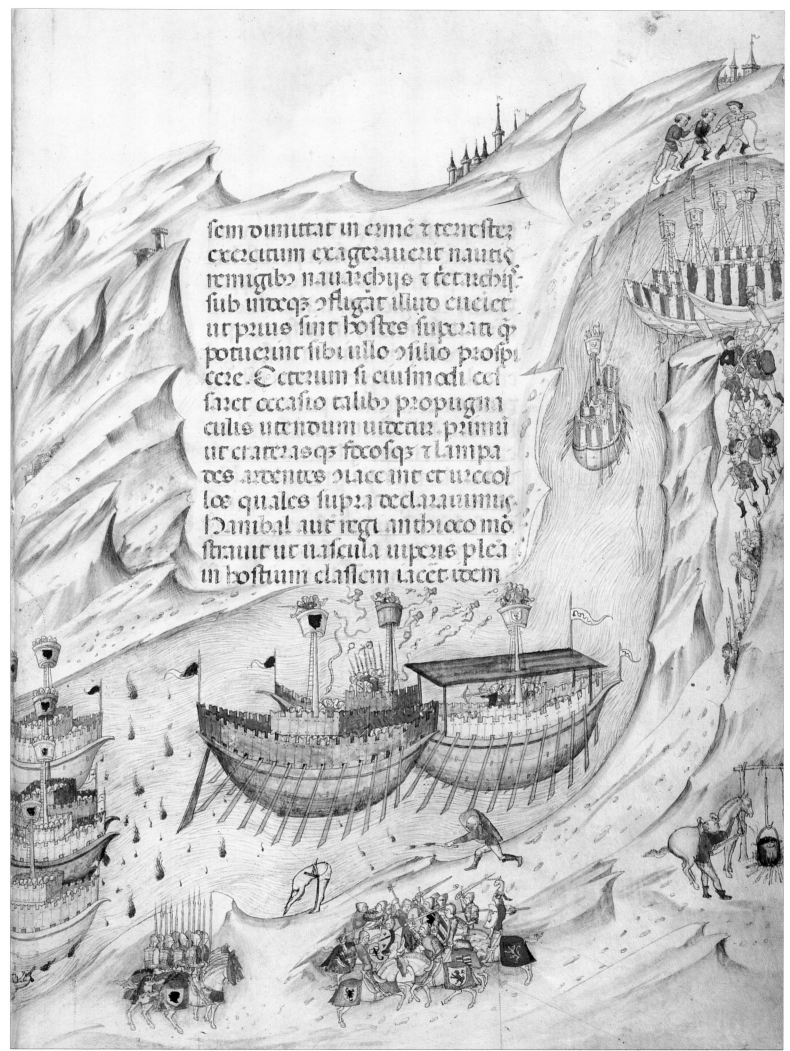

sem dimittat in eme z tenebis
exexcitum exageranerit nauti
remigibz nauarchis z tetudibs
sub mare q conflignt illud emetet
ut prius sint hostes superatu qu
potuerint sibi ullo consilio prospi
cere. Ceterum si cuisinodi cel
saret occasio talibs propugna
culis utendum uideat primu
ut craterasqz facesqz z lampa
des arxentes iacerent et in eol
los quales supra declarauimus
Hannibal aut regi antioco mo
strauit ut uascula mpens plena
in hostium classem iacet tocin

347

LIVY. HISTORY OF ROME (BOOKS I–X, XXI–XXXII, XXXIV–XL)

Titus Livius Patavinus. Ab urbe condita
(libri I–X, XXI–XXXII, XXXIV–XL)

Italy. Second half of the 15th century.
462 ff. 320 x 228 mm (text 210 x 155 mm). Parchment. Latin.
1 miniature opening the manuscript; 28 sheets with initials
in colour and gold, one at the beginning of every book,
26 of them framed with floriated borders, some decorated with
landscape motifs, peacocks, lions and birds.
Binding: 17th century. Parchment over cardboard; banded spine.
Cl.Lat.F.v.2.

The Roman historian Livy (59 BC – 17 AD) was born in Patavum (Padua). In his famous *History of Rome* he recounted year by year the story of the city beginning with its legendary foundation in 9 BC. However, only 35 of the original 142 books have survived: the first ten, covering the events up to the Third Samnite War; and books 21–45, from the Second Punic War to Rome's victory over Macedonia (some of these are missing in the St Petersburg manuscript). Livy's work was very popular during the Renaissance and many copies of it, including the St Petersburg manuscript, were made in the 15th century, during the age of humanism.

The variety of ornamental borders decorating the first page of each book in the volume is a distinctive feature of its illumination. Among them there are large, leafy acanthus designs, delicate traceries of golden tendrils, typical Italian small suns, elements of landscape, genre scenes, birds and beasts of the Lombard type, golden lions, the angels and putti so common to the quattrocento decoration. It may be that the illumination was executed by several masters of different schools. Laborde, probably basing his conclusion on some of the ornamental borders, places the illumination at the end of the 15th century in Northern Italy. However, marginal designs combining putti, beasts and peacocks was typical of Florentine humanist

manuscripts executed for aristocrats as early as the 1450s. The miniature which opens the manuscript also refutes Laborde's supposition. Humanist in spirit, it reveals the artist's awareness of the laws of perspective, and his love for a warm colour range dominated by brown hues. This miniature bears a similarity to the wing of the altar in San Lorenzo Maggiore depicting St Jerome by the Neapolitan artist Colantonio (Naples, Capo-di-Monte). There is no doubt that the manuscript was executed in the second half of the 15th century and that it was commissioned by a bibliophile of high social standing. Its origin is unknown. FF. 1, 178, 292 and 452 show traces of the effaced arms of the first owner, whom Dubrowsky believed to be Lorenzo Medici.

The manuscript was already in France by the first half of the 16th century as part of the Vendôme library of Marie de Luxembourg, the wife of François de Bourbon, Count of Vendôme. In 1588, it was bought by Laurent Bochel, a Parisian lawyer, who in turn sold it to Pierre Séguier. In 1735, it passed to the library of Saint-Germain-des-Prés. Piotr Dubrowsky maintained that in 1750 the manuscript was owned by the famous Parisian bibliophile Marquis de Paulmy, then by Court de Gebelin and finally by Jean Jacques Rousseau. The latter gave it to Dubrowsky as a present in 1778.

ENTERED THE PUBLIC LIBRARY IN 1805 (1840–61 THE HERMITAGE, 5.3.23).

LITERATURE : Cat. Séguier 1686, p. 16; Montfaucon 1739, 2, p. 1090, No 300; Gille 1860, pp. 71, 72; Laborde 1936–38, pp. 112, 113; V.S. Liublinsky; "Jean Jacques Rousseau", in: Neizdannye pisma inostrannykh pisatelei XVIII–XIX vekov iz leningradskikh rukopisnykh sobrany (ed. by M.P. Alexeyev), Moscow, Leningrad, 1960, pp. 127, 128; E.V. Bernadskaya, Italyanskiye gumanisty v sobranii rukopisei Gosudarstvennoi Publichnoi biblioteki imeni M.E. Saltykova-Shchedrina, Leningrad, 1981; Bernadskaya 1984–85, pp. 85–88.

348

348. AUTOGRAPH OF DUBROWSKI ON THE TITUS LIVIUS MANUSCRIPT.

F. 1r: OPENING PAGE.
This marvellous miniature shows a humanist author in his study. Its warm tones blend harmoniously with the gold of the text, the initial and the various colours and gold of the border to form an effective colour ensemble.

350. F. 178r: OPENING PAGE OF BOOK 21.
This page is outstanding for its variety of decoration. Elements of landscape accompany the floral ornament and sun designs in the margin and there are four coats of arms with effaced impresas. Two of them are grouped with a cross and angels in the right margin, one is being carried by haloed angels above the text, and the fourth is at the bottom as part of a heraldic composition with a knight's helmet and a golden lion towering over it and is flanked by the depiction of an author at his desk and an allegorical figure. The initial X is an ingenious combination of two naked figures.

351. F. 443r: OPENING PAGE OF BOOK 29.
Refined floral ornamentation in gold with large red flowers is supplemented by skilfully painted figures of birds and putti.

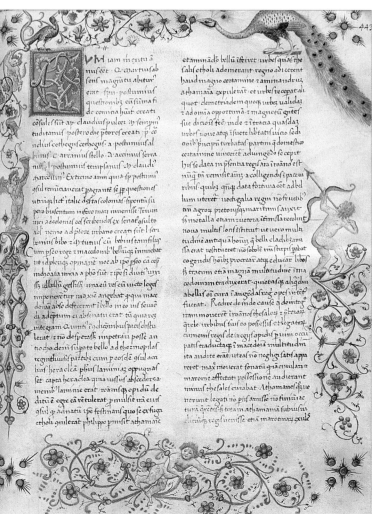

352-354
LACTANTIUS. WORKS
Firmianus Lactantius. Opera
Italy. 15th century.
229 ff. (f. 1 is missing). 350 x 235 mm (text 220 x 130 mm). Parchment. Latin.
4 miniatures; f. 117 and the following leaves have gold initials with floral motifs in red against
greenish-blue background. Binding: 15th century. Brown leather over wooden boards
with gold-tooled border; spine banded; gilt-edged. Lat.F.v.I.100.

Firmianus Lactantius (ca 250–325) is a well-known Christian author, who was styled the Christian Cicero for his eloquent advocacy of the faith. He wrote treatises on theology, grammar and history, the most important of which, *Institutiones divinae*, comprising seven books, was written between 307 and 310. In addition to this work, the St Petersburg manuscript includes some other treatises by Lactantius: *De ire Dei and De officio Dei*. The works of Lactantius were first published in Italy in 1465.

The style of the artist responsible for the miniatures decorating the manuscript is highly individual: the unusual arrangement of the subjects on the page, the crouching figures of Lactantius and, especially, of the elders, whose faces are almost grotesque. Gothic draperies, a Franco-Flemish border on f. 33 and blossoming twigs in the corners of miniatures are suggestive of northern influence. However, the clear, precise lettering and the initials with white vine-stems *(bianchi girari)* in the second part of the manuscript, represent a typical example of the humanist book decoration common in Italy in the 15th century.

F. Avril points out that the singular style of the painter is to be noted in a series of manuscripts illuminated in Naples under the reign of Alphonse I of Aragon, in particular a Book of Hours to be found in the National Library of Naples (m.s. 1.B.55), as well as in another Book of Hours from the John Paul Getty Museum in Malibu (m.s. Ludwig IX.12) which has been studied recently by Ranee Katzenstein (A Neapolitan Book of Hours in the J.P. Getty Museum, in : The Paul Getty Museum Journal, Vol. 18. 1990, P.69-97). It is not known for whom this book was commissioned. Whilst all manuscripts showing the hand of this artist were undoubtedly executed in Naples, there is a possibility that the illuminator learnt his art in Valence, capital and cradle of the Aragonaise dynasty, where the artists were particularly open to the influence of Flemish painting.

The first owner of the manuscript is unknown; in the 17th century, it belonged to Pierre Séguier and in 1735 it entered the Saint-Germain-des-Prés library. At the end of the 18th century it was purchased by Piotr Dubrowsky.

ENTERED THE PUBLIC LIBRARY IN 1805.

LITERATURE : Cat. Séguier 1686, p. 97; Montfaucon 1739, 2, p. 1084, No 37; Golenishchev-Kutuzov 1972, pp. 76, 128 (f. 33); E.V. Bernadskaya, Italyanskiye gumanisty v sobranii rukopisei Gosudarstvennoi Publichnoi biblioteki imeni M.E. Saltykova-Shchedrina, Leningrad, 1981, pp. 99–101.

352. F. 33r: OPENING PAGE OF BOOK ONE OF INSTITUTIONES DIVINAE.
Next to the initial Q the miniaturist depicted a scholar, evidently Lactantius, kneeling in his study and holding his open manuscript out to be blessed. Through the open window we can see a starry sky which echoes the background in the upper representation of Christ in Majesty (Maestà domini).

353. FF. 90v–91r: END OF BOOK THREE AND OPENING OF BOOK FOUR.
This spread shows a complex composition of several scenes: a sibyl who predicts the birth of Christ (extreme left), the Virgin Mary and Joseph (left), and, over Lactantius' study depicted in a similar way to the one on f. 33r (bottom right), the boy Christ engaged in a dispute with the elders in the temple, a popular subject in religious writings.

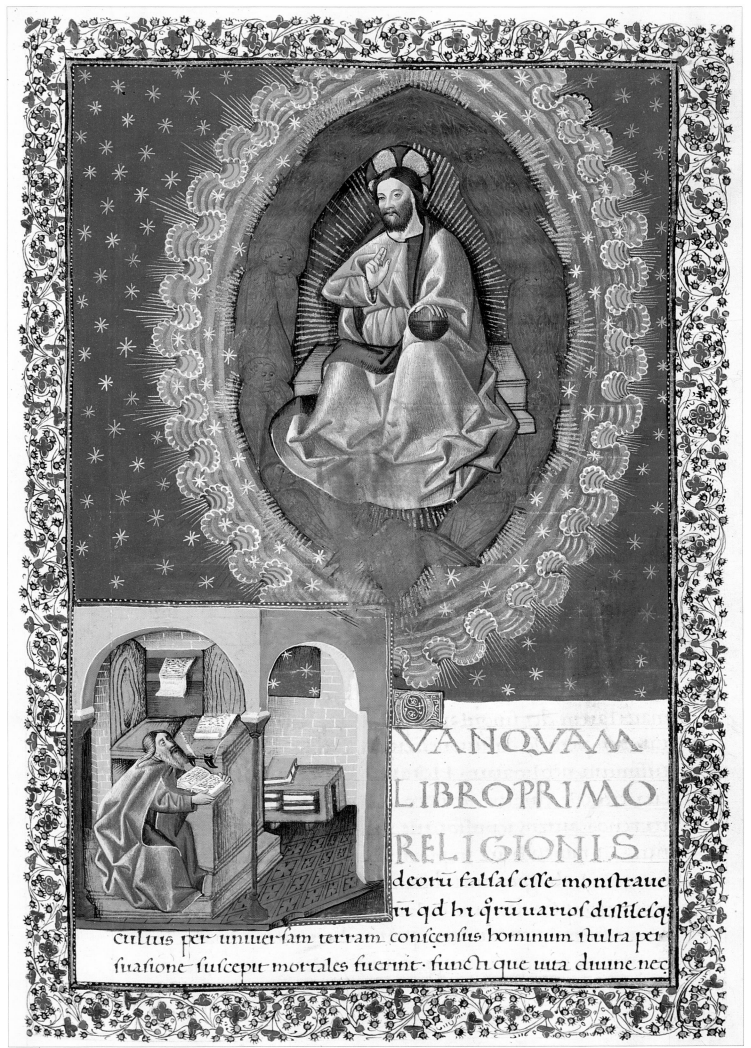

VANQVAM
LIBROPRIMO
RELIGIONIS
deoru fallas esse monstraue
ri qd hi qru uarios disiilesq;
cultus per uniuersam terram consensus hominum stulta per
suasione suscepit mortales fuerint. suncti que uita diuine nec

quibȝ est cura sapientie conferamus an expectabimus donec
socrates aliquid sciat. aut anaxagoras in tenebris lumen inveni-
at. aut democritus ueritatem de puteo extrahat. aut expedoc-
les dilatet animi sui semitas. aut archesilas & carneades uideant
sentiant. percipiant. ⁓ vox ecce de celo ueritatem docens &
nobis sole ipso clarius lumen ostendens. ⁓ uid. nobis iniqui
sumus & sapientiam suscipere cunctamur. quam docti homines
contriti in querendo etatibȝ suis nunꝗ reperire potuerunt. Iu
uult sapiens ac beatus esse audiat dei uocem. discat iustitiam. sa-
cramentum natiuitatis sue norit. humana contempnat. diuina
suscipiat. ut sumum illud bonum ad quod natus est possit adi-
pisci dissolutis religionibȝ uniuersis & omnibȝ quecunꝗ in ea-
rum defensione dici uel solebant uel poterant refutatis deinde
couictis phie disciplinis ad ueram nobis religionem sapientia
que ueniendum est. quoniam est ut docebo utriuque comnc-
tum ut eam uel argumentis uel exemplis uel ydoneis testibȝ as-
seramus & stultitiam quam deorum cultores obiectare non
desinunt ut nullam penes nos sic totam penes ipsos esse docea-
mus & ꝗꝗ prioribȝ libris cum falsis arguerim religiones. &
hic cum falsam sapientiam tollerem ubi ueritas sit ostenderim
planius tamen que religio que sapientia uera sit liber proxi-
mus indicabit.

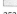

Sibilla

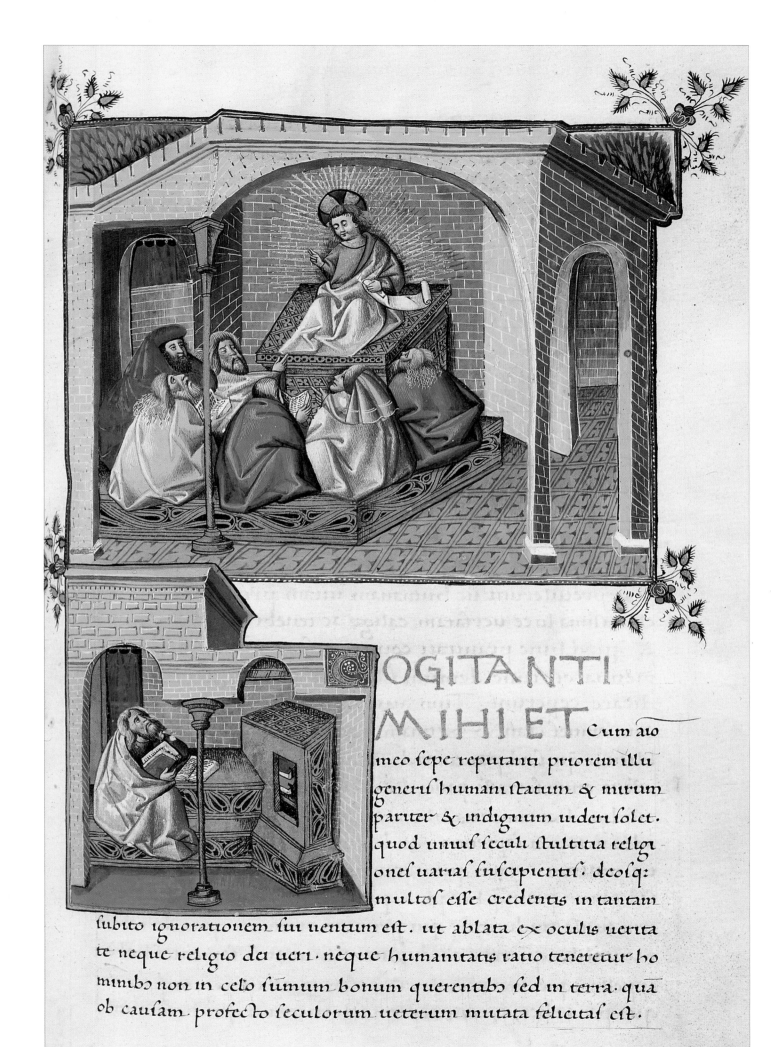

OGITANTI
MIHI ET Cum aio
meo sepe reputanti priorem illu
generis humani statum & mirum
pariter & indignum uideri solet.
quod unius seculi stultitia religi
ones uarias suscipientis. deosq̄
multos esse credentis in tantam
subito ignorationem sui uentum est. ut ablata ex oculis uerita
te neque religio dei ueri. neque humanitatis ratio teneretur ho
minibz non in celo summum bonum querentibz sed in terra. qua
ob causam profecto seculorum ueterum mutata felicitas est.

AGOSTINO BARBADIGO DOGE OF VENICE.
Instructions to Angelo Gradenigo
Agostino Barbadigo. Instructiones datae Angelo Gradenigo
Italy (Venice). 1492.
61 ff. 213 x 141 mm (text 150 x 50 mm). Parchment. Latin.
1 miniature at the beginning of the manuscript.
Binding: contemporary with the manuscript. Light-brown leather over cardboard
with a gold-tooled design of Venetian work; traces of two silk ribbons; gilt-edged.
Lat.Q.v.II.12.

These instructions were intended for the captain of four galleys due to set off to Beirut. The artists usually decorated only the first pages (*pagina dedicata*) of such handwritten documents (oaths, orders, instructions). These pages present some of the best examples of Venetian illumination from the late 15th and early 16th centuries. Giulia M. Zuccolo-Padrona considered this miniature to be an early work by the leading Venetian miniaturist Benedetto Bordona from Padua (died 1530). His workshop in Venice is best known for works produced in the 1510s. His early works are distinguished by a particular severity of composition, soft modelling and an exquisite colour scheme. Andrea Mantegna and Giorgione are usually named among the great masters who contributed to the formation of Bordona's style.

It was bought by Dubrowsky at the end of the 18th century.

ENTERED IN THE PUBLIC LIBRARY IN 1805. (1849-1861 THE HERMITAGE 5.2.3).

LITERATURE : Gille 1860, p. 86; Yaremich 1914, p. 43, ill. between pp. 41 and 42; Laborde 1936–38, p. 127, pl. LI; Bernadskaya 1984–85, pp. 291–293; Giulia M. Zuccolo-Padrona, "Sull'ornamentazione marginale di documenti dogali del XVI secolo", Bulletino dei musei civici Veneziani, 1/2, 1972, No 16, p. 23.

355

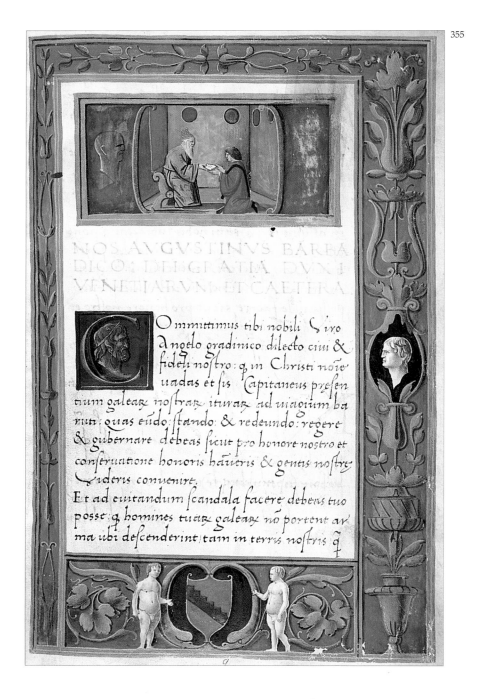

356-359
THE AGNESE PORTOLANO
Portolano di Battista Agnese
Italy (Venice). 1546.

21 ff. 360 x 250 mm. Parchment. Italian.
3 two-page miniatures. Binding: 16th century. Gold-tooled brown leather over wooden boards;
banded spine; gilt-edged. Erm.ital.14

The *portolano*, or world maritime atlas, consisting of thirteen navigation charts, was produced at the Agnese workshop in Venice. Born in Genoa and already famous there, Gian Battista Agnese moved to Venice where, between 1536 and 1564, he made numerous *portolanos* for customers of high social standing (71 atlases have survived).

Rather than being for sailors, these lavishly decorated atlases on fine parchment were luxury reference-books for Venetian aristocrats, military commanders, political figures, major ship-owners and merchants. Agnese's maps were meticulously drawn and coloured with variety and vividness. Decorativeness was not, however, his sole goal, for he also wished to reflect the new geographic discoveries. The St Petersburg *portolano* was one of the most ornate copies produced at the Agnese workshop: in addition to the usual arms of the commissioner on the first sheet, it includes three two-page miniatures of allegorical subjects, which resemble easel paintings (two of them are even "framed") rather than *portolano* illustrations. These pictures, painted in the mid-16th century, are typical examples of Italian Mannerism.

The figures and sometimes whole compositions are direct borrowings from paintings by famous artists. Despite the flaws in the drawing, the artist managed to render an atmosphere of space full of light and air as well as to create a dramatic effect. The date of the portolano is specified in the inscription which Agnese made, as usual, upon completion of his work: Baptista Agnese Janiensis fecit Venetiis 1546 die 26 mai.

ENTERED THE PUBLIC LIBRARY IN 1861 WITH THE HERMITAGE COLLECTION (1.31).

LITERATURE : Bernadskaya 1984–85, pp. 295, 296, No 36. Portolano di Battista Agnese 1546 (Facs). Commentary on the facsimile edition by Tamara P. Vorona, Groz 1993. V. Tchourkine, Les exemplaires léningradiens des portulans de Battista Agnese, in « Problèmes d'histoire des sciences naturelles et techniques", Moscow 1965, n° 18, p 135-136, (in Russian).

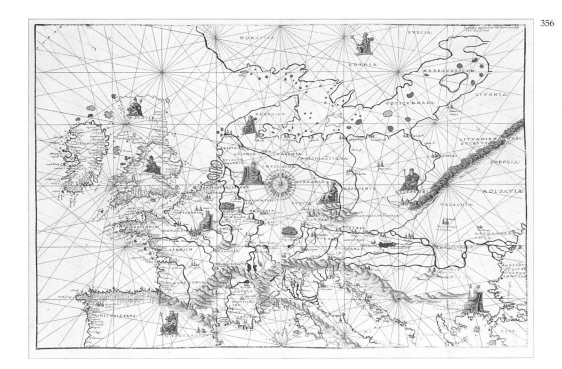

356

355. F. 1r: OPENING PAGE OF THE INSTRUCTIONS.
The whole page is built on a careful architectonic balance of text and illumination. The Renaissance ornament of golden chandeliers against a deep blue background with motifs harking back to antiquity is typical of Bordona.
At the top of the page the Doge is presenting the instructions to Angelo Gradenigo, the captain of the galleys. At the bottom is the coat of arms of the Counts Gradenigo.

356. F. 7v: MAP OF WESTERN EUROPE.
There is a separate map of Italy in the portolano.

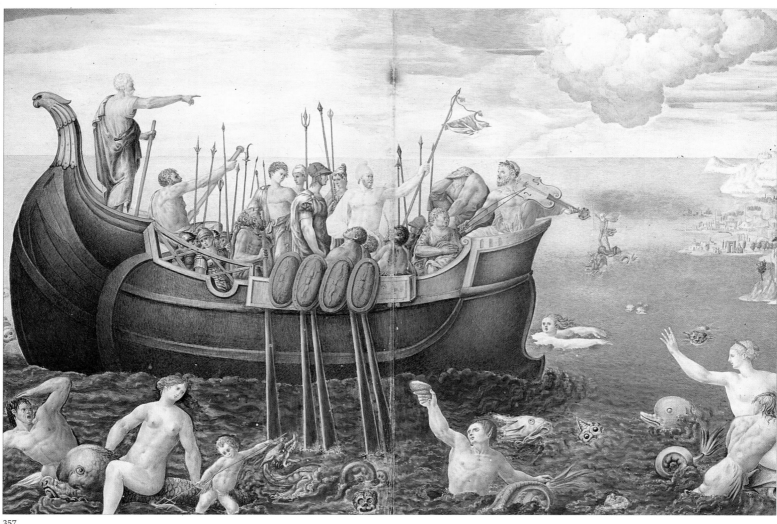

357

357. FF. 1v–2r: JASON SETS OFF TO
CAPTURE THE GOLDEN FLEECE.
The tritons, nereids, dolphins, hippocampi and Neptune
with his trident who is seen in the distance all wish the
Argonauts a successful journey.

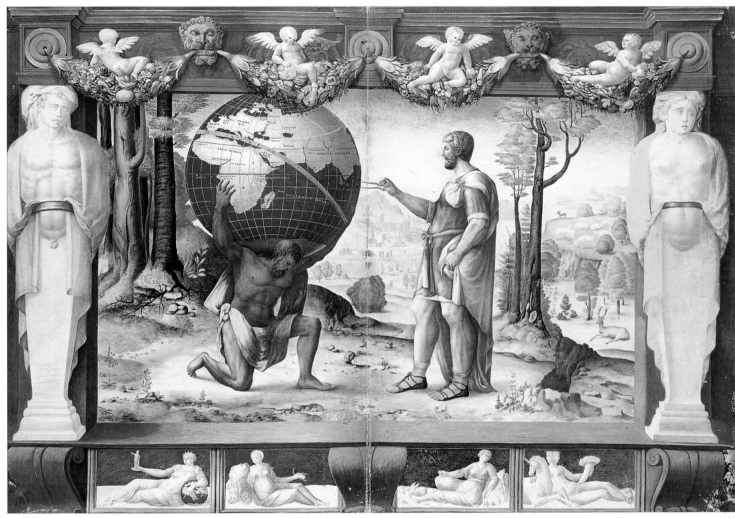

358

358. FF. 19v–20r: ATLAS HOLDING THE
TERRESTRIAL GLOBE AND ARCHIMEDES
<u>MEASURING IT WITH COMPASSES.</u>
The miniature is framed with a portico, its entablature
decorated with hermae, lion masks, flower and fruit garlands
and putti. At the bottom are relief-like allegorical figures.

Page 274-275
359. FF. 18v–19r: NEPTUNE'S CHARIOT.
The artist uses the contrasts of light-coloured figures against
the stormy sky, gloomy cliffs and a darkened sea to create a
dramatic effect. The use of gold on the chariot, reins and
trident stems from the traditions of manuscript illumination.

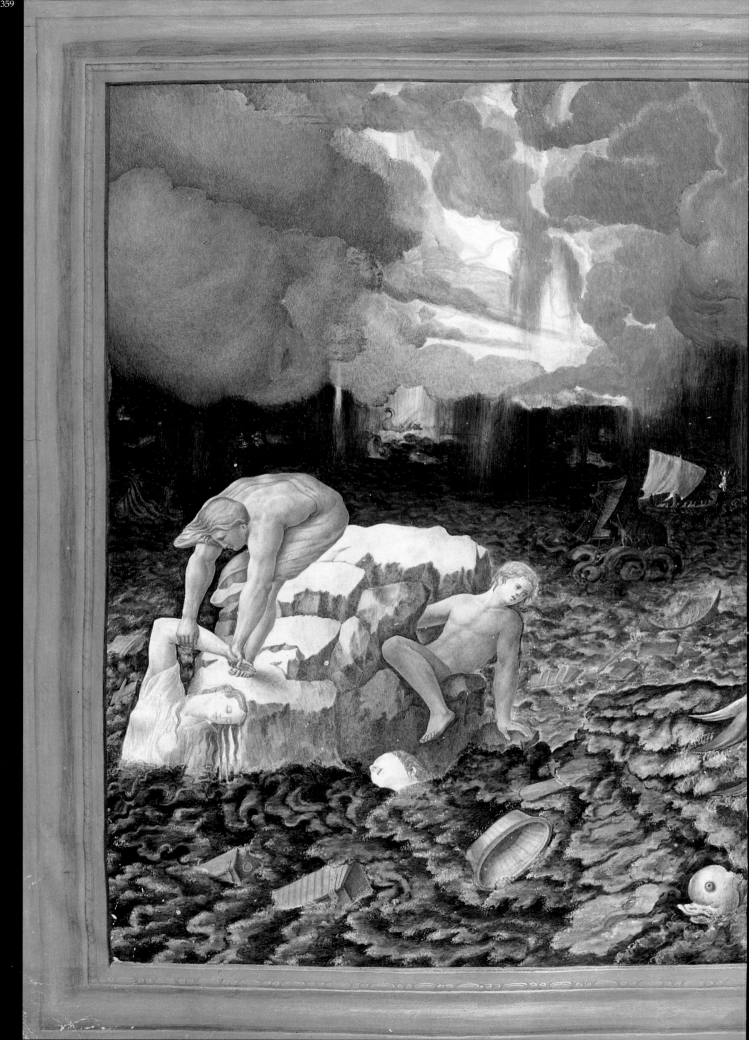

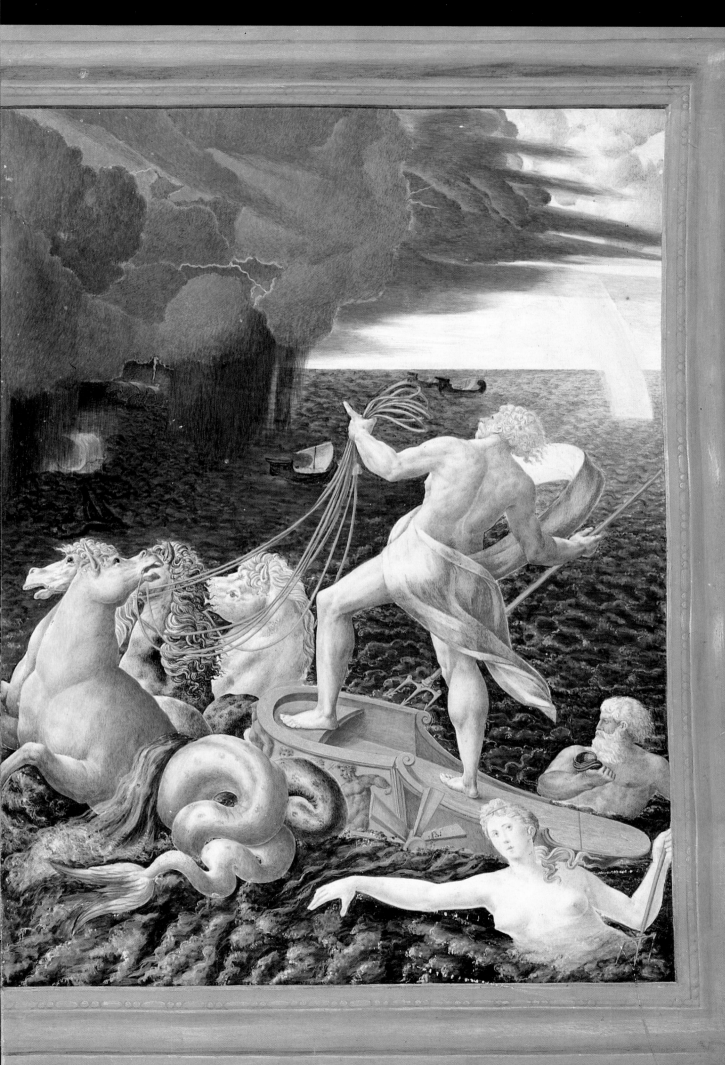

360, 361
ALOISIO MOCENIGO. Instructions to Catarino Contarini
Aloisio Mocenigo. Instruzioni date al podesta di Lendinaria
Catarino Contarini

Italy (Venice). 1571.
101 ff. 223 x 148 mm (text 140 x 90 mm). Parchment. Italian.
2 miniatures.
Binding: 16th century. Brown leather with gold-tooled design of Venetian work.
Ital.O.v.II.1.

The manuscript contains the instructions given in 1570 by Aloisio Mocenigo, Doge of Venice, to Catarino Contarini when the latter was appointed podesta, chief magistrate, of the Italian town of Lendinara in the Rovigo province of the Venetian Republic.
The manuscript belonged to the prominent Venetian aristocratic family of Contarini. At the end of the 18th century it was bought by Dubrowsky.

ENTERED THE PUBLIC LIBRARY IN 1805 (1849–61 THE HERMITAGE, 5.2.108).

LITERATURE : Gille 1860, p. 98; Yaremich 1914, p. 43, ill. between pp. 41 and 42; Laborde 1936–38, pp. 167, 168, pls LXXI, LXXII; Bernadskaya 1984–85, p. 293, No 34.

360

360, 361. FF. 1v–2r:
OPENING PAGES OF THE MANUSCRIPT.
The two-page spread makes up one pictorial composition: on the left, on the steps of the portico, characters dressed in old Roman style (probably representing the population of Lendinara) greet the news of Contarini being appointed podesta. The messenger is shown in a striking posture, pointing to the right, at Contarini, who is sitting at a window. Holding a sword, the symbol of power, in his right hand, he looks straight at the viewer. A sign of Contarini's Christian virtues, the crucifix, stands on the table, and his coat of arms appears at the bottom of the miniature. His finely drawn face is individualized and is undoubtedly a true likeness. The patrician's pale hand against the dark red background is very expressive. The free, sweeping strokes and the colour scheme speak of the manner of a painter rather than a miniaturist, prompting Laborde to describe this manuscript as being "in the Veronese taste".

362-373
CHRONOLOGIE UNIVERSELLE.

The Netherlands (Bruges). Second part of the 15th century ca. 1480.

47 ff. 570 x 385 mm (text 330 x 270 mm). Parchment. French.
22 miniatures; 51 medallions depicting Biblical and historical characters.
Binding: 16th century.
Blind-stamped and gold-tooled brown leather over boards; banded spine; gilt-edged.
Fr.F.v.IV.12.

The manuscript's structure is based on the Tree of Jesse, hence the depiction of a tree trunk with medallions containing portraits of Biblical and historical figures which continues across all the folia. The trunk bears portraits only of the direct ancestors of Jesus Christ along the male line; the medallions hanging from the branches contain either representations of their relatives and other important Biblical characters or simply their names. Both the illustrations and the commentary start with the Creation followed by a detailed description of Jewish history, which then intertwines with Roman history and ends with the Nativity of Christ.

The design of the St Petersburg manuscript is extremely well adapted for the genealogical tree: it resembles a scroll cut into separate sheets and then bound into one volume. The closest analogy to this construction is *Les Chroniques de Jérusalem abrégés* (Vienna, Österreichische Nationalbibliothek, MS.2533), adorned by Maître de Girat after 1455. The style of the illumination in the St Petersburg manuscript, however, is different from that in the Vienna work.

The Netherlandish traits in the illumination are obvious. The reserved grey colour scheme, the townscapes featuring canals with swans swimming in them and the facial types indicate Bruges as the most likely place of origin, and the Master of Edward IV, whose atelier produced a number of richly-embellished manuscripts of large format between 1470 and 1480, as its most likely author.

Gille and Laborde were of the opinion that the manuscript was made for Philip the Good, Duke of Burgundy; in the 17th century, it belonged to Pierre Séguier; in 1735, it was transferred to Saint-Germain-des-Prés, and in 1792, it was purchased by Piotr Dubrowsky.

ENTERED THE PUBLIC LIBRARY IN 1804 (1849–61 THE HERMITAGE, 5.3.40).

LITERATURE : Cat. Séguier 1686, p. 12; Montfaucon 1739, 2, p. 1116, No 1291; Gille 1860, p. 74; Bertrand 1874, p. 109; Nikolayev 1904, le Monde de l'Art, pp. 97, 114, 115; Lutz-Perdrizet, Speculum humanae salvationis, *Mulhouse,* 1907–9, fig. 128–136; Yaremich 1914, p. 41; F. Winkler, Die flämische Buchmalerei des XV–XVI. Jahrhunderts, Leipzig, 1925, p. 137; H. Gilhofer, H. Ranschburg, Bibliotheken aus Österreichischem und Russischem Kaiserlichen Besitz, Lucerne, 1933, p. 52; Laborde 1936–38, pp. 113–115, pl. XLVII.

362

362. F. 24v: BEN-HADAD, KING OF SYRIA, MEDALLION ON ONE OF THE LATERAL BRANCHES OF THE TREE.

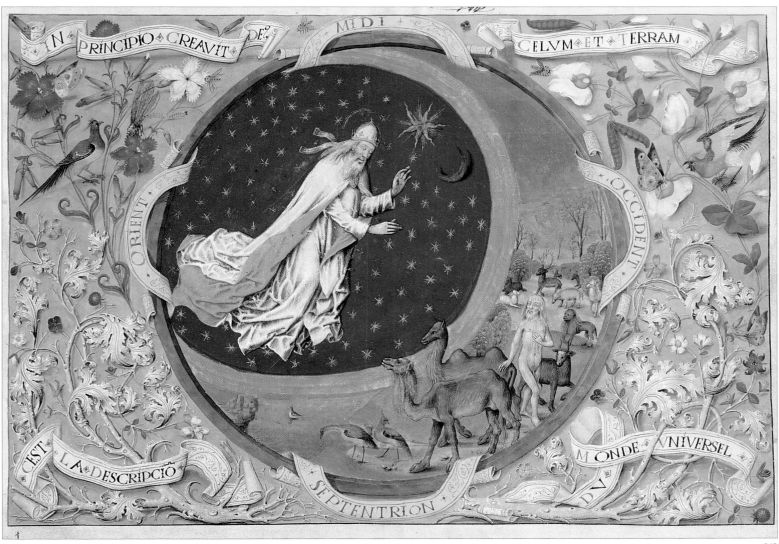

363. F. 1r: INTRODUCTORY PAGE.

The miniature represents the Creation: against a starry sky God
the Father is creating the Sun and the Moon with one hand and
the Earth (on it there is a figure of Adam among the animals)
with the other. The inscriptions on the ribbons around the cen-
tral medallion denote the cardinal points of the compass. The
foliate ornament with butterflies and birds is painted in the
fashion of Netherlandish illumination. At the bottom the ribbons
have an inscription in French: cest la descripcio[n] du monde
universel.

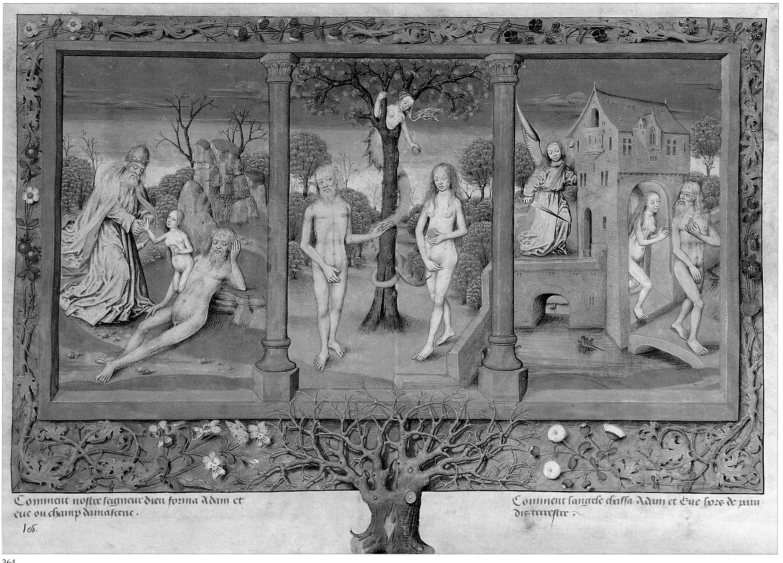

Comment nostre seigneur dieu forma Adam et eue ou champ damascene.

108.

Comment langele chassa Adam et Eue hors de para dis terrestre.

364. F. 1v: CREATION OF EVE, TEMPTATION AND EXPULSION.
The roots shown at the bottom are the beginning of the Tree of Jesse which goes from Adam to Jesus Christ and runs throughout the entire manuscript.

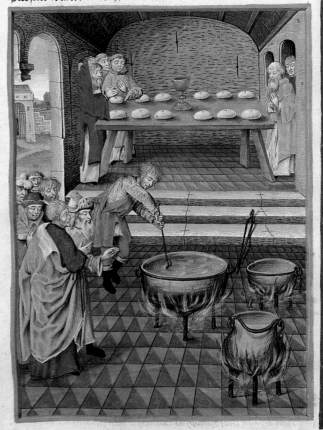

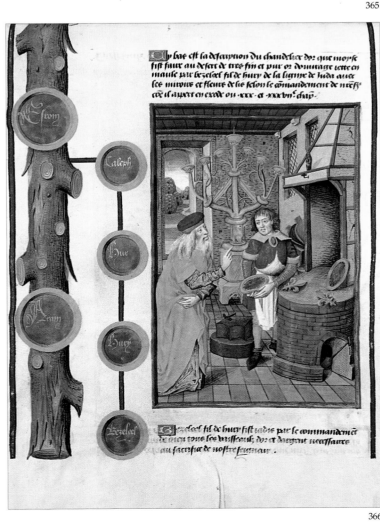

365. F. 13r: ILLUSTRATION TO EXODUS.
The miniature shows the sanctuary made according to the
words "which the Lord hath commanded": in the background
is a "table of shittim wood" with shewbread set upon it,
and in the foreground, the holy anointing oil is being prepared,
and on the right of the tree trunk is the altar of incense.

366. F. 12r: ILLUSTRATION TO EXODUS.
Under the guidance of Moses, Bezaleel is making a menorah
(seven-branched candle-holder) and vessels of gold and silver
for the sanctuary "according to all that the Lord had command-
ed". The artist reflects his own life experience in this series of
"commentary miniatures" rather than adhering precisely to the
Bible, thus making scriptural episodes into everyday scenes.

367

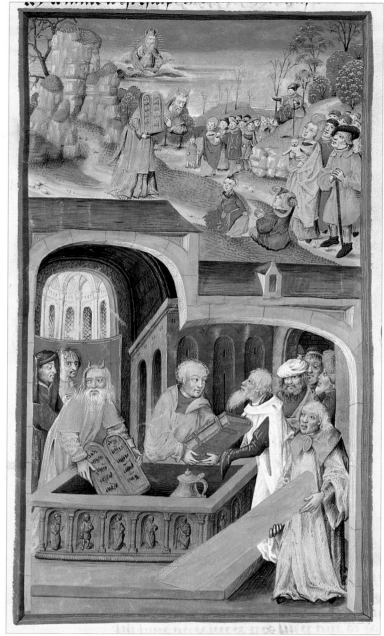

368

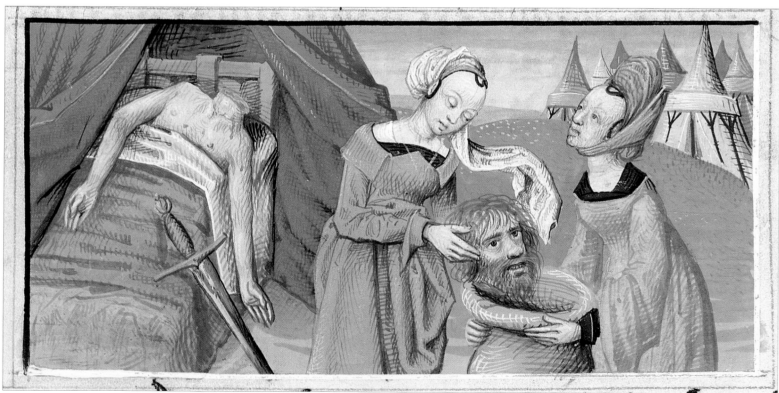

369

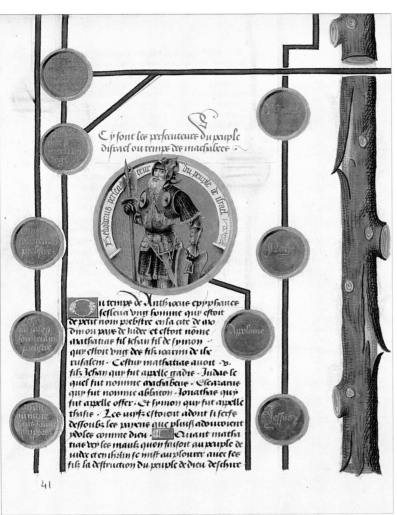

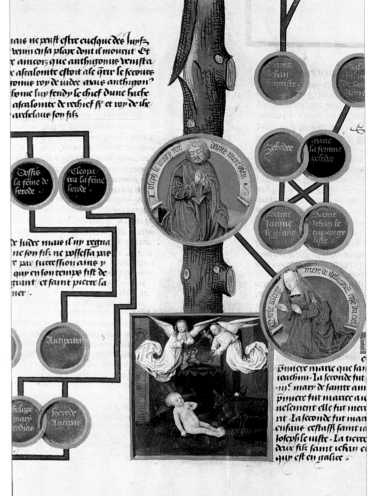

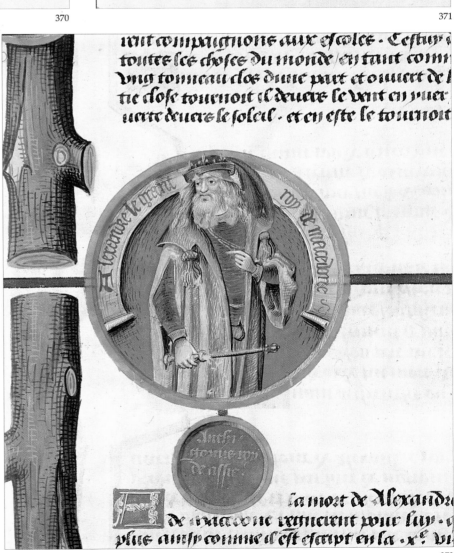

367. F. 32r: ZEDEKIAH, KING OF JUDAH.
Zedekiah rebelled against Nebuchadnezzar, King of Babylon,
but was defeated. He and "all the nobles of Judah and
Jerusalem" were either slain or carried away captive into
Babylon, and Jerusalem was set on fire. The townscape is more
reminiscent of Bruges than Babylon, and the Biblical king's
attire looks rather like stylish dress of the late 15th century.

368. F. 12v: ILLUSTRATION TO EXODUS.
In the upper part Moses is descending from Mount Sinai with
the Tables of the Law; in the lower part he deposits them in the
Ark of the Covenant.

**369. F. 35v: ILLUSTRATION TO THE STORY
OF JUDITH.**
The miniature shows Judith with the severed head of
Holophernes and her maid ready with a sack into which they
put the grisly trophy.

**370. F. 41r: HELIODORUS, PERSECUTER
OF THE PEOPLE OF ISRAËL.**
Heliodorus is shown in the full armour of a knight, but with a
curved Saracen sword hanging from his waist: according to
legend, he was an official at the court of the Syrian Seleucid
kings.

371. F. 47r: END OF THE MANUSCRIPT.
The Tree of Jesse is completed by three miniatures: in the
upper one is Joseph, husband of the Virgin; the side medallion
depicts the Virgin, Mother of Jesus Christ; and the miniature at
the bottom shows the Infant Christ. All three miniatures form a
composition of the Nativity of Christ. The artist very skilfully
included into the lower miniature the separate subject of the
Annunciation to the Shepherds.

**372. F. 39v: ALEXANDER THE GREAT, KING
OF MACEDONIA.**

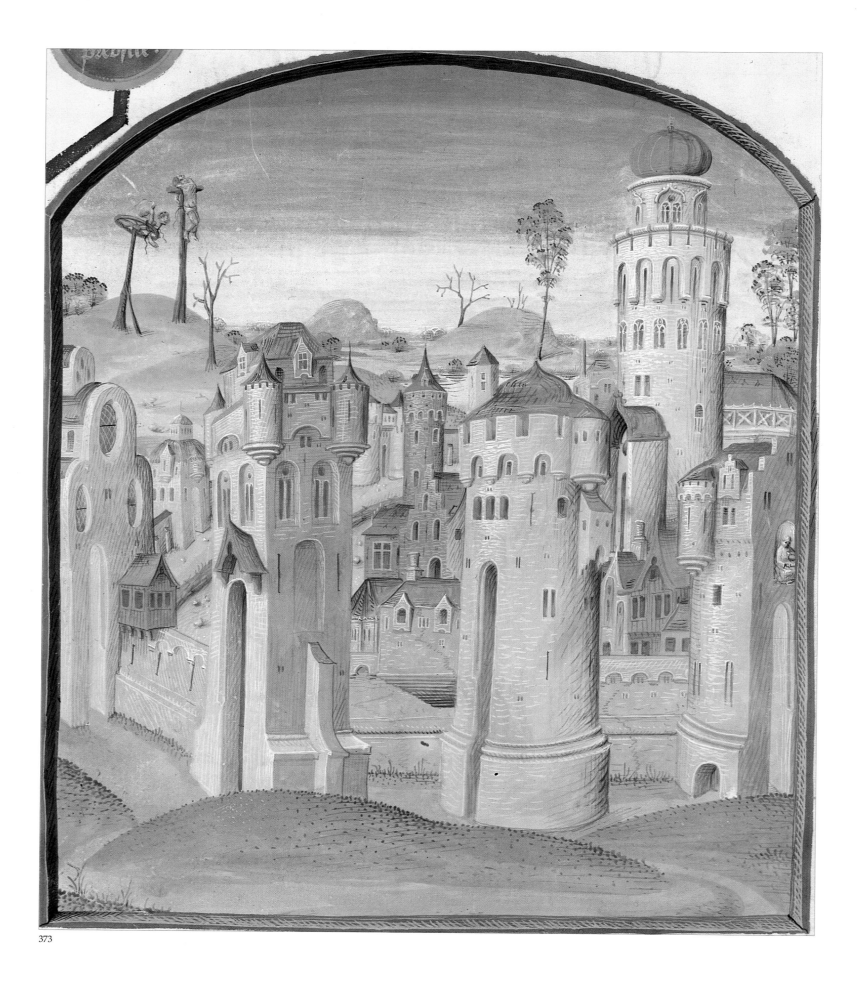

373

373. F. 36r: ILLUSTRATION
TO THE DESCRIPTION OF THE HOLY CITY
OF JERUSALEM AND ITS GATE.

374
OVID. MATAMORPHOSES
Metamorphoses d'Ovide

The Netherlands (Bruges). Late 15th century.

254 ff. 450 x 335 mm (text 265 x 195 mm). Parchment. French.
1 half-page miniature; numerous large red and blue initials with gold. The illumination is incomplete: spaces are left blank inside the initials, and 48 blank spaces at the beginning of the books and sections were left to be filled with miniatures. Binding: 18th century. Dark red leather over cardboard; gold-tooled border and centrepiece; banded spine with a gold-tooled design; marbled-paper fly-leaves; gilt-edged; ex libris of Piotr Suchtelen.
Fr.F.v.XIV.1.

The manuscript is a French prose version of 15 books of Ovid's Metamorphoses. There are numerous translations of the "Bible of the poets", as Ovid's masterpiece is often called in both prose and verse. The manuscript was commissioned by Wolfert van Borssel, a knight of the Order of the Golden Fleece (his coat of arms is depicted under the miniature on f. 13r) who was also related to the famous bibliophile Louis de Brugge (also named Maître de Marguerite d'York).

The miniature is a good example of late 15th-century Flemish illumination and dates to before 1487 (the year of Wolfert van Borssel's death). Having compared it with miniatures in the Utrecht manuscript of St Augustine's *The City of God* (MS.lat.42), Laborde felt justified in placing the execution of the *Metamorphoses* in Bruges or Ghent (but more probably the former). The Bibliothèque Nationale in Paris has a copy from the collection of Louis de Brugge which in all likelihood is related to the St Petersburg manuscript and was probably copied from it. Laborde hypothesized that the St Petersburg volume might have been handled by the famous bibliophile Antoine of Burgundy who married Anna, daughter of Wolfert van Borssel. Piotr Suchtelen purchased the manuscript at the sale of the Meerman library in The Hague in 1824.

ENTERED THE PUBLIC LIBRARY IN 1836 WITH THE COLLECTION OF PIOTR SUCHTELEN.

LITERATURE : Catalogus codicum manuscriptorum quos reliquit vir nob Iohannes Meerman, Bibliotheca Meermanniana, vol. 4, The Hague, Amsterdam, Leyden, 1824, p. 145, No 841; Bertrand 1874, p. 171; Laborde 1936–38, pp. 117, 118, pl. XLIX; Shishmariov Fund 1965, p. 37.

374. F. 13r: A VISIT TO A HUMANIST WRITER.
The nobleman visiting the author (or translator) with his wife and court is probably Wolfert van Borssel. Such scenes of visits are typical of the style of the Burgundian court.
Behind the scholar are seven allegorical figures of planets.
Venus, Mars, Mercury, Nepture, Saturn, Uranus and Jupiter.

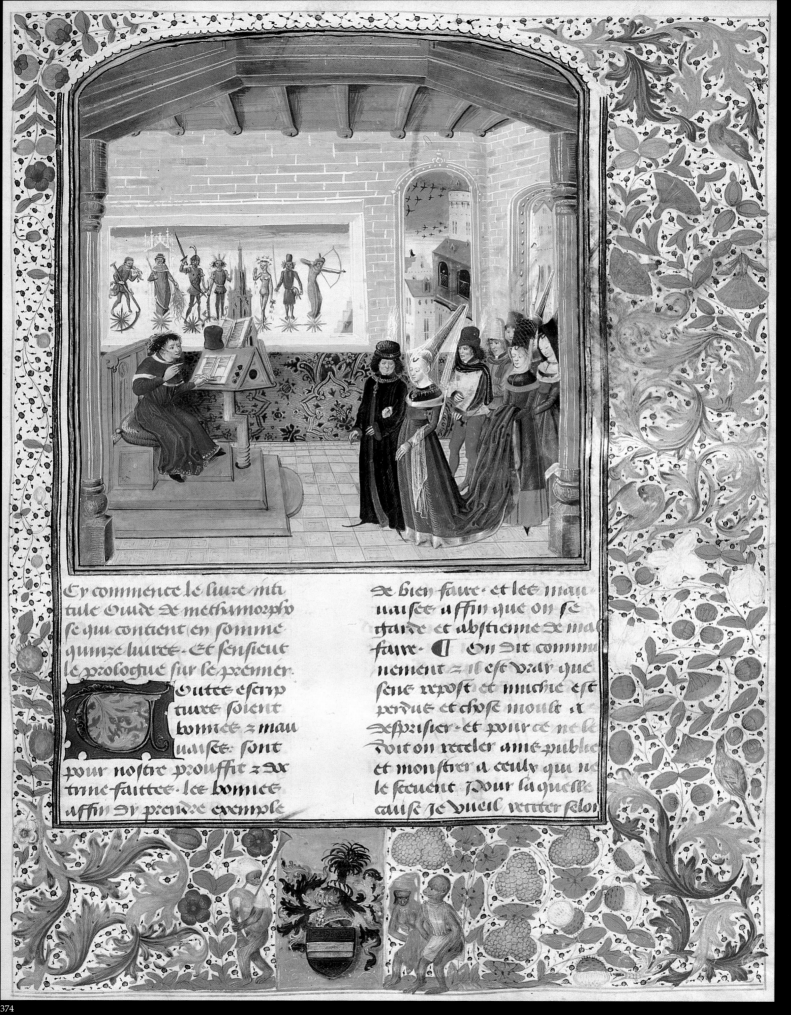

Cy commence le liure inti
tule Ouide de methamorpho
se qui content en somme
quinze liures. Et sensieut
le prologue sur le premier

Toutes escrip
tures soient
bonnes z mau
uaises. sont
pour nostre prousfit z de
tine faittes. Les bonnes
affin pr prende exemple

de bien faire. et les mau
uaises affin que on se
tarde et abstienne de mal
faire. ¶ On dit commu
nement z il est vray que
sens repost et richie est
perdue et chose moult a
desprisier. et pour ce ne le
doit on celeler ains publier
et monstrer a ceulx qui ne
le seuuent. pour laquelle
cause je vueil rciter selon

Avril, Reynaud
F. Ávril, N. Reynaud, *Les manuscrits à peintures en France*, 1140-1520, Paris, 1993

Barrois 1830
J. Barrois, *Bibliothèque protypographique, ou Librairies des fils du roi Jean, Charles V, Jean de Berri, Philippe de Bourgogne et les siens*, Paris, 1830

Bernadskaya
Description
Italian humanists' manuscripts housed in the Saltykov-Chtchedrine Public Library, Leningrad. Description, in : The Middle Ages, Moscow, 1984-1985 (in Russian)

Bertrand
G. Bertrand, *Catalogue des manuscrits français de la Bibliothèque de Saint-Pétersbourg*, Paris, 1874

Delisle
L. Delisle, *Le Cabinet des manuscrits de la Bibliothèque Impériale (Nationale)*, Paris, 1868–81, 4 vols.

Dobias-Rozdestvenskaïa
The Earliest Latin Manuscripts of the Public Library. Catalogue. Part 2 (8th - early 9th century). Edited by O. Dobias-Rozdestvenskaïa, Leningrad, 1965 (in Russian).
Exhibition
O. Dobias-Rozdestvenskaïa, "Exhibition of the illustrated Books of Hours of the Public Library", in *Librarian Revue*, 1927, Leningrad, Books 1-2, (in Russian).

Dobias-Rozdestvenskaïa, Lioublinskaïa
French Miniatures
O. Dobias-Rozdestvenskaïa, A. Lioublinskaïa, *The French Miniatures issuing from the seven codex of the Public Library*, in : Literary Heritage, Moscow, 1939, vol. 33/34, p. 861-869 (in Russian)

Doutrepont 1906
G. Doutrepont, *Inventaire de la "Librairie" de Philippe le Bon (1420)*, Brussels, 1906

Gille 1860
F. Gille, *Musée de l'Ermitage Impérial. Notice sur la formation de ce musée et description des diverses collections qu'il renferme*, St Petersburg, 1860

Gillert 1880; 1881
K. Gillert, "*Lateinische Handschriften in St. Petersburg*", in : Neues Archiv v. 5, n°s 2–3 ; 1881; v.6 n°3.

Golenichtchev-Koutouzov
I.Golenichtchev-Koutouzov, *Latin literature of the Middle Ages in Italy*, Moscow, 1972 (in Russian).

Shishmariov Fund
The V. Shishmariov Fund in the Archives of the Academy of Science of the Soviet Union, (Description and works published). Edited by M. Borodina and B. Malkevitch, in : *Works of the Archives of the Academy of Science of the Soviet Union*, Moscow-Leningrad, 1965, facs.21 (in Russian).

Laborde
A. de Laborde, *Les principaux manuscrits à peintures conservés dans l'ancienne Bibliothèque Impérial publique de Saint-Pétersbourg*, Paris, 1936–38, parts 1, 2.

Latin Manuscripts of the 5th - 8th centuries
The latin manuscripts of the 5th - 8th centuries in the Saltykov-Chtchedrine Public Library. Glimpse of general catalogue of manuscripts housed in the Soviet Union. Edited by E. Bernadskaïa, T. Voronova, S. Vialova, Leningrad, 1938 (in Russian).

Le Monde de l'Art
P. Nikolaiev, "Poetry of the Middle Ages in Miniatures", in *Le Monde de l'Art*, 1904, n° 6 (in Russian)

Meiss The Late 14th Century
M. Meiss, *French Painting in the Time of Jean de Berry: The Late 14th Century and the Patronage of the Duke*, London, 1968-1974.

Meiss The Limbourgs
M. Meiss, *The Limbourgs and Their Contemporaries*, New York, 1974

Mokretsova, Romanova
1200-1270
I. Mokretsova, V. Romanova, *French Illuminated Manuscripts of the 13th century in the collections of the Soviet Union.* 1200–1270, Moscow, 1983 (in Russian).

Mokretsova, Romanova
1270-1300
I. Mokretsova, V. Romanova, *French Illuminated Manuscripts of the 13th century in the collections of the Soviet Union.* 1270–1300, Moscow, 1984 (in Russian).

Montfaucon
B. Montfaucon, *Bibliotheca bibliothecarum manuscriptorum nova*, Paris, 1739, vol. 2.

Romanova
V. Romanova, *Manuscripts and Gothic Script in the 13th and 14th centuries in France*, Moscow, 1975, (in Russian).

Seguier
Catalogue des manuscrits de la bibliothèque de défunt monseigneur le chancelier Séguier, Paris, 1686, p. 119, 48, 36, 45.

Seguier
Inv. des miniatures
Catalogue des manuscrits de la bibliothèque de défunt Monseigneur le Chancelier Séguier, Paris, 1686, p. 1-48.

Shishmariov
Vestiges of the Library of René d'Anjou
V. Shishmariov, *Les vestiges of the Library of René d'Anjou, in the collections of the department of manuscripts of the Public Library*, in : The Middle Ages through the manuscripts of the Public Library. Facs. 2. Edited by O. Dobias-Rojdestvenskaïa, 1927 (in Russian).

Shishmariov
Text Book
V. Shishmariov, *The Text Book on the history of the French language. 9th - 15th centuries*, Moscow-Leningrad, 1955 (in Russian).

Staerk
A. Staerk, *Manuscrits latins des Ve - XIIe siècles conservés à la Bibliothèque impériale de Saint-Pétersbourg*, St Petersburg, 1910, 2 vol.

Yaremitch
S. Yaremitch,"Western European Illuminated Manuscripts in the manuscripts of the 13th - 16th centuries", in : *Starye Gody*, January 1914 (in Russian).

Zimmerman
E. H. Zimmermann, *Vorkarolingische Miniaturen*, Berlin, 1916